Mark Evans

Impressions of Venice
from Turner to Monet

National Museum of Wales/Cardiff
in association with
Lund Humphries/London

Contents

First published in Great Britain in 1992 by
National Museum of Wales
Cathays Park
Cardiff CF1 3NP
in association with
Lund Humphries Publishers
Park House
1 Russell Gardens
London NW11 9NN

on the occasion of the exhibition
IMPRESSIONS OF VENICE
FROM TURNER TO MONET
Museum of the North, Llanberis, 25 July to 20 September 1992
National Museum of Wales, Cardiff, 3 October to 15 November 1992

British Library Cataloguing-in-Publication Data
A catalogue record for this book is available from the British Library

Lund Humphries ISBN: 0 85331 626 0
National Museum of Wales ISBN (English-language edition): 0 7200 0368 7
National Museum of Wales ISBN (Welsh-language edition): 0 7200 0369 5

Frontispiece: Map of Venice, from K. Baedeker, *Northern Italy: Handbook for
Travellers*, Leipzig 1913, between pp.340 and 341

Designed by Alan Bartram
Made and printed in Great Britain by
Balding + Mansell plc, Wisbech

Foreword

The idea for *Impressions of Venice* was suggested by a previous exhibition. In the winter of 1990-91 the National Museum of Wales was host to *The Royal Collection: Paintings from Windsor Castle*. This memorable display, generously lent by Her Majesty the Queen, included thirteen paintings of Venice by Canaletto. At Cardiff these works provided a remarkable contrast with later views of the same city by Eugène Boudin, Claude Monet, W. R. Sickert and J. M. Whistler, bequeathed to the Museum by Gwendoline and Margaret Davies. The Davies sisters were fascinated by Venice and the six paintings of the city which they purchased in 1912-13 were the first Impressionist works to enter their collection, laying the foundations of its principal area of strength.

Arguably the most 'international' city in Europe, Venice has presented many faces over the centuries. This exhibition traces the transformation of Canaletto's classic image of the city during the nineteenth and early twentieth centuries, concentrating on a small but particularly international group of artists: Bonington, heir to the English watercolour tradition and French Romanticism; Turner, constantly touring Europe in search of landscape inspiration; Whistler, Sargent and Sickert, all equally at home in Britain, France and Italy; Boudin, the pioneer of *plein-air* painting; Monet, whose work elicited the term 'Impressionism', and Alvin Langdon Coburn, a leading American photographer who became a British citizen and retired to Wales. Their perception was coloured by the writings of two great authors: John Ruskin and Henry James. Although only Monet could literally be described as an Impressionist, all were fascinated by the transient effects of light, air and water. These were invested with a unique significance by the remarkable topography of the maritime city of Venice.

Venice is a particularly appropriate subject for the momentous year of 1992, which sees the abolition of tarif barriers. This exhibition could not have been realised without the generosity of a dozen individuals and institutions from throughout the United Kingdom and Ireland who have lent works. The Council of the National Museum would like to express its gratitude for their willingness to share. We are also especially grateful to the organisers of the European Arts Festival, which marks the United Kingdom's Presidency of the European Community between July and December 1992. *Impressions of Venice* could not have been presented without their generous support.

Unlike the citizens of Venice, the people of Wales are widely spread. I am pleased that this major exhibition will be seen in North Wales, before transferring to Cardiff. *Impressions of Venice* should attract many visitors from the Principality and further afield. I hope they will return in 1993 to see the new art galleries in the main building of the National Museum of Wales, which will provide a fitting and permanent home for the renowned paintings and sculpture from the Davies Bequest.

THE HONOURABLE JONATHAN DAVIES
President
National Museum of Wales

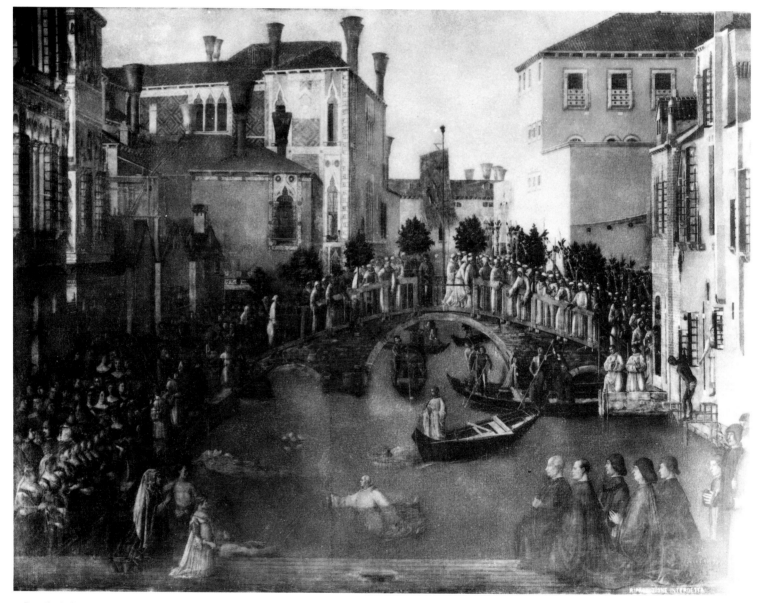

1 Gentile Bellini, *The Miracle of the Reliquary of the True Cross* (Venice, Accademia). Alinari photograph of *c*.1880 from the collection of George Henfrey. Cardiff, National Museum of Wales

Introduction

The Prospect of Venice: Painters, Commentators and Collectors from the Age of Enlightenment to the Eve of the First World War

For nearly two hundred years, from the late fourteenth century to the middle of the sixteenth century, Venice was the principal mercantile and industrial city in Europe, the centre of 'the world economy'.[1] Even after the Habsburg domination of the western Mediterranean and the rise of England and the Dutch Republic, she remained a major but declining power until the Treaty of Passarowitz in 1718. Today, this past economic supremacy is reflected most clearly in the city's extraordinary architectural wealth: from the Doge's Palace, begun in 1340, to Santa Maria della Salute, completed in 1687. During the seventeenth century the rising powers of northern Europe courted Venice as a potential ally; a republican trading city in Counter-Reformation Italy. Sir Henry Wotton, English ambassador from 1604 until 1610, eulogised the longevity of its political institutions and the wisdom and justice of its government.[2] Its state university in Padua, where Galileo taught from 1592, was sought out by Protestant visitors such as William Harvey as a principal centre for the study of medicine, mathematics and the natural sciences.[3]

During his stay in the Veneto, Wotton collected pictures for Sir Robert Cecil and engaged the French merchant Daniel Nys to look for suitable acquisitions. In 1626-30 the latter was instrumental in the purchase by Charles I of the finest collection in North Italy, that of the Gonzaga of Mantua, for the enormous sum of £30,000.[4] The royal collection was dispersed after the King's execution in 1649 with the result that such paintings as Titian's moving *Entombment*, purchased by Louis XIV, now grace the Louvre. The visit to Italy in 1613-14 of Charles's favourite architect, Inigo Jones, had a permanent and much more pervasive influence upon British culture. Entranced by the villas of Andrea Palladio in Vicenza and his churches in Venice, Jones designed the Banqueting House, Whitehall of 1619-22 and a handful of other buildings which transplanted the architecture of humanism to Stuart England.[5]

Venetian Renaissance masters and later painters, especially Palma Giovane, Domenico Fetti and Pietro Liberi, were popular with seventeenth-century British collectors, including Lord Fielding, ambassador to Venice from 1634 to 1639, Sir Peter Lely, court painter to Charles II, and the Earl of Exeter, who visited Italy during the 1680s.[6] In 1709 the English ambassador Lord Manchester returned from Venice with the painters Giovanni Antonio Pellegrini and Marco Ricci, whom he initially employed to paint scenes for Scarlatti's opera of *Phyrrus and Demetrius* and to decorate his mansions in London and Huntingdonshire.[7] After a brief visit to Venice, in 1713 Ricci returned with his uncle Sebastiano to London, where they enjoyed lucrative patronage from mainly Whig nobles and gentlemen until 1716. At about the same time, the architecture of Palladio and Inigo Jones was being rediscovered by the Neo-Palladians, Colen Campbell, Lord Burlington and William Kent. They and their followers dominated British architecture during the first half of the eighteenth century, re-casting the English country house in the Palladian form which predominates to the present day.[8]

The origins of Venetian topographical art may be traced back to the turn of the fifteenth and sixteenth centuries and such works as Vittore Carpaccio's *Miracle of the Reliquary of the True Cross* of 1494, Gentile Bellini's painting of the same subject, dated 1500 (both Venice, Accademia) [fig.1] and Jacopo de' Barbari's huge woodcut *View of Venice* of 1498-1500. It is noteworthy that the last, the most famous 'map' of Venice of all time, was published by an expatriate German merchant, Jacob Kolb – a combination of Venetian talent and northern capital which foreshadows Consul Smith's activities over two centuries later.[9] During the seventeenth century, Dutch painters such as Pieter Saenredam and Jan van der Heyden transformed architectural painting.[10] The freshness and accuracy of their vision was first applied to the Venetian scene by the expatriate Dutchman Gaspar van Wittel, known as Vanvitelli, who visited the city in 1694/95.[11] At the turn of the seventeenth and eighteenth centuries, the Venetian townscape was effectively reinvented by the painter, etcher, architect and mathematician Luca Carlevarijs.[12] When Lord Manchester arrived in Venice on his second embassy in 1707, he employed Carlevarijs to record his entry in a monumental painting (Birmingham, City Art Gallery).[13]

Giovanni Antonio Canal, called Canaletto, was born in Venice in 1697. The son of a theatrical scene painter, he accompanied his father to Rome and returned to his home city in 1720/22. His reputation grew swiftly: in 1725 the Veronese painter Alessandro Marchesini advised the Lucchese collector Stefano Conti against purchasing views by Carlevarijs, recommending instead 'Sigr. Antonio Canale, who astounds everyone who sees his work in this city – it is like that of Carlevarijs, but you can see the sun shining in it'.[14] An exceptionally large but otherwise representative Canaletto of the late 1720s is the view from the Giudecca of the *Bacino di*

San Marco, in the National Museum of Wales [fig.2].[15] This work has the painterly handling and dramatic lighting contrasts which distinguish his earlier paintings. Later works, produced under the pressure of excessive demand, are more blandly illuminated. George Vertue recognised this falling-off in quality as early as 1749 when he described the pictures which Canaletto was then producing as 'much inferior to those done abroad, which are surprizingly well done and with great freedom and variety'.[16]

From the beginning of his career Canaletto had British patrons. The first was the Irish actor, impresario and art agent Owen McSwinny. In about 1720, acting on behalf of Lord March, later Duke of Richmond, McSwinny engaged a team of Bolognese and Venetian artists, including Sebastiano and Marco Ricci as well as Canaletto, to paint a series of large canvases depicting allegorical tombs of famous Englishmen associated with the Glorious Revolution of 1688.[17] By 1730 Canaletto's agent with British clients was Joseph Smith, a merchant, banker and subsequently Consul, who had been resident in Venice since the beginning of the eighteenth century.[18] Previously a collector of works by the Ricci and the portraitist Rosalba Carriera, Smith assembled a huge collection of Canaletto's paintings, many of which he published in a series of engravings between 1735 and 1744. Partly through Smith's agency, Englishmen such as Samuel Hill, Bishop Howard, the Earl of Essex and the Dukes of Leeds and Bedford became Canaletto's principal customers. Encouraged by these sales, the artist spent most of the period 1746-55 in England, painting views of London and country seats. The largest single purchase of his work occurred in 1762, when George III paid £20,000 for Consul Smith's collection, which included more than 50 Canaletto oils and 140 drawings, to furnish his new residence at Buckingham House.[19]

The seemingly inexhaustible appetite of British collectors for Canaletto's views of Venice is comparable in some respects with their enthusiasm for an earlier and very different landscape painter – Claude Lorraine. Claude's carefully arranged compositions of landscape motifs present an arcadian vision of nature which was profoundly influential on the gardens of Capability Brown as well as British landscape painting from Wilson to Constable. Utilising Venice's unique topography, Canaletto's paintings present a similarly varied but idealised townscape, replete with the classicising and often specifically Palladian buildings so influential upon English architecture during the eighteenth century. His *vedute* were so compelling that when British visitors arrived in Venice for the first time, they could not but view the city through his eyes. In 1785 Mrs Hester Lynch Piozzi found that Venice 'revived all the ideas inspired by Canaletti, whose views of this town are most scrupulously exact; those especially which one sees at the Queen of England's house in St James's Park; to such a degree indeed, that we knew all the famous towers, steeples, etc before we reached them. It was wonderfully entertaining to find thus realized all the pleasures that excellent painter had given us so many times to expect.'[20]

During the age of the Grand Tour, the classical antiquities of Rome and Naples were the principal destinations of visitors to Italy, but Venice remained a frequent destination. Joseph Addison summarised its more hedonistic pleasures in his *Remarks on Several Parts of Italy, &c.*, published at the beginning of the eighteenth century:

Venice has several Particulars, which are not to be found in other Cities, and is therefore very entertaining to a Traveller. It looks, at a distance, like a great Town half floated by a Deluge. There are Canals every where crossing it, so that one may go to most Houses either by Land or Water. This is a very great Convenience to the Inhabitants; for a *Gondola* with two oars at *Venice*, is as magnificent as a Coach and six Horses with a large Equipage ... The Carnival of *Venice* is every where talk'd of. The great Diversion of the Place at that time, as well as on all other high Occasions, is Masking. The *Venetians*, who are naturally Grave, love to give into the Follies and Entertainments of such Seasons, when disguised in a false Personage ... These Disguises give Occasion to abundance of Love-Adventures; for there is something more intriguing in the Amours of *Venice*, than in those of other Countries; and I question not but the secret History of a Carnival would make a Collection of very diverting Novels.[21]

Addison and later authors were as disturbed by the ruthlessness of Venetian government as they were impressed by its efficiency, but Lady Mary Wortley Montagu was relieved that it did not impose petty indignities upon foreigners, such as searching their books for items on the papal index, as happened in Tuscany. Resident in Venice in 1739-40, Lady Mary wrote numerous letters which provide a vivid picture of Venetian high society, the Carnival and Regatta.[22] In June 1740 she complained of how Venice was '... at present infested with English who torment me as much as the frogs and lice did the palace of Pharoah, and are surprized that I will not suffer them to skip about my house from morning till night'.[23] This seems to have remained true throughout the eighteenth century, as during his visit to Venice in 1786 Goethe commented on a new play at the Teatro San Luca, *L'Inglicismo in Italia*: 'Since there are a great many Englishmen living in Italy, it is only natural that notice should be taken of their behaviour, and I hoped to hear what the Italians think about their wealthy and welcome guests. But the play amounted to nothing.'[24]

That Venice was in severe decline had already been apparent to Addison at the beginning of the century:

Our Voyage-Writers will needs have this City in great Danger of being left, within an Age or two, on the *Terra firma*; and represent it in such a manner, as if the Sea was insensibly shrinking from it, and retiring into its Channel ... their Trade is far from being in a flourishing Condition for many Reasons. The Duties are great that are laid on Merchandises. Their Nobles think it below their Quality to engage in Traffic. Their Merchants who are grown rich, and able to manage great Dealings, buy their Nobility, and generally give over Trade. Their Manufactures of cloth, Glass, and Silk, formerly the best in *Europe*, are now excell'd by those of other Countries. They are tenacious of old Laws and customs to their great Prejudice, whereas a Trading Nation must be still for new Changes and Expedients, as different Junctures and Emergencies arise ... This Republic has been much more powerful than it is at present, as it is still likelier to sink than increase in its Dominions.[25]

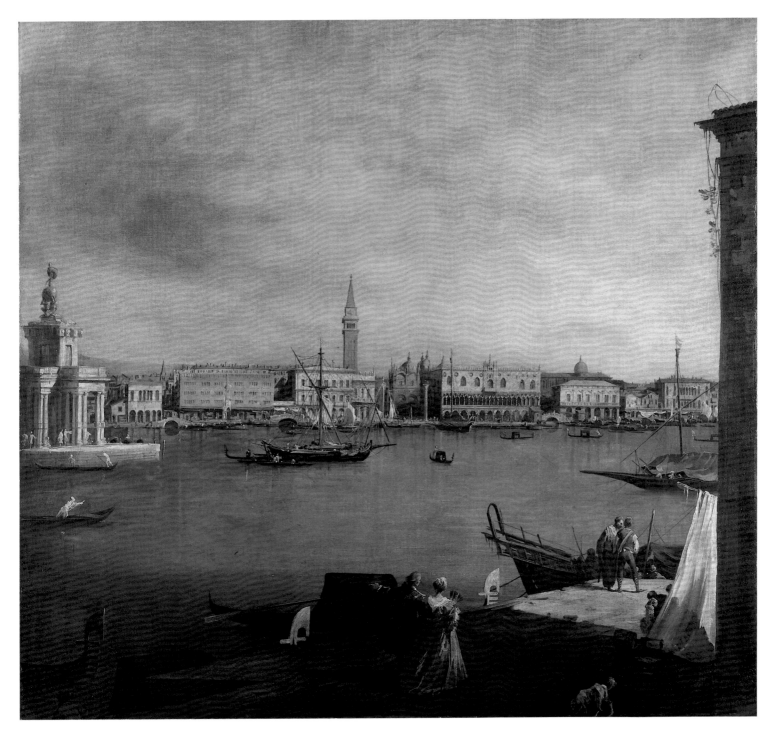

2 Antonio Canaletto, *Venice, Bacino di San Marco, looking North*. Oil on canvas, *c*.1728-30. Cardiff, National Museum of Wales

The end of the Republic came in May 1797 when Napoleon defeated the Austrian army in North Italy. Lacking its own forces, the Great Council of Venice submitted and the last Doge resigned. French troops occupied the city, removing numerous works of art, including the bronze horses of St Mark's. William Wordsworth's sonnet *On the Extinction of the Venetian Republic*, published in 1807, nostalgically recalled Venice's independent republican past.[26]

Once did She hold the gorgeous East in fee;
And was the safeguard of the West; the worth
Of Venice did not fall below her birth,
Venice, the eldest Child of Liberty.
She was a Maiden City, bright and free;
No guile seduced, no force could violate;
And when She took unto herself a Mate
She must espouse the everlasting Sea.

And what if she had seen those glories fade,
Those titles vanish, and that strength decay,
Yet shall some tribute of regret be paid
When her long life hath reach'd its final day:
Men are we, and must grieve when even the Shade
Of that which once was great is pass'd away.

Initially ceded to Austria, Venice was reclaimed by France in 1805. It remained part of Napoleon's Kingdom of Italy until 1815, when it was returned to Habsburg control. Throughout the Republican and Napoleonic Wars, European travel had been severely restricted. Accordingly, the end of hostilities witnessed a flood of visitors to Italy. New arrivals such as Lady Morgan found a Venice very different to that immortalised by Canaletto and Lady Mary Wortley Montagu: a city sadly reduced by years of foreign occupation and naval blocade. As she observed in *Italy*, published in 1821:

Every pre-conceived idea of Venice, as a city or a society, belongs purely to the imagination. One is apt to consider it as the seat of some giddy authority, whose councils are debated amidst the orgies of '*midnight mirth and jollity*', where time consumes itself in endless revels, and love is the religion, and pleasure the law of the land! where the nights are all moonlight, the days all sunshine; and where life passes in perpetual carnival, under the fantastic guise of a domino and mask ... that moment is now over; and such images of desolation and ruin are encountered, in every detail of the moral and exterior aspect of the city, as dissipate all visionary anticipations, and sadden down the spirit to that pitch, which best harmonizes with the misery of this once superb mistress of the waves.[27]

Lady Morgan squarely attributed this collapse to Austria:

Beneath the active despotism of France, the Venetians had at least a chance of recovering some of those qualities, of which time and accident had bereaved them; but the leaden sway of Austria, even where its intentions are the purest, is little calculated to better the condition of humanity; – and to Venice all its policy is notoriously sinister ... the Austrian Cabinet, from its first possession of the Venetian territory, has directed all its energies to the destruction of a city whose proximity may one day become dangerous to its other possessions; and every effort has been, and continues to be made, to annihilate its trade, and to force commerce into other channels, more certainly within the grasp of the Imperial eagle ... Throughout every department of the state, Germans alone preside. At the period of our visit not a single Venetian was at the head of any one branch of government, save only the President of the Academy of Arts ... While commercial restrictions throw every impediment in the way of making money, an heavy and oppressive taxation has gradually drained the Venetian territory of its currency ... The Venetians, thus plundered of their last sequin, are rendered incapable of conducting the great public works which are absolutely necessary for the preservation of their city. The lagunes are gradually filling up, and the houses falling into the canals, from the impossibility of renewing the piles on which they stand. The population, which at the extinction of the Republic was one hundred and forty thousand, is reduced to an hundred thousand ... Within the last twenty years, twenty-four of the large palaces have been sold and demolished; and the folorn and dismantled condition of those which remain, but too plainly indicates their approaching fate ... Should the present political influence continue, its fate as a city would soon be decided:

it would vanish from the view of its oppressors. Of this monument of a thousand years of glory not a wreck would remain; the waves of the Adriatic would close over the palaces of the Foscari and the Priuli; and the works of Sansovino and Palladio would sink into the Lagunes, where now they already moulder in premature decay.[28]

Contemporary French commentators were equally pessimistic. In *Un mois à Venise* published in 1825, the Comte de Forbin stated: 'Venice, it can be affirmed conclusively, is now in a state of agony: the sea will soon reconquer what the genius of man has torn from her; the lion of San Marco will be an effigy covered by the waves'.[29] Antoine Valery observed in *Voyages historiques et littéraires en Italie*, published in 1831:

The aspect of Venice has something in it more gloomy than that of ordinary ruins: nature lives still in the latter, and sometimes adds to their beauty, and although they are the remains of by-gone centuries, we feel they will live for centuries to come ... here these new ruins will rapidly perish ... No time ought to be lost in visiting Venice, to contemplate the works of Titian, the frescoes of Tintoretto and Paolo Veronese, the statues, the palaces, the temples ... tottering on the verge of destruction.[30]

However, such was the aesthetic of Romanticism that Valery continued: 'There is a soft and melancholy pleasure in gliding amid those superb palaces, those ancient aristocratic dwellings ... which are the memorial of so much power and glory, but are now desolate, shattered or in ruins'.[31] Lady Morgan agreed: 'Yet if the character of interest with which Venice was once visited is changed, its intensity is rather increased than lessened; and in a picturesque point of view, it never perhaps was more beautiful, or more striking, than at the present moment'.[32]

The first great Romantic artist to arrive in Venice was not a painter but a poet. Lord Byron arrived in November 1816 and remained, with a short interval at Rome, until July 1819. He rented the third Palazzo Mocenigo on the Grand Canal, south of the Rialto Bridge. Shortly after his departure to follow Teresa Guiccioli to Ravenna, Lady Morgan passed down the Grand Canal,

... the most superb and original scene that any city in the world presents, gliding in silence, which not a breath disturbed, through rows of magnificent, but decaying palaces, which with their light and beautiful arabesque balconies and casements, their marble porticoes and singular chimnies, looked as if they had been transported from some metropolis of the East, the former abode of Moslem chiefs! There was one whose dark façade was spotted irregularly with casements; the anchorage poles before its portico were surmounted with an English coronet and arms: it was now silent and deserted like the rest – 'Palazzo di Lord Byron', said the capo of our gondolieri, as we rowed by it.[33]

The exotic decay of Venice admirably suited the mood of Byron's poetry and he immortalised the Romantic vision of the city in a stanza of the fourth canto of *Child Harold's Pilgrimage*, published in 1818.[34]

I stood in Venice, on the Bridge of Sighs;
A palace and a prison on each hand:
I saw from out the wave her structures rise

As from the stroke of the enchanter's wand:
A thousand years their cloudy wings expand
Around me, and a dying Glory smiles
O'er the far times, when many a subject land
Look'd to the winged Lion's marble piles,
Where Venice sat in state, thron'd on her hundred isles! ...

In 1819 Turner briefly visited Venice, where he made numerous pencil sketches and four atmospheric watercolours of early morning with the silhouettes of buildings against the mist rising 'from out the wave' – as in Byron's poem.[35] He was initially more moved by his experiences in Rome and southern Italy, with the result that the earliest Venetian views exhibited by a British artist were the watercolours by Samuel Prout displayed at the Old Water-Colour Society and the Royal Academy in 1825-6. Although praised by Ruskin for the 'perfect apostolic faithfulness' of 'his much arrested and humble manner', the composition of his large watercolour *The Ducal Palace, Venice* of 1826 remains heavily dependent on Canaletto. Subsequently, he preferred architectural close-ups, many of which appeared in his *Sketches from Venetian History*, published in 1831-2.[36]

Bonington probably saw the portfolio which Prout brought back from his first visit to Venice when the watercolourist passed through Paris early in 1825 and during his own visit to London, later the same year.[37] He was evidently inspired by what he saw, for on his journey to Italy the following spring, his companion Baron Charles Rivet wrote 'Bonington thinks only of Venice; he makes sketches and works a little everywhere, but without satisfaction and without interest in the country'.[38] At Venice in April and May 1826 they encountered poor weather which made working difficult. This problem is only obliquely alluded to by the swollen clouds hurrying across the sky in Bonington's views, which are illuminated by limpid spring light. He had no inclination to make extreme weather conditions the subject of paintings, as did Turner. However, the airy clarity of the watercolours and oil sketches which Bonington painted on the Venetian canals has little precedent, save for the studies Thomas Jones made in Naples some forty years earlier.[39]

When first exhibited in 1827 and 1828, Bonington's Venetian compositions proved highly successful, inevitably inviting comparison with Canaletto. In 1831 Antoine Valery observed:

The paintings of Canaletto have so familiarised us with the harbour, the squares, and monuments of Venice that when we penetrate into the city itself, it appears as if already known to us. Bonington, an English artist of melancholy cast, has painted some new views of Venice, in which is most perfectly sketched its present sense of desolation; these, compared with those of the Venetian painter, resemble the picture of a woman still beautiful, but worn down by age and misfortune.[40]

Valery probably found Bonington's paintings melancholic on account of their tendency to dwell on Gothic architectural details and because they depict a quiet, emptier Venice than that in which Canaletto set his festivals and regattas.

Turner's first oil painting of a Venetian subject, *Bridge of Sighs, Ducal Palace and Custom-House, Venice: Canaletti Painting* (London, Tate Gallery), was exhibited at the Royal Academy in 1833. Contemporary reviewers claimed that it had been painted in a matter of days as a *riposte* to Clarkson Stanfield's much larger *Venice, from the Dogana* (coll. Earl of Shelburne) in the same exhibition.[41] Although Turner was painting from memory, his sparkling light effects of sunshine reflected off the polychrome marble façade of the Doge's Palace on the surface of the water before the Molo are remarkably vivid. The painting's title indicates that it was intended it as an act of homage to Canaletto, who is depicted calmly standing on a landing stage lashed to the side of the Dogana, working at an easel on a framed painting. In reality it is unlikely that the Venetian artist ever painted out-of-doors, as did Bonington – whose work Turner clearly knew. An enthusiastic reviewer claimed that Turner's painting was 'more his own than he seems aware of: he imagines he has painted it in the Canaletti style: the style is his, and worth Canaletti's ten times over'.[42] Its reflections are certainly far more lively than in any painting by Canaletto, who generally depicted water as an inert surface scored with a formal pattern of ripples.

Shortly after this work was exhibited, in September 1833 Turner returned to Venice. There he produced a series of remarkable watercolour studies on brown paper, nocturnes portraying the city in dramatic lighting: moonlight, lightning, fire, lamplight and fireworks.[43] He drew inspiration from these sketches in a series of major Venetian canvases, of which the most celebrated is *Juliet and her Nurse* (private collection), exhibited at the Royal Academy in 1836. Its composition and lighting were profoundly innovatory, depicting the Piazza San Marco from a high viewpoint at twilight, with light spilling out from the Procuratie Nuove and a low moon at the right. A reviewer attacked it as 'A strange jumble – "confusion worse confounded". It is neither sunlight, moonlight, nor starlight, nor firelight ...'[44] These comments incensed the young John Ruskin, moving him to a poetic description of the painting – his first known essay in art criticism:

Many-coloured mists are floating above the distant city, but such mists as you might imagine to be aetherial spirits, souls of the mighty dead breathed out of the tombs of Italy into the blue of her bright heaven, and wandering in vague and infinite glory around the earth they have loved. Instinct with the beauty of uncertain light, they move and mingle among the pale stars, and rise up into the brightness of the illimitable heaven, whose soft, sad blue eye gazes down into the deep waters of the sea forever, – that sea whose motionless and silent transparency is beaming with phosphor light, that emanates out of its sapphire serenity like bright dreams breathed into the spirit of a deep sleep. And the spires of the glorious city rise indistinctly bright into those living mists like pyramids of pale fire from some vast altar; and amidst the glory of the dream, there is as it were the voice of a multitude entering by the eye – arising from the stillness of the city like the summer wind passing over the leaves of the forest, when a murmur is heard amidst their multitude.[45]

The architectural monuments of Venice had been the principal subject-matter of Turner's earlier views of the city. In the watercolours which he painted during his final visit in 1840

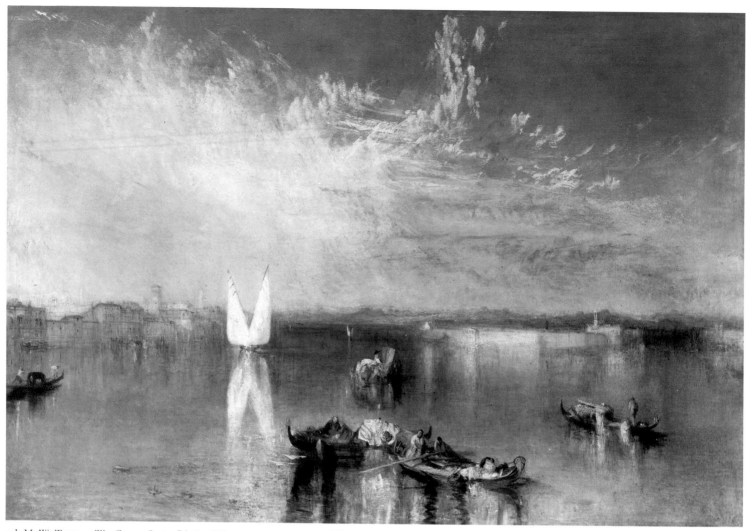

3 J. M. W. Turner, *The Campo Santo, Venice*. Oil on canvas, *c*.1840-2. Toledo Museum of Art

and the oil paintings executed after his return, the buildings slip increasingly into the distance, as the artist concentrated upon effects of sunset, sunrise, storms, reflections and haze on the water. This development is more clearly apparent in *The Campo Santo, Venice* (Toledo Museum of Art) [fig.3] than in the painting exhibited with it at the Royal Academy in 1842, *The Dogana, San Giorgio, Citella, from the Steps of the Europa* [cat. no.2], which is probably based on a drawing of 1819. The *Athaeum* reviewer was one of those who appreciated Turner's broken colours and atmospheric effects: '... the aspect of the City of Waters is hardly one iota idealised. As pieces of effect, too, these works are curious; close at hand, a splashed palette – an arm's length distant, a clear and delicate shadowing forth of a scene made up of crowded and minute objects!'[46] The *Literary Gazette* was severely critical of this revolutionary technique: '... a gorgeous *ensemble*, and produced by wonderful art, but they mean nothing. They are produced as if by throwing handfuls of white, and blue, and red, at the canvas, letting what chances to stick, stick; and then shadowing in some forms to make the appearance of a picture.'[47] Similarly 'impressionistic' effects appear in Turner's British seascapes of the 1840s [fig.4]. In a letter written from Venice in 1851 Ruskin praised *The Campo Santo, Venice* as 'the second most lovely picture he [Turner] ever painted of Venice'.[48]

John Ruskin had visited Venice with his parents in 1835 and 1841. The first volume of his *Modern Painters*, published in 1843, glorified the achievements of Turner at the expense of earlier landscape painters, including Canaletto: 'The mannerism of Canaletto is the most degrading that I know in the whole range of art. Professing the most servile and mindless imitation, it imitates nothing but the blackness of the shadows ... Canaletto possesses no virtue except that of dexterous imitation of commonplace light and shade ...'[49] Planning the second volume of *Modern Painters*, Ruskin returned in September 1845 for five weeks to study Venetian painting and architecture. He lodged, like his hero Turner, at the Hotel Europa and made numerous sketches [fig.5] while his valet took daguerrotypes of monuments. Two and a half years later, Venice underwent its most violent upheaval of the nineteenth century. In March 1848 Daniele Manin re-proclaimed the Venetian Republic and endured a siege of fifteen months and a bombardment before the Austrian General Radetzky recaptured Venice in August 1849. Three months after the capitulation Ruskin and his wife Effie visited the war-torn city, where they stayed for four months at the Hotel Danieli on the Riva degli Schiavoni while he worked on the first volume of *The Stones of Venice*. After its successful publication, they returned for eight months from September

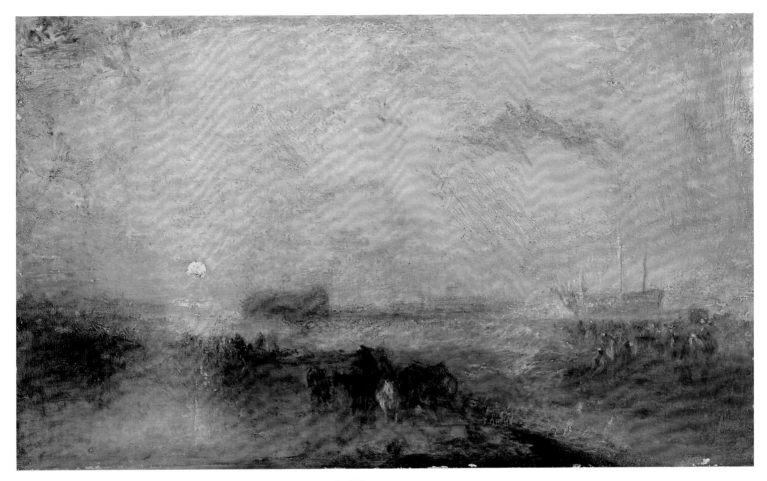

4 J. M. W. Turner, *The Day after the Storm*. Oil on canvas, *c*.1840-5. Cardiff, National Museum of Wales

1851 to July 1852, renting rooms in the Casa Wetzlar on the Grand Canal and later moving to lodgings in the Piazza San Marco. Following this period of research, the second and third volumes of *The Stones of Venice* appeared in 1853.[50]

In an appendix to the third volume, Ruskin offered a blunt rebuttal to British opponents of the Austrian regime in Venice, who had grown no less vocal since Lady Morgan, thirty years earlier:

I cannot close these volumes without expressing my astonishment and regret at the facility with which the English allow themselves to be misled by any representations, however openly groundless or ridiculous, proceeding from the Italian Liberal party, respecting the present administration of the Austrian Government ... I never once was able to ascertain, from any liberal Italian, that he had a single *definite* ground of complaint against the Government. There was much general grumbling and vague discontent : but I never was able to bring one of them to the point, or to discover what it was they wanted, or in what way they felt themselves injured; nor did I ever myself witness an instance of oppression on the part of the Government, though several of much kindness and consideration. The indignation of those of my own countrymen and countrywomen whom I happened to see during their sojourn in Venice was always vivid, but by no means large in its grounds. English ladies on their first arrival invariably began the conversation with the same remark : 'What a dreadful thing it was to be ground under the iron heel of

despotism!' ... In like manner, travellers after two or three days' residence in the city, used to return with pitiful lamentations over 'the misery of the Italian people' ... The misery of the Italians consists in having three festa days a week, and doing in their days of exertion about one-fourth as much work as an English labourer.[51]

One of Ruskin's finest works, running to over 1,200 pages, *The Stones of Venice* was a moral and political homily, a discourse in aesthetics, a history of Venetian architecture and art and a theoretical foundation for the Gothic Revival and the Arts and Crafts Movement. Its praise of Venetian Gothic entailed a violent attack on Renaissance art:

Now Venice, as she was once the most religious, was in her fall the most corrupt, of European states; and as she was in her strength the centre of the pure currents of Christian architecture, so she is in her decline the source of the Renaissance ... It is in Venice, therefore, and in Venice only, that effectual blows can be struck at this pestilent art of the Renaissance. Destroy its claims to admiration there, and it can assert them nowhere else.[52]

In 1874 in his preface to the third edition of *The Stones of Venice*, Ruskin provided a rueful anecdote which acknowledged that its success had not been entirely unmixed:

No book of mine has had so much influence on contemporary art as the Stones of Venice. ... On last Waterloo day, I was driving

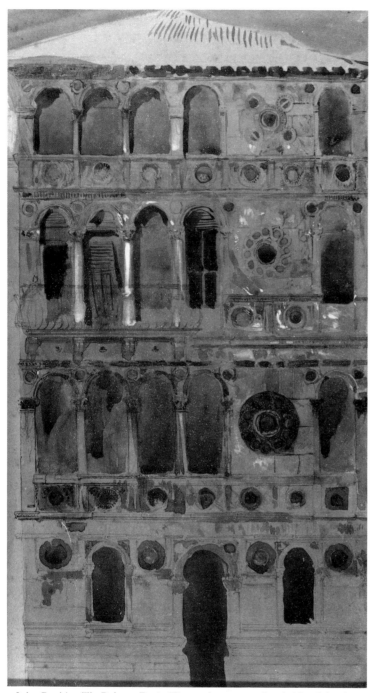

5 John Ruskin, *The Palazzo Dario*. Watercolour, 1845. Bembridge School, Ruskin Galleries

through Ealing towards Brentford just as the sun set ... and as I was watching the red light fade ... I was startled by suddenly finding, between me and the evening sky, a piece of Italian Gothic in the style of its best time ... But this good and true piece of brickwork was the porch of a public house and its total motive was the provocation of thirst, and the encouragement of idleness.[53]

Ruskin did not return to Venice until 1869, three years after the defeat of the Austrians and the unification of the city with the newly established Kingdom of Italy. Thereafter, he

returned repeatedly, working on his *Guide to the Academy at Venice*, published in 1877, and *St Mark's Rest*, which appeared in three parts between 1877 and 1884. Together with *The Stones of Venice*, reissued in an abridged 'Travellers' Edition' in 1877, these books remained the principal guides to Venice until well into the twentieth century. Ironically, having long complained of the decay of Venice's monuments, in the 1870s Ruskin found that its historic buildings were threatened with over-restoration by the Italian government. To preserve a record, he acquired plaster-casts of sculptures from St Mark's and the Ducal Palace, purchased photographs from Naya's studio [fig.6] and commissioned watercolours of mosaics and paintings from various artists.[54] Concerned that the façade of St Mark's was threatened, in 1877 Ruskin commissioned John Wharlton Bunney to paint a large canvas of its west front (Sheffield, The Ruskin Gallery, Collection of the Guild of St George) [fig.7].[55] Feeling on this issue ran so high that William Morris, the architect G. E. Street and others organised a petition against the restoration, whose signatories included Benjamin Disraeli and W. E. Gladstone.[56]

Ruskin's guides were used by an ever-widening stream of tourists and numerous artists from throughout Europe and the United States, who flooded Venice in increasing numbers following the opening of the railway bridge linking the island with the mainland in 1846. In his day, the best-known French painter of the city was Félix Ziem (1822-1911), who specialised in highly-coloured Venetian views from the beginning of his career in 1849 [fig.8]. The Impressionists, the French artists with potentially most to gain from the city's extraordinary atmospheric effects, were generally slow to visit, although Edouard Manet went there late in 1875 with his friend the painter James Tissot.[57] Manet painted little during his stay, only two small but very vivid oils of gondolas on the Grand Canal, the abrupt cropping of which foreshadows Sargent's later watercolours [fig.9].[58]

In conversation with Charles Toché at the Café Florian in the Piazza San Marco, Manet outlined plans for a painting of a regatta, which was never executed. These provide a fascinating Impressionist perspective of Venice, which would also have been appreciated by Turner:

When faced with such a distractingly complicated scene, I must first of all choose a typical incident and define my picture, as if I could already see it framed. In this case, the most striking features are the masts with their fluttering, multicoloured banners, the red-white-and-green Italian flag, the dark swaying line of boats crowded with spectators, and the gondolas like black and white arrows shooting away from the horizon; then, at the top of the picture, the watery horizon, the marked target and the islands in the distant haze. I would first try to work out logically the different values, in their nearer or more distant relationships, according to spatial and aerial perspective. The lagoon mirrors the sky, and at the same time acts as a great stage for the boats and their passengers, the masts, the banners, etc. It has its own particular colour, the nuances it borrows from the sky, the clouds, from crowds, from objects reflected in the water. There can be no sharp definition, no linear structure in something that is all movement; only tonal values which, if correctly observed, will constitute its true volume, its essential, underlying

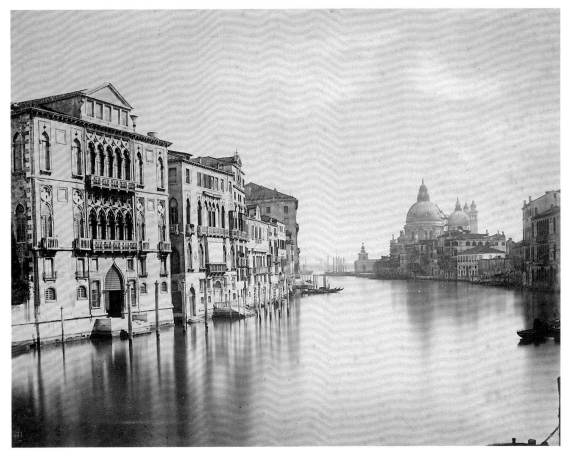

6 Naya Studio, *Venice, The Grand Canal*. Photograph, *c*.1880. Cardiff,
National Museum of Wales

7 John Wharlton Bunney, *St Mark's, from the Piazza*. Oil on canvas, 1877-82.
Sheffield, The Ruskin Gallery, Collection of the Guild of St George

8 Félix Ziem, *Venice, The Bacino di San Marco with Fishing Boats*. Oil on canvas, *c*.1865. London, The Wallace Collection

design. The gondolas and other boats, with their generally dark colours and reflections, provide a base on which to set my watery stage. The figures, seated or in action, dressed in dark colours or brilliantly vivid materials, with their parasols, handkerchiefs and hats, appear as crenellated forms of differing tonal values, providing the necessary *repoussoir* and defining the specific character of the areas of water and gondolas that I can see through them. Crowds, rowers, flags and masts must be sketched in with a mosaic of coloured tones, in an attempt to convey the fleeting quality of gestures, the fluttering flags, the swaying masts. On the horizon, right at the top, are the islands. There should be no more than a suggestion of the most distant planes, veiled in the subtlest, most accurately observed tints. Finally the sky should cover and envelop the whole scene, like an immense shining canopy whose light plays over all the figures and objects.[59]

Auguste Renoir visited Venice in late October and early November 1881, in the course of a tour of Italy. Most of the views which he painted there depict the famous sights, such as the *Grand Canal* (Boston, Museum of Fine Arts), the *Doge's Palace* (Williamstown, Clark Art Institute) and the *Piazza San Marco* (Minneapolis Institute of Arts), with bright colours and

tight, broken brushwork. The dealer Durand-Ruel purchased two of them, which were included in the seventh Impressionist exhibition in 1882, but they were not well received, being described by Armand Silvestre as 'a thoroughly bad compromise between Ziem and Monticelli'.[60] One, *Fog in Venice* [fig.10], is so different in subject and handling that it suggests contact with Whistler or, possibly, Sargent [see cat. nos 11 and 12].

John Ruskin was indirectly responsible for the arrival in Venice of a man he detested, whose interpretation of the city was more profound and influential than that of any other artist since Turner, James McNeill Whistler. *Nocturne in Black and Gold: The Falling Rocket* (Detroit Institute of Arts) and seven other pictures were exhibited by Whistler at the Grosvenor Gallery in 1877. In a review, Ruskin acidly commented:

For Mr. Whistler's own sake, no less than for the protection of the purchaser, Sir Coutts Lindsey [the proprietor] ought not to have admitted works into the gallery in which the ill-educated conceit of the artist so nearly approached the aspect of wilful imposture. I have seen, and heard, much of cockney impudence before now; but never

expected to hear a coxcomb ask two hundred guineas for flinging a pot of paint in the public's face.[61]

Whistler claimed that these comments were libellous and sued Ruskin for £1,000 damages plus costs. After a sensational court case in November 1878, judgement was found in the plaintiff's favour – but with damages of a farthing and no costs. Whistler's bankruptcy followed in May 1879. Since 1876 he had been planning to visit Venice to make a set of twelve etchings. Now in real need, he accepted a commission for the prints from the Fine Art Society with an advance of £150 to make the trip.

Arriving in Venice in September 1879, Whistler took a studio in the palatial but dilapidated Ca' Rezzonico on the Grand Canal, before moving to rooms near the Frari and, subsequently, to the Casa Jankowitz on the Riva degli Schiavoni. When pressed by a director of the Fine Art Society after the elapse of the three months originally allocated to his task, Whistler replied in January 1880:

The 'Venice' my dear Mr. Huish will be superb ... now I have learned to know a Venice in Venice that the others never seem to have perceived ... The etchings are far more delicate in execution, more beautiful in subject and more important in interest ... Then I shall bring fifty or sixty if not more pastels totally new and of a brilliancy very different from the customary watercolour – and [they] will sell – I don't see how they can help it – But then my dear Huish, the revers de la medaille: I am frozen – and have been for months – and you cannot hold a [engraver's] needle with numbed fingers, and beautiful work cannot be finished in bodily agony – Also I am starving – or shall be soon – for it must be amazing even to you that I should have made my money last this long – you had better send me fifty pounds at once and trust to a thaw which will put us all right.[62]

Huish sent the money, but nothing more until the autumn of 1880, when Whistler was finally persuaded to return to London after more than a year away.

Whistler was clearly inspired by the effects of light and colour in Venice, which he described in a letter to his mother:

Perhaps tomorrow may be fine – And then Venice will be simply glorious, as now and then I have seen it – After the wet, the colours upon the walls and their reflections in the canals are more gorgeous than ever – and with the sun shining on the polished marble mingled with the rich toned bricks and plaster, this amazing city of palaces becomes really a fairy land – created one would think especially for the painter. The people with their gay gowns and handkerchiefs – and the many tinted buildings for them to lounge against or pose before, seem to exist especially for one's pictures – and to have no other reason for being![63]

Using a large gondola filled with working materials as a mobile studio, Whistler sought his 'Venice in Venice that the others never seem to have perceived' in the narrow canals and byways of the city. When he depicted the famous sights, he almost invariably did so from a novel viewpoint or under unusual lighting conditions. Etchings were made directly, with the result that Whistler's prints of Venice were reversed by the process of printing: a method which his student Sickert later found disconcerting [cat. nos 5 and 9]. Whistler's pastels were

9 Edouard Manet, *Venice, The Grand Canal*. Oil on canvas, 1875. Private collection

similarly made *en plein air*, but the few oils he produced during his stay were painted from memory [cat. no.4].

Whereas Ruskin had praised Turner at the expense of Canaletto, Whistler did the reverse. Mortimer Menpes recalled a visit to the National Gallery:

I felt that Turner's work must be touching him, but the Master shook his head, and said: 'No: this is not big work. The colour is not good. It is too prismatic. There is no reserve. Moreover, it is not the work of the man who knows his trade. Turner was struggling with the wrong medium. He ought not to have painted. He should have written. Come from this work, which is full of uncertainty. Come and look at the paintings of a man who was a true workman.' So saying, he led me straight to a Canaletto. 'Now', he said, 'here is the man who was absolute master of his materials. In this work you will find no uncertainty.' He talked of his drawing and of the crisp, clean way in which the tones were put on. ... Whistler broke off suddenly, 'after all, what's the use? His work is as little understood as mine.'[64]

In 1843 Ruskin had claimed in the first volume of *Modern Painters* that Canaletto's painting 'imitates nothing but the blackness of the shadows'. Otto Bacher recalled that Whistler observed in 1881: 'Canaletto could paint a white building against a white cloud. That was enough to make any man great.'[65] The exactitude of this antithesis suggests that

10 Auguste Renoir, *Fog in Venice*. Oil on canvas, 1881. Private collection

Whistler's championing of Canaletto against Turner may have arisen partly from his dispute with Ruskin.

During his stay in Venice Whistler became a leading light in the growing Anglo-American community. Ralph Curtis wrote a nostalgic account of how, 'Very late, on hot sirocco nights, long after the concert crowd had dispersed, one little knot of men might often be seen in the deserted Piazza San Marco, sipping refreshment in front of Florian's. You might be sure that was Whistler, in white duck, praising France, abusing England, and thoroughly enjoying Italy.'[66] This community included, in addition to visiting artists and authors, wealthy expatriates such as Lady Layard, Katherine De Kay Bronson and Ralph Curtis's mother Ariana, who held frequent soirées in their residences on the Grand Canal. With her Bostonian husband Daniel, Mrs Curtis rented part of the Palazzo Barbaro in 1878 and purchased it in 1885 [cat. nos 1 and 27]. Their son

Ralph trained as a painter and married the heiress to the Colt firearm fortune. His childhood friend and distant cousin J. S. Sargent was a frequent guest at the Palazzo [cat. nos 12 and 15]. Following a visit in 1898, he immortalised the family and their home in *An Interior in Venice* (London, Royal Academy) [fig.11].[67] Mrs Curtis declined Sargent's gift of the group portrait as she disliked the nonchalant pose of her son and thought it made her look old. Subsequently the artist deposited it with the Royal Academy as his diploma picture. Other visitors at the Palazzo Barbaro included the collector Isabella Stewart Gardner, who frequently rented it for the summer, Monet [cat. nos 28-30], and Henry James. In 1890 the novelist expressed his appreciation of 'Their upstairs appartment (empty and still unoffered – at forty pounds a year – to anyone but me) ... The great charm of such an idea is the having in Italy, a little cheap and private refuge independent of

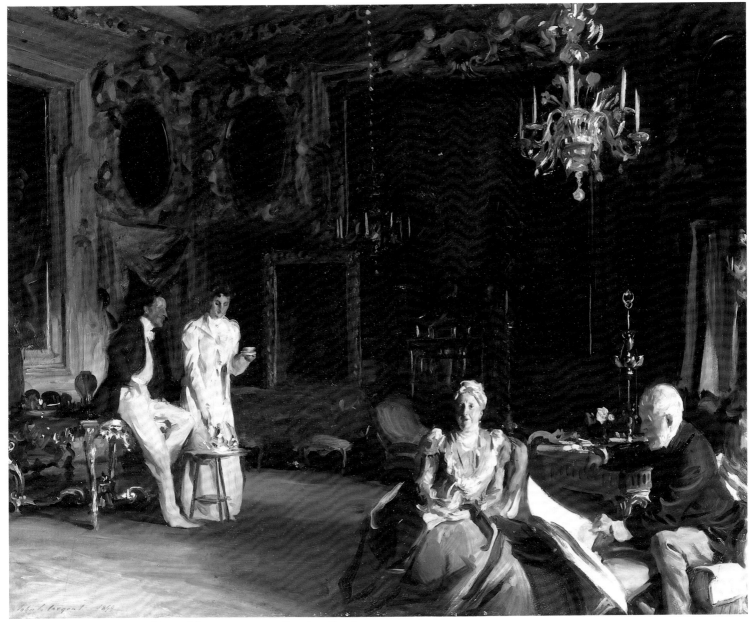

11 J. S. Sargent, *An Interior in Venice*. Oil on canvas, 1899. London, Royal Academy

hotels etc. which every year grow more disagreeable and German and tiresome to face – not to say dearer too.'[68]

James had first visited Venice in 1869 and returned briefly in 1872. His first essay on the city, published the following year, remains heavily dependent upon Ruskin's *Stones of Venice*, but includes a memorable description of its atmosphere:

The light here is in fact a mighty magician and, with all respect to Titian, Veronese and Tintoret, the greatest artist of them all. You should see in places the materials with which it deals – slimy brick, marble battered and befouled, rags, dirt, decay. Sea and sky seem to meet half-way, to blend their tones into a soft iridescence, a lustrous compound of wave and cloud and a hundred nameless local reflections, and then to fling the clear tissue against every object of vision. You may see these elements at work everywhere, but to see them in their intensity you should choose the finest day in the month and have yourself rowed far away across the lagoon to Torcello.

Without making this excursion you can hardly pretend to know Venice or to sympathize with that longing for pure radiance which animated her great colourists. It is a perfect bath of light, and I couldn't get rid of a fancy that we were cleaving the upper atmosphere on some hurrying cloud-skiff.[69]

In 1881 James stayed in rooms on the Riva degli Schiavoni, where he wrote most of *The Portrait of a Lady*. He also gathered the experiences for an essay, *Venice*, which was published the following year. Starting with an affectionate critique of the writings of 'Mr Ruskin who beyond anyone helps us to enjoy', it includes several beautiful passages descriptive of Venetian light and colour [see also cat. nos 8, 11 and 25].[70] One portrays the view from the author's window, immortalised by many artists from Turner to Monet:

Straight across, before my windows, rose the great pink mass of San

Giorgio Maggiore, which has for an ugly Palladian church a success beyond all reason. It is a success of position, of colour, of the immense detached *campanile*, tipped with a tall gold angel. I know not whether it is because San Giorgio is so grandly conspicuous, with a great deal of worn, faded-looking brickwork; but for many persons the whole place has a kind of suffusion of rosiness. Asked what may be the leading colour in the Venetian concert, we should inveterately say Pink, and yet without remembering after all that this elegant hue occurs very often. It is a faint, shimmering, airy, watery pink; the very sea-light seems to flush with it and the pale whitish-green of lagoon and canal to drink it in. There is indeed a great deal of very evident brickwork, which is never fresh or loud in colour, but always burnt out, as it were, always exquisitely mild.[71]

This is followed by an appreciation of the colouristic effects which accompany the arrival of summer:

It was all cold colour, and the steel-grey floor of the lagoon was stroked the wrong way by the wind. Then there were charming cool intervals, when the churches, the houses, the anchored fishing-boats, the whole gently-curving line of the Riva, seemed to be washed with a pearly white. Later it all turned warm – warm to the eye as well as to the other senses. After the middle of May the whole place was in a glow. The sea took on a thousand shades, but there were only infinite variations of blue, and those rosy walls I just spoke of began to flush in the thick sunshine. Every patch of colour, every yard of weather-stained stucco, every glimpse of nestling garden or daub of sky above a *calle*, began to shine and sparkle – began, as the painters say, to 'compose'. The lagoon was streaked with odd currents, which played across it like huge smooth finger-marks. The gondolas multiplied and spotted it all over; every gondola and gondolier looking, at a distance, precisely like every other.[72]

Henry James visited Venice twice in 1887, staying at the Ca' Alvisi on the Grand Canal in the guest suite of the American hostess Mrs Bronson. She appears, thinly disguised, as Mrs Prest in *The Aspern Papers* on which he was then engaged [see cat. no.26]. This short story draws on legends surrounding Lord Byron, who had died in 1824, and is mostly set in a palazzo based upon the Ca' Capello on the Rio Marin, the home of another American expatriate, the author Constance Fletcher. Most of the novel takes place indoors and James's vignette of the Piazza San Marco by night has an 'interior' feel, reminiscent of Napoleon's famous designation of it as 'the finest drawing room in Europe' and Whistler's *St Mark's Venice: Nocturne in Blue and Gold* [cat. no.4], which was first exhibited in 1886:

… I spent the late hours either on the water – the moonlights of Venice are famous – or in the splendid square which serves as a vast forecourt to the strange old church of Saint Mark. I sat in front of Florian's café eating ices, listening to music, talking with acquaintances: the traveller will remember how the immense cluster of tables and little chairs stretches like a promontory into the smooth lake of the Piazza. The whole place, of a summer's evening, under the stars and with all the lamps, all the voices and light footsteps on marble – the only sounds of the immense arcade that encloses it – is an open-air saloon dedicated to cooling drinks and to a still finer degustation, that of the splendid impressions received during the day. When I didn't prefer to keep mine to myself there was always a stray tourist, disencumbered of his Bädeker, to discuss them with, or

some domesticated painter rejoicing in the return of the season of strong effects. The great basilica, with its low domes and bristling embroideries, the mystery of its mosaic and sculpture, looked ghostly in the tempered gloom, and the sea-breeze passed between the twin columns of the Piazzetta, the lintels of a door no longer guarded, as gently as if a rich curtain swayed there.[73]

The principal fruit of James's visit to Venice in 1890 was a descriptive essay entitled *The Grand Canal*, published in 1892 [see also cat. nos 14, 16, 18, 22 and 23]. It opens with a disillusioned account of the consequences of tourism, which remain painfully apt a century later:

Venetian life, in the large old sense, has long since come to an end, and the essential present character of the most melancholy of cities resides simply in its being the most beautiful of tombs. Nowhere else has the past been laid to rest with such tenderness, such a sadness of resignation and remembrance. Nowhere else is the present so alien, so discontinuous, so like a crowd in a cemetery without garlands for the graves. It has no flowers in its hands, but, as a compensation perhaps – and the thing is doubtless more to the point – it has money and little red books. The everlasting shuffle of these irresponsible visitors in the Piazza is contemporary Venetian life. Everything else is only a reverberation of that. The vast mausoleum has a turnstile at the door, and a functionary in a shabby uniform lets you in, as per tariff, to see how dead it is. From this *constatation*, this cold curiosity, proceed all the industry, the prosperity, the vitality of the place. The shopkeepers and gondoliers, the beggars and the models, depend upon it for a living; they are the custodians and the ushers of the great museum – they are even themselves to a certain extent the objects of exhibition.[74]

In 1894, 1899 and 1907, James returned, staying mainly at the Palazzo Barbaro. He vainly tried to persuade Mrs Curtis to accept Sargent's *An Interior in Venice* [fig.11] and envisaged her palace as the setting for a major part of his long novel *The Wings of the Dove*, published in 1902.[75] The same year he published an appreciation of the late Mrs Bronson as the introduction to her reminiscences of Robert Browning in Venice.[76] In 1906 he engaged the young Anglo-American photographer Alvin Langdon Coburn to take photographs of the Ca' Capello and the Palazzo Barbaro for the frontispieces to *The Aspern Papers* and *The Wings of the Dove* in the complete edition of his works, published in New York in 1907-9 [cat. nos 26 and 27]. Sixty years later, in his autobiography, Coburn praised the acute visual sensitivity which informed so much of James's writing:

Although not literally a photographer, I believe Henry James must have had sensitive plates in his brain on which to record his impressions! He always knew exactly what he wanted, although many of the pictures were but images in his mind and imagination, and what we did was to browse diligently until we found such a subject. It was a great pleasure to collaborate in this way, and I number the days thus spent among my most precious recollections.[77]

In an article on J. S. Sargent, published in 1887, Henry James was highly appreciative of an oil painting of a Venetian interior:

… a pure gem, a small picture … representing a small group of

12 Frank Brangwyn, *Venice from the Lagoon*. Oil on canvas, 1896. Cardiff, National Museum of Wales

Venetian girls of the lower class, sitting in gossip together one summer's day in the big, dim hall of a shabby old palazzo. The shutters let in a clink of light; the scagliola pavement gleams faintly in it; the whole place is bathed in a kind of transparent shade; the tone of the picture is dark and cool ... The figures are extraordinarily natural and vivid ... [and] the whole thing free from that element of humbug which has ever attended most attempts to reproduce the Italian picturesque.[78]

This painting was one of about a dozen medium-sized figure compositions set in shady interiors or alleys which Sargent painted on his first two working visits to Venice in 1880-2 [cat. no.13]. He spent part of these stays in a studio at the Ca' Rezzonico, where Whistler had also worked in 1879, and with his cousins the Curtises in the Palazzo Barbaro. Sargent's subject-matter probably derived from studio photographs of 'characteristic' Venetians, which had been increasingly in demand since the 1850s, and Whistler's pastels and etchings of Venetian backstreets [cat. nos 6 and 10].[79] His distinguished

but almost monochromatic palette, emphasising rich greys, soft browns and dusty blacks, enlivened by bright highlights of red or pink, was highly indebted to Velasquez, whose paintings he had studied in Madrid in 1879. These cool yet highly-charged scenes imbue their potentially prosaic subjects with an air of mystery. Initially, their critical reception was mixed, but in 1925 Sargent's biographer observed: 'When one contemplates such pictures ... some regret must be felt that so much of his time and energy were given to portrait painting ... [The Venetian scenes] have as distinct a *cachet* of their own as a Vermeer or a Chardin.'[80]

Pressures of his success as a society portraitist kept Sargent from working in Venice until 1898. In that year he began *An Interior in Venice* [fig.11] during a stay at the Palazzo Barbaro, which he described in a letter to Mrs Curtis as 'a sort of Fontaine de Jouvence, for it sends one back twenty years, besides making the present seem remarkably all right'.[81] Such associations are evident in *An Interior in Venice*, which

constitutes a *rapprochement* between Sargent's society portraits and his Venetian scenes of nearly twenty years earlier. Thereafter he visited Venice repeatedly until the eve of the First World War, painting the famous sights and scenes on the canals which he had generally avoided at the beginning of his career [cat. nos 14-18]. Above all, Sargent turned to watercolour, using the freshness of this medium to capture the transient effects of sunlight reflected from the surface of the Venetian waterways on the marble or plaster façades of overlooking buildings. Like Whistler's old pupil W. R. Sickert [cat. no.21], he painted a number of asymmetrical views and snapshot-like details of famous Venetian buildings which probably reflect the influence of photography. Although Henry James had found Venice little altered in 1907, on his last visit in 1913 Sargent was disconcerted to find himself surrounded by 'swarms of smart Londoners'.[82]

The revival and transformation of Venice, which had begun with the inauguration of the railway link with the mainland in 1846, the opening of the first bathing establishment on the Lido in 1857 and unification with the Kingdom of Italy in 1866, was almost complete by the turn of the century. In 1906 Baedeker's guide observed:

The population, which had dwindled from 200,000 to 96,000 after its dissolution as an independent state (1797), is now about 148,500. The industry of Venice is practically confined to ship-building, the making of cotton and torpedoes, and the flourishing production of art-objects for its enormous annual invasion of strangers ... A visit to the Lido, which is now the most fashionable bathing-resort in Italy, is the favourite excursion from Venice.[83]

In 1892 Henry James likened the city to a great museum, with its inhabitants as custodians. Three years later, Louis Eugène Boudin [cat. no.19] and W. R. Sickert [cat. nos 20-23] first visited Venice, and King Umberto I and Queen Margherita of Savoy attended the opening of the first of what was to become the regular series of Biennale art exhibitions in the Giardini Pubblici. Although organised by a committee of Venetians, it was from the outset an international event, attracting 224,327 visitors to view 516 works.[84] From its inauguration until the First World War, the exhibition was an immense success, its attendance reaching a peak of 457,960 visitors in 1909.[85] The Anglo-Belgian artist Frank Brangwyn first visited Venice in 1896 and was commissioned to decorate the British Room at the Biennale in 1905 and 1907.[86] His *Venice from the Lagoon* of 1896 (National Museum of Wales) [fig.12] epitomises the moderately progressive, international style espoused by the Biennale during its early years.

Like Whistler and Sargent, W. R. Sickert came from a widely-travelled and multilingual background. Consequently, he fitted readily into the salons of the cosmopolitan high society which had colonised Venice, including the Anglo-American residents, as well as Madame Fortuny at the Palazzo Pesaro Orfei, Baron Giorgio Franchetti at the Ca' d'Oro and the Comtesse de Baume and Madame Bulteau in the Palazzo Dario.[87] Sickert concentrated on a limited number of the better-known sights, such as the façade of St Mark's and Santa Maria della Salute [cat. nos 20-22], making numerous preparatory studies. These were utilised to produce methodically squared-off cartoons, from which oil paintings were produced – sometimes on demand, years after his final return from Venice in 1904. As he did not normally paint canvases out-of-doors and had little analytical interest in the variable effects of light on a subject, the similarity of these architectural views to Monet's series paintings is superficial. In 1903-4, when it was frequently too wet to draw out of doors, Sickert worked in his room for six hours a day, producing numerous drawings and paintings of a few female models which recall the works of his friend Degas. These foreshadow the realistic interiors which he subsequently produced in Paris and London.

In the autumn of 1908, decades after the visits of his friends Manet and Renoir and thirteen years after that of Boudin, Claude Monet visited Venice. He and his wife Alice were invited to stay at the Palazzo Barbaro by Mary Hunter, a friend of Sargent and patron of Rodin.[88] They subsequently moved further down the Grand Canal, to the Hotel Britannia. Monet started work, from the steps of the Palazzo Barbaro, on a series of compositions of *Venise, Le Grand Canal* [fig.13]; a view which had been treated by innumerable artists and photographers since the time of Bonington [cat. no.1]. Avoiding the Piazza San Marco, he concentrated on famous waterfront sights: the Molo, the Palazzo Ducale, San Giorgio Maggiore and palaces on the Grand Canal [cat. nos 28-30]. Monet was somewhat intimidated at the prospect of painting a city which had been immortalised by so many artists. On 6 November, when he was working from the Isola di San Giorgio on a view of the Molo, his wife wrote: 'The number of painters here, on the little Piazza San Giorgio, is dreadful. There are five, plus a lady and Monet ...'[89] Although he worked hard, changeable weather and the limited time available were inimical to his methodical and demanding approach. Like Boudin, who had first encouraged him to paint out-of-doors [cat. no.19], he felt old and tired. Towards the end of his stay, on 7 December, he wrote: 'It is so beautiful ... I am consoled at the thought that I may return next year, for I have only made first attempts, beginnings. What a pity I never came here when I was younger, when I was full of daring! However, I have enjoyed some delicious times here and almost forget that once I was not the old man I am now.'[90]

Owing to pressure of work and the illness of his wife, who died in 1911, Monet never returned. Consequently, he was obliged to finish the paintings at Giverny: a procedure which caused him much soul-searching, as he was diffident about his memory of Venetian effects.[91] Despite his reservations, Monet's views of Venice received an enthusiastic critical reception when exhibited at Bernheim-Jeune between May and June 1912.[92] In 1923, W. R. Sickert, a painter younger and more familiar with Venice than Monet, observed:

Monet's large view of the Ducal Palace and the Piazzetta, smouldering before their extinction in twilight, must remain one of the masterpieces that have been rung from the city in the sea. None

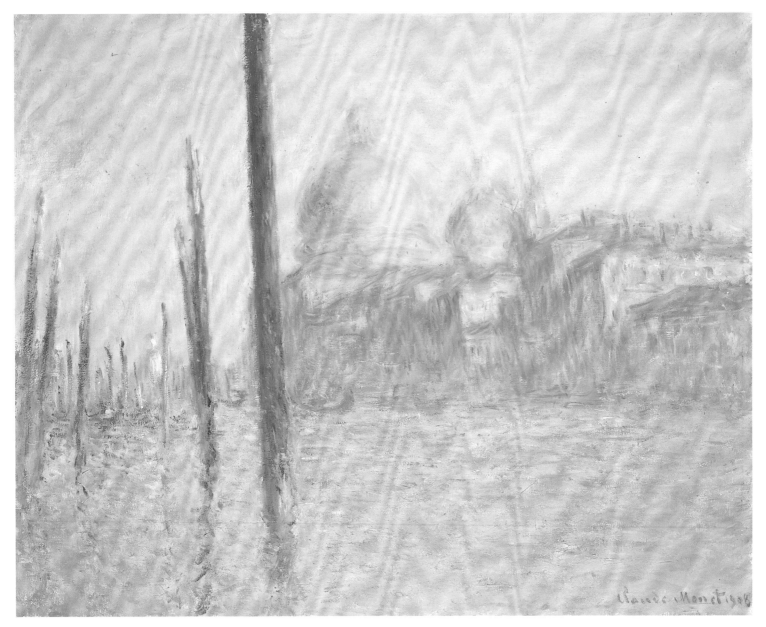

13 Claude Monet, *Venise, Le Grand Canal*. Oil on canvas, 1908. The Fine Arts Museums of San Francisco, Gift of Osgood Hooker

of the painter's august predecessors have done just that, or indeed anything at all like it. It is neither the Venice of Canaletto nor that of Byron or Turner. It is very modern. The ghost of one gondola is hurrying to the *traghetto*, but the rest, with the marionettes and the *bautte*, have been put away in their boxes. The modern painter offers us the austere consolation that may be found in the play of light on an empty stage.[93]

Monet retained two of the Venice views and gave two away. Mrs Hunter was offered a version of *Saint-Georges Majeur* as thanks for her hospitality and the painter's old friend the politician Georges Clemenceau received an oil sketch of a gondola. Of the twenty-nine paintings exhibited in Paris in 1912, at least eighteen had been sold by the end of the following year, thirteen to American buyers. The most

enthusiastic of these were Alexander Cochrane of Boston, who bought two canvases in July and November 1912, and Arthur B. Emmons of Newport, Rhode Island, who bought one in December 1912 and three more in May and December 1913. However, the readiest purchasers of Monet's Venetian views were two Welsh sisters who had never previously bought an Impressionist painting, Gwendoline and Margaret Davies. In October 1912 they spent 100,000 francs on versions of *Venise, Le Grand Canal*, *Saint-Georges Majeur* and *Saint-Georges Majeur au Crépuscule* and the following July an additional £1,310 on a painting of *Le Palais Dario* [cat. nos 28-30].[94]

Gwendoline Davies (1882-1951) and Margaret Davies (1884-1963) were the granddaughters of David Davies of Llandinam (1818-90), a self-made man who had made a fortune from

contracting, railways, coal-owning and dock-building [figs 14 and 15].[95] The sisters' mother died in 1888 and their father ten years later, leaving them to be brought up in the family faith as Calvinistic Methodists by their step-mother Elizabeth. They lived at Plas Dinam, a country house near Llandinam in mid-Wales. Their grandfather had his portrait painted by Ford Madox Brown in 1874 and Margaret briefly attended the Slade School of Art as an external pupil, but their family cannot be said to have had any tradition of collecting. However, in their youth the sisters travelled regularly. This was by no means uncommon. For example, George Henfrey of Tregib, near Llandeilo, travelled extensively in Italy in 1862-90 and maintained a villa near La Spezia. An amateur archaeologist, he excavated in Sardinia and assembled a large collection of Alinari photographs, acquired by the National Museum of Wales in 1921 [fig.1]. Margaret Davies's surviving travel diaries indicate that she and her sister were in Italy for the second time, stopping off at Paris on the way home, between 30 March and 7 May 1909 and that they visited Egypt, Greece and Italy in March-April of 1911.[96] In April 1912, Gwendoline and Margaret Davies were once again in Italy and almost certainly visited Paris on the return journey.[97]

The sisters would also have been aware of the activities in South Wales of the Unitarian corn merchant James Pyke Thompson and his friend Sir Frederick Wedmore, art critic of the London Standard. Pyke Thompson lived in Penarth, near Cardiff, and was an enthusiastic collector of British watercolours. In 1888 he opened a small public art gallery adjoining his home, named the Turner House at Wedmore's suggestion, for the display of part of his collection.[98] He lent, and subsequently bequeathed, the rest of his collection to the Cardiff Museum. Following Pyke Thompson's death in 1897, Wedmore was empowered in 1905 to utilise the income from his bequest to purchase pictures for the Museum, whose collections constituted the nucleus of the National Museum of Wales on its foundation in 1907. In that year, as Art Adviser to the National Museum, he argued in a report that its collections should seek 'to represent Art generally – whether English, or even Foreign … to see that the modern phases of Art are not forgotten'.[99] Given the small sums of money available, Wedmore was highly successful. Between 1907 and 1912 he acquired paintings by Bonvin, Boudin and Courbet. He continued, between 1914 and 1917, to add works by Bonvin, Boudin, Ribot, Isabey, Lepine and Le Sidaner.[100]

In 1908-12 Gwendoline and Margaret Davies began to buy oil paintings. Initially they favoured works by revered British artists of the previous century, such as would have appealed to the traditionally-minded James Pyke Thompson: portraits by Romney and Raeburn, three landscapes by Cox and a group of six late Turner sketches of seascapes [fig.4].[101] The presence amongst the sisters' papers of a large photograph of Turner's *The Campo Santo* [fig.3], with typed catalogue information on the back, suggests that they may have contemplated the purchase of this great Venetian seascape, which was eventually sold by its owner to an American collector in 1916.[102] From the beginning, they also acquired paintings by well-established

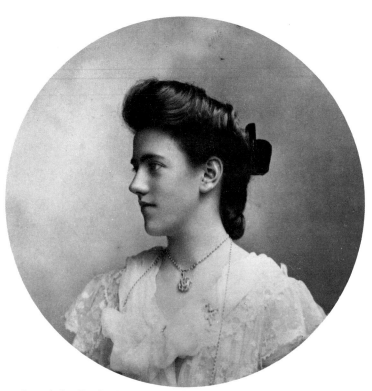

14 Gwendoline Davies (1882-1951). Photograph. Cardiff, National Museum of Wales

15 Margaret Davies (1884-1963). Photograph. Cardiff, National Museum of Wales

French painters: four Corot landscapes, representative works by Diaz de la Peña, Meissonier, Charles Bargue and, above all, Millet. The sisters were especially fond of his peasant scenes, buying nine between 1909 and 1912.[103]

Margaret Davies's diary entries for the week she and her sister spent in Paris between 30 April and 5 May 1909 shed light on their still orthodox tastes. An afternoon was spent in the Louvre, looking mainly at the Italian old masters they had recently seen so much of in Italy. Margaret also wrote:

We want to see the Corots, so mount the stairs, to rooms where there are pictures by more modern French painters. There is a very good collection by Corot, they are indeed all lovely, one finds it difficult to pick out a favourite. The beautiful light in them all, and the softness, and the touch of colour which the little figures give, in most of them. There [are] some very beautiful tiny gems by Millet of peasant life. One, an old woman sewing, the earnestness in it. In the third room, there are lovely small pictures by Meissonier. The fineness in his painting to every detail whatever it may be, the lovely horses in his groups of horses and the battle scenes. Besides these, there are many others by French landscape painters from 1830 on, Daubigny, Decamps, Delacroix, Diaz, Dupré, Troyon and others.[104]

The sisters also enjoyed an exhibition of a hundred eighteenth-century female portraits, Margaret adding 'The French, although I like some very much, I do not care for so much on the whole as the English'.[105] Her most revealing aside occurs at the end of a tantalisingly brief account of the 'paintings by the French artists of our day' at the recently opened Salon in the Grand Palais: 'One sees some very striking portraits, some pretty landscapes, some good groups, and also many I do not care for, they are too impressionist to suit me'.[106]

In Paris, the Davies sisters were accompanied by Jane Blaker, their step-mother's companion and formerly their governess. Her brother Hugh (1873-1936) had studied painting in Antwerp and Paris before being appointed Curator of the Holburne of Menstrie Museum at Bath in 1905. In 1914 he was an unsuccessful candidate for the post of first Keeper of Art at the National Museum of Wales. An enthusiast for modern French painting, his diaries for 1909-10 express admiration for Carrière, Daumier, Manet, Corot, Denis and Gauguin and, in 1913, Cézanne, Monet, Renoir, Rodin, Vlaminck and Legros.[107] Blaker was also an art dealer and from 1908 he bid regularly for the sisters and acted generally as an art adviser. By the summer of 1912, the Davies sisters were clearly expressing an interest in Impressionist art, as on 11 August Blaker wrote to them:

I will certainly keep my eyes open in Paris for anything good, and am delighted that you think of getting some examples of the Impressionists of 1870. Very few English collectors except Hugh Lane have bought them at all, although much of their best work is in America. I expect you also know the work of Sisley, Pissarro and Renoir. These can still be got quite cheaply. Sisley, whose parents were English, was as good as any in my opinion, and Degas and Daumier are desirable, of course.[108]

Blaker's letter was probably a reply to one about Monet's recently-exhibited Venetian paintings. On 15 October 1912,

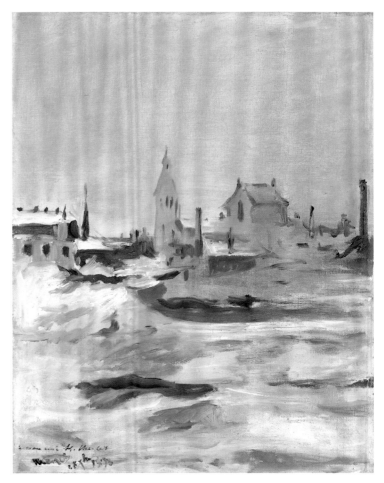

16 Edouard Manet, *Church of Petit-Montrouge, Paris*. Oil on canvas, 1870. Cardiff, National Museum of Wales

eleven days after their purchase of *Venise, Le Grand Canal* [fig.13] and nine days before they bought *Saint-Georges Majeur* and *Saint-Georges Majeur au Crépuscule* [cat. nos 29 and 30], Blaker encouraged the sisters to buy *Rodin's St Jean Baptiste* instead: 'The bronze will probably never again be on the market, and if there is any choice between it and the Monets, I should certainly advise the former, as more of the Venice series may be forthcoming from Durand-Ruel'.[109] He also wrote to Emile Bernheim in Paris to clarify this issue, receiving a negative reply dated 10 November:

There is not, nor will there ever be, another Venice series by Monet. M. Monet complains a great deal about his eyes and his oculist fears he will have to operate on a cataract. That is why Monet has not painted for quite some time; he was telling us today that he did not know when he would start painting again. Two of the Venetian paintings, *Le Palais Dario* and *Le Palais Ducal*, remain with us; the others have been sold or have left for America whence they will not return as 15% import duty has been paid on them. These two pictures are still here because, since they were not signed, we sent them to Monet who signed them, slowly, today.[110]

In October 1912, Gwendoline and Margaret Davies also acquired their first early Impressionist work, Manet's *Church of*

Petit-Montrouge, *Paris* of 1870 [fig.16]. The following April they bought the Rodin bronze urged on them by Blaker and on 25 July 1913 purchased Monet's *Le Palais Dario*, mentioned in Bernheim's letter [cat. no.28].

Gwendoline and Margaret Davies bought four further paintings by Monet in 1913 and his magisterial *Rouen Cathedral, Sunset, Symphony in Grey and Pink* in 1917. However, their initial decision to purchase his work in particular and Impressionist art in general was based upon Monet's Venetian scenes, which they almost certainly saw when exhibited for the first time at Bernheim-Jeune in Paris between May and June 1912. The significance of this group of paintings is no longer so clear as it once was, on account of the later growth of the Davies collection and the decision of Margaret Davies to sell *Venise, Le Grand Canal* at Sotheby's in May 1960. Purchased by M. Osgood Hooker, it followed most of Monet's other Venetian views to the United States and now forms part of the collection of the California Palace of the Legion of Honor in San Francisco.

In retrospect, the crucial purchases of 1912 may be seen to have decided the future direction of the Davies sisters' collecting – leading ultimately to one of the principal collections of French art in the United Kingdom. In that year they also acquired two other views of Venice. The first of these was Whistler's *St Mark's Venice: Nocturne in Blue and Gold*, bought for £2,850 on 20 January 1912 [cat. no.4]. The other, Boudin's *The Dogana, Santa Maria della Salute and the Entrance to the Grand Canal* [cat. no.19] was purchased for the comparatively modest price of 7,000 francs from Durand-Ruel's stock on 10 October 1912, within days of the acquisition of their first three Venetian scenes by Monet. More than two decades later, in 1935 Margaret Davies added a last painting of Venice to the collection, Sickert's *Palazzo Eleonora Duse* [cat. no.23]. The Davies sisters' susceptibility to Monet's late work may be related to their taste for Turner's late seascapes [figs 3 and 4]. Nostalgia probably played a part in their decision to acquire Whistler's nocturne of St Mark's, to judge from the entry Margaret Davies wrote in her diary on the eve of their departure from Venice on 27 April 1909: 'It is a lovely starlight night, many like ourselves take advantage of it to wander up and down in their gondolas. We pass by the Piazza, giving a last look at St. Marks, the little lamps, on the façade which faces us, before the mosaic of the Madonna, are burning brightly, as they do each night …'[111] An abiding love of Venice appears to have exercised a powerful motivation on Gwendoline and Margaret Davies, in common with so many other artists, commentators and collectors.

Notes

1 F. Braudel, *Civilisation & Capitalism 15th-18th Century*, vol.III, *The Perspective of the World*, London 1985, pp.116-38.
2 A. Lytton Sells, *The Paradise of Travellers: The Italian Influence on Englishmen in the Seventeenth Century*, London 1964, pp.52-76.
3 *ibid*, pp.110-25.
4 D. Howarth, '"Mantua Peeces": Charles I and the Gonzaga Collections', *Splendours of the Gonzaga* (ed. D. Chambers and J. Martineau), London 1981, pp.95-100.
5 J. Summerson, *Architecture in Britain 1530 to 1830*, Harmondsworth 1970, pp.111-53.
6 H. Potterton, *Venetian Seventeenth Century Painting*, London 1979, pp.29-32.
7 F. Haskell, *Patrons and Painters: A Study in the Relations Between Italian Art and Society in the Age of the Baroque*, New Haven and London 1980, pp.276-81.
8 J. Summerson, *op.cit*. pp.317-46 and 359-80.
9 J. A. Levenson, K. Oberhuber and J. L. Sheehan, *Early Italian Engravings from the National Gallery of Art*, Washington 1973, pp.342 and 553-4.
10 J. Rosenberg, S. Slive and E. H. ter Kuile, *Dutch Art and Architecture: 1600 to 1800*, Harmondsworth 1966, pp.323-32.
11 J. G. Links, *Canaletto and his Patrons*, London 1977, pp.2-3.
12 *ibid*, pp.1-2.
13 F. Haskell, *op.cit*. p.276.
14 *ibid*, pp.227-8 and J. G. Links, *op.cit*. pp.1 and 12-19.
15 W. G. Constable, *Canaletto*, Oxford 1962, vol.I, pl.33, and vol.II, p.243.
16 K. Baetjer and J. G. Links, *Canaletto*, New York 1989, pp.31-2.
17 F. Haskell, *op.cit*. pp.287-92, and J. G. Links, *op.cit*. pp.24-30.
18 F. Haskell, *op.cit*. pp.299-310, and J. G. Links, *op.cit*. pp.31-48.
19 J. G. Links, *op.cit*. p.86.
20 *Canaletto Paintings & Drawings*, The Queen's Gallery, London 1981, pp.23-4.
21 J. Addison, *Remarks on Several Parts of Italy, &c.*, London 1753 edition, pp.59 and 65.
22 M. Wortley Montagu (ed. R. Halsband), *The Complete Letters of Lady Mary Wortley Montagu*, vol.II, Oxford 1968, pp.151-202.
23 *ibid*, p.196.
24 J. W. Goethe (trans. W. H. Auden and E. Mayer), *Italian Journey*, Harmondsworth 1970, p.102.
25 J. Addison, *op.cit*. pp.58-9 and 62.
26 W. Wordsworth, *Selected Poems*, London and Glasgow 1959, p.439.
27 Lady Morgan, *Italy*, London 1821, vol.II, p.451.
28 *ibid*, pp.473-6.
29 P. Noon, *Richard Parkes Bonington 'On the Pleasure of Painting'*, New Haven and London 1991, p.57.
30 *ibid*, p.57.
31 *ibid*, p.58.
32 Lady Morgan, *op.cit*. pp.451-2.

33 *ibid*, p.454.

34 Lord Byron (ed. J. J. McGann), *The Complete Poetical Works*, vol.II, Oxford 1980, p.124.

35 L. Stainton, *Turner's Venice*, London 1985, pp.42-3.

36 J. Halsby, *Venice: The Artist's Vision*, London 1990, pp.26-9, and L. Stainton, *op.cit.* p.19.

37 P. Noon, *op.cit.* pp.202-3.

38 J. Halsby, *op.cit.* p.20.

39 L. Gowing, *The Originality of Thomas Jones*, London 1985, pp.44-54.

40 P. Noon, *op.cit.* p.58.

41 M. Butlin and E. Joll, *The Paintings of J. M. W. Turner*, New Haven and London 1984, pp.200-1.

42 *ibid*, p.201.

43 L. Stainton, *op.cit.* pp.45-50.

44 M. Butlin and E. Joll, *op.cit.* pp.215-16.

45 *ibid*, p.216.

46 *ibid*, p.245.

47 *ibid*, p.246.

48 L. Stainton, *op.cit.* pp.70-1, and *Ruskin's Letters from Venice 1851-1852* (ed. J. L. Bradley), New Haven 1955, p.112.

49 K. Baetjer and J. G. Links, *op.cit.* p.35.

50 J. Halsby, *op.cit.* pp.40-59; *Venice Rediscovered*, Wildenstein, London 1972, pp.9-10 and 12-13, and J. Clegg, *Ruskin and Venice*, London 1981.

51 J. Ruskin, *The Stones of Venice*, 4th ed., Orpington 1886, vol.3, *The Fall*, pp.221-3.

52 J. Ruskin, *op.cit.* vol.1, *The Foundations*, pp.24-5.

53 J. Ruskin, *op.cit.* vol.2, *The Sea-Stories*, pp.v-vi.

54 *John Ruskin*, Arts Council 1983, pp.52-62.

55 J. Halsby, *op.cit.* pp.50-2.

56 E. P. Thompson, *William Morris: Romantic to Revolutionary*, New York 1976, p.229.

57 *Manet 1832-1883*, Grand Palais, Paris 1983, pp.373-6, and D. Rouart and D. Wildenstein, *Edouard Manet*, vol.I, *Peintures*, Lausanne/Paris 1975, pp.192-3.

58 *ibid*.

59 J. Wilson-Bareau (ed.), *Manet by himself*, London and Sydney 1991, p.172.

60 *Renoir*, Arts Council of Great Britain, London 1985, pp.230-1.

61 A. McLaren Young, M. MacDonald and R. Spencer, *The Paintings of James McNeill Whistler*, New Haven and London 1980, pp.97-9.

62 M. M. Lovell, *Venice: The American View 1860-1920*, San Francisco 1984, p.134.

63 *ibid*.

64 K. Baetjer and J. G. Links, *op.cit.* p.37, and M. Menpes, *Whistler as I knew him*, London 1905, pp.80-1.

65 K. Baetjer and J. G. Links, *op.cit.* p.35, and M. M. Lovell, *op.cit.* p.138.

66 M. M. Lovell, *op.cit.* p.139.

67 *ibid*, pp.107-9; J. Halsby, *op.cit.* pp.116-18; *Venice Rediscovered*, Wildenstein, London 1972, pp.16-17 and 56-7; H. Honour and J. Fleming, *The Venetian Hours of Henry James, Whistler and Sargent*, London 1991, pp.56, 83 and 146-7; and S. Olson, *John Singer Sargent: His Portrait*, London 1986, pp.84-6.

68 H. Honour and J. Fleming, *op.cit.* pp.80-2.

69 *ibid*, pp.28-9.

70 *ibid*, pp.69 and 92-3.

71 *ibid*, p.101.

72 *ibid*, p.102.

73 *ibid*, pp.74-80, and H. James, *The Aspern Papers, The Novels and Tales of Henry James* (New York Edition), vol.12, repr. New Jersey 1971, p.51.

74 H. Honour and J. Fleming, *op.cit.* p.115.

75 *ibid*, pp.145-51.

76 *ibid*, pp.138-41.

77 A. L. Coburn (ed. H. and A. Gernsheim), *Alvin Langdon Coburn Photographer, an Autobiography*, London 1966, p.58.

78 P. Hills (ed.), *John Singer Sargent*, New York 1986, p.50.

79 *ibid*, pp.54, 64-6 and 70.

80 *ibid*, p.70.

81 R. Ormond, *John Singer Sargent*, London 1970, p.251.

82 H. Honour and J. Fleming, *op.cit.* pp.159 and 162.

83 K. Baedeker, *Italy: Handbook for Travellers: Northern Italy*, Leipzig 1906, pp.292 and 341.

84 L. Alloway, *The Venice Biennale 1895-1968*, London 1969, pp.31-2, 43-6 and 193.

85 *ibid*.

86 *ibid*, p.49, and J. Halsby, *op.cit.* pp.146-9.

87 J. Halsby, *op.cit.* pp.128-9, and *Venice Rediscovered*, Wildenstein, London 1972, pp.18-19.

88 P. Piguet, *Monet et Venise*, Paris 1986, pp.16, 25, 27-30 and 52-3, and S. Olson, *op.cit.* pp.212-15.

89 P. Piguet, *op.cit.* p.41.

90 *ibid*, p.53, J. Ingamells, *The Davies Collection of French Art*, Cardiff 1967, p.77, and *Venice Rediscovered*, Wildenstein, London 1972, p.18.

91 P. Piguet, *op.cit.* pp.108-10, and J. Ingamells, *op.cit.* pp.77-8.

92 P. Piguet, *op.cit.* pp.110-20.

93 W. R. Sickert, *A Free House! or The Artist as Craftsman*, London 1947, p.156.

94 D. Wildenstein, *Claude Monet*, vol.4: *1899-1926*, Lausanne/Paris 1985, pp.232-47.

95 J. Ingamells, *op.cit.* pp.4-31, and E. White, *The Ladies of Gregynog*, Newtown 1985.

96 Davies family papers, unpaginated manuscripts.

97 J. Ingamells, *op.cit.* p.10.

98 J. M. Gibbs, *James Pyke Thompson: The Turner House, Penarth 1888-1988*, Cardiff 1990, pp.6-22.

99 *The Welsh Museum of Natural History, Arts and Antiquities: Cardiff Report*, Cardiff 1907, pp.9-10.

100 *National Museum of Wales: Catalogue of Oil-Paintings*, Cardiff 1955, pp.134-5, 140, 147-8 and 157.

101 *ibid*, pp.24-5, 76 and 90-2, and *Catalogue of the Margaret S. Davies Bequest: Paintings, Drawings and Sculpture*, Cardiff 1963, pp.6-7.

102 M. Butlin and E. Joll, *op.cit.* p.246.

103 *National Museum of Wales: Catalogue of Oil-Paintings*, Cardiff 1955, pp.138-9, 151-2, and *Catalogue of the Margaret S. Davies Bequest: Paintings, Drawings and Sculpture*, Cardiff 1963, pp.23, 25, 27 and 31-2.

104 Davies family papers, unpaginated manuscript.

105 *ibid*.

106 *ibid*.

107 J. Ingamells, *op.cit.* pp.19-22.

108 *ibid*, p.11, and original letter in National Museum of Wales archives.

109 Original letter in National Museum of Wales archives.

110 J. Ingamells, *op.cit.* p.11.

111 Davies family papers, unpaginated manuscript.

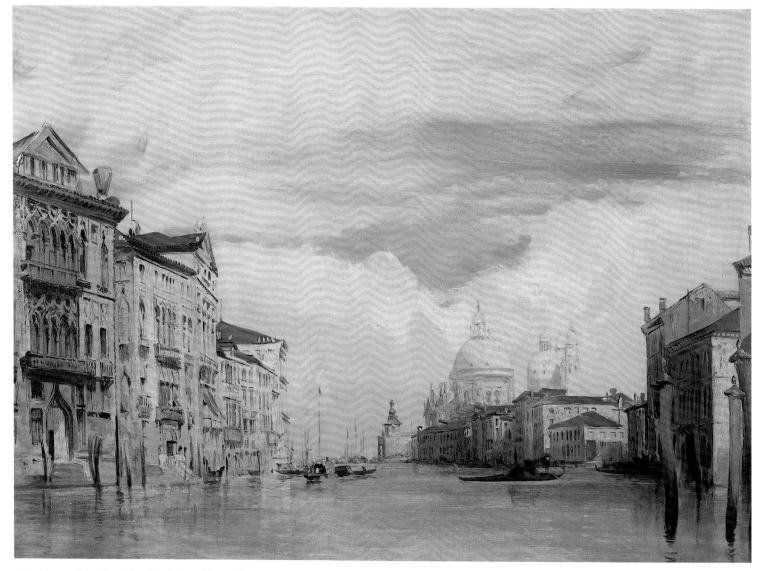

1 Bonington, *The Grand Canal and Santa Maria della Salute*, 1826-8

Richard Parkes Bonington (1802-28)

The son of a drawing master and printseller, Bonington was born in Arnold, Nottinghamshire. Shortly after, his family moved to Nottingham. In 1817 his parents sold up and moved, as partners in a lace-making firm, to Calais, where Bonington received initial tuition in watercolour painting from Louis Francia. The following year, his parents set up a lace shop in Paris, where he studied paintings in the Louvre and met James Roberts and, probably, Eugène Delacroix. In 1820 Bonington enrolled in the École des Beaux-Arts at the studio of the history painter and follower of David, Baron Antoine-Jean Gros. He toured Normandy in 1821, making watercolours, two of which were exhibited in 1822 at the Salon and the Société des Amis des Arts. After leaving Gros, he toured Flanders in 1823 and began work on a portfolio of lithographs of Gothic remains, *Restes et fragmens d'architecture du moyen age*, which was published the following year. In 1824 Bonington stayed at Dunkerque and exhibited at the Salon, where he received a gold medal. He probably met Samuel Prout, on the way home from Italy, early in 1825. That summer Bonington visited London, where he became friendly with Eugène Isabey and Delacroix, subsequently sketching with the former on the Channel coast and sharing the Paris studio of the latter.

In January 1826 Bonington exhibited at the British Institution; thereafter he increasingly cultivated British patrons. That April, accompanied by the painter and friend of Delacroix, Baron Charles Rivet, he set out for Venice, via Geneva, Brig, Milan and Verona. They remained at Venice for about a month, staying at the Hotel Danieli on the Riva degli Schiavoni, near the Piazza San Marco. Returning via Pisa, Florence, Genoa, Turin and Switzerland, they were back in Paris in June. The following year Bonington visited London, exhibited at the Royal Academy, and submitted a Venetian view to the Salon, which was well received. In 1828 he exhibited again at the Salon, the British Institution and the Royal Academy and met Sir Thomas Lawrence in London. Stricken by sunstroke in June while sketching on the Seine, he and his mother returned to London, where he died in September, probably of pulmonary consumption. Sir Thomas Lawrence assisted in the return of his studio contents to London, where they were sold in a series of auctions between 1829 and 1838.

I. RICHARD PARKES BONINGTON
The Grand Canal and Santa Maria della Salute 1826-8
Oil on canvas, 30.5 × 42.6 cm (12 × 16½ in)
Nottingham, City of Nottingham Museums, Castle Museum and Art Gallery

PROV: Lord Maugham; from whom purchased by Nottingham Corporation 1958

EXH: Nottingham, Castle Museum and Art Gallery, *R. P. Bonington* 1965 (280); London, Wildenstein, *Venice Rediscovered* 1972 (4)

LIT: J. Ruskin, *The Stones of Venice*, 4th ed., Orpington 1886, vol.3, *The Fall*, p.278; *R. P. Bonington* 1965, pp.36-7, and 39; *Venice Rediscovered* 1972, pp.47-8; L. Stainton, *Turner's Venice*, London 1985, pp.4-5, and 74; J. Halsby, *Venice: The Artist's Vision*, London 1990, pp.19-24, 31-4, and 70; C. Lloyd and M. Evans, *The Royal Collection: Paintings from Windsor Castle*, Cardiff and London 1990, pp.20-3, and 28-9; H. Honour and J. Fleming, *The Venetian Hours of Henry James, Whistler and Sargent*, London 1991, p.160; P. Noon, *Richard Parkes Bonington 'On the Pleasure of Painting'*, New Haven and London 1991, pp.56-62, and 210-15

This view of the lower reaches of the Grand Canal, facing eastwards towards the tower of the Dogana and the domes of Santa Maria della Salute, is related to a painting commissioned by James Carpenter in 1827 (private collection, 101.6 × 134.6 cm). Exhibited at the Paris Salon and the Royal Academy in 1828 and reproduced as a lithograph in 1830, this large oil version became the best known of Bonington's Venetian views, but was seriously damaged by fire in 1901. In the right foreground it incorporates several boats tied up at the edge of the Campo di Carità, which is immediately to the right of the present composition.

This motif also appears in Bonington's ink sketch of the scene scribbled in a letter of 21 October 1827 to the publisher John Barnett, and in a rough oil sketch on millboard (Edinburgh, National Gallery of Scotland, 22.5 × 30.1 cm). In the mid-nineteenth century both the latter and the large version exhibited in 1828 belonged to H. A. J. Munro of Novar, an enthusiastic patron of J. M. W. Turner. The Edinburgh sketch is usually identified as a *plein-air* study by Bonington, although it has recently been suggested that it is a later pastiche derived from prints after the large version. The present composition, without the group of boats tied up at bottom right, is probably a replica, painted after Bonington's return to Paris in June 1826, of a painting currently on loan to the Ashmolean Museum from a private collection. The latter was included in the sale held in 1829 after Bonington's death and, as it includes graphite *pentimenti* in the sky, has been identified as a preparatory study made on the spot.

Canaletto had never painted this view, although two of his most popular compositions depict the scene facing east from higher up the Grand Canal, with the façade of Santa Maria della Carità as a principal motif, and from the Campo San Vio, rather lower down. These compositions were very well known, as engravings after them by Antonio Visentini appear in the *Prospectus Magni Canalis Venetiarum* ('A view of the Grand Canal of the Venetians'), published with the sponsorship of Consul Smith in 1735. It seems implausible that Bonington had no prior knowledge of Visentini's engravings after Canaletto and he may consciously have sought a new viewpoint in this scene. His paintings of the Rialto bridge similarly prefer the view from the south to that from the north, which was treated more frequently by Canaletto and reproduced in the 1735 series of prints of the Grand Canal.

This scene, with the richly arcaded fifteenth-century Palazzo Cavalli-Franchetti (which lost its attic during a restoration of 1896) and the Palazzo Barbaro [see no.27 below] at the left, and the vista down the canal to the Salute at the right, was treated subsequently during the first half of the nineteenth century by various British artists, including W. J. Müller, James Duffield Harding and Edward Pritchett. In his note on the palaces in *The Stones of Venice*, first published in 1853, Ruskin observed: 'These two buildings form the principal objects in the foreground of the view which almost every artist seizes on his first traverse of the Grand Canal, the Church of the Salute forming a most graceful distance. Neither is, however, of much value, except in general effect ...' The following year, this view became one of the most accessible in Venice as a result of the opening of the first Ponte dell'Accademia, an iron structure designed by an English engineer. In Bonington's day, it could only be enjoyed from a gondola.

Joseph Mallord William Turner (1775-1851)

The eldest child of a barber and wig-maker, Turner was born in London. A precocious artist, he was admitted to the Royal Academy Schools in 1789 and exhibited there for the first time in 1790. In 1792 Turner made the first of a regular series of sketching tours, to South and mid-Wales. He was awarded a prize for landscape drawing by the Society of Arts in 1793 and in 1794 his watercolours at the Royal Academy began to attract critical attention. His first oil painting was exhibited there in 1796. Elected an Associate of the Royal Academy in 1799, Turner became a full Academician in 1802, Professor of Perspective in 1807 and Deputy President in 1845. Having toured Wales, the Lake District, Lancaster and Scotland, he visited France and Switzerland during the Peace of Amiens in 1802. Thereafter, the Napoleonic Wars prevented him from travelling abroad for over a decade. Confined to England, Turner was welcomed at several country houses, including Tabley House in Cheshire, Petworth House and Farnley Hall, Yorkshire, which he visited nearly every year between 1810 and 1824.

In 1817 he toured Belgium, the Rhine and Holland. The following year Turner visited Edinburgh in connection with Walter Scott's *The Provincial Antiquities of Scotland* and was commissioned to make watercolours after drawings by James Hakewill for the latter's *Picturesque Tour in Italy*. Between August 1819 and February 1820 he toured Italy, from Turin via Venice and Rome to Naples and back via Florence. Although only five days in Venice, where he seems to have stayed at the Leone Bianco, an old inn slightly north of the Rialto, he made numerous sketches. Turner was commissioned in 1822 to paint the *Battle of Trafalgar* for St James' Palace. His *Picturesque Views in England and Wales* was begun in 1825 and his *The Ports of England* mezzotints were issued in 1826, 1827 and 1828. In 1827 he visited Petworth House, returning regularly until 1837. Having toured in France, Scotland, Holland, the Rhine and Belgium, he returned to Italy in 1828, visiting Florence, Rome, Bologna and Turin. Roger's *Italy* was published with vignettes by Turner in 1830. The following year Turner toured Scotland, working on illustrations to Sir Walter Scott's poems. In 1832 he went to Paris and met Delacroix. Views of the Loire and the Seine were published in 1833, 1834 and 1835. He almost certainly returned to Venice in 1833, having travelled via Berlin, Dresden, Prague and Vienna. Between 1833 and 1837 Turner exhibited at least one Venetian subject every year at the Royal Academy. He toured the Meuse, Moselle and Rhine, France, Switzerland, the Val d'Aosta and Belgium between 1834 and 1839.

Turner met John Ruskin for the first time in 1840. That August he returned for a fortnight to Venice, where he stayed at the Hotel Europa at the mouth of the Grand Canal. Between 1840 and 1846 he exhibited numerous Venetian subjects. Between 1841 and 1845 Turner toured Belgium, the Rhine, Switzerland, North Italy and France. He refused to authorise a retrospective exhibition in 1849 but on his death bequeathed to the nation his studio contents of nearly 300 oils and 20,000 watercolours and drawings.

2. JOSEPH MALLORD WILLIAM TURNER
The Dogana, San Giorgio, Citella, from the Steps of the Europa
1840-2
Oil on canvas, 62 × 92.5 cm ($24\frac{13}{32}$ × $36\frac{13}{32}$ in)
London, Tate Gallery

PROV: Purchased at the Royal Academy in 1842 by Robert Vernon; by whom given to the National Gallery in 1847; transferred to the Tate Gallery 1949

EXH: London, Royal Academy 1842 (52); Chelsea Society May 1948; Hamburg, Kunsthalle, Oslo, Kunsternernes Hus, Stockholm, Nationalmuseum, and Copenhagen, Statens Museum for Kunst, *British Painting from Hogarth to Turner* 1949-50 (98); Arts Council tour, *J. M. W. Turner, R. A.* 1952-3 (19); Edinburgh, National Gallery of Scotland, *J. M. W. Turner* 1968 (19); London, Royal Academy, *Turner 1775-1851* 1974-5 (532); Leningrad, Hermitage, and Moscow, Pushkin Museum, *Turner 1775-1851* 1975-6 (66); Munich, Haus der Kunst, *Zwei Jahrhunderte Englische Malerei* 1979-80 (260); Paris, Grand Palais, *J. M. W. Turner* 1983-4 (67)

LIT: J. Addison, *Remarks on Several Parts of Italy, &c.*, London 1753, pp.58-9; Lady Morgan, *Italy*, London 1821, vol.II, pp.473-8; J. Ruskin, *The Stones of Venice*, 4th ed., Orpington 1886, vol.3, *The Fall*, pp.292-3; C. Burney (ed. H. Edmund Poole), *Music, Men, and Manners in France and Italy 1770*, London 1969, p.75; M. Butlin and E. Joll, *The Paintings of J. M. W. Turner*, New Haven and London 1984, pp.245-6 (396); L. Stainton, *Turner's Venice*, London 1985, pp.33-4, and 70-1; J. Halsby, *Venice: The Artist's Vision* London 1990, pp.17-18

Turner visited Venice for what was probably the third and last time between 20 August and 3 September 1840. Although apparently based upon a pencil drawing in a sketchbook dating from his first visit in 1819, the present composition was painted after his return home in 1840 and was exhibited for the first time at the Royal Academy in 1842. The same year, Turner submitted an oil painting of similar size entitled *The Campo Santo, Venice* (Toledo Museum of Art) [see fig.3]. Contemporary critics interpreted the two as a pair, although both were purchased from the Academy by different collectors. For the *Athaneum* reviewer of 7 May 1842, they were

among the loveliest, because least exaggerated pictures, which this magician (for such he is, in right of his command over the spirits of Air, Fire, and Water) has recently given us. Fairer dreams never floated past poets' eye; and the aspect of the City of Waters is hardly one iota idealised. As pieces of effect, too, these works are curious; close at hand, a splashed palette – an arm's length distant, a clear and delicate shadowing forth of a scene made up of crowded and minute objects!

The *Art Union* of 1 June was more critical of Turner's technique: 'Venice was surely built to be painted by Canaletto and Turner ... The Venetian pictures are now among the best this artist paints, but the present specimens are of a decayed brilliancy; we mean, they are by no means comparable with others he has within a few years exhibited.'

It has been proposed that Turner intended the two paintings iconographically as a pair. The view of the Dogana or custom's house with the tiny pair of vases at the bottom right, typical of imported oriental goods, has been interpreted as representing Venice at the height of its commercial power. In contrast, the prospect of the Campo Santo or cemetery on the Island of San Michele with rubbish floating in the foreground may characterise the city's recent decay. Joseph Addison had noted the decline in the fortunes of the Venetian Republic as early as the beginning of the eighteenth century. In 1821, after the city's succession to Austria, Lady Morgan observed that the Imperial government appeared to be deliberately stifling the economy and breaking the public spirit of Venice.

During his 1840 visit Turner stayed at the Hotel Europa in the former Palazzo Giustinian, at the mouth of the Grand Canal not far from the Piazza San Marco. A fellow guest, the English

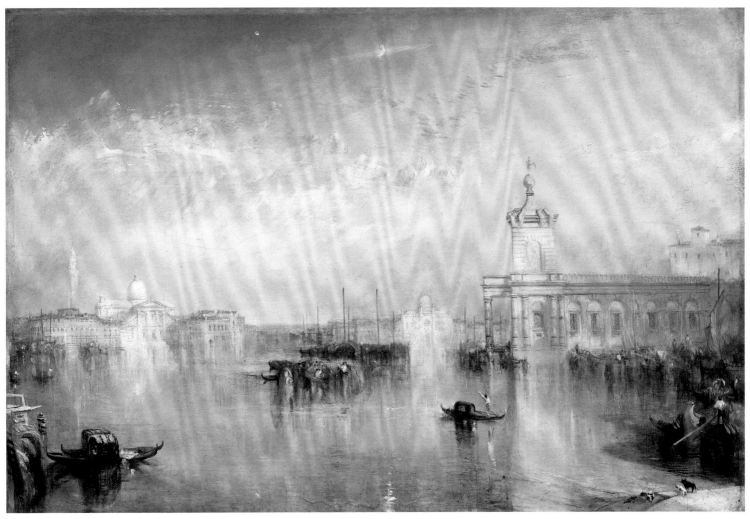

2 Turner, *The Dogana, San Giorgio, Citella, from the Steps of the Europa*, 1840-2

watercolourist William Callow later recalled 'we sat opposite at meals and entered into conversation. One evening whilst I was enjoying a cigar in a gondola I saw in another one Turner sketching San Giorgio.' The 'steps of the Europa', mentioned in the title, appear at the bottom right corner and the view is south, past the Dogana towards the Palladian church of Le Zitelle on the Giudecca and eastwards across to San Giorgio Maggiore.

San Giorgio Maggiore, prominent at the left of the composition, was one of the principal sights for earlier British visitors to Venice. Turner's view of it recalls Charles Burney's enthusiastic description of 1770:

There is such a noble elegance and simplicity in this structure that it inclines one to prostrate one's self upon entering it, as it has the true appearance of a temple to the Supreme Being ... At the front of this church, placed on an island facing the Gran Piazza di S. Marco I could not help stepping back 17 or 1800 years in history and supposing myself in view of some ancient Greek city – the number of public buildings had so beautiful an appearance across the water, which was smooth as glass – the sun just setting and there was a sky as we never see in England except in the landscapes of Claude Lorraine.

In the third volume of *The Stones of Venice*, first published in 1853, John Ruskin described Palladio's church in very different terms, as 'A building which owes its interesting effect chiefly to its isolated

position, being seen over a great space of lagoon ... It is impossible to conceive a design more gross, more barbarous, more childish in conception, more servile in plagiarism, more insipid in result, more contemptible under every point of rational regard.'

3. JOSEPH MALLORD WILLIAM TURNER
The Grand Canal and Santa Maria della Salute *c.*1840-5
Oil on canvas, 62 × 92.5 cm (24½ × 36½ in)
London, Tate Gallery

PROV: Turner Bequest 1856; transferred to the Tate Gallery 1947

EXH: London, Royal Academy, *Turner 1775-1851* 1974-5 (536); Leningrad, Hermitage, and Moscow, Pushkin Museum, Turner *1775-1851* 1975-6 (68); Paris, Grand Palais, *J. M. W. Turner* 1983-4 (68)

LIT: J. Ruskin, *The Stones of Venice*, 4th ed., Orpington 1886, vol.3, *The Fall*, p.344; M. Butlin and E. Joll, *The Paintings of J. M. W. Turner*, New Haven and London 1984, pp.212-13, 259 and 296 (502); L. Stainton, *Turner's Venice*, London 1985, pp.57 and 66; J. House, *Monet: Nature into Art*, New Haven and London 1986, pp.28-9

3 Turner, *The Grand Canal and Santa Maria della Salute, c.1840-5*

This is one of two unfinished views of the Grand Canal in the Turner Bequest which were unknown until the early 1970s. Both are probably abandoned compositions dating from the first half of the 1840s, when the artist submitted numerous Venetian views of this size to the Royal Academy. In 1844 he exhibited one of the Salute and the mouth of the Grand Canal viewed from the opposite direction, which the *Spectator* reviewer thought 'too evanescent for any thing but a fairy city'.

The central motif is the pale, shining white dome of Santa Maria della Salute. At the left of the composition are two rectangles, probably faint outlines of palaces on the Grand Canal, which indicate that Turner's viewpoint was close to that of Bonington's *The Grand Canal and Santa Maria della Salute* [see no.1 above], which he would have known in the large version exhibited at the Royal Academy in 1828. During or after his 1840 visit to Venice, Turner painted two watercolours of this view, a sketch in the Turner Bequest and a more finished version, which was given by John Ruskin to the Ashmolean Museum in 1861.

Ruskin's ownership of this watercolour reflects his grudging admiration of the Salute:

One of the earliest buildings of the Grotesque Renaissance, rendered impressive by its position, size, and general proportions. These latter are exceedingly good; the grace of the whole building being chiefly dependent on the inequality of size in its cupolas, and pretty grouping of the two campaniles behind them. It is to be generally observed that the proportions of buildings have nothing whatever to do with the style or general merits of their architecture. An architect trained in the worst schools, and utterly devoid of all meaning or purpose in his work, may yet have such a natural gift of massing and grouping as will render all his structures effective when seen from a distance: such a gift is very general with the late Italian builders, so that many of the most contemptible edifices in the country have good stage effect so long as we do not approach them. The church of the Salute is further assisted by the beautiful flight of steps in front of it down to the canal; and its façade is rich and beautiful of its kind, and was chosen by Turner for the principal object in his well-known view of the Grand Canal [probably *Venice, from the Porch of Madonna della Salute*, 1835, New York, Metropolitan Museum of Art].

This unfinished work demonstrates how the elderly Turner conceived the overall balance of a painting in atmospheric, tonal terms, before beginning to work up compositional motifs or topographic details. Its luminous beauty is doubtless more apparent

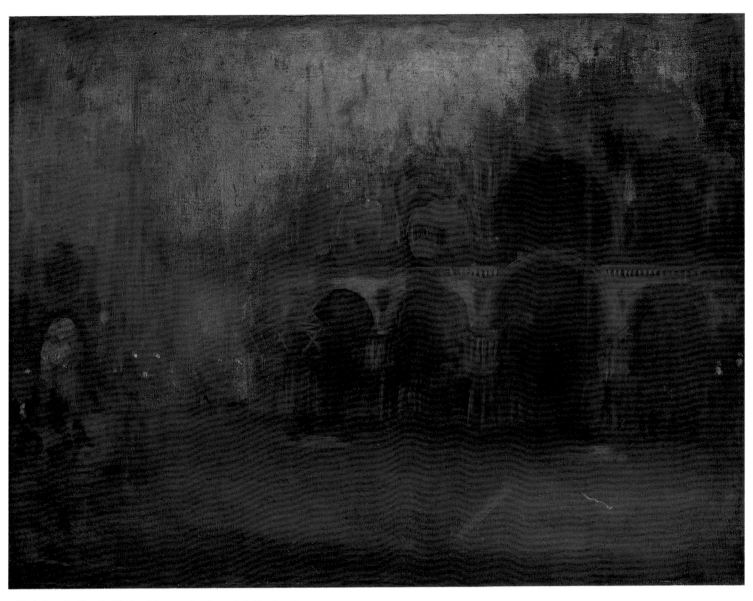

4 Whistler, *St Mark's Venice: Nocturne in Blue and Gold*, 1879-80

to late twentieth-century eyes, schooled by experience of abstract art, than to those of the previous century, which would have considered it a barely begun rather than unfinished painting. Nevertheless, *The Grand Canal and Santa Maria della Salute* would have been appreciated by Claude Monet during the 1890s when his admiration for Turner was at its height, and he described his own aims in the following terms: 'I want to paint the air in which the bridge, the house and the boat are to be found – the beauty of the air around them, and that is nothing less than the impossible' [see nos 28, 29 and 30, below].

James Abbott McNeill Whistler (1834-1903)

Whistler was born in Lowell, Massachusetts, the son of a civil engineer who moved to Russia in 1842 to work on the St Petersburg–Moscow railway. In 1845-6 he attended drawing lessons at the Imperial Academy of Fine Arts in St Petersburg, before returning via England to the United States in 1849. In 1851-4 Whistler attended the US military academy at West Point, and subsequently worked briefly at the US Coast and Geodetic Survey, Washington. Resigning in 1855, he painted portraits for a few months in Washington before moving to Paris, where he studied for two years at the École Impériale et Spéciale de Dessin and in the studio of Marc-Gabriel Charles Gleyre. In 1858 Whistler met Fantin-Latour, Legros, Carolus-Duran and Courbet and published his first portfolio of etchings, 'The French Set'.

The following year he moved to London, began 'The Thames Set' etchings and exhibited prints at the Salon and the Royal Academy. In 1860-2 he exhibited his first painting at the Royal Academy, met Manet and Rossetti and completed 'The Thames Set', which was praised by Baudelaire. Whistler exhibited at the Salon de Refusés in

1863 and in 1864 posed with Manet, Baudelaire and others for Fantin-Latour's *Hommage à Delacroix*. After visiting Coblenz, Trouville and Valparaiso in 1865-6, he exhibited his first painting with a musical title at the Royal Academy in 1867. In 1869 he made the first of many visits to the Liverpool home of his patron F. R. Leyland. Whistler painted the portrait of his mother *Arrangement in Grey and Black* and began to exhibit at Durand-Ruel in 1871. His first one-man show was held in London in 1874. In 1877 his relationship with Leyland ended with a dispute over the decoration of the *Peacock Room* at the latter's London house and he sued John Ruskin for libel over the latter's fierce criticism of his painting *Nocturne in Black and Gold: The Falling Rocket*. Although successful in his court case, he was awarded a farthing's damages without costs in 1878 and consequently declared bankrupt the following year.

In the autumn of 1879 the Fine Art Society made Whistler an advance to enable him to visit Venice to make a suite of etchings. He arrived in September, first took a studio in the Ca' Rezzonico and later moved to the Casa Jankowitz on the Riva degli Schiavoni. By the time of his return to London in November 1880 he had made a few oil paintings, fifty etchings and over ninety pastels, which were exhibited in that year, 1881, 1883 and 1884. In 1881 he became friendly with Oscar Wilde and in 1882 accepted W. R. Sickert as an assistant. Whistler joined the Society of British Artists in 1884, was elected President in 1886 but forced to resign in 1888. That year he married, and exhibited in Brussels, Paris and at the first exhibition of the New English Art Club. In 1889-91 he received increasingly widespread public recognition; medals from Munich, Paris and Amsterdam, an invitation to serve on the hanging committee of the Liverpool Autumn Exhibition and major sales to Glasgow Corporation and the Musée du Luxembourg. Made an Officier of the Légion d'Honneur in 1892, he held a major retrospective at the Goupil Gallery and moved to Paris for two years. Public recognition from the United States followed in 1893-4, with a major sale to the Wilstach collection and a gold medal from the Pennsylvania Academy of Fine Arts. In 1895-8 Whistler became estranged from Sickert, won a law suit brought by Sir William Eden, published his account of the case, *The Baronet and the Butterfly*, and was elected Chairman of the International Society of Sculptors, Painters and Gravers. Despite failing health, he travelled in France, Italy, Holland, Corsica and North Africa between 1898 and 1900, when he was elected an honorary academician of the Academy of St Luke in Rome. He was too ill to attend the ceremony at Glasgow University, from which he received an honorary degree in 1903. Following his death, major memorial exhibitions of his work were held in Boston, London and Paris in 1904-5.

4. JAMES ABBOTT MCNEILL WHISTLER

St Mark's Venice: Nocturne in Blue and Gold 1879-80
Oil on canvas, 44.5 × 59.7 cm (17½ × 23½ in)
Cardiff, National Museum of Wales

PROV: Gallimard, Paris; probably reacquired by Whistler 1892; John J. Cowan, Edinburgh, by 1905; Wallis & Son, London; from whom purchased for £2,850 by Gwendoline Davies 20 January 1912; by whom bequeathed 1952

EXH: London, Society of British Artists 1886-7 (331); London, Goupil Gallery 1892 (38); Paris, Société Nationale des Beaux-Arts 1892 (1071); London, New Gallery, *The International Society of Sculptors, Painters and Gravers: Memorial Exhibition of the Works of the*

Late James McNeill Whistler 1905 (2); Cardiff, National Museum of Wales, and Bath, Holburne of Menstrie Museum, *Loan Exhibition of Paintings* 1913 (50); San Francisco, California Palace of the Legion of Honor, *Venice: The American View 1860-1920* 1984-5 (89); Yokohama, Sogo Museum of Art, and tour, *Masterpieces from the National Museum of Wales* 1986-7 (67)

LIT: J. Ruskin, *The Stones of Venice*, 4th ed., Orpington 1886, vol.2, *The Sea-Stories*, pp.66-7; K. Baedeker, *Italy: Handbook for Travellers: Northern Italy*, Leipzig 1906, p.294; *Catalogue of Loan Exhibition of Paintings*, Cardiff 1913, p.31; J. Spence (ed. S. Klima), *Letters from the Grand Tour*, Montreal and London 1975, p.89; A. McLaren Young, M. MacDonald and R. Spencer, *The Paintings of James McNeill Whistler*, New Haven and London 1980, pp.123-4 (213); L. Stainton, *Turner's Venice*, London 1985, pp.45 and 68; J. Halsby, *Venice: The Artist's Vision*, London 1990, pp.16, 41, 50-2 and 85-7; H. Honour and J. Fleming, *The Venetian Hours of Henry James, Whistler and Sargent*, London 1991, p.48

Of the thirteen oil paintings thought to have been painted by Whistler during his visit to Venice in 1879-80, only this picture, another nocturne of the Lagoon with San Giorgio Maggiore (Boston, Museum of Fine Arts) and a sketch of a girl (private collection) can currently be located. According to the American artist Otto Bacher, in Venice at the same time as Whistler, these oils were painted mainly from memory: 'Night after night he watched ... without making a stroke with brush or pen. Then he would return to his rooms and paint the scene, or as much of it as he could remember, going again and again to refresh some particular impression.' When the present work was exhibited at the Society of British Artists in 1886-7, the artist observed 'I think it is the best of my noctur-n-nes'.

Although spurned by eighteenth-century visitors such as Joseph Spence, who wrote in 1732 'Of all the celebrated buildings one of the most ugly is the *Church of St Mark*', the basilica's reputation was assertively rehabilitated by John Ruskin [see no.20 below]. Concerned, like William Morris, that misguided restoration was ruining St Mark's, in 1877 Ruskin commissioned John Wharlton Bunney to paint a large canvas of its West Front (Sheffield, The Ruskin Gallery, Collection of the Guild of St George) [see fig.7]. There is an anecdote that Whistler crept up while he was on a scaffold studying the façade and pinned to his back a note reading 'I am totally blind'. This may be apocryphal, but it seems likely that the unconventional composition and lighting of *St Mark's Venice: Nocturne in Blue and Gold* represent a conscious critique of Bunney's painstaking but fundamentally dull painting.

Taking his viewpoint from the north side of the Piazza San Marco, around one third of the way down the Procuratie Vecchie and about fifteen metres south of its arcade, Whistler depicted the Renaissance Torre' del Orologio at the extreme left and the façade of St Mark's at a slight angle, with its southernmost, fifth portal cut off by the right edge of the canvas. Seen at night, the polychromy of the West Front is transformed into a series of pools of darkness of variable profundity. The only intense points of light are provided by the gas lights to the left – the recent introduction of which had disgusted Ruskin in 1845. One of the few earlier artists to have painted nocturnal views of St Mark's was his hero, J. M. W. Turner. Two watercolours on brown paper in the Turner Bequest, depicting the Piazzetta by night, probably date from 1833. Three years later, an attack on Turner's moonlit view of the Piazza San Marco entitled *Juliet and her Nurse* (private collection), stimulated a spirited defence from the young Ruskin which marked the beginning of his career as an art critic.

5 Whistler, *Nocturne*, 1879

The catalogue entry on this painting in the 1913 Cardiff exhibition, almost certainly by the art critic Sir Frederick Wedmore, enthused 'To Whistler, the night is not blackness but mystery, full of colour, infinitely varied, and wonderfully lovely, and in this painting he suggests, as he alone can, its tender and subtle beauty. The great Cathedral rises before us like a phantom, its glory of arch and pillar, gorgeous façade, and delicate tracery dimly seen through the veil of darkness, its upper towers melting into a liquid sky of lovely blue.' Baedeker's guide agreed that 'By moonlight the piazza is strikingly impressive'. This subtle and mysterious vision has been lost, as a result of modern floodlighting.

5. JAMES ABBOTT MCNEILL WHISTLER
Nocturne 1879
Etching and drypoint on white Van Gelder laid paper, 20 × 29.6 cm
($7\frac{7}{8}$ × $11\frac{21}{32}$ in)
Signed with butterfly in pencil in margin and inscribed
imp. 1st state – 1st proof – Venice 1879
From the First Venice Set, Kennedy 184, State 1, First Proof
Glasgow, Hunterian Art Gallery, University of Glasgow, Birnie Philip Bequest

PROV: Bequeathed by Rosalind Birnie Philip 1958

EXH: Glasgow, University, *Whistler in Venice* 1971 (3); Venice, Museo Correr, *Venezia nell'Ottocento* 1983 (32); Ontario, Art Gallery of Ontario, and New York, Metropolitan Museum of Art 1984; Glasgow, Hunterian Art Gallery, *Whistler in Europe* 1990 (21)

LIT: E. G. Kennedy, *The Etched Work of Whistler*, New York 1910, no.184; W. R. Sickert (ed. O. Sitwell), *A Free House! or The Artist as Craftsman*, London 1947, pp.12-13; *Whistler: The Graphic Work: Amsterdam, Liverpool, London, Venice*, Thomas Agnew & Sons, London 1976, p.40; A. McLaren Young, M. MacDonald and R. Spencer, *The Paintings of James McNeill Whistler*, New Haven and London 1980, p.123; K. Lochnan, *The Etchings of James McNeill Whistler*, New Haven 1984, pp.194, 196-9, 214 and 281; M. M. Lovell, *Venice: The American View 1860-1920*, San Francisco 1984, p.149; L. Stainton, *Turner's Venice*, London 1985, pp.59-60; M. MacDonald, 'Lines on a Venetian Lagoon', *The Whistler Papers* (ed. L. De Girolami Cheney and P. G. Marks), Lowell, Mass. 1986, p.3; K. A. Lochan, '"To pick and choose, and group with science": The Thames, Venice and Amsterdam Etchings of James McNeill Whistler', *ibid*, p.27; H. Honour and J. Fleming, *The Venetian Hours of Henry James, Whistler and Sargent*, London 1991, pp.36-7, 48-9 and 91

A Turner watercolour of *c*.1840 in the Fitzwilliam Museum, which formerly belonged to Ruskin, presents a comparably monochrome but early-morning panorama of the same view of the Bacino di San Marco, from San Giorgio Maggiore in the east to Santa Maria della Salute in the west. One of Whistler's two known oil paintings of Venice, *Nocturne in Blue and Silver: The Lagoon, Venice*, is a similar composition with a tall ship to the left, but depicts the view eastwards from San Giorgio towards the Lido. As in all Whistler's etchings of Venice, this print depicts a mirror image, owing to the artist's spontaneous method of drawing directly on the etching plate. W. R. Sickert had the present composition in mind in 1906 when, in a criticism of Whistler's reversal of Venetian topography, he remarked 'It worries me, and spoils my pleasure to see the Salute on the Giudecca and San Giorgio on the Zattere. Whistler is great – but so is Venice.' [See also no.9 below]

The pencil inscription on this first proof indicates that it was pulled during 1879 and is therefore one of the earliest of Whistler's Venetian prints. He had arrived in Venice on 19 September and on 1 January 1880 wrote a letter expressing disgust at 'struggling on in a sort of Opera Comique country when the audience is absent and the season is over'. Notwithstanding his circumstances this work is one of the most poetic and moving of Whistler's prints. As a first proof, the plate was wiped clean after inking prior to printing this impression, to reveal any mistakes. Later states were strengthened with a fine network of drypoint lines and selectively inked and wiped to bring out the full subtlety of the shimmering effects of reflected light and contrasting pools of darkness. Whistler considered this beyond the competence of commercial printers and when pressed on 22 February 1882 to complete the edition, he snorted 'you have only to send at once for the plates – and rely on Mr Goulding or others for Nocturnes and Doorways, Beggars and Lagoons – I need scarcely say that once any proof pulled [*sic*] by any one else, I should under no circumstances be induced to print from the degraded plate.'

When first exhibited at the Fine Art Society in December 1880, this extraordinarily atmospheric, transient image was not appreciated by the critics. On 10 December, the *British Architect* commented

'Nocturne', is different in treatment to the rest of the prints, and can hardly be called, as it stands, an etching; the bones as it were of the picture have been etched, which bones consist of some shipping and distant objects, and then over the whole of the plate ink has apparently been smeared. We have seen a great many representations of Venetian skies, but never saw one before consisting of brown smoke with clots of ink in diagonal lines.

Nearly thirty years later, Monet painted a similar view, but at twilight [see no.30 below].

6. JAMES ABBOTT MCNEILL WHISTLER
The Little Mast 1880
Etching and drypoint on white wove paper, 26.6 × 18.4 cm (10$\frac{15}{32}$ × 7$\frac{1}{4}$ in)
Signed with butterfly in plate and in pencil on tab and inscribed *imp* on tab
From the First Venice Set, Kennedy 185, State III
Glasgow, Hunterian Art Gallery, University of Glasgow,
J. A. McCallum Collection

PROV: Given by Dr James A. McCallum 1939/48

EXH: Arts Council of Great Britain 1960 (141)

LIT: K. Baedeker, *Italy: Handbook for Travellers: Northern Italy*, Leipzig 1906, pp.329-30; E. G. Kennedy, *The Etched Work of Whistler*, New York 1910, no.185; K. Lochnan, *The Etchings of James McNeill Whistler*, New Haven 1984, pp.193 and 281; M. M. Lovell, *Venice: The American View 1860-1920*, San Francisco 1984, pp.22-3, 150 and 158-9; J. Halsby, *Venice: The Artist's Vision*, London 1990, pp.82-6 and 137-49; H. Honour and J. Fleming, *The Venetian Hours of Henry James, Whistler and Sargent*, London 1991, pp.40-1 and 171

This etching depicts a scene near the west end of the Via Garibaldi, where it joins the western extremity of the Riva dei Sette Martiri. The footbridge in the left background is that over the Rio della Tana to the Riva San Biagio. Beyond, shipping in the Bacino di San Marco is visible. In a working-class area near the Arsenal, the Via Garibaldi is one of the few streets in Venice of conventional width and length. It was created in 1808 by filling in a canal. Its east end opens into the Giardini Garibaldi, which adjoin the Giardini Pubblici where the Venice Biennale has been held since 1895.

At the time of Whistler's visit, the Via Garibaldi was in an unfashionable area of the city, ignored by most earlier artists in Venice. In the spring of 1880 the American Frank Duveneck, who ran an art school in Munich, arrived with a group of American students and rented accommodation nearby, on the Riva degli Schiavoni. Whistler soon became friendly with them and took rooms beside theirs in the Casa Jankovitz. Round the corner in the Via Garibaldi was a modest trattoria named La Panada where they frequently dined. Mortimer Menpes, a student of Whistler's at the same time as Sickert, later described it thus:

The Panada had a sanded floor and was the noisiest restaurant in Venice. It was not clean; there was a great deal of smoke, and so much talk! The guests seemed to be screaming and talking at once in all the languages of the world … They dressed like artists and talked like artists … The waiters were also soiled and very apathetic – toes turned inwards, heads bent slightly forward … All was soiled at the Panada – the waiters, the artists and the linen.

Whistler's etchings of the bead-stringers [see no.10 below] and other working-class inhabitants of this part of Venice include a slightly larger print of a comparable scene entitled *The Mast*. It has been suggested that the lofty flagpole towering above the modest buildings and people was intended to evoke the contrast between Venice's past glories and present poverty – a literary theme which may be traced back to the early eighteenth century [see no.2 above]. Probably also in 1880, Duveneck's student Otto Bacher made an etching entitled *View of the Castello Quarter from Near the Casa Jankovitz, where Whistler Lodges*. This depicts, in reverse – following Whistler's own method – the view in the opposite direction, from the footbridge over the Rio della Tana towards the mast and the Via Garibaldi. Monet's *Saint-Georges Majeur au Crépuscule* of 1908 [see no.30 below] was painted from a viewpoint on the Riva degli Schiavoni between the mast and the bridge.

7. JAMES ABBOTT MCNEILL WHISTLER
The Palaces 1879-80
Etching and drypoint on white laid paper, 25.2 × 36 cm (9$\frac{15}{16}$ × 14$\frac{3}{16}$ in)
Signed with butterfly in plate and in pencil on tab and inscribed in pencil on reverse *Proof before later and completed state* and signed with butterfly
From the First Venice Set, Kennedy 187, State II
Glasgow, Hunterian Art Gallery, University of Glasgow, Birnie Philip Bequest

6 Whistler, *The Little Mast*, 1880

PROV: Bequeathed by Rosalind Birnie Philip 1958

EXH: Nottingham, University 1978 (16); Venice, Museo Correr, *Venezia nell'Ottocento* 1983 (34); Tokyo, Isetan Museum of Art, and tour 1987/88 (91)

LIT: J. Ruskin, *The Stones of Venice*, 4th ed., Orpington 1886, vol.2, *The Sea-Stories*, p.257, and vol.3, *The Fall*, pp.343-4; K. Baedeker, *Italy: Handbook for Travellers: Northern Italy*, Leipzig 1906, pp.318-19; E. G. Kennedy, *The Etched Work of Whistler*, New York 1910, no.187 and pls 56, 57, 61, 71 and 74; *Whistler: The Graphic Work: Amsterdam, Liverpool, London, Venice*, Thomas Agnew & Sons, London 1976, pp.39 and 45-6; *John Ruskin*, Arts Council of Great Britain 1983, p.51; K. Lochnan, *The Etchings of James McNeill Whistler*, New Haven 1984, pp.214 and 280; M. M. Lovell, *Venice: The American View 1860-1920*, San Francisco 1984, pp.151-2; J. Halsby, *Venice: The Artist's Vision*, London 1990, pp.42 and 52

This view of the medieval Palazzo Morosini-Sagredo and the smaller fifteenth-century Palazzo Pesaro Rava was etched from a viewpoint north of the Rialto Bridge and across the Grand Canal on the Fondamento dell'Olio between the Palazzo Morosini-Brandolin and the Pescheria. Although it barely obtained a mention in Baedeker's guide, Ruskin had been fascinated by the fenestration of the Palazzo Sagredo:

Much defaced, but full of interest. Its sea story is restored: its first floor has a most interesting arcade of the early thirteenth century third-order windows; its upper windows are the finest fourth and fifth orders of early fourteenth century: the group of fourth orders in the centre being brought into some resemblance to the late Gothic traceries by the subsequent introduction of the quatrefoils above them.

As an aid to their architectural studies, Ruskin and John Wharlton Bunney had previously made a number of meticulous watercolours of the façades of Venetian palaces which depict them four-square rather than at an oblique angle.

With sky and water barely indicated and architectural ornament depicted as a broken pattern of light and shade, *The Palaces* imbues the earlier topographical tradition with the sense of atmosphere encountered most forcibly in Whistler's nocturnes [see no.5 above]. In Venice the artist etched several similarly formal, frontal compositions of façades and doorways. Subsequently, several artists painted similar views [see nos 23 and 28 below]. Whistler was doubtless drawn to this part of the Grand Canal by a desire to see the Ca' d'Oro, the most spectacular fifteenth-century palace in Venice, the side of which is visible at the right of the composition. It is characteristic that he chose to etch these two comparatively little-known palaces, in preference to the Ca' d'Oro, a much more famous view which had been treated by numerous earlier artists.

The Palaces was the largest plate Whistler ever etched and it may have been intended as a centrepiece to the twelve prints in the First Venice Set. This impression is an early proof, before the first set exhibited in December 1880. Whistler did not complete the printing of all of the sets promised to the Fine Art Society and in August 1894 wrote excusing the slow progress of the last plates, which included *The Palaces*, 'plates are as whimsical and as difficult to deal with as horses! and when I do take up these two or three remaining ones the Lord knows how they may jib and shy and buck and bolt with me – the trouble they will give I know well – and the amount of coaxing and light handling required before I get them back into anything like training again!-!!'

8. JAMES ABBOTT MCNEILL WHISTLER
The Piazzetta 1880
Etching and drypoint on white laid paper, 25.3 × 17.9 cm
($9\frac{31}{32} × 7\frac{1}{16}$ in)
Signed with butterfly in plate and in pencil on tab and inscribed *imp* on tab
From the First Venice Set, Kennedy 189, State II
Glasgow, Hunterian Art Gallery, University of Glasgow, Birnie Philip Bequest

PROV: Bequeathed by Rosalind Birnie Philip 1958

LIT: E. G. Kennedy, *The Etched Work of Whistler*, New York 1910, no.189; W. G. Constable, *Canaletto*, Oxford 1962, vol.1, pl.24 and vol.2, pp.208-9; *Whistler: The Graphic Work: Amsterdam, Liverpool, London, Venice*, Thomas Agnew & Sons, London 1976, pp.42-3; K. Lochnan, *The Etchings of James McNeill Whistler*, New Haven 1984, p.281; M. M. Lovell, *Venice: The American View 1860-1920*, San Francisco 1984, pp.153-4; J. Halsby, *Venice: The Artist's Vision*, London 1990, p.80; H. Honour and J. Fleming, *The Venetian Hours of Henry James, Whistler and Sargent*, London 1991, pp.96-8

Canaletto's monumental early cycle of paintings of the Piazzetta in the Royal Collection includes a composition with a similar viewpoint, from the edge of the Molo, looking past the column of St Theodore down a vista framed by Sansovino's Library and the basilica of St Mark's towards the late fifteenth-century clock tower, the Torre del Orologio. It includes men lounging on the steps at the base of the column, but shows its full height and that of the campanile. In Whistler's etching, the upper parts of the column and the library fade into nothingness, none of the campanile is visible and the column is situated to obscure most of the façade of St Mark's. Beyond the children feeding the pigeons are the 'idle Venetians of the middle classes' whom Ruskin had observed lounging in the cafés in the piazza, the Loggetta at the base of the campanile and the three flagpoles. The scaffolding at the northern corner of the basilica's façade, visible in Whistler's *St Mark's Venice: Nocturne in Blue and Gold* [see no.4 above], also appears in this print, but at the opposite side, owing to the reversal caused by the etching process. As in the oil painting of the façade of St Mark's, the artist has gone out of his way to present an informal and unusual interpretation of a very famous subject.

Henry James visited Venice in April and May of 1881 and his essay *Venice* was published in the November 1882 issue of *Century Magazine*. It includes a memorable description of the precincts of St Mark's:

… The condition of this ancient sanctuary is surely a great scandal. The pedlars and commissioners ply their trade – often a very unclean one – at the very door of the temple; they follow you across the threshold, into the sacred dusk, and pull your sleeve, and hiss into your ear, scuffling with each other for customers. There is a great deal of dishonour about St Mark's altogether, and if Venice, as I say, has become a great bazaar, this exquisite edifice is now the biggest booth … The restoration of the outer walls, which has lately been so much attacked and defended, is certainly a great shock … Today, at any rate, that admirable harmony of faded mosaic and marble which, to the eye of the traveller emerging from the narrow streets that lead to the Piazza, filled all the further end of it with a sort of dazzling silvery presence – today this lovely vision is in a way to be completely reformed and indeed well-nigh abolished. The old softness and mellowness of colour – the work of the quiet centuries and of the breath of the salt sea – is giving way to large crude patches of new material which have the effect of a monstrous malady rather than a restoration to health. They look like blotches of red

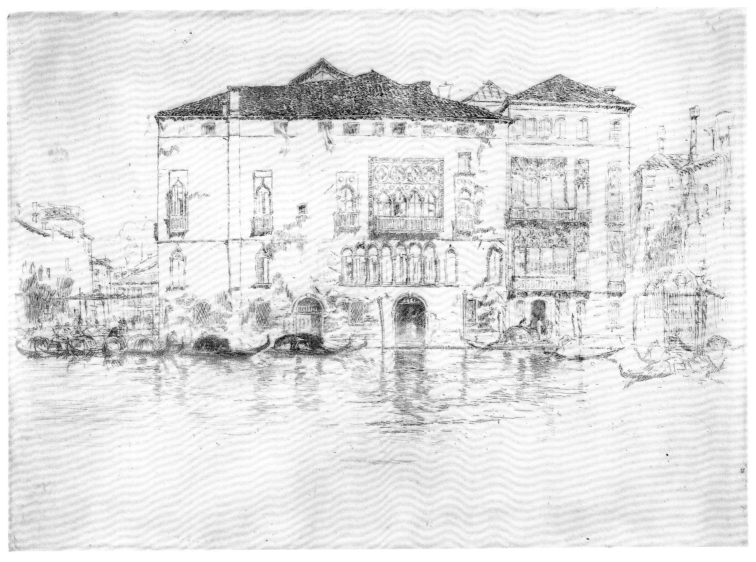

7 Whistler, *The Palaces*, 1879-80

and white paint and dishonourable smears of chalk on the cheeks of a noble matron. The face towards the Piazzetta is in especial the newest-looking thing conceivable – as new as a new pair of boots or as the morning's paper.

9. JAMES ABBOTT MCNEILL WHISTLER
The Riva, No.1 1880
Etching and drypoint, 20 × 29.5 cm (7⅞ × 11⅝ in)
Signed with butterfly in plate and in pencil on tab and inscribed *imp* on tab
From the First Venice Set, Kennedy 192, State III
London, Victoria and Albert Museum, Acc. Circ. 640-1968

PROV: Purchased 1968

LIT: E. G. Kennedy, *The Etched Work of Whistler*, New York 1910, no.192; W. R. Sickert (ed. O. Sitwell), *A Free House! or The Artist as Craftsman*, London 1947, pp.12-13; W. G. Constable, *Canaletto*, Oxford 1962, vol.1, pl.30 and vol.2, pp.234-5; T. Mann (trans. H. T. Lowe-Porter), *Death in Venice*, Harmondsworth 1971, p.20;

Whistler: The Graphic Work: Amsterdam, Liverpool, London, Venice, Thomas Agnew & Sons, London 1976, p.41; K. Lochnan, *The Etchings of James McNeill Whistler*, New Haven 1984, pp.182, 214, 219 and 281; M. M. Lovell, *Venice: The American View 1860-1920*, San Francisco 1984, pp.155-6; M. MacDonald, 'Lines on a Venetian Lagoon', *The Whistler Papers* (ed. L. De Girolami Cheney and P. G. Marks), Lowell, Mass. 1986, p.2; J. Halsby, *Venice: The Artist's Vision*, London 1990, pp.89 and 100-1; H. Honour and J. Fleming, *The Venetian Hours of Henry James, Whistler and Sargent*, London 1991, pp.43-4 and 171

This sweeping view of the Venice waterfront, facing westwards along the Riva degli Schiavoni from the Riva San Biagio, had already been painted by Canaletto. Nearly 200 years later, the prospect up the Canale di San Marco retained its power to amaze, as Thomas Mann recalled in *Death in Venice*, published in 1912:

He saw it once more, that landing-place that takes the breath away, that amazing group of incredible structures the Republic set up to meet the awe-struck eye of the approaching seafarer ... Looking, he thought that to come

8 Whistler, *The Piazzetta*, 1880

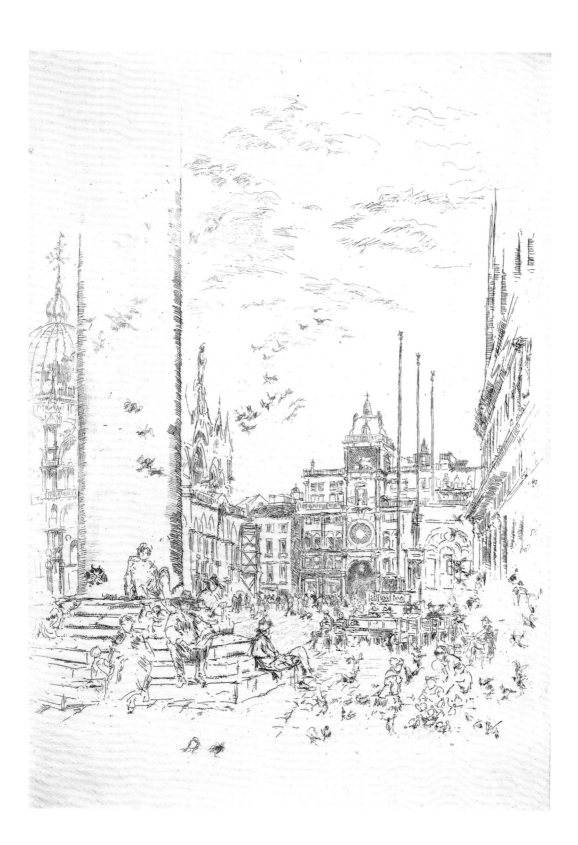

to Venice by the station is like entering a palace by the back door. No one should approach, save by the high seas as he was doing now, this most improbable of cities.

Whistler etched two versions of this scene. *The Riva, No.2* is a rather simpler composition and probably somewhat later in date. It has been proposed that this composition combines viewpoints on either side of the footbridge over the Canale dell' Arsenale and that its high viewpoint is invented. Alternately, it has been pointed out that he could have utilised a photographer's platform. Both compositions are distinctly asymmetrical, with the sky cropped very tightly at the top and a wide empty space left at the bottom. St Mark's campanile, a major focal point in most pictures with this viewpoint, is compressed into the top right-hand corner [see no.12 below].

This part of the Riva San Biagio is near the Casa Jankovitz where Whistler, Duveneck and his students lodged [see no.6 above]. Duveneck executed a very similar etching entitled *The Riva, Looking Towards the Grand Ducal Palace*, which was mistaken for Whistler's work when exhibited at the Society of Painter-Etchers in 1881. Otto Bacher explained the similarity: 'It is only fair to say that Duveneck made the etchings of the Riva before Whistler made his. Whistler saw them as I was helping Duveneck bite the plates, and frankly

said:"Whistler must do the Riva also".' A year or two later, Sargent painted the closely comparable composition of *Venise par temps gris* from a nearby viewpoint [see no.12 below]. These scenes may have been in the back of Julia Cartwright's mind in 1884 when she observed:

Next to the Piazza, the Riva dei Schiaveni [*sic*] is, perhaps, the most attractive place in Venice … there you see whatever is left of the vivacity and joyousness of Venetian life … This is the place for the artist who knows dextrously to combine groups of figures with shipping and buildings. He has but to take his stand on a balcony overlooking the Riva … and he will see every type and variety conceivable.

In a review published in 1906, W. R. Sickert commented on this composition

… it is a virtue to etch from nature, and a sin not to do so. So that the criticism that I have to make on the Venice etchings will sound, I fear, in the ears of the faithful, almost like a blasphemy. My criticism is in the form of a suggestion to some publisher in England or America who can see three yards ahead of his fellows. Let him bring out a book of good reproductions of the Venice etchings *reversed*, the same size as the originals. Let there be a brief, careful topographical note to each, by someone who knows Venice well from San Simeone Profeta to San Pietro di Castello. Let us enjoy, *for the*

9 Whistler, *The Riva, No.1*, 1880

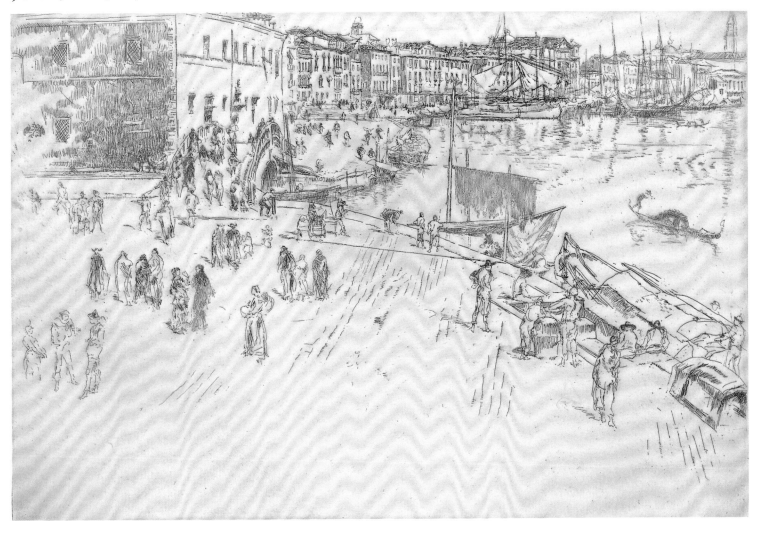

10 Whistler, *Bead Stringers*, 1879-80

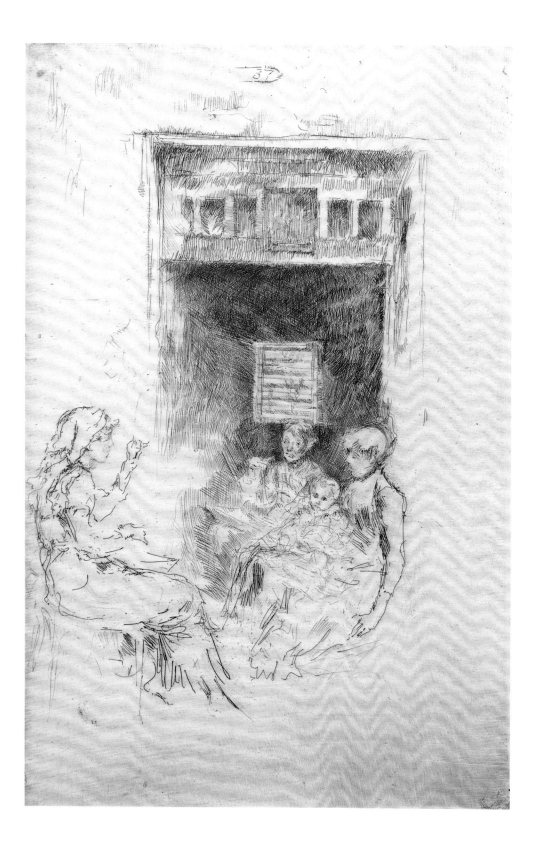

first time, without having to reverse them in a looking-glass, the witty comments of the hand that flew like a swallow over the surface of the copper in lyrical appreciation of the loveliest city in the world. I do not want to think that I am looking along the Riva towards the Via Garibaldi when I am really looking towards the Ducal Palace. [See also no.5 above]

10. JAMES ABBOTT MCNEILL WHISTLER
Bead Stringers 1879-80
Etching and drypoint on white laid paper, 22.7 × 15.1 cm
($8\frac{15}{16}$ × $5\frac{15}{16}$ in)
Signed in pencil on tab and inscribed *imp* on tab
From the Second Venice Set, Kennedy 198, State VI-VII
Glasgow, Hunterian Art Gallery, University of Glasgow, Birnie Philip Bequest

PROV: Bequeathed by Rosalind Birnie Philip 1958

LIT: J. Ruskin, *The Stones of Venice*, 4th ed., Orpington 1886, vol.2, *The Sea-Stories*, p.166; E. G. Kennedy, *The Etched Work of Whistler*, New York 1910, no.198; C. Dodgson, *The Etchings of James McNeill Whistler*, London 1922, pp.5-6, 17, 22, 27 and 36, and pls 7, 8, 37, 63, 65, 71, 74 and 79; K. Lochnan, *The Etchings of James McNeill Whistler*, New Haven 1984, pp.182, 191, 232 and 281; M. M. Lovell, *Venice:*

The American View 1860-1920, San Francisco 1984, p.160; P. Hills (ed.), *John Singer Sargent*, New York 1986, pp.54, 57, 66 and 70; J. Halsby, *Venice: The Artist's Vision*, London 1990, pp.73-6; H. Honour and J. Fleming, *The Venetian Hours of Henry James, Whistler and Sargent*, London 1991, pp.71-4

Whistler had etched comparable scenes of women working, framed by a dark doorway, for the so-called 'French Set', published in 1858. Such compositions as *La Vieille aux Loques* and *La Marchande de Moutarde* were probably inspired by the work of contemporary French painters such as François Bonvin, and seventeenth-century Dutch genre scenes. The motif of figures before a doorway appears repeatedly in his Venetian prints. Here, two women string beads, picking them from the wooden trays on their laps, whilst a third attends to a baby. While the oldest woman is heavily modelled and shrouded in shadow, the mother and child are illuminated by a beam of sunlight and the youngest of the three, the girl at the left, is insubstantially sketched in a flickering series of broken lines without any modelling. It has been pointed out that this variation in technique is consistent with the implicit subject-matter of the four ages of life, from childhood to old age.

Bead manufacture was a well known by-product of the Murano glass industry. Narrow-bore coloured glass tubes were drawn, cut

11 Whistler, *Nocturne: Salute*, 1879-80

into bead-sized pieces and smoothed, before being passed out to stringers working at home, such as the women in Whistler's print. In vol.2 of *The Stones of Venice*, first published in 1853, Ruskin roundly condemned bead manufacture as an example of his maxim *Never encourage the manufacture of anything not necessary, in the production of which invention has no share*:

Glass beads are utterly unnecessary, and there is no design or thought employed in their manufacture. They are formed by first drawing out the glass into rods; these rods are chopped up into fragments of the size of beads by the human hand, and the fragments are then rounded in the furnace. The men who chop up the rods sit at their work all day, their hands vibrating with a perpetual and exquisitely timed palsy, and the beads dropping beneath their vibration like hail. Neither they, nor the men who draw out the rods, or fuse the fragments, have the smallest occasion for the use of any single human faculty; and every young lady, therefore, who buys glass beads is engaged in the slave trade, and in a much more cruel one than that which we have so long been endeavouring to put down.

Ruskin made no comment on the work of the stringers, possibly because he perceived a faint element of invention in the making up of strings of beads.

Before Whistler, few artists had considered ordinary Venetian people a subject-matter, except as compositional elements in the foreground of views of the famous sights of the city. J. S. Sargent, who probably met Whistler in Venice in 1880, began his series of paintings of Venetian working-class life shortly after [see no.13 below] and Carlo Naya's photographic studio produced photographs of bead-stringers during the 1880s. In Henry James's drama *The Princess Casamassima*, published in 1886, the hero Hyacinth Robinson writes:

The Venetian girl-face is wonderfully sweet and the effect is charming when its pale and sad oval (they all look underfed) is framed in the old faded shawl … I've seen none of the beautiful patricians who sat for the great painters – the gorgeous beings whose golden hair was intertwined with pearls; but I'm studying Italian in order to talk with the shuffling clicking maidens who work in the bead-factories …

This sentimentality is more in tune with idealised genre scenes, such as Luke Fildes' *Venetians* of 1885 (Manchester City Art Gallery), than the shabby inhabitants of Whistler's back alleys.

11. JAMES ABBOTT MCNEILL WHISTLER
Nocturne: Salute 1879-80
Etching on white laid paper, 15.3 × 22.7 cm (6 × 8¹⁵⁄₁₆ in)
Signed with butterfly in plate
Kennedy 226, State V
Glasgow, Hunterian Art Gallery, University of Glasgow, Birnie Philip Bequest

PROV: Bequeathed by Rosalind Birnie Philip 1958

EXH: Aldeburgh 1968 (26); Venice, Museo Correr, *Venezia nell'Ottocento* 1983 (48); Glasgow, Hunterian Art Gallery, *Whistler Pastels* 1984 (116)

LIT: E. G. Kennedy, *The Etched Work of Whistler*, New York 1910, no.226; W. G. Constable, *Canaletto*, Oxford 1962, vol.1, pls 34-6, and vol.2, pp.244-53; T. Mann (trans. H. T. Lowe-Porter), *Death in Venice*, Harmondsworth 1971, p.21; K. Lochnan, *The Etchings of James McNeill Whistler*, New Haven 1984, pp.187 and 281; M. M. Lovell, *Venice: The American View 1860-1920*, San Francisco 1984, pp.168-9; M. Butlin and E. Joll, *The Paintings of J. M. W. Turner*, New Haven and London 1984, pp.252 and 259; L. Stainton, *Turner's Venice*,

London 1985, p.56; M. MacDonald, 'Lines on a Venetian Lagoon', *The Whistler Papers* (ed. L. De Girolami Cheney and P. G. Marks), Lowell, Mass. 1986, p.11; H. Honour and J. Fleming, *The Venetian Hours of Henry James, Whistler and Sargent*, London 1991, pp.58-9 and 102-3.

Although not included in either of the Venice sets, probably because its fine lines wore down so quickly that it was difficult to print, this etching is probably one of the first Whistler made after his arrival there, and is close in date and technique to *Nocturne* [see no.5 above]. It depicts Santa Maria della Salute and the Dogana point with shipping beyond in the Canale della Giudecca, viewed from the edge of the Molo in front of the Piazzetta [see no. 8 above]. The faintly etched structure at the left of the composition is probably the corner of Sansovino's Library, which forms one face of the Piazzetta. This view is one of the best known in Venice and had been painted by many artists since Canaletto. However, only Turner had previously captured the ethereality of the scene at sunset, in a pair of oil paintings and some watercolours of the early 1840s [see also no. 3 above]. Otto Bacher aptly described the first impression of this etching as 'like a breath in its delicate elusiveness'. Renoir may have seen this print when he met Whistler in Paris in the spring of 1881, a few months before his own departure for Venice. Renoir's uncharacteristic oil painting *Fog in Venice* [see fig.10] depicts the same view (but not reversed, as in the etching) with the Salute as a faint silhouette on the horizon and gondolas in the foreground [see also no.12 below].

Gondolas have never failed to fascinate visitors to Venice, such as Henry James in the article *Venice*, first published in 1882:

There is something strange and fascinating in this mysterious impersonality of the gondola. It has an identity when you are in it, but, thanks to their all being the same size, shape and colour, and of the same deportment and gait, it has none, or as little as possible, as you see it pass before you. From my windows on the Riva there was always the same silhouette – the long, black, slender skiff, lifting its head and throwing it back a little, moving yet seeming not to move, with the grotesquely-graceful figure on the poop. This figure inclines, as may be, more to the graceful or to the grotesque … It has the boldness of a plunging bird and the regularity of a pendulum. Sometimes, as you see this movement in profile, in a gondola that passes you – see, as you recline on your own low cushions, the arching body of the gondolier lifted up against the sky – it has a kind of nobleness which suggests an image on a Greek frieze.

In Whistler's mysterious etching, the gondola passing the ghostly Salute is more evocative of the sinister description in Thomas Mann's *Death in Venice* of 1912:

Is there anyone but must repress a secret thrill, on arriving in Venice for the first time – or returning thither after long absence – and stepping into a Venetian gondola? That singular conveyance, come down unchanged from ballad times, black as nothing else on earth except a coffin – what pictures it calls up of lawless, silent adventures in the plashing night; or even more, what visions of death itself, the bier and solemn rites and last soundless voyage! And has anyone remarked that the seat in such a bark, the arm-chair lacquered in coffin-black, and dully upholstered, is the softest, most luxurious, most relaxing seat in the world?

John Singer Sargent (1856-1925)

The son of a Philadelphia surgeon persuaded by his wife to live in Italy, Sargent was born in Florence and brought up in Italy, France, Switzerland and Germany. He attended the Accademia delle Belle Arti in Florence during 1873-4, before transferring to Paris in 1874. There he studied at the École des Beaux-Arts and the studio of Émile Auguste Carolus-Duran, an imitator of Impressionist techniques and an admirer of Velasquez. In 1876 Sargent met Monet and visited the United States. The following year he completed his studies and was elected to the newly founded Association of American Artists; in 1878 he began to exhibit at the Paris Salon. During 1879-80 Sargent travelled widely in Spain, North Africa and Holland and began to specialise in portraits of visiting Americans.

Although Sargent had visited Venice as a boy in 1870 and 1873 and spent a week there during the summer of 1880, his first protracted visit began in September 1880, when he and his family stayed at the Hotel d'Italie at the mouth of the Grand Canal. After his family left, he took a studio in the Ca' Rezzonico and lodgings at 290 Piazza San Marco, next to the Torre dell' Orologio, where he remained until the following spring. In 1882 Sargent returned and stayed for two months with his cousins, the Curtises, at the Palazzo Barbaro.

During the 1880s, Sargent exhibited at the Royal Academy, the Galerie Georges Petit in Paris, Les XX in Brussels and the New English Art Club, of which he was a founder member. He became friendly with Henry James in 1884 and in 1886 moved his studio from Paris to London. There Sargent joined the American expatriate circle of E. A. Abbey and soon became the leading fashionable portrait painter of his generation. In 1887-9 he made an extended visit to the United States and visited Monet at Giverny several times. His international reputation was confirmed in 1889 when he served on the jury of the Salon and was made a Chevalier of the Legion of Honour. Sargent spent 1890 in the United States and travelled widely in Egypt, Greece and Turkey during 1891. Elected an Associate of the Royal Academy in 1894, he became a full Academician in 1897. In 1898 he returned to Venice and began the group portrait of the Curtis family, *An Interior in Venice*. When this was refused by Mrs Curtis as a gift, he submitted it to the Royal Academy as his diploma picture.

Thereafter, Sargent visited Venice, where he usually stayed at the Palazzo Barbaro, in 1902, 1903, 1904, 1906, 1907, 1909, 1911 and 1913. Following his decision to give up commission portraiture in 1907, he turned increasingly to watercolour. In 1912 Sargent painted a portrait of Henry James to commemorate the author's seventieth birthday. The following year he received an honorary degree from Cambridge and in 1914 the gold medal of the American Academy of Arts and Sciences. Prevented from travelling in Europe by the outbreak of the First World War, he spent 1916-18 in the United States. In 1918 Sargent returned to France as an official war artist, began the monumental painting *Gassed* and refused to run for the presidency of the Royal Academy. For the remainder of his life, he worked increasingly in Boston. In 1926, following his death, his studio sale realised £175,000 and he received retrospective exhibitions at the Royal Academy, the Metropolitan Museum of Art and the Walker Art Gallery, Liverpool.

12. JOHN SINGER SARGENT
Venise par temps gris 1880-2
Oil on canvas, 50.8 × 71cm (20 × 27$\frac{15}{16}$ in)

Signed and inscribed lower right:
A mon ami Flameng
John S. Sargent
Private Collection

PROV: François Flameng; Sir Philip Sassoon; Mrs Hannah Gubbay and thence by descent

EXH: London, Royal Academy, *Works by the Late John S. Sargent, R. A.* 1926 (37); Birmingham, City Museum & Art Gallery, *J. S. Sargent* 1964 (6); London, Wildenstein, *Venice Rediscovered* 1972 (33); King's Lynn, Fermoy Gallery, *The Venetian Scene* n.d.(23)

LIT: W. G. Constable, *Canaletto*, Oxford 1962, vol.1, pl.30, and vol.2, pp.234-5; J. Ingamells, *The Davies Collection of French Art*, Cardiff 1967, pp.63-4; R. Ormond, *John Singer Sargent*, London 1970, pp.30 and 237, and pl.13; P. Hills (ed.), *John Singer Sargent*, New York 1986, p.54; S. Olson, *John Singer Sargent: His Portrait*, London 1986, pp.95-6, 148 and 258-61; H. Honour and J. Fleming, *The Venetian Hours of Henry James, Whistler and Sargent*, London 1991, pp.57-9

The dedicatee of this picture, François Flameng (1856-1923), was a well-known French painter, of whom Sargent made a portrait sketch. A subsequent owner, Sir Philip Sassoon (1888-1939), was also a friend of the artist. As private secretary to Field Marshal Haig, Sassoon looked after Sargent when he visited France in 1918 to paint his tragic masterpiece *Gassed*.

This painting more probably dates from the artist's second painting visit to Venice in 1882 than his previous stay in 1880/81. Its composition is more conventional than Whistler's analogous *The Riva, No.1* [see no.9 above]. As in Canaletto's much earlier paintings of the scene, St Mark's campanile is a prominent motif and the curve of the Riva degli Schiavoni is continued across to terminate with the mouth of the Grand Canal and the dome of Santa Maria della Salute. Nevertheless, its mysterious atmospheric qualities are distinctly Whistlerian. As Sargent probably met Whistler in Venice in 1880, the scene may have been suggested by the latter's etchings. Sargent appears to have been working from the Riva di Ca' di Dio, possibly no.2187, where the corner overlooking the Calle dei Forni permits an elevated view along the Riva degli Schiavoni and across to Santa Maria della Salute.

The similarity in feeling which has been noted between this painting and Renoir's approximately contemporary *Fog in Venice* of 1881 [see fig.10] may not reflect the influence of the young American on the older Frenchman so much as the impact of Whistler on both [see no.11 above]. Moreover, the wintry tonalities of *Venise par temps gris* may be paralleled in earlier Impressionist winter scenes, such as Manet's *Church of Petit-Montrouge* of 1870 (National Museum of Wales, Cardiff, fig.16). In 1895 Eugène Boudin also commented on the appearance of the city in dull weather [see no.19 below]. Sargent's letter of 4 December 1882 to his American hostess in Venice, Mrs Curtis, provides an eloquent commentary on the foggy scene: 'If you stay there late enough you will perhaps see how curious Venice looks with snow clinging to the roofs and balconies, with a dull sky and the canals of a dull opaque green, not unlike pea soup, *con rispetto*, and very different from the julienne of the Grand Canal in summer.' In October 1882 an observer wrote an ambivalent account of his Venetian scenes: 'He had ... some half-finished pictures of Venice. They are very clever, but a good deal inspired by the desire of finding what no one else has sought here – unpicturesque subjects, absence of colour, absence of sunlight. It seems hardly worth while to travel so far for these.'

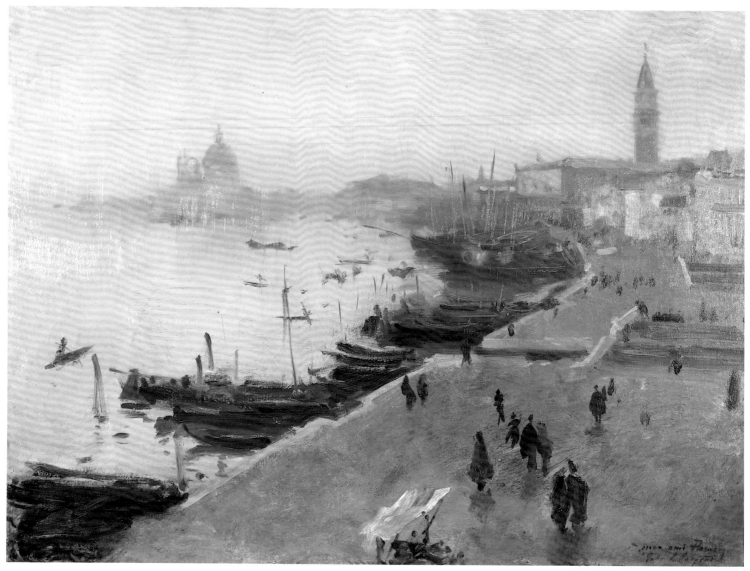

12 Sargent, *Venise par temps gris*, 1880-2

13. JOHN SINGER SARGENT
The Bead Stringers of Venice *c*.1880-2
Oil on canvas laid on board, 56.2 × 81.9 cm (22⅛ × 32¼ in)
Signed and inscribed, bottom centre:
To my friend Lawless
John S. Sargent
Dublin, National Gallery of Ireland

PROV: Given by the artist to Valentine Lawless, Lord Cloncurry; by whom bequeathed 1929

EXH: Dublin, National Gallery, *Centenary Exhibition 1864-1964* 1964 (180); London, Wildenstein, *Venice Rediscovered* 1972 (34); San Francisco, California Palace of the Legion of Honor, *Venice: The American View 1860-1920* 1984-5 (56)

LIT: R. Ormond, *John Singer Sargent* London 1970, pp.29, 30, 69 and 238, and pl.21; M. M. Lovell, *Venice: The American View 1860-1920*, San Francisco 1984, pp.95-107, P. Hills (ed.), *John Singer Sargent*, New York 1986, pp.55, 59 and 70; H. Honour and J. Fleming, *The Venetian Hours of Henry James, Whistler and Sargent*, London 1991, pp.71-4

This unfinished painting was apparently painted in the company of Lord Cloncurry (1840-1928). Unsatisfied with it, Sargent cut out the figure at the top right, whereupon the dedicatee requested the remainder of the picture and had it roughly repaired. It is one of several Venetian genre scenes, principally of working-class women in shadowy alleys and interiors, which the artist painted during the 1880s.

Whistler's slightly earlier prints of similar subjects probably provided inspiration [see no.10 above]. However, Whistler's etched *Bead Stringers* inter-relate from one to the other as though in conversation, while Sargent's Venetian women seem lost in their own thoughts. A similar melancholic atmosphere pervades his related paintings, *Venetian Bead Stringers* (Buffalo, Albright-Knox Art Gallery) and *Venetian Glass Workers* (Art Institute of Chicago). This sense of isolation and the artist's dark palette reflect the artist's study of Velasquez. Sargent had already painted a copy (Dublin, Beit Collection) of the latter's *Story of Pallas and Arachne* (Madrid, Museo del Prado), which juxtaposes back-turned working women against brightly-lit background figures. It has been noted that such silence seems to have been characteristically Venetian, to judge from the author of *Sketches of a Summer Tour*, published in 1866: 'The very nature of the *employments* in Venice, conduces to its Sybaritic quiet.

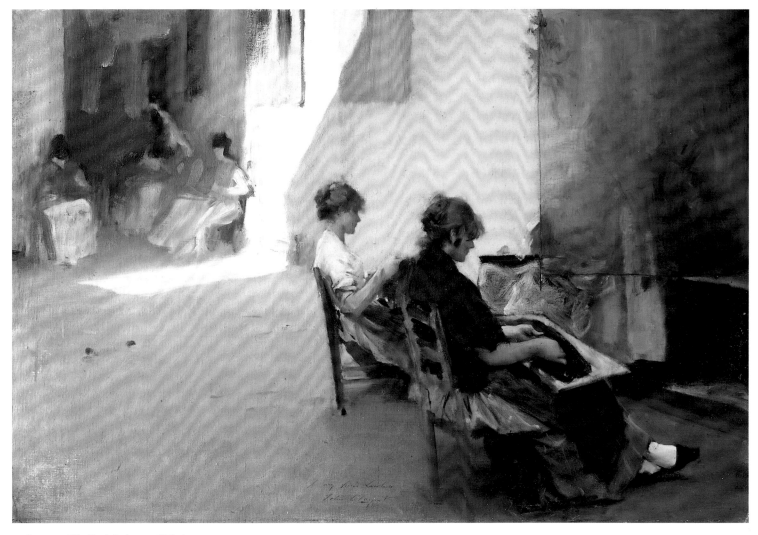

13 Sargent, *The Bead Stringers of Venice*, c.1880-2

The whole population, wander where you will through its narrow lanes, is employed in fabricating pretty trifles ... there was hardly an article of merchandise in the city, that weighed twenty pounds, or an artisan, who wielded an instrument bigger than a darning needle.'

In 1882 Sargent exhibited several Venetian genre pictures in London and Paris, eliciting the following response from the critic Arthur Baignères in *Gazette des Beaux-Arts* for February 1883:

We see neither the Grand Canal, nor the Piazza San Marco ... Mr. Sargent takes us into gloomy little squares and mean dark rooms which are pierced by a single ray of sunshine. Where are Titian's beautiful women? These are certainly not their descendants, women we can scarcely see under their unkempt hair, cloaked in an old shawl as though suffering from a fever. Why need one go to Italy to collect such impressions?

Henry James's remarks on the looks of Venetian working girls in *The Princess Casamassima* of 1886 read almost like a riposte to this criticism [see no.10 above]. When exhibited in New York in 1888, Sargent's genre scenes received positive reviews, such as that in *The New York Times* for 8 April: 'Observe the difference when Mr Sargent paints Venetian women of the middle class under his own inspiration – Velasquez and Spain ... How delightfully he catches the slouchy picturesqueness of the Venetian girls! How well he paints the curves inside the inevitable shawl drawn closely round the figure!'

14. JOHN SINGER SARGENT
Santa Maria della Salute 1904 or 1908
Oil on canvas, 64.1 × 92.4 cm (25¼ × 36⅜ in)
The Syndics of the Fitzwilliam Museum, Cambridge

PROV: The Artist's estate, sold by his executors at Christie, Manson & Woods, 24 July 1925 (102); bought Martin; Harold, First Viscount Rothermere 1926; by whom given to the Fitzwilliam Museum 1926.

EXH: London, Royal Academy, *Exhibition of Works by the Late John S. Sargent, R. A.* 1926 (22); London, Wildenstein, *Venice Rediscovered* 1972 (39); Nottingham, University Art Gallery, *Queen of Marble and Mud, The Anglo-American Vision of Venice: 1880-1910* 1978 (30); San Francisco, California Palace of the Legion of Honor, *Venice: The American View 1860-1920* 1984-5 (67)

LIT: M. Davies, 'Diary of my Second Trip to Italy. April 1909', unpaginated manuscript, Davies family papers; E. Degas (ed. T. Reff), *The Notebooks of Edgar Degas: A Catalogue of the Thirty-eight Notebooks in the Bibliothèque Nationale and Other Collections*, Oxford 1976, vol.1, pp.134-5; J. W. Goodison, *Fitzwilliam Museum Cambridge, Catalogue of Paintings*, vol.3, Cambridge 1977, pp.215-16; M. M. Lovell, *Venice: The American View 1860-1920*, San Francisco 1984, pp.112-15;

14 Sargent, *Santa Maria della Salute*, 1904 or 1908

H. Honour and J. Fleming, *The Venetian Hours of Henry James, Whistler and Sargent*, London 1991, pp.116-17

This is one of several views of parts of the exterior of Santa Maria della Salute painted by Sargent in the first decade of the century. A closely related watercolour is in the Museum of Fine Arts, Boston, and an oil is in Johannesburg Art Gallery. It has been observed that these different versions of the same motif recall the series painting of Monet [see nos 28-30 below]. Sickert's preoccupation with the façade of St Mark's is perhaps more comparable [see nos 20 and 21 below]. Sargent apparently utilised a photograph of this view of the church, found in his studio, in devising these compositions – a method also employed by Sickert, perhaps as early as 1899. Sargent produced numerous such 'cryptically sliced and partial compositions' in Venice [see nos 15 and 17-18 below]. These have been related to a remark in Degas' notebooks: 'No one has ever done monuments or houses from below, from beneath, up close, as one sees them going by on the streets.' This congruence may not be entirely accidental as Sickert, who was a friend of Degas, also painted partial architectural scenes viewed from a low point [see no.21 below]. Whistler's taste

for unusual, oblique viewpoints [see nos 4, 8 and 9 above] also foreshadows this development.

Following a devastating outbreak of plague in 1629-30, the Republic resolved to build Santa Maria della Salute in thanksgiving for the deliverance of the city. Designed by Baldassare Longhena, it was begun in 1631 and completed in 1687. Ruskin appreciated the Salute and its monumental steps [see no.3 above]. In the essay *The Grand Canal*, published in *Scribner's Magazine* for November 1892, Henry James remarked on the contrast between St Mark's and the Salute [see no.22 below] and observed

... the shady steps of the Salute. These steps are cool in the morning, yet I don't know that I can justify my excessive fondness for them any better than I can explain a hundred of the other vague infatuations with which Venice sophisticates the spirit. Under such an influence fortunately one needn't explain – it keeps account of nothing but perceptions and affections. It is from the Salute steps perhaps, of a summer morning, that this view of the open mouth of the city is most brilliantly amusing.

After watching the regatta for the opening of the Venice Biennale on 24 April 1909, Margaret Davies wrote in her diary 'After this is over, we cross the Canal to the church Santa Maria della Salute. The exterior looks very imposing but the interior is not so interesting.'

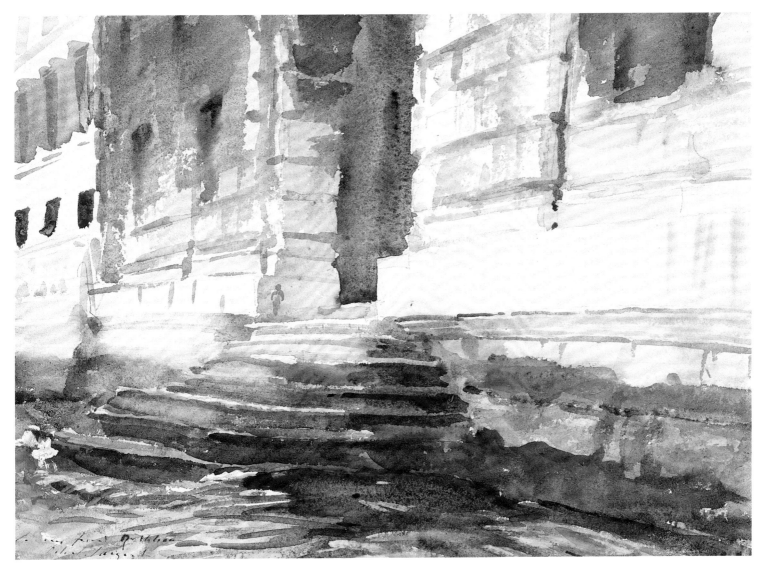

15 Sargent, *Steps of the Palazzo, Venice, c.1906-11*

15. JOHN SINGER SARGENT
Steps of the Palazzo, Venice *c.*1906-11
Watercolour, gouache and pencil, 25.4 × 35.6 cm (10 × 14 in)
Signed and inscribed, lower left:
To my friend Rathbone
John S. Sargent
Private Collection

PROV: William G. Rathbone VII and thence by descent

EXH: London, Royal Academy, *Exhibition of Works by the Late John
S. Sargent R. A.* 1926 (495); Liverpool, Walker Art Gallery, *American
Artists in Europe, 1800-1900* 1976-7 (56)

LIT: J. Ruskin, *The Stones of Venice*, 4th ed., Orpington 1886, vol.3,
The Fall, p.32; H. James, *The Aspern Papers*, *The Novels and Tales of
Henry James* (New York Edition), vol.12, repr. New Jersey 1971,
pp.9-10; *Venice Rediscovered*, Wildenstein, London 1972, pp.27-8;
M. M. Lovell, *Venice: The American View 1860-1920*, San Francisco
1984, pp.107-8; P. Hills (ed.), *John Singer Sargent*, New York 1986,
pp.219-25; H. Honour and J. Fleming, *The Venetian Hours of Henry
James, Whistler and Sargent*, London 1991, pp.118-19, 126 and 128

Towards the end of his life, Sargent used watercolour increasingly,
not as a preliminary technique but as an end in itself for exhibition
and sale. Although he made use of numerous easels and umbrellas to
keep off the wind, his essential watercolour equipment was 'an
ordinary folding tin box of colours in pans, with dabs of dirty colour
all around'. Sometimes with rough pencil under-drawing, he
generally worked on a layer of wash applied to damp paper,
completing pictures in a single session. Sargent was particularly
fascinated by the effects of sunlight, modified by shadow or reflected
off water and polished surfaces – conditions frequently encountered
on the waterways of Venice.

This characteristic view from a gondola belonged to William
G. Rathbone VII (1849-1919), a financier, champion of contemporary
composers such as Wagner and Fauré and friend of Sargent [see also
nos 16-18 below]. It depicts an unidentified classicising palace with a
rusticated ground floor. The Venetian palace with which Sargent was
personally best acquainted was the fifteenth-century Palazzo Barbaro,
slightly south of the Accademia bridge, where the artist was often
entertained by the parents of his friend and contemporary, Ralph
Curtis. Another frequent guest was Henry James [see no.26 below].
In *The Aspern Papers*, published in 1888, the hostess Mrs Prest

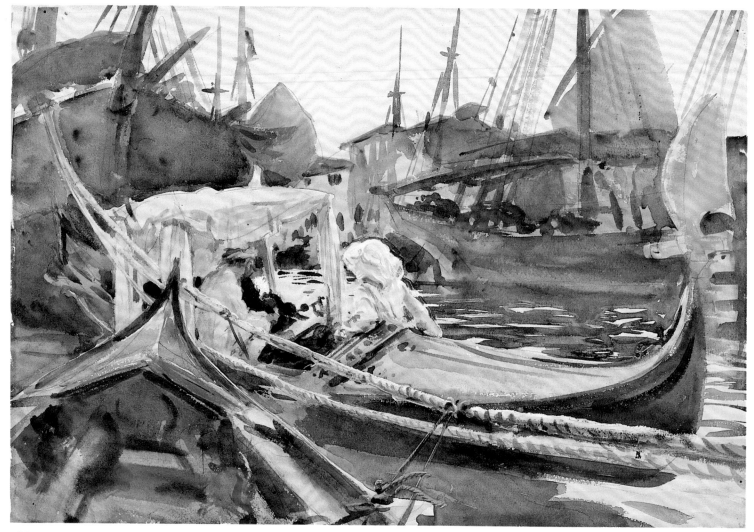

16 Sargent, *Sketching on the Giudecca*, *c.*1904

somewhat over-states the case when she observes: 'Dilapidated old palazzi, if you'll go out of the way for them, are to be had for five shillings a year'. In 1840 Robert Browning began a poem 'I MUSE ... on a ruined palace-step At Venice ...' and in 1853 Ruskin noted that the magnificent Palazzo Grimani '... having been condemned by its proprietor, not many years ago, to be pulled down and sold for the value of its materials, was rescued by the Austrian Government, and appropriated – the Government officers having no other use for it – to the business of the Post-Office ...' [see no.17 below]. Despite conversion into hotels and lodgings to meet an ever-growing tourist trade and occasional purchase and renovation by the state or wealthy foreigners, the maintenance of Venice's innumerable palaces remains an intractable problem.

16. JOHN SINGER SARGENT
Sketching on the Giudecca *c.*1904
Watercolour, pencil and gouache, 36.8 × 53.3 cm (14½ × 21 in)
Private Collection

PROV: William G. Rathbone VII; his daughter, Lady Richmond, and thence by descent

EXH: Birmingham, Museum and Art Gallery, *Exhibition of Works by John Singer Sargent, R. A.* 1964 (60); London, Wildenstein, *Venice Rediscovered* 1972 (38); Liverpool, Walker Art Gallery, *American Artists in Europe, 1800-1900* 1976-7 (53); Nottingham, University Art Gallery, *Queen of Marble and Mud, The Anglo-American Vision of Venice: 1880-1910* 1978 (33); Leeds, City Art Gallery, *John Singer Sargent and the Edwardian Age* 1979 (83); New York, Coe Kerr Gallery, *John Singer Sargent: His Own Work* 1980 (29); San Francisco, California Palace of the Legion of Honor, *Venice: The American View 1860-1920* 1984-5 (72); New York, Whitney Museum of American Art, *John Singer Sargent* 1986-7 (187)

LIT: R. Ormond, *John Singer Sargent*, London 1970, p.255 and pl.106; M. M. Lovell, *Venice: The American View 1860-1920*, San Francisco 1984, pp.118-19; P. Hills (ed.), *John Singer Sargent*, New York 1986, p.222; S. Olson, *John Singer Sargent: His Portrait*, London 1986, pp.197, 200, 211, 227-8 and 238-9 and pl.xxx; J. Halsby, *Venice: The Artist's Vision*, London 1990, pp.121-2; H. Honour and J. Fleming, *The Venetian Hours of Henry James, Whistler and Sargent*, London 1991, pp.155-6

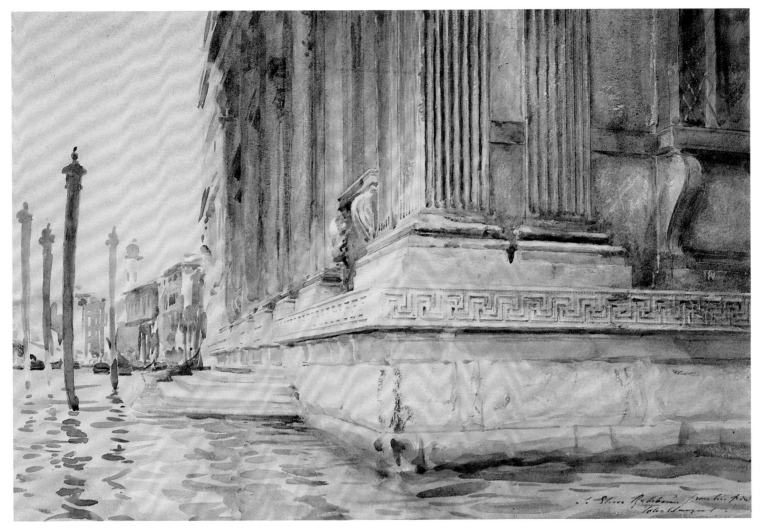

17 Sargent, *Venetian Palace Steps, Palazzo Grimani, c.*1907

One of the attractions of Venice for artists was the abundance and variety of its shipping, from gondolas and barges to sailing ships and steamers [see fig.12]. This scene depicts the busy Giudecca Canal which separates the Giudecca Island from the main island of Venice. From this location Sargent painted several watercolours of the dome of Santa Maria della Salute framed by the rigging of ships. The couple sketching in the gondola, dressed in white against the heat of the sun, are Wilfred de Glehn (1870-1951) and his American wife Jane Emmet. De Glehn worked as Sargent's assistant on the Boston Library murals during the 1890s and his style was deeply indebted to that of the older artist. He also executed views of Venice, two of which were in Sargent's collection. His wife was a distant cousin of Henry James and was herself an able painter who specialised in portraits of children. After their marriage in 1904, they were frequent travelling companions of the artist, who painted another double portrait of them, at Frascati in 1907.

Henry James included a memorable description of Venetian water traffic in *The Grand Canal*, published in 1892:

... Venice comes and goes, and the particular stretch you command contains all the characteristics. Everything has its turn, from the heavy barges of merchandise, pushed by long poles and the patient shoulder, to the floating pavilions of the great serenade, and you may study at your leisure the

admirable Venetian arts of managing a boat and organising a spectacle. Of the beautiful free stroke with which the gondola, especially when there are two oars, is impelled, you never, in the Venetian scene, grow weary; it is always in the picture, and the large profiled action that lets the standing rowers throw themselves forward to a constant recovery has the double value of being, at the fag-end of greatness, the only energetic note. The people from the hotels are always afloat ... The crush of boats, the universal sociable bumping and squeezing, is great when, on the summer nights, the ladies shriek with alarm, the city pays the fiddlers and the illuminated barges, scattering music and song, lead a long train down the Canal.

17. JOHN SINGER SARGENT
Venetian Palace Steps, Palazzo Grimani *c.*1907
Watercolour and pencil, 30.5 × 45.8 cm (12 × 18 in)
Signed and inscribed lower right:
to Elena Rathbone from her friend
John S. Sargent
Private Collection

PROV: Given by the artist to Elena Rathbone, later Lady Richmond, as a wedding present in 1913 and thence by descent

EXH: London, Royal Academy, *Exhibition of Works by the Late John S. Sargent R. A.* 1926 (128); Birmingham, Museum and Art Gallery, *Exhibition of Works by John Singer Sargent, R. A.* 1964 (67); Liverpool, Walker Art Gallery, *American Artists in Europe, 1800-1900* 1976-7 (54)

LIT: J. Ruskin, *The Stones of Venice*, 4th ed., Orpington 1886, vol.3, *The Fall*, p.32; K. Baedeker, *Italy: Handbook for Travellers: Northern Italy*, Leipzig 1906, p.317; *American Artists in Europe, 1800-1900*, Walker Art Gallery, Liverpool 1976, p.25; P. Hills (ed.), *John Singer Sargent*, New York 1986, p.213; H. Honour and J. Fleming, *The Venetian Hours of Henry James, Whistler and Sargent*, London 1991, pp.118-20

Sargent had sketched informal studies of odd corners of interiors and buildings since the 1880s. This is one of numerous watercolours of Venice which he painted from the low viewpoint of a seat in a gondola [see nos 15 and 16 above]. By emphasising the massive rusticated basement and the great pilasters which frame its façade, the artist hints at the great bulk of the Palazzo Grimani towering over an onlooker. He wryly claimed to have painted the key pattern running round the base of the palace, which is painted carefully over squared-off underdrawing, to demonstrate 'what a damned conscientious fellow I am'.

The Palazzo Grimani is about a third of the way up the Grand Canal, on its east bank. This composition depicts the south-west corner of the palace. On the left is the Grand Canal and the approaches of the Rialto bridge and on the right is the Rio di San Luca. Designed by Michele Sanmicheli, it was built after his death in 1559 by Giangiacomo dei Grigi. Ruskin held the palace in high regard:

Of all the buildings in Venice, later in date than the final additions of the Ducal Palace, the noblest is, beyond all question, that ... still known to the gondolier by its ancient name, the Casa Grimani. It is composed of three stories of the Corinthian order, at once simple, delicate, and sublime; but on so colossal a scale, that the three-storied palaces on its right and left only reach to the cornice which marks the level of its first floor. Yet it is not at first perceived to be so vast ... Nor is the finish of its details less notable than the grandeur of their scale. There is not an erring line, nor a mistaken proportion, throughout its noble front; and the exceeding fineness of the chiselling gives an appearance of lightness to the vast blocks of stone out of whose perfect union the front is composed. The decoration is sparing, but delicate: the first storey only simpler than the rest, in that it has pilasters instead of shafts, but all with Corinthian capitals, rich in leafage, and fluted delicately; the rest of the walls flat and smooth, and their mouldings sharp and shallow, so that the bold shafts look like crystals of beryl running through a block of quartz.

18. JOHN SINGER SARGENT
Statue of Fortune on the Dogana *c.*1911
Watercolour and pencil, 48.9 × 34.9 cm (19¼ × 13¾ in)
Signed and inscribed, upper left:
to Elena Rathbone
John S. Sargent
Private Collection

PROV: Given by the artist to Elena Rathbone, later Lady Richmond, as a wedding present in 1913 and thence by descent

EXH: Birmingham, Museum and Art Gallery, *Exhibition of Works by John Singer Sargent, R. A.* 1964 (79); Liverpool, Walker Art Gallery, *American Artists in Europe, 1800-1900* 1976-7 (55)

LIT: J. Ruskin, *The Stones of Venice*, 4th ed., Orpington 1886, vol.3, *The Fall*, p.285; M. M. Lovell, *Venice: The American View 1860-1920*, San Francisco 1984, p.116; H. Honour and J. Fleming, *The Venetian Hours of Henry James, Whistler and Sargent*, London 1991, pp.116-17

Sargent and Sickert both painted views of architectural details from famous Venetian landmarks seen sharply from below [see no.14 above and no.21 below]. This watercolour depicts Bernardo Falcone's bronze statue of Fortune upon a huge gilt orb supported by telamones at the top of the turret of the Dogana di Mare, built by Giuseppe Benoni in 1676-82 [see no.2 above]. Fortune holds a sail which catches the wind, causing the statue to swivel from side to side, serving as a weather-vane. Another Sargent watercolour of similar size in the Boston Museum of Fine Arts depicts the whole turret, with the statue on a correspondingly smaller scale. Here the motif of *Fortune* has been enlarged to fill the picture field, while its extraordinary profile is further emphasised by the extreme foreshortening. Sargent doubtless selected this watercolour as a wedding present for the daughter of his friend William G. Rathbone VII on account of its appropriate subject-matter.

Ruskin was dismissive of the Dogana di Mare, which he described in 1853 as: 'A barbarous building of the time of the Grotesque Renaissance (1676), rendered interesting only by its position. The statue of Fortune forming the weathercock, standing on the world, is alike characteristic of the conceits of the time, and of the hopes and principles of the last days of Venice.' Henry James was more appreciative in 1892:

The charming architectural promontory of the Dogana stretches out the most graceful of arms, balancing in its hand the gilded globe on which revolves the delightful satirical figure of a little weathercock of a woman. This Fortune, this Navigation, or whatever she is called – she surely needs no name – catches the wind in the bit of drapery of which she has divested her rotary loveliness. On the other side of the Canal twinkles and glitters the long row of the happy palaces which are mainly expensive hotels. There is a little of everything everywhere, in the bright Venetian air, but to these houses belongs especially the appearance of sitting, across the water, at the receipt of custom, of watching in their hypocritical loveliness for the stranger and the victim.

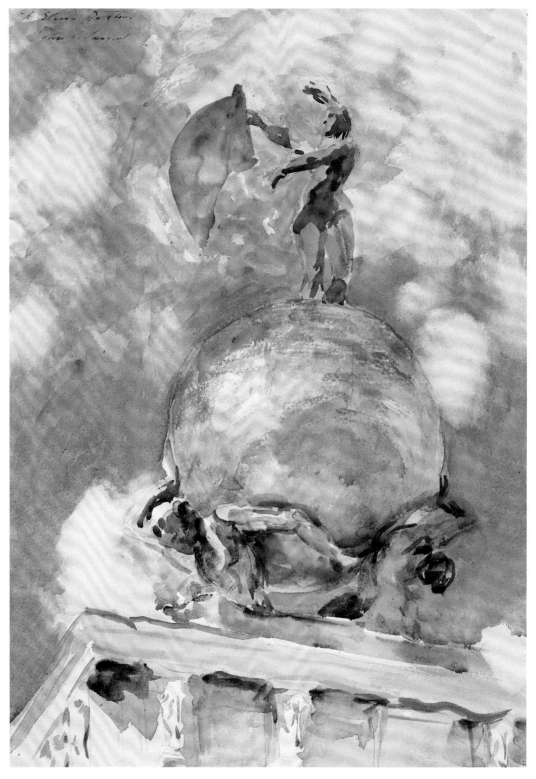

18 Sargent, *Statue of Fortune on the Dogana, c.*1911

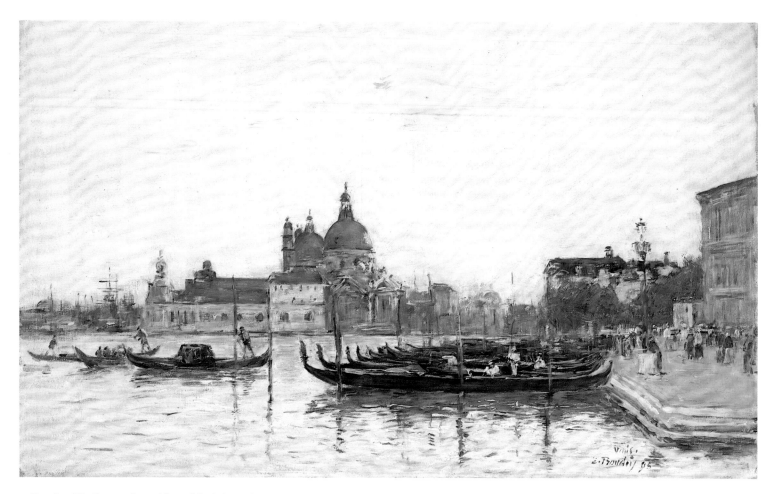

19 Boudin, *The Dogana, Santa Maria della Salute and the Entrance to the Grand Canal*, 1895

Louis Eugène Boudin (1824-98)

Born in Honfleur into a modest seafaring family, Boudin began his working life in 1834 as a deckboy on his father's boat. In 1835 his family moved to Le Havre, where he began work at a stationer's before opening his own shop with a partner in 1844. Two years later Boudin sold his share in the business, purchased a substitute to perform his military service and devoted himself entirely to painting. In 1847 he moved to Paris, visiting Belgium the following year. Awarded a grant from Le Havre in 1851, he worked in the Honfleur region and began to exhibit, initially at Le Havre and Bordeaux. From 1853 he worked mainly out-of-doors – a practice which he encouraged the young Claude Monet to adopt.

In 1859 Boudin moved to Paris, met Baudelaire, became friendly with Courbet and began to exhibit regularly at the Paris Salon. He met Corot and Daubigny in 1861. The following year he met Jongkind and, on the advice of the marine painter Eugène-Gabriel Isabey, began to paint beach scenes. During the 1860s Boudin's maritime subjects, especially views of Trouville, began to attract critical attention and in 1868 he exhibited beside Courbet, Manet, Monet and Daubigny at Le Havre. After fleeing to Brussels to escape the Franco-Prussian War, he returned to Paris and was included in the first Impressionist exhibition of 1874. In 1883 he received a one-man show at Durand-Ruel in Paris which cemented his reputation. State purchases from the Salons of 1886 and 1888 were followed in 1889 by another one-man show at Durand-Ruel. From 1890 Boudin

exhibited regularly at the Societé des Beaux-Arts, founded by the dissenters of the Salon. The following year he painted a major series of pictures at Etaples and was the subject of exhibitions at Durand-Ruel, in Paris and Boston.

In 1892 the state purchased another of his paintings and he was awarded the Cross of the Legion of Honour. Obliged by a nervous disease to spend the winters in the south, Boudin made a first visit to Venice. He returned there on a painting expedition in 1895 and lodged with M. Placeo at Calle San Zaccaria 4688, a narrow street linking the Campo San Zaccaria with the Riva degli Schiavoni. He exhibited eight Venetian views in the Paris Salon and others were included in the studio sale held after his death. In 1898, dying of cancer, he returned from Paris to his villa at Deauville. The same year Durand-Ruel mounted a one-man show of his work in New York. Major retrospectives followed his death, at the École Nationale des Beaux-Arts in 1899, at Le Havre in 1906 and at the Grand Palais in 1908.

19. LOUIS EUGÈNE BOUDIN
The Dogana, Santa Maria della Salute and the Entrance to the Grand Canal 1895
Oil on canvas, 33.5 × 57 cm (13 3/16 × 22 7/16 in)
Signed and dated lower right:
Venise
E. Boudin 95
Cardiff, National Museum of Wales

PROV: Boudin Studio Sale, Paris, Hôtel Drouot 20/21 March 1899 (6); Guyotin (Paris) 1899; from whom purchased by Durand-Ruel 28 November 1899; from whom purchased for 7,000 francs by Gwendoline Davies 10 October 1912; by whom bequeathed 1952

EXH: Cardiff, National Museum of Wales and Bath, Holburne of Menstrie Museum, *Loan Exhibition of Paintings* 1913 (15); Aberystwyth, National Library of Wales 1948 and 1951; London, Wildenstein, *Venice Rediscovered* 1972 (10); Japan tour, *Masterpieces from the National Museum of Wales* 1986-7 (41)

LIT: *Catalogue of Loan Exhibition of Paintings*, Cardiff 1913, pp.14-15; C. Roger-Marx, *Eugène Boudin*, Paris 1927, pl.43; *Catalogue of Oil-Paintings*, Cardiff 1955, p.135 (748); W. G. Constable, *Canaletto*, Oxford 1962, vol.1, pls 34-5, and vol.2, pp.244-6; J. Ingamells, *The Davies Collection of French Art*, Cardiff 1967, pp.25 and 55-8, and pl.19; R. Schmit, *Eugène Boudin 1824-1898*, Paris 1973, vol.3, p.305 (3412); P. Hughes, *French Art from the Davies Bequest*, Cardiff 1982, p.22; P. Piguet, *Monet et Venise*, Paris 1986, p.15

This composition depicts, from the left, shipping in the Giudecca Canal, the Dogana, Santa Maria della Salute, the mouth of the Grand Canal, the Giardinetti Reali and the Molo with the façade of Sansovino's Zecca. Boudin was looking south-west, from a viewpoint at the water's edge, outside the Prisons and next to the Ponte de la Pagia which crosses the Rio di Palazzo to link the Riva degli Schiavoni with the Molo. Only a short distance from his lodgings on the Calle San Zaccaria, this view is one of the most famous in Venice. Painted repeatedly by artists since Canaletto, by the turn of the nineteenth century it was the subject of picture postcards. Boudin painted a number of closely related compositions at the same time, including a smaller version (28.5 × 41.5 cm), one the same size, and larger canvases (47 × 66 cm and 50.5 × 74.3 cm). The artist implicitly acknowledged his lack of invention with the regret which he expressed during his stay in Venice: 'I wish I were twenty years younger so that my stay here might be useful to me and to art, but I am tired …' When exhibited at Cardiff in 1913, the catalogue entry on this painting, probably by Sir Frederick Wedmore, observed: 'A late afternoon effect, and a typical example of Boudin's straightforward and direct painting … a stepping stone between the impressionists and the French painters who preceded them'.

In March 1924, when Margaret Davies purchased two small Boudin panels from the Lefevre Galleries, its proprietor also gave her a letter which Boudin had written from Venice on 9 June 1895. This sheds light on his aspirations as well as his perception of the city's atmosphere and monuments:

I do not want to criticise the master [Félix Ziem, 1821-1911 – see fig.8]; he cast his impressions of Venice in his own mould – it is certainly a merit because he seems to me to have somewhat poeticised the place. Today a storm wraps everything in a grey and dull mist, something which we still see fairly frequently, but sometimes the sun shines and even gives some warmth. But the waters, which don't resemble those of the Mediterranean, are mostly green and do not differ from the waters of the Channel. Aside from that, what a magnificent country – with its splendid palaces, this city is a real museum – the only things which strike a false note in this setting are our great modern steamers. They come too often, to our sensitive eye and place themselves in front of this beautiful line of silver-toned palaces, these beautiful monuments, like the Doges' Palace, so delicate in the lace-like tracery of their sculptural decoration … I should like to bring back a few paintings as faithful and in particular as sincere as possible, but it is so difficult what with our modern attitudes and our striving after atmospheric effects which preoccupies us. The lines of the monuments barely show the ravages of time which can be seen elsewhere – as in Monet's [Rouen] *Cathedrals* exhibited at Durand-Ruel …

Walter Richard Sickert (1860-1942)

Born in Munich to an Anglo-Irish mother and a painter of Danish descent, Sickert accompanied his family to England, via Dieppe, in 1868. After a brief career as an actor, he studied at the Slade School in 1881-2 and shortly after worked with Whistler as an assistant and pupil. In 1883 he went to Paris where he visited Manet's studio and met Degas, who became a crucial influence upon his work. In 1885 he married and made the first of a regular series of visits to Dieppe, where he again met Degas. Between 1884 and 1889 Sickert exhibited with the Royal Society of British Artists, the Belgian avant-garde society *Les XX* and the New English Art Club. With Wilson Steer, he led the rebel group which mounted *The London Impressionists* exhibition at the Goupil Gallery in 1889. In the same year he visited the Paris Universal Exhibition with Degas, from whom he bought a painting. At this time he specialised in music-hall scenes.

Sickert went to Venice for the first time in May 1895 and remained there for about a year. At first he stayed in a friend's flat on the Zattere. Following separation from his wife in February 1896, he moved to the nearby 940 Calle dei Frati, which was also his home on subsequent visits. After his return to London, his friendship with Whistler ended in 1897 over a lawsuit. He ran an art school until 1899, when he divorced his wife and moved to Dieppe. In 1900 Sickert returned to Venice during the summer and held his first one-man show in Paris, at Durand-Ruel. Encouraged by the good reception of Venetian subjects in this exhibition, in January 1901 he returned for six months to Venice and was well received by expatriate Anglo-American society. Sickert visited Venice for the last time between September 1903 and the summer of 1904. Bad weather kept him indoors for much of the time and he concentrated on portraits and figure paintings. Although he never returned, his numerous sketches and studies provided the inspiration for Venetian subjects for over thirty years.

Returning to London in 1905, he rejoined the New English Art Club and concentrated on realistic urban interiors. Sickert was soon the leader of a group of urban painters known as the Fitzroy Street Group, until 1911 when they formally constituted the Camden Town Group. He exhibited extensively until the First World War, during which he spent much time in Bath. In 1919-22 he returned to Dieppe and in 1926 married the painter Thérèse Lessore, with whom he settled in England for good. President of the Royal Society of British Artists in 1927-9, he was elected an Associate Member of the Royal Academy in 1924 and a full Academician in 1934. During the 1920s and 1930s he taught at Manchester, Thanet, Bath and the Royal Academy Schools, as well as at his own private school. Exhibitions of his work were held at the New English Art Club in 1926, in Chicago and Pittsburgh in 1938 and, following his death, at the National Gallery in 1942.

20. WALTER RICHARD SICKERT
The Façade of St Mark's. Red Sky at Night *c*.1896
Oil on canvas, 45.7 × 61 cm (18 × 24 in)
Signed lower right: *Sickert*
Southampton Art Gallery

PROV: Arthur Crossland; Lord Cottesloe; Arthur Tilden Jefress; purchased 1963

EXH: London, National Gallery 1941 (72); Leeds, Temple Newsam House 1942 (122); London, Wildenstein 1970, *Pictures from Southampton* (30)

LIT: J. Ruskin, *The Stones of Venice*, 4th ed., Orpington 1886, vol.2, *The Sea-Stories*, pp.66-7; K. Baedeker, *Italy: Handbook for Travellers: Northern Italy*, Leipzig 1906, pp.293-7; W. Baron, *Sickert*, London 1973, pp.48, 312-13, 316 and 325; A. Troyen, *Walter Sickert as Printmaker*, New Haven 1979, pp.28-9; W. R. *Sickert: Drawings and Paintings 1890-1942*, Tate Gallery, Liverpool 1988, pp.34-5; J. Halsby, *Venice: The Artist's Vision*, London 1990, pp.50-1 and 127; H. Honour and J. Fleming, *The Venetian Hours of Henry James, Whistler and Sargent*, London 1991, pp.17 and 96-9

The basilica of St Mark's, erected between the eleventh and fifteenth centuries, is arguably the most famous sight in Venice. Since Gentile Bellini's colossal *Procession in the Piazza San Marco* of 1496 (Venice, Accademia), it has been the subject of innumerable paintings. Its façade was celebrated by John Ruskin with one of the most purple passages in *The Stones of Venice*. This opens:

beyond those troops of ordered arches there rises a vision out of the earth, and all the great square seems to have opened from it in a kind of awe, that we may see it far away; – a multitude of pillars and white domes, clustered

into a long low pyramid of coloured light; a treasure-heap, it seems, partly of gold, and partly of opal and mother-of-pearl, hollowed beneath into five great vaulted porches, ceiled with fair mosaic, and beset with sculpture of alabaster, clear as amber and delicate as ivory ...

This hyperbole was intended to contrast with his following section:

And what effect has this splendour on those who pass beneath it? You may walk from sunrise to sunset, to and fro, before the gateway of St. Mark's, and you will not see an eye lifted to it, nor a countenance brightened by it ... Round the whole square in front of the church there is almost a continuous line of cafés, where the idle Venetians of the middle classes lounge, and read empty journals; in its centre the Austrian bands play during the time of vespers, their martial music jarring with the organ notes ...

This composition of the façade of St Mark's, viewed from slightly to right of centre, derives from two oil sketches (Oxford, Ashmolean Museum, 22.3 × 29.9 cm, and private collection, 47.7 × 60.4 cm) and an almost full-scale black chalk and watercolour sketch, squared off and inscribed with colour notes (Manchester City Art Gallery, 45.1 × 58.4 cm). Sickert may also have used photographs of the

20 Sickert, *The Façade of St Mark's. Red Sky at Night*, c.1896

façade as an aid, as in a letter of 1899 he mentioned a parcel of 'small scale drawings, of panels of Venice that is to say of St. Mark's façade and the Rialto, pen drawings and photographs of sitters and photographs of Venice'. Numerous later versions of the composition exist, some of which may date from as late as 1914-18. In 1905-6 he also made an etching of the composition.

Sickert may have seen and been impressed by the exhibition of Monet's paintings of Rouen Cathedral at Durand-Ruel in Paris, while on his way to Venice in 1895. However, it has been pointed out in this context that he wrote in 1923: 'The theory that it is the main business of an artist to paint half a dozen views of one object in different lights cannot be seriously maintained. It would be nearer the

21 Sickert, *The Horses of St Mark's, Venice*, c.1901-6

truth to say that the artist existed to disentangle from nature the illumination that brings out most clearly the character of each scene.' He appears to have followed the latter course in this juxtaposition of the façade of St Mark's, based upon detailed sketches, with a red background evocative of a Venetian sunset. Monet's own, later views of Venice [see nos 28-30 below] reveal a fundamentally different approach. Sickert would also have known *St Mark's Venice: Nocturne in Blue and Gold* by his teacher, Whistler [see no.4 above] and may similarly have chosen unusual lighting to add novelty to a subject made over-familiar by generations of painters, photography and the picture-postcard.

21. WALTER RICHARD SICKERT
The Horses of St Mark's, Venice *c.*1901-6
Oil on canvas, 53.6 × 45.7 cm (21⅛ × 18 in)
Signed lower right: *Sickert*
Bristol, City Art Gallery

PROV: Private Collection, Paris; Daniel de Pass; Arthur Tooth & Sons Ltd.; sold Christie's 14 July 1967; Agnew & Roland, Browse & Delbanco; from whom purchased 1967

LIT: J. Ruskin, *The Stones of Venice*, 4th ed., Orpington 1886, vol.1, *The Foundations*, p.228, and vol.2, *The Sea-Stories*, pp.61 and 66-7; *Catalogue of Oil Paintings*, City Art Gallery, Bristol 1970, pp.107 and 108; *Venice Rediscovered*, Wildenstein, London 1972, pp.9-10 and 12; W. Baron, *Sickert*, London 1973, pp.64-5 and 325-6; A. Troyen, *Walter Sickert as Printmaker*, New Haven 1979, pp.30-1; F. Haskell and N. Penny, *Taste and the Antique*, New Haven and London 1981, pp.114-15 and 236-40; M. Lovell, *Venice: The American View 1860-1920*, San Francisco 1984, pp.34-5; *W. R. Sickert: Drawings and Paintings 1890-1942*, Liverpool 1988, pp.34-5

This composition depicts the upper central element of the façade of St Mark's, with the arch of its central doorway, the balcony with the four bronze horses, the semi-circular central window and the late Gothic ogival gable with the lion of St Mark and statues of angels on the sky-line. The crowning pinnacle figure of St Mark is cropped by the top of the canvas. Brought to Venice as booty after the sack of Constantinople in 1204, the horses of St Mark's are the most important classical antiquities in Venice. Their confiscation by the French in 1797 and return after the fall of Napoleon in 1815 aroused a lively debate on their date and original nationality, which remains unresolved. There are numerous medieval examples of animals decorating the exteriors of buildings, such as the oxen on the west towers of Laon cathedral, and Ruskin himself observed that 'Quadrupeds of course form the noblest subjects of ornament next to the human form; this latter, the chief subject of sculpture, being sometimes the end of architecture rather than its decoration'. However, in *The Stones of Venice*, he remains surprisingly taciturn on the horses, only mentioning them in the course of his extended poetic description of the façade [see no.20 above], which concludes:

… above these, another range of glittering pinnacles, mixed with white arches edged with scarlet flowers, – a confusion of delight, amongst which the breasts of the Greek horses are seen blazing in their breadth of golden strength, and the St Mark's lion, lifted on a blue field covered with stars, until at last, as if in ecstasy, the crests of the arches break into a marble foam, and toss themselves far into the blue sky in flashes and wreaths of sculptured spray, as if the breakers on the Lido shore had been frost-bound before they fell, and the sea-nymphs had inlaid them with coral and amethyst.

During his first visit to Venice in 1895-6, Sickert had painted several versions of a view of the façade of St Mark's, seen from the Piazza [see no.20 above]. He returned to the subject in 1901, with a view of the northern part of the façade and the present composition. As usual, it was based upon several detailed preparatory drawings, including two large sketches (Manchester, Whitworth Art Gallery, 48.6 × 39 cm and private collection, 47 × 37.5 cm) and a smaller study, squared off for transfer (Ottawa, National Gallery of Canada, 25.1 × 19.7 cm). At least six oil versions of this composition followed, in addition to the present work (private collections, 50.8 × 40, 62.2 × 48.3, 57.1 × 45.7, 50.2 × 39.4 and 21.6 × 17.1 cm, and Birmingham, City Art Gallery, 50.2 × 42.3 cm). Several of these pictures, including the present work, are more thinly painted and may have been executed after Sickert's departure from Venice, possibly in 1903 or as late as 1905-6. He also made an etching of the composition at about this time. The abrupt cropping of this composition imbues it with a snapshot-like sense of immediacy, suggesting that the artist was working partly from photographs of architectural details of St Mark's – such as had been available since the 1840s when Ruskin had acquired several [see no.20 above]. There is evidence that Sargent also occasionally used photographs as an aid in similar compositions of fragments and details of Venetian buildings which he painted at about the same time [see nos 14 and 18 above].

22. WALTER RICHARD SICKERT
Santa Maria della Salute *c.*1901
Oil on canvas, 55.9 × 45.7 cm (22 × 18 in)
Signed lower left: *Sickert*
London, Royal Academy

PROV: Sylvia Gosse; deposited by the artist as his diploma work 1934

EXH: London, Royal Academy 1935 (532); Bournemouth, *Loan Exhibition from the R. A.* 1957; Arts Council of Great Britain (Midland Area), *Sickert* 1964 (5); Bournemouth, *Loan Exhibition from the R. A.* 1965 (56); London, Royal Academy, *Bicentenary Exhibition* 1968 (448); London, Wildenstein, *Venice Rediscovered* 1972 (47)

LIT: W. Baron, *Sickert*, London 1973, pp.62, 63, 65, 119, 165, 171 and 326; M. Lovell, *Venice: The American View 1860-1920*, San Francisco 1984, pp.112-15; L. Stainton, *Turner's Venice*, London 1985, p.66; *W. R. Sickert: Drawings and Paintings 1890-1942*, Liverpool 1988, pp.36-7; H. Honour and J. Fleming, *The Venetian Hours of Henry James, Whistler and Sargent*, London 1991, p.116

Here, Santa Maria della Salute is viewed from the north-east, on the opposite bank of the Grand Canal, from a point near the Rio di San Moise between the Hotel Britannia and the Hotel Europa. Since the time of Canaletto and Guardi, most earlier views of this church had depicted it at a distance, as the centre-piece to the picturesque group of buildings around the mouth of the Grand Canal [see no.19 above]. Turner, who stayed at the nearby Hotel Europa in 1840, painted a comparable watercolour view of the Salute seen from up close on the Grand Canal, in which its bulk overwhelmingly dominates the scene. Sickert executed at least four other versions of this composition of various sizes (all in private collections, 59.7 × 48.3 cm, 76.2 × 63.5 cm, 23.5 × 19 cm and 61 × 50.8 cm). He also painted a landscape-format view of the church, from a point further west, showing more of the Campo della Salute but omitting its drum and dome. Sargent painted other, more drastically cropped views of the building slightly later [see no.14 above].

In his essay *The Grand Canal*, published in 1892, Henry James

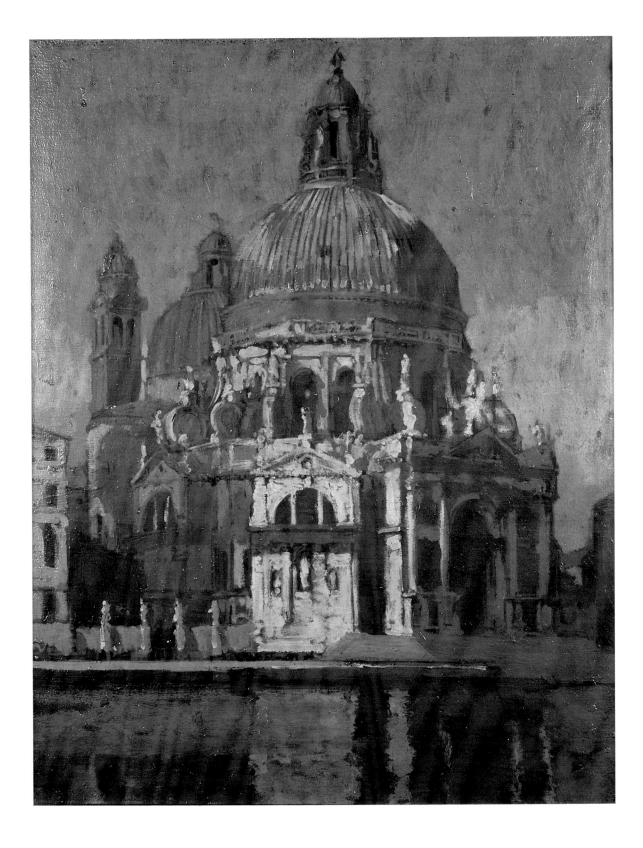

22 Sickert, *Santa Maria della Salute*, c.1901

evokes the surprise which the Salute continues to induce in visitors entering the waters of the Grand Canal:

We have been treated to it again and again, of course, even if we have never stirred from home; but that is only a reason the more for catching at any freshness that may be left in the world of photography. It is in Venice above all that we hear the small buzz of this vulgarizing voice of the familiar; yet perhaps it is in Venice too that the picturesque fact has best mastered the pious secret of how to wait for us. Even the classic Salute waits like some great lady on the threshold of her saloon. She is more ample and serene, more seated at her door, than all the copyists have told us, with her domes and scrolls, her scolloped buttresses and statues forming a pompous crown, and her wide steps disposed on the ground like the train of a robe. This fine air of the woman of the world is carried out by the well-bred assurance with which she looks in the direction of her old-fashioned Byzantine neighbour [The basilica of St Mark's]; and the juxtaposition of two churches so distinguished and so different, each splendid in its sort, is a sufficient mark of the scale and range of Venice.

Following his customary method, Sickert carried out the underdrawing of this painting in his studio, by squaring up from detailed drawings made previously *in situ*. It has been suggested that he employed the deep, thick oil technique in which this work is painted specifically to do justice to the rich light and shade of Venetian architecture. Other versions of *Santa Maria della Salute* are thinly and lightly painted, and at least one was probably executed entirely from sketches, after his return to London. The original recipient of this work, Sylvia Gosse (1881-1968) was a student of Sickert's, co-principal of his art school at Rowlandson House from 1910 to 1914 and an enthusiastic supporter of his work. An Associate of the Royal Academy since 1924, Sickert taught at the Academy Schools in 1926. He reclaimed this painting for presentation as his diploma work when he was elected a full Royal Academician in 1934, but resigned a year later.

23. WALTER RICHARD SICKERT
Palazzo Eleonora Duse *c.*1901
Oil on canvas, 54.5 × 45.7 cm (21¾ × 18 in)
Signed lower left: *Sickert*
Cardiff, National Museum of Wales

PROV: Reid & Lefevre Ltd, London; from whom purchased for £125 by Margaret Davies July 1935; by whom bequeathed 1963

EXH: Wales, Institute of Adult Education tour 1940-1; Aberystwyth, National Library of Wales 1951 (57); Japan tour, *Masterpieces from the National Museum of Wales* 1986-7 (73)

LIT: J. Ruskin, *The Stones of Venice*, 4th ed., Orpington 1886, vol.3, *The Fall*, pp.15-16 and 223-4; R. Ormond, *John Singer Sargent*, London 1970, p.248; D. Sutton, *Walter Sickert*, London 1976, p.118; *John Ruskin*, Arts Council of Great Britain, London 1983, pp.50-1; M. M. Lovell, *Venice: The American View 1860-1920*, San Francisco 1984, pp.129-30; R. Shone, *Walter Sickert*, Oxford 1988, p.32; J. Halsby, *Venice: The Artist's Vision*, London 1990, pp.118 and 125; H. Honour and J. Fleming, *The Venetian Hours of Henry James, Whistler and Sargent*, London 1991, p.124

This painting depicts, on the left, the fifteenth-century Palazzo Barbaro-Wolkoff and, on the right, the Palazzo Dario, a building of 1487 attributed to Pietro Lombardo. They are situated on the south side of the Grand Canal, about 350 metres from its end. Like Monet a few years later [see no.28 below], Sickert's viewpoint was from slightly to the east of the Palazzo Corner della Ca' Grande. As there is no quay at this point, he was presumably working from a gondola or a floating landing stage outside the Palazzo Minotto on the opposite side of the Grand Canal. This composition of two Venetian palazzi may have been partly inspired by *The Palaces*, the large etching of 1880 by Sickert's master Whistler [see no.7 above].

Ruskin was impressed by the Palazzo Dario, which he considered typical of a 'Byzantine Renaissance' in Quattrocento Venice:

And, accordingly, the first distinct school of architecture which arose under the new dynasty was one in which the method of inlaying marble, and the general forms of shaft and arch, were adopted from the buildings of the twelfth century, and applied with the utmost possible refinements of modern skill … adorned with sculpture which for sharpness of touch and delicacy of minute form, cannot be rivalled, and rendered especially brilliant and beautiful by the introduction of those inlaid circles of coloured marble, serpentine, and porphyry, by which Phillippe de Commynes [the French chronicler, who visited Venice in 1495] was so much struck on his first entrance into the city … The Casa Dario, and Casa Manzoni, on the Grand Canal, are exquisite examples of the school, as applied to domestic architecture …

In his essay *The Grand Canal*, published in 1892, Henry James remarked on the popularity of the Palazzo Dario with visitors to Venice:

… the delightful little Palazzo Dario, intimately familiar to English and American travellers, picks itself out in the foreshortened brightness. The Dario is covered with the loveliest little marble plates and sculptured circles; it is made up of exquisite pieces – as if there had only been enough to make it small – so that it looks, in its extreme antiquity, a good deal like a house of cards that hold together by a tenure it would be fatal to touch. An old Venetian house dies hard indeed, and I should add that this delicate thing, with submission in every feature, continues to resist the contact of generations of lodgers. It is let out in floors (it used to be let as a whole) and in how many eager hands – for it is in great requisition – under how many fleeting dispensations have we not known and loved it? People are always writing in advance to secure it, as they are to secure the Jenkins's gondolier, and as the gondola passes we see strange faces at the windows – though it's ten to one we recognize them – and the millionth artist coming forth with his traps at the water-gate. The poor little patient Dario is one of the most flourishing booths at the fair.

Since Ruskin painted a watercolour of its façade in 1845 [fig.5], the Palazzo Dario had been the subject of pictures by various artists, including the American John Lindon Smith (1863-1950) and the Scottish etcher David Young Cameron (1865-1945). Sickert knew the palace personally, as he lodged not far away in the Calle dei Frati and attended *conversazioni* held there by two of its residents, the Comtesse de Baume and Madame Bulteau. The inlaid marble roundels for which the palace was famous appear to have been boarded up in this view of it, possibly in preparation for the restoration which it underwent in 1905-6 [see no.28 below].

Next door, the Palazzo Barbaro-Wolkoff belonged to the Russian painter Alexander Wolkoff, a friend of Eleonora Duse (1858-1924). The most celebrated Italian actress of the day, comparable only with Sarah Bernhardt as an international star, Duse found her greatest roles in the plays of Ibsen. J. S. Sargent saw her perform *Feodora* in 1893 and painted her portrait (private collection). In 1894, the same year that she took an apartment on the top floor of the Palazzo Barbaro-Wolkoff, Duse fell in love with the symbolist poet Gabriele d'Annunzio. He exposed their relationship in the erotic novel *Il Fuoco*, published in 1900. Rapidly translated into English as *The Flame of Life*, it caused immense controversy. The actress's fame and Sickert's own great love of the theatre probably account for his titling this painting, not strictly correctly, *Palazzo Eleonora Duse*.

23 Sickert, *Palazzo Eleonora Duse, c.*1901

Alvin Langdon Coburn (1882-1966)

Coburn was born into a middle-class Boston family. In 1890 he visited his mother's relations in Los Angeles and was given his first camera. He accompanied his mother to London in 1899 and in 1900 was included with Edward Steichen and his distant cousin Fred Holland Day in a large exhibition of American photographs at the Royal Photographic Society. In 1900 Coburn also exhibited for the first time with the Linked Ring Brotherhood, a group of British photographers with Masonic interests. After touring Europe, he opened a photographic studio in New York in 1902. He held his first one-man show the following year and in 1904 returned to London to study at Frank Brangwyn's art school. Coburn met and profoundly impressed George Bernard Shaw. In 1905 he became friendly with the socialist and moral reformer Edward Carpenter, the Symbolist poet Arthur Symons, and Henry James, whom he photographed for *The Century* magazine. Two photographs of Venetian canals, dated 1905 [see nos 24 and 25 below], suggest that he visited Venice in that year.

In 1906 Coburn began to study photogravure and visited the Mediterranean. His reputation was confirmed by two one-man shows, at Liverpool and the Royal Photographic Society, where George Bernard Shaw contributed a preface to the catalogue. Later that year he visited Paris, Rome and Venice to take photographs for the New York complete edition of Henry James. Like Whistler before him, he found Venice in winter unpleasantly cold and damp, but found warm lodgings at a German pensione. His photographs were an immense success with James, who wrote in January 1907 to congratulate him and order prints of all of them.

Coburn experimented with colour photography in 1907-8 and held one-man shows in New York in 1907 and 1909. His portfolios *London* and *New York* were published in 1909 and 1910 with introductions by Hilaire Belloc and H. G. Wells. In 1910-12 he photographed at Pittsburgh, Yosemite, the Grand Canyon and New York. Coburn married in 1912 and moved permanently to Britain. He held a one-man show at the Goupil Gallery and published the portfolio of portraits *Men of Mark* in 1913. In 1915 he organised the exhibition *Old Masters of Photography* in Buffalo and in 1917 made abstract Vortographs which were exhibited with an introduction by Ezra Pound. After Coburn became a Freemason in 1919, his mystic and religious interests gradually supplanted his activity as a photographer. In 1922 he published *More Men of Mark* and became a member of the Societas Rosicruciana. The following year Coburn began his association with the comparative religious group, the Universal Order and in 1927 he was made an honorary Ovate of the Welsh Gorsedd. He gave his photographic collection to the Royal Photographic Society and moved to North Wales in 1930. Like his mentor Henry James, Coburn became a British subject in 1932. From 1935 a lay reader of the Church in Wales, he wrote a play for children in 1938 and was active in the British Red Cross Society during the Second World War. A major retrospective of his work was held at Reading University in 1962.

24. ALVIN LANGDON COBURN
The White Bridge, Venice 1905
Mounted platinum print, 40.7 × 48.1 cm (16 × 18⅞ in)
Image size 32.1 × 39.2 cm (12⅝ × 15⁷⁄₁₆ in)
Signed bottom right of mount: *Alvin Langdon Coburn*
Bath, Royal Photographic Society

PROV: Gift of Alvin Langdon Coburn 1930

LIT: A. L. Coburn (ed. H. and A. Gernsheim), *Alvin Langdon Coburn Photographer, an Autobiography*, London 1966, pp.44 and 58; E. H. Gombrich, *Henri Cartier-Bresson*, Scottish Arts Council, Edinburgh 1978, pp.6-7; M. Weaver, *Alvin Langdon Coburn: Symbolist Photographer 1882-1966*, New York 1986, pp.6, 12-19, 25, 29 and 33-7.

In his autobiography Coburn stated: 'My aim in landscape photography, as Bernard Shaw wrote, "is always to convey a mood and not to impart local information". This is not an easy matter, for the camera if left to its own devices will simply impart local information to the exclusion of everything else.' Viewed in this context, it is unsurprising that the bridge in this photograph is unidentified, although it is clearly a substantial structure crossing one of the larger canals.

In terms reminiscent of Henri Cartier-Bresson's famous dictum of 'the right moment', Coburn also observed:

The artist-photographer must be constantly on the alert for the perfect moment, when a fragment of a jumble of nature is isolated by the conditions of light or atmosphere, until every detail is just right. I always think in this connection of Whistler's classic remark that 'nature was creeping up a bit'. The astonishing thing about it is that nature will 'creep up a bit' if you sit patiently and wait for her in ambush.

Like Whistler, Coburn was fascinated by the reflected and diffused light of waterways, especially when thrown into contrast by the sharp silhouettes of bridges [see no.25 below]. He even described the 'purely photographic qualities' of his own work as 'photographic in the sense that Whistler was photographic'. Where the master etcher selectively inked and carefully printed his plates to achieve profoundly atmospheric effects in a graphic medium [see nos 5 and 11 above], the photographer employed the recently invented soft-focus lens and platinum printing to combine clarity of vision with the appearance of insubstantiality.

In 1905, the year in which the photographer first met Henry James, the latter's *English Hours* was published. Its account of London has a passage with Symbolist overtones, evocative of Coburn's photographs: '... the atmosphere, with its magnificent mystifications, which flatters and superfuses, makes everything brown, rich, dim, vague, magnifies distances and minimises details, confirms the inference of vastness by suggesting that, as the great city makes everything, it makes its own system of weather and its own optical laws ...'. Such photographs as *The White Bridge, Venice* indicate why James turned to Coburn in 1906 to illustrate the frontispieces to the New York complete edition of his writings. As the author explained, he required 'images always confessing themselves mere optical symbols or echoes, expressions of no particular thing in the text, but only of the type of idea of this or that thing. They were to remain at the most small pictures of our "set" stage with the actors left out.'

25. ALVIN LANGDON COBURN
Shadows and Reflections, Venice 1905
Fibre print, 35.2 × 27.7cm (13⅞ × 10⅞ in)
Image size 31.1 × 25 cm (12¼ × 9¹³⁄₁₆ in)
Cardiff, National Museum of Wales

PROV: Modern print, purchased from George Eastman House 1992

LIT: *Camera Work*, 1908, no.21, pl.VII; C. Dodgson, *The Etchings of James McNeill Whistler*, London 1922, pl.73; A. L. Coburn (ed. H. and A. Gernsheim), *Alvin Langdon Coburn Photographer, an Autobiography*,

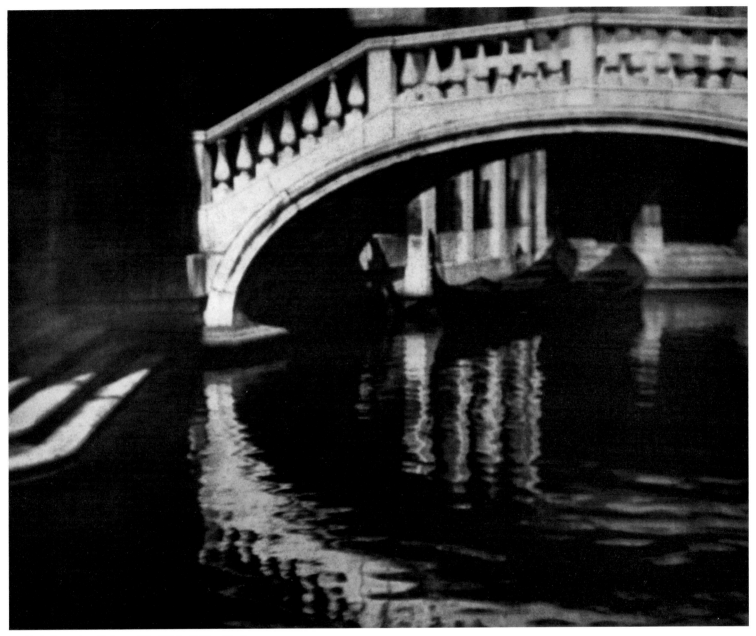

24 Alvin Langdon Coburn, *The White Bridge, Venice*, 1905

London 1966, pp.44-6; M. Weaver, *Alvin Langdon Coburn: Symbolist Photographer 1882-1966*, New York 1986, pp.29-30 and 48-9; H. Honour and J. Fleming, *The Venetian Hours of Henry James, Whistler and Sargent*, London 1991, pp.101 and 160-3

In connection with this photograph, Coburn wrote in his autobiography:

Sunshine and water form, I believe, the landscape photographer's finest subject matter. Is there a more perfect way of studying and permanently recording the subtle play of sunlight on moving water than photography? I have spent hours on the canals of Venice and on the waterways of many other places feasting my eyes on the rhythmic beauty and the poetry of liquid surfaces, hours punctuated at intervals of exceptional charm by the click of my shutter.

Whistler's Venetian pastels and etchings include several views of narrow canals spanned by bridges. For example, the *Ponte del Piovan*, from the 'Second Venetian Set', depicts from water level a comparable bridge with women on it. A passage from James's essay *Venice*, published in 1882, is evocative of this scene:

Certain little mental pictures rise before the collector of memories at the simple mention, written or spoken, of the places he has loved. When I hear, when I see, the magical name I have written above these pages, it is not of the great Square that I think, with its strange basilica and its high arcades, nor the wide mouth of the Grand Canal, with the stately steps and the well-poised dome of the Salute; it is not of the low lagoon, nor the sweet Piazzetta, nor the dark chambers of St. Mark's. I simply see a narrow canal in the heart of the city – a patch of green water and a surface of pink wall. The gondola moves slowly; it gives a great smooth swerve, passes under a bridge,

and the gondolier's cry, carried over the quiet water, makes a kind of splash in the stillness. A girl crosses the little bridge which has an arch like a camel's back, with an old shawl on her head, which makes her characteristic and charming; you see her against the sky as you float beneath. The pink of the old wall seems to fill the whole place; it sinks even into the opaque water …

When first published in 1908, this photograph was printed utilising the photogravure process, an intaglio technique which Coburn had begun to study in 1906. Able to reproduce tone with comparable quality to platinum printing, it was a fraction of the cost of the latter process. In 1907-8 he also experimented with colour photography,

25 Alvin Langdon Coburn, *Shadows and Reflections, Venice*, 1905

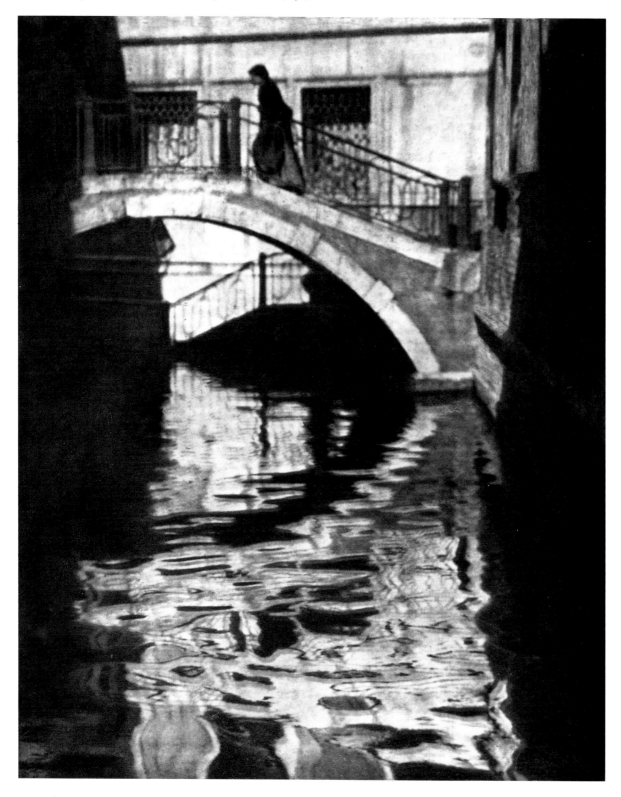

then in its infancy. The crude and unnatural appearance of early colour photographs moved a contemporary to suggest that 'If a little more attention were paid to the paintings of Monet and Le Sidaner, which are examples of science applied by artists to pictorial ends, colour photography might make some real progress'. Although in black-and-white, the broken pattern of reflections in the foreground of this composition is comparable with the water effects in Monet's Venetian scenes [see nos 28-30 below].

26. ALVIN LANGDON COBURN
Juliana's Court 1906
Fibre print, 35.2 × 27.7cm ($13\frac{7}{8}$ × $10\frac{7}{8}$ in)
Image size 31.2 × 25.1 cm ($12\frac{5}{16}$ × $10\frac{15}{16}$ in)
Cardiff, National Museum of Wales

PROV: Modern print, purchased from George Eastman House 1992

LIT: A. L. Coburn (ed. H. and A. Gernsheim), *Alvin Langdon Coburn Photographer, an Autobiography*, London 1966, pp.52-60; H. James, *The Aspern Papers, The Novels and Tales of Henry James* (New York Edition), vol.12, repr. New Jersey 1971, pp.3-143; L. Edel, *The Life of Henry James*, Harmondsworth 1977, vol.1, pp.801-16; *Henry James Letters* (ed. L. Edel), vol.IV, Cambridge, Mass., and London 1984, pp.417 and 426-8; H. Honour and J. Fleming, *The Venetian Hours of Henry James, Whistler and Sargent*, London 1991, pp.60-1, 76-7 and 161-2

This photograph served as the frontispiece to volume 12 of the complete works of Henry James, which opens with *The Aspern Papers*. Written in Italy in 1887, this short novel tells the story of a writer who seeks to gain access to unpublished letters by a Romantic poet named Jeffrey Aspern, a character based upon that of Lord Byron. He tries to do so by winning the confidence of the reclusive and elderly Juliana Bordereau, a former lover of Aspern and custodian of his letters. She lives in a Venetian palace described thus: 'It was not particularly old, only two or three centuries; and it had an air not so much of decay as of quiet discouragement, as if it had rather missed its career … It overlooked a clean melancholy rather lonely canal, which had a narrow *riva* or convenient footway on either side.' The hero of the novel obtains lodgings at the palace and undertakes to replant its dilapidated garden, hoping to '… succeed by big nosegays. I would batter the old women with lilies – I would bombard their citadel with roses. Their door would have to yield to the pressure when a mound of fragrance should be heaped against it.'

Henry James envisaged Juliana's home as the Ca' Capello on the Rio Marin, near the Scuola di San Giovanni Evangelista. He knew the palace personally, as it was the home of the American author Constance Fletcher and her elderly mother – who were drawn on by the author in part for the characters of Miss Bordereau and her niece Tina. In a letter of 16 December 1906 he gave Coburn exhaustive directions to this comparatively secluded area of the city, mentioned that he had written to Miss Fletcher on his behalf and expressed a preference for an interior view or one of the garden. Nevertheless, James let the photographer be the ultimate judge, even permitting him to seek an alternative location if he found the palace unsatisfactory. Coburn took this softly focused photograph at the Ca' Capello, but its precise setting is unidentifiable. As a motif, it recalls James's advice to Coburn in a letter of 2 October 1906, prior to a trip to Paris: 'Look out *there* for some combination of objects that won't be hackneyed and commonplace and panoramic; some fountain or statue or balustrade or vista or suggestion …'. His poignant image

of a solitary potted tree in an empty court is evocative of James's story without being in any sense anecdotal. In composition and atmosphere of gentle melancholy, it is reminiscent of Sargent's earlier studies of empty Venetian backstreets.

27. ALVIN LANGDON COBURN
The Venetian Palace 1906
Fibre print, 35.2 × 27.7cm ($13\frac{7}{8}$ × $10\frac{7}{8}$ in)
Image size 32.1 × 16.3 cm ($12\frac{5}{8}$ × $6\frac{3}{8}$ in)
Cardiff, National Museum of Wales

PROV: Modern print, purchased from George Eastman House 1992

LIT: A. L. Coburn (ed. H. and A. Gernsheim), *Alvin Langdon Coburn Photographer, an Autobiography*, London 1966, pp.52-60; H. James, *The Wings of the Dove, The Novels and Tales of Henry James* (New York Edition), vols 19 and 20, repr. New Jersey 1976; L. Edel, *The Life of Henry James*, vol.2, Harmondsworth 1977, pp.443-55; *Henry James Letters* (ed. L. Edel), vol.IV, Cambridge, Mass., and London 1984, pp.426-8; H. Honour and J. Fleming, *The Venetian Hours of Henry James, Whistler and Sargent*, London 1991, pp.81-2, 85-7, 148-51 and 160-3

This photograph was included as the frontispiece to part two of *The Wings of the Dove*, volume 20 of the New York edition of the complete works of Henry James. *The Wings of the Dove* is a long novel written in 1901-2 whose heroine is a young woman named Milly Theale. Her personality is based in part on that of the novelist Constance Fenimore Woolson, whose suicide in 1894 by jumping from the top floor of a palace on the Grand Canal deeply depressed the author. Terminally ill, Milly Theale moves to a Venetian palazzo called the Palazzo Leporelli, where she is courted, betrayed and subsequently dies. It is described thus (part 2, pp.134-5):

Eugenio had … so admirably, so perfectly established her. Her weak word, as a general hint, had been: 'At Venice, please, if possible, no dreadful, no vulgar hotel; but, if it can be at all managed – you know what I mean – some fine old rooms, wholly independent, for a series of months. Plenty of them too, and the more interesting the better: part of a palace, historic and picturesque, but strictly inodorous, where we shall be to ourselves … with servants, frescoes, tapestries, antiquities, the thorough make-believe of a settlement.' … Charming people, conscious Venice-lovers, evidently, had given up their house to her … Palazzo Leporelli held its history still in its great lap, even like a painted idol, a solemn puppet hung about with decorations. Hung about with pictures and relics, the rich Venetian past, was here the presence revered and served …

Henry James envisaged Milly Theale's palazzo as the Palazzo Barbaro, near the Accademia bridge over the Grand Canal. James had been a guest of the expatriate Bostonian Daniel Curtis and his British wife Ariana, who had rented part of this fifteenth-century palace from 1878 and purchased it in 1885 [see fig.11]. In his letter of 6 December 1906 James wrote to Coburn:

… I don't propose you should attempt here anything but the outside; and you must judge best if you can take the object most effectively from the bridge itself, from the little campo in front of the Academy, from some other like spot further – that is further toward the Salute, or from a gondola (if your gondolier can keep it steady enough) out on the bosom of the Canal.

He conceded that, should this seem unsuitable, Coburn might try other palaces on the Grand Canal '… yet especially *not* choosing the pompous and obvious things that one everywhere sees photos of'. As the Palazzo Barbaro was itself quite well known [see no.1 above], James must have included in the latter category such edifices as the

26 Alvin Langdon Coburn, *Juliana's Court*, 1906

Ca' d'Oro, the Palazzo Dario and the Palazzo Grimani [see nos 1, 7, 17 and 23 above, and no.28 below]. Coburn's photograph of the façade was taken from slightly to the south-west, evidently from a gondola. At an angle to the observer and with its top storey cropped in a manner reminiscent of Monet's *Rouen Cathedral* series, the palace looms above the observer while cold winter light emphasises the shadowy Gothic arcade on its first floor. This gaunt and forbidding aspect are entirely appropriate to James's tragedy.

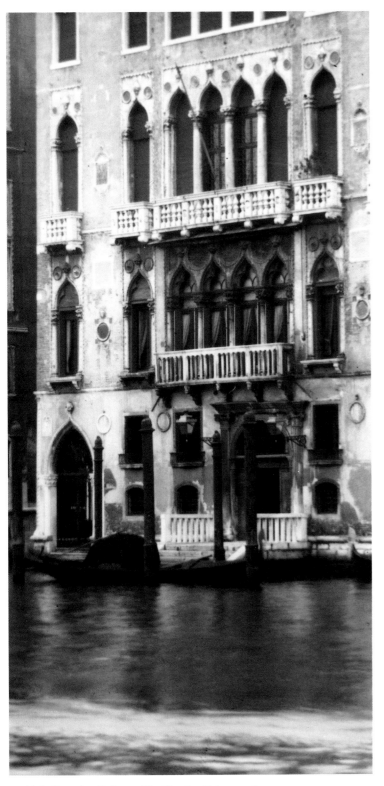

27 Alvin Langdon Coburn, *The Venetian Palace*, 1906

Claude Monet (1840-1926)

The son of a grocer, Monet was born in Paris and moved with his parents to Le Havre around 1845. There he met Eugène Boudin, who introduced him to open-air painting in around 1856. On his first trip to Paris in 1859-60 he met Troyon and Pissarro. Following military service, in 1862 Monet entered the studio of Charles Gleyre, where he met Bazille, Renoir and Sisley. Following painting expeditions to Fontainebleau and on the Channel coast, his first paintings were accepted by the Paris Salon in 1865. Despite a medal at an exhibition at Le Havre in 1868, from the following year his submissions were rejected by the Salon. In 1870 Monet married and fled from the Franco-Prussian War to London, where he encountered Pissarro and the dealer Durand-Ruel, who subsequently bought many paintings from him. Returning to France the following year, he settled at Argenteuil on the Seine, which remained his principal base until 1878.

At the first Impressionist exhibition in 1874, Monet's *Impression, Sunrise* led to the christening of the group. Subsequently, he submitted to the 1876, 1877, 1879 and 1882 Impressionist exhibitions. In 1880 Monet had a painting accepted by the Salon and the first of an increasingly regular series of one-man shows in Paris. The following year, Durand-Ruel resumed regular purchases and in 1883 Monet moved to Giverny. During the 1880s he worked mainly on coastal views. Public recognition had grown to the point that he was offered, but refused, the Légion d'Honneur in 1888 and received a major retrospective at Georges Petit's gallery in 1889. The 1890s were dominated by the execution and exhibition of Monet's great series paintings: 1890-1 *Grain Stacks*; 1891-2 *Poplars*; 1892-5 *Rouen Cathedral*; 1896-8 *Pourville* and *Early Mornings on the Seine*. In 1899 he began the first series of his water-gardens and began painting in London, where he returned in 1901 and 1902. At Durand-Ruel, the London series was exhibited in 1904, followed by a large group of water-garden pictures in 1909.

For two months between October and December 1908, at the invitation of Sargent's friend Mary Hunter, Monet and his second wife Alice visited Venice. They stayed on the Grand Canal, first at the Palazzo Barbaro and subsequently at the Hotel Britannia. Although Monet worked hard, on a dozen canvases at a time, from nine different Venetian series, he was obliged to finish many from memory at Giverny. Despite worsening eyesight and the death of his wife in 1911, the following year he exhibited twenty-nine Venetian views at Bernheim-Jeune, where they were enthusiastically received. Thereafter Monet devoted most of his remaining energies to the monumental cycle of Water Lily Decorations, which he presented to the State in 1920, for installation in the Musée de l'Orangerie.

28. CLAUDE MONET
Le Palais Dario 1908
Oil on canvas, 92.3 × 73.6 cm (36⅜ × 29 in)
Signed lower left: *Claude Monet 1908*
Cardiff, National Museum of Wales

PROV: Purchased from the artist in May 1912 by Bernheim-Jeune and Durand-Ruel; purchased from Durand-Ruel on 25 July 1913 for £1,310 by Margaret Davies; by whom bequeathed 1963

EXH: Paris, Bernheim-Jeune, *Monet. Venise* 1912 (21); Manchester, Agnews, *Masterpieces of French Art* 1923; Aberystwyth, National Library of Wales 1946 and 1951-2; London, Royal Academy, *Landscape in French Art* 1949-50 (259); London, Wildenstein, *Venice*

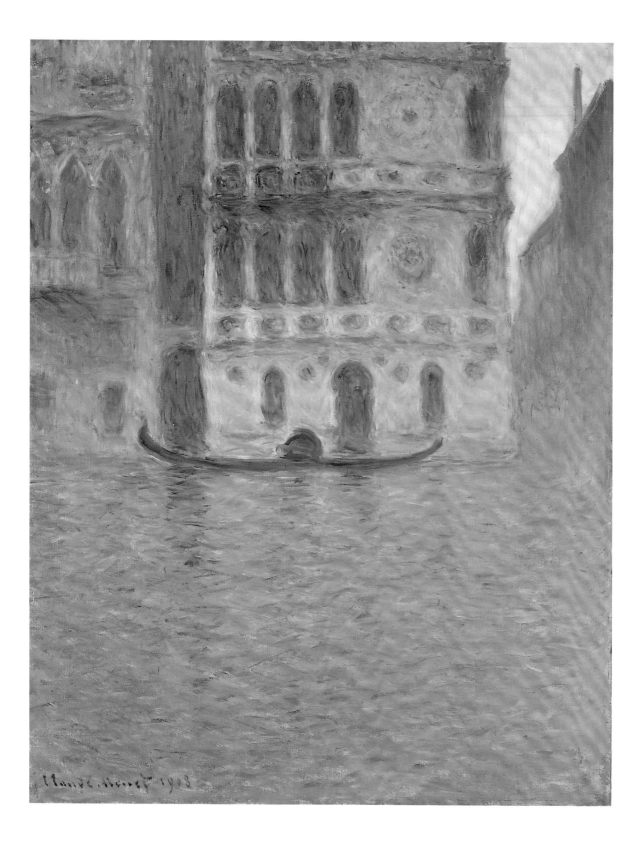

28 Monet, *Le Palais Dario*, 1908

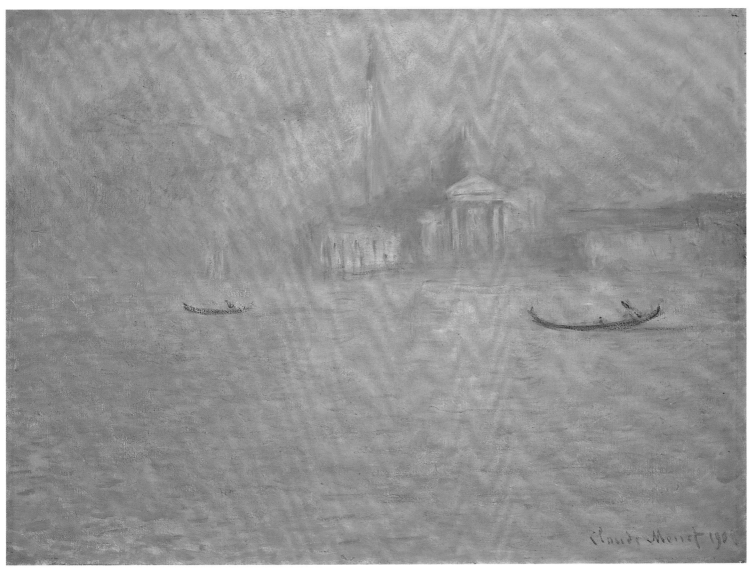

29 Monet, *Saint-Georges Majeur*, 1908

Rediscovered 1972 (24) and *Paintings from the Davies Collection* 1979 (26); Japan tour, *Masterpieces from the National Museum of Wales* 1986-7 (55)

LIT: K. Baedeker, *Italy: Handbook for Travellers: Northern Italy*, Leipzig 1906, pp.314-15; J. Ingamells, *The Davies Collection of French Art*, Cardiff 1967, pp.11, 77 and 78; D. Wildenstein, *Claude Monet*, vol.4: *1899-1926*, Lausanne/Paris 1985, pp.240-2 (1759); S. Olson, *John Singer Sargent: His Portrait*, London 1986, pp.212-15; P. Piguet, *Monet et Venise*, Paris 1986, pp.29-31, 62, 66, 71, 98-100 and 116; J. Halsby, *Venice: The Artist's Vision*, London 1990, p.152

From their arrival in Venice on 2 October 1908, Monet and his wife stayed for a fortnight at the Curtis residence, the Palazzo Barbaro [see no.27 above]. Alice Monet's letter of 12 October states that her husband was working, after lunch, from the steps of the palace. The composition which he painted from this viewpoint, *Venise, Le Grand Canal* [see fig.13], includes the sunlit side of the Palazzo Dario, about 200 metres down the Canal. Several artists, notably Sickert and Ruskin [see fig.5 and no.23 above], had previously painted its eye-catching façade, which underwent restoration in 1905-6.

On 17 October Monet's wife wrote that he was working 'in the canal' for his 'troisième motif', the first part of the afternoon between two o'clock and four o'clock. *Le Palais Dario* was probably painted at this time of day, as the light is muted but remains sufficiently strong to pick out the polychrome decoration on its façade. The artist's viewpoint, very close to that previously utilised by Sickert [see no.23 above], was from slightly to the east of the Palazzo Corner della Ca' Grande, already in 1908 the seat of the Prefettura. As there is no quay at this point, he was presumably working from a gondola or a floating landing stage outside the Palazzo Minotto on the opposite side of the Grand Canal.

The sole surviving drawing of Monet's Venetian sojourn (Musée Marmottan, inv.5135, fol.1r) repeats this composition, as does a slightly smaller oil version (private collection, 81 × 66 cm). The artist also painted two landscape-format versions of the Palazzo Dario (Art Institute of Chicago, 65 × 81 cm, and private collection, 56 × 65 cm), which depict more of the Palazzo Barbaro-Wolkoff to its left and the narrow *rio* and building to its right. Monet's paintings of the nearby *Palazzo da Mula* and the *Palazzo Contarini* are rather darker in tone,

but broadly similar in composition. Earlier artists had set the Palazzo Dario square within the pictorial field. Monet located it off-centre, with its top storey cropped by the top edge of the canvas, as in his *Rouen Cathedral* series of 1892-4. A gondola with its bulbous *felze* or cabin marks the dividing line between the palaces in the upper register and the lower part of the composition, filled by the waters of the Grand Canal. For Monet both halves were of equal significance: the architectural elements softened by shadows above and disintegrating into ripples beneath. This characteristic is alluded to by the art critic Gustave Geffroy in his essay on Monet's Venetian paintings, published in *La Vie* on 1 June 1912: 'in front of the Palazzo Dario … the façades fiery or moss-coloured, the windows, the balusters, the arcades of round and pointed arches, appearing to become longer or wider in their reflections in the undulations of the water as it flows past'.

29. CLAUDE MONET
Saint-Georges Majeur 1908
Oil on canvas, 55.9 × 78.7 cm (22 × 31 in)
Signed lower right: *Claude Monet 1908*
Cardiff, National Museum of Wales

PROV: Purchased from the artist in May 1912 by Bernheim-Jeune and Durand-Ruel; purchased from Bernheim-Jeune on 24 October 1912 for 25,000 francs (with no.30 below) by Gwendoline Davies; by whom bequeathed 1952

EXH: Paris, Bernheim-Jeune, *Monet. Venise* 1912 (11); Cardiff, National Museum of Wales, and Bath, Holburne of Menstrie Museum, *Loan Exhibition* 1913 (54) ; Aberystwyth, National Library of Wales 1946-8 and 1951; London, Royal Academy, *Landscape in French Art* 1949-50 (262); London, Wildenstein, *Venice Rediscovered* 1972 (22) and *Paintings from the Davies Collection* 1979 (27); Japan tour, *Masterpieces from the National Museum of Wales* 1986-7 (56)

LIT: G. d'Annunzio (trans. K. Vivaria), *The Flame of Life*, London 1900, pp.24-5 and 59; K. Baedeker, *Italy: Handbook for Travellers: Northern Italy*, Leipzig 1906, p.287; *Catalogue of Loan Exhibition of Paintings*, Cardiff 1913, p.34; J. Ingamells, *The Davies Collection of French Art*, Cardiff 1967, pp.10, 25, 74 and 77; *Venice Rediscovered*, Wildenstein, London 1972, p.53; P. Hughes, *French Art from the Davies Bequest*, Cardiff 1982, p.43; L. Stainton, *Turner's Venice*, London 1985, p.62; D. Wildenstein, *Claude Monet*, vol.4: *1899-1926*, Lausanne/Paris 1985, p.236 (1747); P. Piguet, *Monet et Venise*, Paris 1986, pp.17, 30, 31, 41, 82-4 and 116

Alice Monet's correspondence with her daughter Germaine Salerou includes an invaluable account of the variable climatic conditions between 2 October and 7 December 1908, in which these Venetian scenes were painted. On the whole, her commentary confirms the prosaic remarks of Baedeker's guide: 'The Climate of Venice is tempered by the sea and the Lagune, though cold N. E. winds and thick fogs are not uncommon in winter … October 58.5°; November 46.5°; December 39°. The air is very humid, and often favourable to catarrhal affections, but rheumatism is prevalent.' During Monet's stay the mornings were often as foggy as London but the afternoons dazzlingly sunny until 21 October, when a strong and sometimes freezing wind arose. From 24 until 28 October, it was changeable with rain and fog. Fine weather returned, but between 9 and 12 November, fog, rain and a very cold wind made painting difficult. For the remainder of his sojourn there was brilliant sunshine, interspersed with occasional days of fog and cold wind.

According to Gabriele d'Annunzio's novel *Il Fuoco*, published in 1900 [see no.23 above], 'The mutual passion of Venice and Autumn that exalts the one and the other to the highest degree of their sensuous beauty has its origin in a deep affinity; for the soul of Venice, the soul fashioned for the City Beautiful by its great artists is autumnal'. This celebrated account of the poet's love affair with Eleonora Duse abounds with visual descriptions which would have informed a contemporary observer of Monet's paintings:

He cast an exploring glance round sky and water as if to discover an invisible presence, or recognise some newly arrived phantom. A yellowish glare was stretching to the more solitary shores, that stood out in it as if drawn there in finely pencilled lines, like the opaque veining of agates; behind him towards the Salute, the sky was scattering over with light spreading vapours, violet and rosy, that made it comparable to a changing sea peopled by sea-anemones. From the neighbouring gardens there descended an exhaled fragrance of plants saturated with light and warmth, like floating aromatic oils heavy on the bronze-like water.

There are four other versions of this composition (Art Institute of Chicago and Indianapolis Museum of Art, both 65 × 92 cm, and two in private collections, both 60 × 73 cm). All depict the Isola di San Giorgio bathed in long shadows and raking light from the west. Turner had previously painted a watercolour of the same view with similar lighting, but in a less misty, summer atmosphere, from the tip of the Dogana. Monet's viewpoint was probably a window in the Hotel Britannia near the mouth of the Grand Canal, where he stayed from 17 October 1908. This commands a similar angle of vision, but from slightly further to the north-west. Alice Monet mentioned on 16 October that the Hotel Britannia had '… a more beautiful view than that from the Palazzo [Barbaro] …'. The following day, 17 October, she wrote that her husband was painting from four o'clock until six o'clock from their window. The lighting in *Saint-Georges Majeur* is consistent with such a time, during Monet's late afternoon 'quatrième motif'.

In his essay on Monet's Venetian paintings, published in *La Vie* on 1 June 1912, the art critic Gustave Geffroy described this composition: '… mists at once pearly and sulphurous half obscure the fine church, or else all rosy above the water, it is outlined against a lemon-yellow sky. Gondolas rear up, and, caught by the leaning gondoliers' oars, they take flight, their prows and sterns clear of the water, and glide over the green and gold surface of the sea.' Edouard Vuillard later included a version of this picture in the background of a painting, *Two Business Men at Home*. The catalogue entry for its exhibition at Cardiff in 1913, probably written by Frederick Wedmore, described it as

A misty morning effect in Venice, and an extremely difficult subject by reason of the very high key of tone and colour. Turner, whose influence Monet acknowledges, has treated similar effects in several canvasses in the Tate Gallery, but with a thin method of painting entirely opposite to the general impasto of this picture. The sense of movement of the gondolas is well expressed by a few touches of pigment.

30. CLAUDE MONET
Saint-Georges Majeur au Crépuscule 1908
Oil on canvas, 63.5 × 88.9 cm (25 × 35 in)
Signed lower right: *Claude Monet 1908*
Cardiff, National Museum of Wales

PROV: Purchased from the artist in May 1912 by Bernheim-Jeune and Durand-Ruel; purchased from Bernheim-Jeune on 24 October 1912 for 35,000 francs (with no.29 above) by Gwendoline Davies; by whom bequeathed 1952

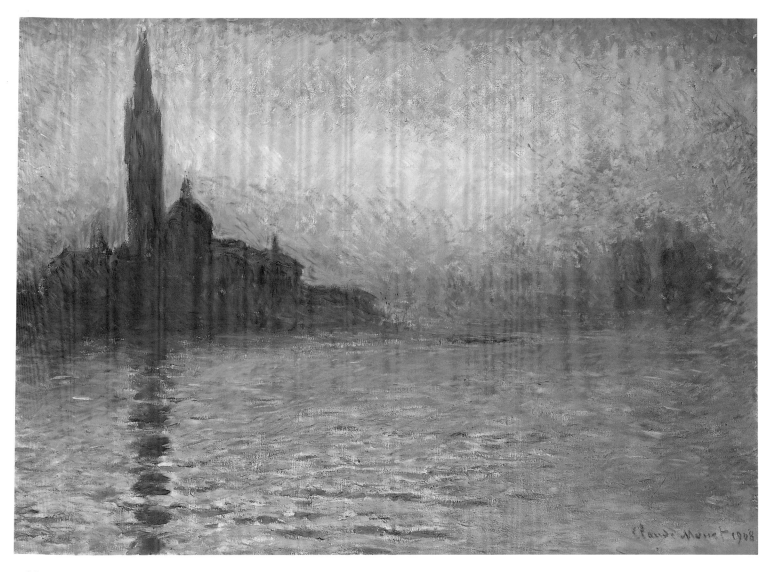

30 Monet, *Saint-Georges Majeur au Crépuscule*, 1908

EXH: Paris, Bernehim-Jeune, *Monet. Venise* 1912 (29); Cardiff, National Museum of Wales, and Bath, Holburne of Menstrie Museum, *Loan Exhibition* 1913 (56); Aberystwyth, National Library of Wales 1946-8 and 1951; Edinburgh and London, *Monet* 1957 (108); New York and Los Angeles, *Monet* 1960 (95); London, Wildenstein, *Venice Rediscovered* 1972 (23); *Paintings from the Davies Collection* 1979 (28); Japan tour, *Masterpieces from the National Museum of Wales* 1986-7 (57)

LIT: G. d'Annunzio (trans. K. Vivaria), *The Flame of Life*, London 1900, pp.86-7 and 90-1; *Catalogue of Loan Exhibition of Paintings*, Cardiff 1913, p.34; J. Ingamells, *The Davies Collection of French Art*, Cardiff 1967, pp.10, 25, 74, 77 and 78; D. Wildenstein, *Claude Monet*, vol.4: *1899-1926*, Lausanne/Paris 1985, p.244 (1768); P. Piguet, *Monet et Venise*, Paris 1986, pp.17, 30, 43, 49, 86-8, and 116

According to a letter from Alice Monet, on 12 October the artist was working from the Piazza San Marco on a painting of San Giorgio Maggiore during his 'deuxième motif' from ten am until twelve am, although no paintings of this view are known. In the same letter she added '... then at three o'clock, we set out on a tour by gondola to admire the sunset and got back at seven o'clock ...'. She wrote on 13 November, following bad weather, '... yesterday evening, we were at last able to see the setting sun once more', and on 28 November, shortly before their departure, '... each evening, we repeat our long gondola trips to see the sunset ... we are delighted to be able to enjoy once more, before our departure, these splendid sunsets which are unique in the world'. *Saint-Georges Majeur au Crépuscule* was probably painted in the course of these gondola journeys, towards the end of Monet's 'quatrième motif' between four pm and six pm.

This painting depicts the silhouette of the Palladian monastery of San Giorgio Maggiore at the left and, dissolving into the haze at the right, the dome of the Salute, lit by the afterglow from the setting sun. Monet appears to have been looking south-west from near the water's edge, at the end of the Via Garibaldi, just south of the bridge over the Rio della Tana. Nearly thirty years earlier, Whistler had lodged and worked in this unfashionable locality east of the Riva degli Schiavoni [see nos 6 and 9 above]. The latter's etched *Nocturne* of 1879 depicts a similar view and a late time of day, but from a more westerly location and in reverse [see no.5 above]. Monet painted another, slightly larger version of *Saint-Georges Majeur au Crépuscule*

(Tokyo, Bridgestone Museum of Art, 73 × 92 cm).

Gabriele D'Annunzio's famous novel *Il Fuoco*, published in 1900, includes a remarkable description of an autumnal sunset in Venice:

The immense cry rising round the outer walls of the palace reached him and then lost itself in the heavens that were illuminated by a red glare as of a conflagration. An almost terrible joy seemed spreading over the Sea-City ... the signal of the conflagration in which the beauty of Venice was finally to stand resplendent ... All the innumerable appearances of volatile and many-coloured Fire spread over the firmament, crawled on the water, twined round the masts of the vessels, garlanded the cupolas and the towers, adorned the entablatures, wrapped themselves round the statues, budded on the capitals, enriched every line, transfigured every aspect of the sacred and profane architectures in the midst of which the deep harbour was like an enchanted mirror that multiplied the marble. The astonished eye could no longer distinguish the quality of the various elements: it was deluded by a mobile and measureless vision ... That which in the twilight had seemed a silvery palace dedicated to Neptune and built after the likeness of tortuous marine forms, had now become a temple built by the willing genii of Fire.

Although analogous in subject to Monet's key early work, *Impression, Sunrise* of 1872 (Paris, Musée Marmottan), this is an exceptionally strongly-coloured and highly-charged scene, which demonstrates the powerful impact of Venice's unique sunsets. In his essay on Monet's Venetian paintings, published in *La Vie* on 1 June 1912, the art critic Gustave Geffroy described it: 'From his window on the Riva degli Schiavoni, where he is living during the mild and radiant autumn of 1908, Claude Monet also sees on the flat island, level with the surface of the water, the silhouette of San Giorgio Maggiore, the tiny pediment, the insubstantial dome, the upward thrust of the campanile, the dark pinnacle of which is illuminated by a pink patch of sunlight'. The catalogue entry for its exhibition at Cardiff in 1913, probably written by Frederick Wedmore, provided hints to visitors unfamiliar with the painter:

A strongly painted twilight scene in Venice, illustrating Monet's later method of strong touches of juxtaposed colours which harmonise and give an effect of extraordinary strength as the spectator stands back from the picture. The treatment of the water, a branch of art in which Monet has no superior, is especially successful. As in the other pictures, the emotion produced by colour is the artist's principal aim, in preference to the easier and more prosaic effects produced by scientific drawing.

Acknowledgements

Books on Venice, like pictures of the city, are legion. However, I am particularly indebted to the insights and information in the following works: *Venice Rediscovered*, Wildenstein 1972, M. M. Lovell, *Venice: The American View 1860-1920*, 1984, L. Stainton, *Turner's Venice*, 1985, J. Halsby, *Venice: The Artist's Vision*, 1990, and H. Honour and J. Fleming, *The Venetian Hours of Henry James, Whistler and Sargent*, 1991. Lord Davies of Llandinam kindly provided information on the surviving papers of the Davies sisters and access to Margaret Davies's diary of their second trip to Italy in 1909. For assistance with loans, photographs and numerous requests for information and advice I am most grateful to Janet Barnes, Wendy Baron, Eirionedd Baskerville, David Brown, Fiona Brown, John Corr, Fionnuala Croke, Lyn Davies, James Dearden, Bryan Dovey, Tony Dyer, Robin Francis, Elizabeth Goodall, Francis Greenacre, Mark Haworth-Booth, Margot Heller, Tim Henbrey, Paula Hicks, Martin Hopkinson, Debbie Ireland, Simon Jervis, Iwan Michael Jones, Raymond Keaveney, Susan Lambert, Brian Loughborough, Janice Madhu, Freda Matassa, Lee Mooney, Amanda Nevill, Lynn Federle Orr, Harry S. Parker, Denise Perry, Pam Roberts, Lesley Ronayne, David Scrase, Nicholas Serota, Gyongyi Smee, Mary Anne Stevens, Sheena Stoddart, John Taylor, Roger Taylor, Helen Valentine, Neil Walker, Reinhild Weiss, Baroness Eirene White, Patricia J. Whitesides, Andrew Wilton and others who prefer to remain anonymous. At the Department of Art of the National Museum my colleagues have been unstinting in their practical assistance and have cheerfully accepted the increased workload which my absences writing this catalogue have entailed. Kate Lowry has handled the practical arrangements of transport, storage and display with the assistance of Tim Egan, Mike Jones and Keith Bowen. Timothy Stevens, Oliver Fairclough and Chris King have read the catalogue text and provided numerous helpful suggestions. I am also grateful to Rachel Duberley, Rosa Freeman, Avril Haynes, Christine Mackay, Rachel Oliver, Judi Pinkham, Paul Rees and Sylvia Richards. Elsewhere in the National Museum, considerable assistance with the exhibition has been provided by David Beecham, Cliff Darch, Owain Tudur Jones, John Kenyon, Colin Plain, Hywel Rees, Dafydd Roberts, John Rowlands, Basil Thomas, Kevin Thomas and many others. As ever, I have received every courtesy from the library staff of the British Library, the Courtauld Institute, the Warburg Institute, the University of Wales College of Cardiff and the National Library of Wales.

MARK L. EVANS

Photographic Acknowledgements

Fig.5: The Education Trust Ltd, Brantwood, Coniston, Cumbria
Fig.9 & pls 15-18: National Museum of Wales, Cardiff
Fig.10: Witt Library, Courtauld Institute of Art, London
Pl.12: Dick Goodchild, King's Lynn, Norfolk
Pls 25-27: George Eastman House, Rochester, USA

All other photographs have been supplied by the owners of the original works.

SUCCESSFUL SMALL GARDENS

NEW DESIGNS *for* TIME-CONSCIOUS GARDENERS

ROY STRONG

This book is a tribute to the garden owners and designers whose work we have been able to include. Their gardens are evidence of the enormous vitality and variety in small garden-making today. I am grateful to all of them for letting us share in their achievement, as it has meant providing us with plans and planting details as well as responding to our many small queries. I am indebted to Prue Bucknall in our search to find a new way of presenting the information in this book to make it as clear as possible to the reader. In the search we have been hugely assisted by Joanna Logan's delightful but down-to-earth groundplans. **Roy Strong**

Endpapers Cushions of clipped box and santolina, both needing shearing annually, are in perfect harmony with the stone sculpture.
Page 1 Virginia creeper can transform a garden wall into a beacon of crimson when its leaves change colour in the autumn, but it requires hard winter pruning.
Pages 2-3 An avenue of standard maples underplanted with blocks of pale colour and backed by thuja topiary is deceptively elaborate: the trees need only annual attention, and the density of the planting beneath them acts as weed-suppressor.

First published in Great Britain in 1994 by
Conran Octopus Limited
a part of Octopus Publishing Group
2-4 Heron Quays
London E14 4JP
www.conran-octopus.co.uk

This paperback edition published in 1999, 2001

British Library Cataloguing-in-Publication Data
A record for this book is available from the British library.

ISBN 1 84091 062 3

Illustrations by JOANNA LOGAN

Horticultural Consultant TONY LORD
Designer PRUE BUCKNALL
Picture Research NADINE BAZAR
Index HELEN BAZ
Production JULIA GOLDING

The publishers would like to thank Penny David and Caroline Taylor for
editorial help and Alison Shackleton and Alastair Plumb for design help.

Printed in China

CONTENTS

Above and right Two informally planted areas in my garden at The Laskett, in Herefordshire, are given a feeling of firm structure by the large ornaments that provide year-round focal points. Drifts of flowers attendant on a statue of Flora (*above*) bring a succession of bloom from mid-winter to the late spring. They include snowdrops, crocuses, aconites, scillas, narcissi, fritillaries, miniature daffodils, tulips, chionodoxas and irises. The grass is not cut until late summer to allow the bulbs to multiply, and although the bulbs need topping up from time to time, the area requires very little attention. A small sheltered glade beneath birch and rowan trees (*right*) houses a collection of hellebores, primulas, cyclamen, miniature daffodils, sternbergia and crown imperials with drifts of hardy geraniums and pulmonaria. It flourishes in the spring and lies dormant while the trees are in leaf. This is a deceptively simple-looking area; it does, in fact demand regular doses of compost and summer weeding.

MAKING A GARDEN

A small garden is a vision which must be firmly rooted in practicality. This consists of your own interest in terms of time and money, on which depends the fulfilment of the design. Begin by defining your interest quite precisely, for it will determine the kind of garden you can have (although not, I hasten to add, its style, for virtually every option will be open to you). Other factors which affect choice are external: soil, aspect and climate, all of which must be taken into account. Armed with this information, you are ready to peruse the elements which have gone into the making of the gardens in this book. Although all very different in style, they share one thing in common: they are proven successes.

It is often assumed that a desire for low maintenance narrows your choice down to a very few options and that these actually amount to a style. This is not true. The first nine gardens for those hard-pressed for time demand only about an hour a week, yet they embrace virtually every garden effect from water to training, from topiary to herbaceous planting. Seven out of the twelve other gardens, for those who are either time-conscious or with time to spare, are adaptable for people with little time by the simple process of simplifying the planting. The reason that so many options are open with so little input is because of the importance attached throughout this book to the role of structure. It reminds us that historically gardening is a branch of architecture: it is about defining space in which people will move. By structure I mean the initial design elements embodied in hard built surfaces such as paths and ornaments or living ones such as grass and hedges. The more time and money spent on getting these right in the first place, the better your garden will be and the easier to maintain.

It is often assumed that structure is only relevant to formal styles. This again is not true. Informality, when its principles are analysed, calls for as much, if not more structure: it is simply not so immediately obvious. For each garden featured in this book the structure has been deliberately separated from the more general planting to reinforce its importance.

There is, however, a second general truth: the more built and plant structure you have, the fewer maintenance problems you will have.

Above and right My own garden, although large overall, is made up of a series of small, contrasting, gardens, each of which is a complete composition in its own right. This late spring view of the Rose Garden looking through to the Silver Jubilee Garden beyond (*above*) shows the firm structure of both gardens. The Rose Garden, held in by yew hedges, has a symmetrical pattern of box-edged beds planted with a mixture of spring-flowering tulips and perennials, neither requiring a great deal of maintenance. In summer the central circular bed is a froth of pale violet nepeta encircled by *Alchemilla mollis*, while the outer beds are filled with purple *Lavandula angustifolia* 'Hidcote' and rue. Four standard amelanchiers, four roses in the spandrels and a large urn provide the vertical accents.

Conversely, the more complex the planting, the greater will be the demand on your time. Hard surfaces such as stone, slabs, brick, setts and gravel, complemented by permanent plant features, like low box hedging or grass, mark out the ground pattern. Structures of stone, brick, metal or fibreglass – arches, statues, containers or pavilions – together with living structures, such as hedging or topiary, establish a garden's verticals.

Every design decision about your garden has such practical implications and these should be taken on board at the planning stage. A stone or brick path for example will need only sweeping and possibly an annual application of weedkiller. Gravel will call for raking plus weeding or weedkilling. A grass path will require almost weekly mowing during the season, but if you make the path the width of your mower it will be necessary to go down it only once. Similar upkeep

considerations apply when planting hedges. Privet, for example, will have to be cut several times in a season, whereas yew or box need be clipped only once.

Effort only really multiplies with elaboration in terms of planting. Some plants are inevitably more demanding than others. There are, for instance, specific clematis and roses which do not require any pruning, while others have to be pruned annually at particular seasons. Containers may have to be emptied and filled and planted up several times a year. The lesson is to select plants that reflect your ability to cope with them. Never buy or sow any before taking on board all they will demand in terms of attention, as well as whether they suit your soil, climate and the aspect.

One final word. When it comes to gardening a Scrooge-like mentality seems to seize people. It is essential to grasp that long-term ease

Above Looking back through the Silver Jubilee Garden into the Rose Garden in winter, demonstrates the crucial importance of structural planting and ornament in the creation of year-round garden interest. Devoid of seasonal flowers, the composition of clipped beech, yew and box with a considered placing of hard-surface elements makes the garden a theatre for the play of light throughout the winter months.

of maintenance is a fair return for what may seem initially a heavy financial outlay. Modern machinery such as petrol-driven shears, strimmers and mowers make easy what were once tedious, time-consuming chores. A sprinkler system with a timer will solve almost every watering problem at one blow. Do not stint on such things, nor on good-quality built and plant structure. If working out basic structure daunts you, there is much to be said for employing a professional garden designer who will bring a great deal of expert know-how to tailoring a garden to your level of commitment. That again is a worth-while investment. Use this collection of designs to indicate your preferences and aspirations. In the main, however, this selection has been assembled for those who, although they may use a professional builder for some of the structure, will, by and large, make their gardens themselves both for the economy and the enjoyment of doing so.

Left The parterre in the Yew Garden at The Laskett is planted with crown imperials and tulips for the spring. The beds are left bare during summer; the pattern made by the box hedging and the stone basket of fruit provides enough interest. The box and yew call for an annual clip and the bulbs, if fed with bonemeal, will last up to five years so that, apart from the lawn-mowing, this is a surprisingly easy area to maintain.

Above The Fountain Court at The Laskett is another example of the importance of structural planting and ornament. Irish yew and statues provide year-round vertical accents that need no attention, the beech hedges and box domes need an annual clip, and the rosemary screens beds filled with ground-cover plants. The fountain is turned off and baled out at the first frost.

GARDENS *for the* HARD-PRESSED

Previous pages A parterre is a surprisingly stylish low-maintenance solution for a tiny garden, once it is established, calling only for annual clipping and feeding. Here the dwarf box is shaped in an exciting contemporary idiom. The parterre is framed by a gravel path which needs occasional raking and perhaps annual weedkilling. The surrounding narrow beds are filled with low-maintenance plants; including a bold display of *Hydrangea macrophylla* and on the other side by a seat flanked by Solomon's seal and bergenia. A hornbeam hedge (also clipped annually) conceals a side passage with arches of jasmine.

Left A deeply satisfying garden in a cool, shady corner is made by texturally contrasting hard elements – the curving sculpted finial, the asymmetrical random stone walling and the regular geometry of the setts. These frame the tiny 'lawn' of baby's tears (*Soleirolia soleirolii*). Pots provide structure and interest even when empty; the flowers could vary with the seasons or from year to year.

Right The chief delight of this tiny but highly sophisticated garden of silvery grey plants lies in the subtly contrasting variations of colour, leaf shape and habit. They include santolina, rosemary, *Salvia nipponica officinalis* Purpurascens Group, *Phlomis fruticosa*, *Helichrysum lanatum*, artemisia, thyme and lavender. Although many do best in a sunny, sheltered site, they retain their leaves throughout the year and will go on for several years calling only for annual cutting back before they need replacing by new plants easily struck from cuttings.

Some of the most stylish of all gardens are in fact labour-saving. The nine included here call for only about an hour or so a week, plus a couple of annual blitzes in spring and autumn when major tasks such as pruning need to be done. They are also some of the most sophisticated and understated, because their design is founded on year-round built and evergreen structure rather than time-consuming planting schemes that vary with the seasons. There are few more elegant forms, for example, than the parterre and yet, once established, it calls only for an annual clip. Or, to take a contrasting style, naturalized bulbs provide a stunning garden picture which, with clever planting, will provide a continuous sequence of flower from late winter through spring till early summer. All that the bulbs require is careful planting in grass which should not be cut until late summer.

The more hard-surface structures you have, the easier the upkeep will be. These include paths, walls, balustrading, steps, urns and finials, obelisks and statues, arbours and pavilions. Their drawback is the initial cost, but that should be offset against the time saved in the long run, and their great advantage is the strength and immediacy of their effect. Built structures come in a wide range of materials: they can be of stone or reconstituted stone; or of wood, metal, or fibreglass (that can also simulate bronze), all of which bring other possibilities, especially in terms of colour and paint finishes. Avoid, if you can, cheap concrete and plastic. If these have to be used, site them where the eye will not dwell on them or where planting will conceal them. For the most conspicuous items do not stint on buying beautiful materials – old mellow brick, stone and reconstituted stone, cobbles and setts – as you will be looking at them the whole year round.

Left and right The same garden in early summer and autumn presents two very different but striking pictures. The basic structure is easily cared for. Brick and stone paths define a symmetrical group of box-hedged beds filled with a permanent planting of low maintenance weed-suppressors. The frothy lime-coloured flowerheads of *Alchemilla mollis* match the buds and young leaves of *Hydrangea macrophylla*. In their summer glory the hydrangea flowerheads make a luxuriant display of dusty pink – and the colour is echoed by the seat; all through the winter they will stay on the leafless stems, providing a still-life of dried flowers in bronze-brown. The cornucopia effect of the massed hydrangeas almost bursting the bounds of their confining box edging and dwarfing the acorn finial makes an interesting change from the conventional parterre where everything is neat and well defined.

The best structural planting for hedges is yew or box, both evergreen and with dense growth. If you can afford large plants, the effect will be virtually instant (although if nurtured, both grow far quicker than is supposed). Beech and hornbeam are also possibilities, for they also only require an annual cut. For vertical accents, choose small trees such as amelanchiers that will not call for annual pruning; some of the

Those fortunate enough to be making a garden in a damp woodland area can create a moss garden reminiscent of the ones in Japan. All that has to be done is to clear the scrub and allow the moss to grow and thicken. The main annual chore is to keep it clear of fallen leaves; and brushing with a stiff brush from time to time will keep the moss lawn in good trim. Here the wooded area is given articulation by a winding gravel path and an enclosing hedge, while the downy surface of the moss serves as an exhibition arena for contemporary art works. You can create a woodland by planting a group of tall saplings. Choose species with good bark such as maples and birches. Instead of encouraging moss, you could underplant the trees with bulbs.

prunus or crataegus give not only spring flowers but autumn fruits. For accents that are evergreen look towards fastigiate yew and certain of the cypresses and junipers with narrow and columnar growth. Then choose climbers to clothe man-made verticals. Look for species which require the minimum pruning and which will not ramp. Check their flowering season and aim for a sequence of bloom through as much of the year as possible.

Then embark on the infill planting. Look for shrubs which will not require much pruning and have both flowers and fruit or have a long flowering season as well as good foliage colour. Move on next to select perennials which rarely, if ever, call for lifting and dividing, and ground-cover plants. Careful research and planning at this stage will save countless hours in the garden later on.

Preparation of the soil is fundamental as it will reduce the weeds and ensure healthy plants. A weedkilling treatment may be necessary to eradicate infestations of perennial weeds before you embark on new planting. The soil must be annually dressed with fertilizer and compost. Mulching with things like wood chippings is a recent garden abomination; its labour-saving purpose can be achieved through either ground-cover plants or dense planting.

Remember that in a small garden one important feature will hold the entire composition together. Avoid being fussy and go for a single large statue, urn, finial or arbour. In a single gesture your garden will acquire instant identity. The rest should follow it, but beware, above all, the blandishments of the garden centres. They will tempt you to buy what you have not the time to care for or cultivate.

An informal garden, or area within a garden, can be made to give extra value by planting deciduous trees that have both spring and autumn interest, and underplanting them with bulbs or shade-loving plants. Bird cherry (*Prunus padus*) is a deciduous spreading tree with spikes of white flowers in late spring and small black fruits in late summer. The lilac beneath makes a pretty spring picture. Lilac is perhaps a luxury in a small garden because its glorious flowering season is short, but for many its scent makes it worth it. The delightful underplanting of narcissi will multiply if the grass is left uncut until mid-summer. The inclusion of both earlier and later bulbs would produce a succession of flower from mid-winter till late spring.

Above Permanent low-maintenance planting need not be dull. A carefully orchestrated planting of heathers can make a striking ground-cover garden in a site where the soil is on the acid side. Coming in a huge variety of foliage tints from darkest green to sulphur yellow, and with tiny flowers ranging from white through every shade of pink to deepest purple, heather calls only for annual shearing after flowering. Here heathers have been inset into good structure. A flight of steps is flanked by pairs of slow-growing conifers including thuja and *Chamaecyparis lawsoniana* 'Ellwoodii'. A terracotta pot flanked by hydrangeas forms a tableau at the close of the vista. The tapestry of cherry laurel and *Lonicera nitida* that forms the backdrop needs an annual clipping, and the ivy and hart's-tongue ferns colonizing the steps need a periodic tidy-up.

Right Choose plants that will enjoy not only your soil type but the aspect of the beds where you plant them. This path of setts winding through the green world of a shrubbery is bordered by lower-growing plants that make a ground cover full of textural contrast. Height on the sunnier side (to the left) is provided by mahonia, oak-leaved hydrangea and a viburnum. The pale-outlined foliage of *Fuchsia magellanica gracilis* 'Variegata' is echoed at ground level by a variegated ivy. On the shadier side the variegated theme is taken up by a mound of *Hosta fortunei* 'Albomarginata' and the smaller leaves of shrubby *Pieris japonica* 'Variegata'. Heart-shaped leaves of epimedium and a mossy carpet of *Soleirolia soleirolii* are interspersed with a variety of glossy-foliaged plants. The palmate leaves of *Fatsia japonica* deepen the shade below.

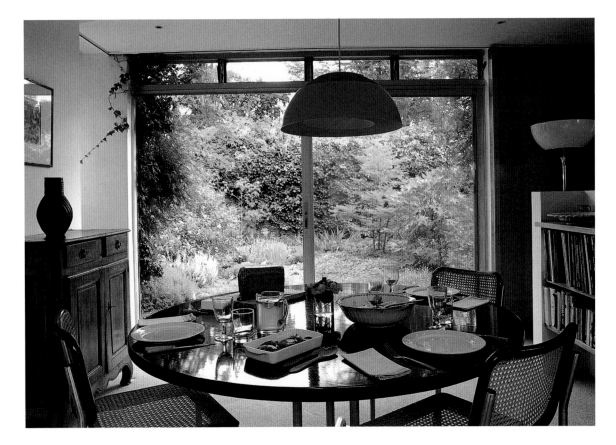

Left The shape of the paving echoes both the straight lines of the room within and the courtyard without, and the small sized slabs help to make the garden seem larger than it is. To the left, facing south, are the sun-loving plants, rosemary, santolina and roses. To the right a small but elegant specimen tree, *Gleditsia triacanthos* 'Sunburst', arises from a halo of ivy. The drifts of *Erigeron karvinskianus*, mostly self-sown between the bricks, are a master touch.

Right This tiny garden offers a really superb solution for a modern house. It deliberately accentuates the juxtaposition of two rectangular spaces, one indoor and one outdoor, and then treats their design in two contrasting but complementary styles. The softness that is usually provided by the interior in extensive use of fabrics is here left to the foliage outside.

A WILD COURTYARD GARDEN

Nostalgic gardens are apt to sit very uneasily with late twentieth-century architecture, which seems to call for a style of its own age. Here the artful disorder of the paved garden forms a surprising but wholly appropriate contrast to the clean-cut lines of the contemporary interior from where it is viewed. The effect is of two rooms, separated by a wall of glass that can be slid to one side in warm summers.

Well built walls, high enough not to be looked over, are essential to the success of this scheme: they give it the atmosphere of a private, if outdoor room. Good quality paving is also important. Neither material is cheap, but after this initial extravagant expenditure, the planting is positively inexpensive. Climbers clad the walls, and this backcloth is used for a sparing but considered planting of flowering shrubs, roses and ground-cover plants with one choice small tree and a tiny herb bed at the centre.

Unlike most gardens this one never sets out to confuse its contours. That is its secret. There is a profusion of branch and foliage, but one is constantly aware that everything is held in by a firm containing rectangle that echoes the dining room. Although the garden presents, at first glance, a scene of calculated confusion, it is in fact quite the reverse. The simplicity of the design elements and the permanent nature of most of the planting mean that very little maintenance is required. Apart from winter and spring pruning and autumn cutting back, this outdoor room – like an indoor one – needs only generally tidying up: dead-heading, some clipping and gentle weeding.

THE STRUCTURE

The courtyard is 6 x 10 m/ 20 x 30 ft with brick walls of about 2.2 m/8 ft on all three sides. It is essential to ensure a free flow between the outside and the inside room, so that ideally the paving should be on the same level as the floor of the room, and the dividing window should be as unobtrusive as possible. The main view from the window is kept clear, apart from a small bed of low-growing herbs, and the border against the far wall is very narrow, ensuring as much sense of distance as possible.

BEDS AND BORDERS

Apart from the borders which line the three enclosing walls, there are two small beds let into the brick paving. One is a tiny herb bed, emphasized by a low clipped hedge on three sides of it. The other supports the small tree and a ground-cover of ivy but its edges have been obscured by the encroaching ivy from the south wall and border.

PAVING

The ground surface has been treated uniformly both in terms of colour and size; the introduction of mixtures of materials or pattern of any kind would upset the sense of ordered balance and unity of space that is so important, especially as it acts as a striking counterfoil to the range of texture and colour of the encroaching foliage. The choice of these frost-resistant bricks was made because they do not attract lichen and therefore do not become treacherously slippery during wet weather. They were laid over a firm hard core base, and then a mixture of sand and compost was brushed into the crevices. These are now host to an increasing number of ground-hugging plants that soften the hard look of the bricks.

THE PLANTING

The most striking feature of the planting is the extensive use, on the shady areas of the walls, of *Hedera helix* 'Angularis Aurea', which has bright glossy green leaves streaked and splashed with butter-yellow. The result is a leafy tapestry of green and gold that lightens up what would otherwise be dark corners. This also gives the garden its background winter coat, for apart from the architectural leaves of the fatsia and the bergenia, most of the planting is geared towards providing a sequence of bloom running from spring to autumn. The workload is minimal: after the rampant ivy has been severely pruned back in the spring, there is just some cutting back, especially of the low teucrium hedge, dead-heading, occasional weeding and, of course, watering in dry weather, before the main autumn tidying up, and the winter pruning of the vines.

NORTH WALL AND BORDER

1 *Vitis vinifera* "Fragola' and *Actinidia deliciosa* clothe the wall.
2 The south-facing border is filled with soft-coloured and contrasting plants: *Rosmarinus* 'Miss Jessopp's Upright', *Helichrysum italicum*, *Hydrangea aspera* Villosa Group*, Rosa* 'Penelope', *Rosa* x *odorata* "Mutabilis", and *Rudbeckia fulgida deamii* with low-growing *Alchemilla mollis* and *Armeria maritima*.

EAST WALL AND BORDER

3 *Jasminum officinale* and *Abutilon* x *suntense* grow against the wall in the sunniest corner.
4 *Clematis montana* adds spring colour to the background of *Hedera helix* 'Angularis Aurea'.
5 *Rosa* 'Alister Stella Gray', *Brunnera macrophylla* 'Hadspen Cream', the white-streaked spears of *Iris pallida pallida* and the large glossy leaves of *Bergenia* Ballawley hybrids make up the border.

SOUTH WALL AND BORDER

6 The *Hedera helix* that clothes the wall also spills over into the border, making good ground cover around the bole of the garden's single tree.
7 *Gleditsia triacanthos* 'Sunburst'.
8 A big pot of *Fatsia japonica*.
9 A drift of *Macleaya microcarpa* 'Kelway's Coral Plume' grows in the corner.

HERB BED

10 A small range of herbs is contained in a bed

which has, on three sides, a low hedge of clipped *Teucrium* x *lucidrys*. The evergreen hedge needs clipping two or three times in the growing season to keep it in control, but as it is not integral to the design of the garden as a whole, it could be dispensed with.

HOUSE WALLS

11 *Jasminum officinale* adds summer scent round the large windows.

PAVING

12 The small cracks between the bricks have been colonized chiefly by self-seeded *Erigeron karvinskianus* which needs to be sheared back in the autumn.
13 Origanum grows in the sunnier areas.
14 *Soleirolia soleirolii* has taken over the shady corner beneath the house wall.

Below Rosa 'Penelope', a Hybrid Musk rose with vigorous growth and recurrent flowering.

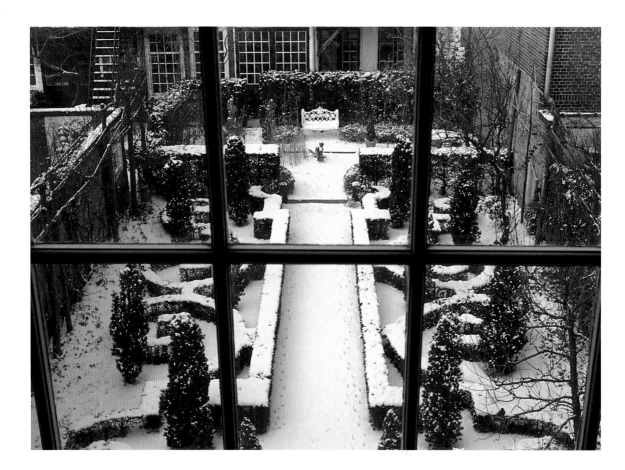

Right The view from an upstairs window, looking down on the pattern below, is an additional pleasure. Symmetry of this kind gives a sense of order and tranquillity, while any feeling of rigidity is dispelled by the luxuriant planting frothing from the boundary walls, the pots of flowers, and the relaxed atmosphere of the sunny patio with its bench, table and chairs for alfresco living.

Left Winter is always the great test of a good garden. Here, under snow, the parterre looks magnificent, its curvilinear shapes emphasized to advantage. Notice how both the side walls have posts with linking cross members to support the planting.

A PERIOD PARTERRE GARDEN

The formal parterre, one of the great classics of garden design, is undergoing a renaissance today. Its effect is immediate from the moment of planting, and it is also, apart from the clipping required, labour-saving. At the back of this town house in Holland, two contrasting shades of gravel provide a dramatic foil to bold baroque scrollwork in glossy green box, while handsome fastigiate yew provides dark columns to emphasize the small but stately vista. This is a supremely elegant solution to an urban back garden site.

The parterre uses the rhythms of the seventeenth century, a golden age in Holland for the art of gardening. This is an appropriate style for an old town house, but just as the design of the parterre itself can be adapted – as here – to the smallest of sites, so a more contemporary design could easily be introduced for a more modern house.

Two thirds of the garden site are given over to the parterre, which provides a year-round evergreen pattern. Flowers in containers enliven the garden during the summer, and the boundary walls are softened by climbers and trained apple trees. The end third has been made into a sunny patio contained by hedges and with a delightful small pond and fountain as a focal point. The garden calls for little more than a couple of hours a week during the growing season to maintain it in top order. The only major undertaking is clipping the box, which needs to be carried out with precision once or twice a year.

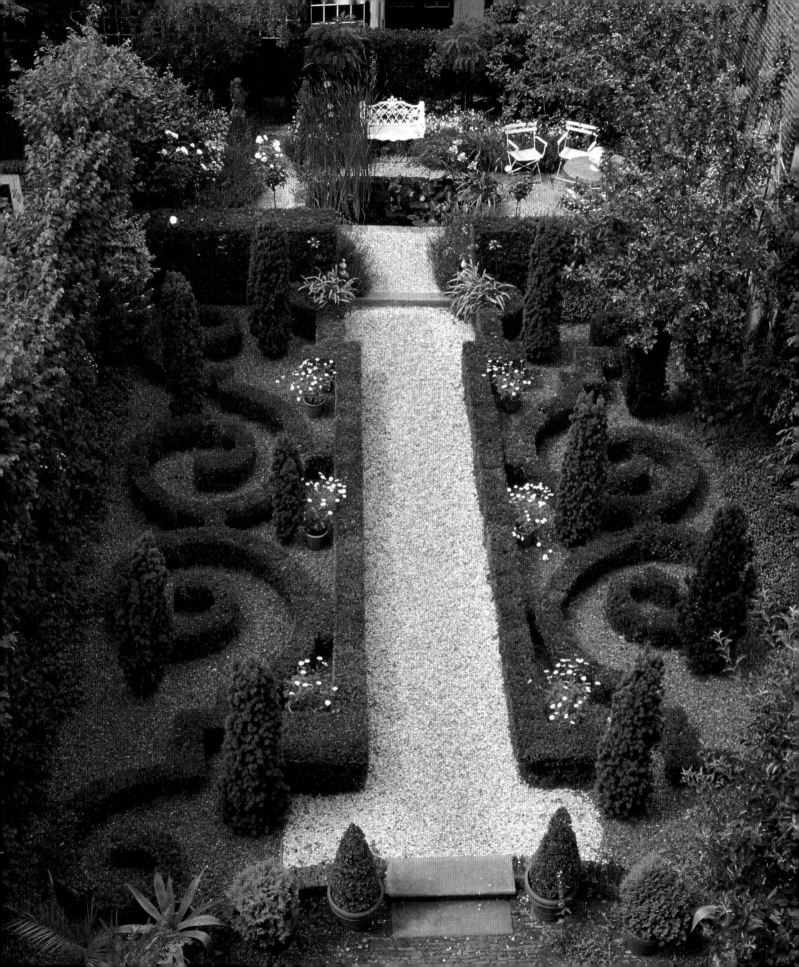

THE PLANTING

Box is the ideal plant for low hedging of this kind as it is frost hardy, can be clipped hard to keep it in shape, and is evergreen. *Santolina chamaecyparissus nana* or *Teucrium* x *lucidrys* are other possibilities, although not as satisfactory. For a parterre on a larger scale, *Lonicera nitida* or euonymus might be used. Dwarf box requires clipping in late spring or early summer, and sometimes again in late summer.

PARTERRE

1 Scrollwork and hedging are of the small-leaved *Buxus sempervirens* 'Suffruticosa'. An interesting variation would be to use golden box, *B.s.* 'Latifolia Maculata', for the scrollwork.
2 The fastigiate Irish yews (*Taxus baccata* 'Fastigiata') that have been used as the vertical accents will outgrow this tiny space within fifteen years; the grey-green *Juniperus communis* 'Hibernica' or the very narrow *J. scopulorum* 'Skyrocket' are slower growers and more easily clipped.
3 Containers add colour in summer: Shasta daisies (*Leucanthemum* x *superbum*) line the path, with blue and white agapanthus varieties beside the steps.
4 The north-facing wall has espalier apples and *Hydrangea anomala petiolaris* against it.
5 The south-facing wall has more trained apples. Both walls have a creeping ground-cover of ivy at their feet.
6 There is a quince (*Cydonia oblonga*) in the corner near the patio.

PATIO GARDEN

7 A clipped hedge encloses the patio area.
8 A weeping laburnum hangs over a statue.
9 Two false acacias (*Robinia pseudoacacia*) in containers flank the central seat. These will need heavy annual pruning.
10 The borders behind the hedge are filled with lavender and planted with four standard *Rosa* 'Snow White'. In severe winters these have to be wrapped for protection.
11 The north-facing bed is lined with lavender, and planted with *Rosa* 'Belle de Tuylers', while *R.* 'Gloire de Dijon' climbs on the wall behind.
12 The south-facing wall supports another quince.
13 The pond has a planting of waterlilies and *Iris* 'Brown Cigar'.
14 Pots of evergreens and flowering plants such as white agapanthus are moved in and out of the area during the seasons.

THE STRUCTURE

Steps lead down from the house to a long narrow plot of about 33 x 6.5 m/ 110 x 21 ft. The central path is flanked by box hedges and mirror-image scrollwork parterres. A patio enclosure with a pond and a small fountain terminates the vista.

GRAVEL

Stone chippings and gravels come in a wide variety of colours, and the contrast between red and pale cream has been used in this garden to great effect to define the layout. The pale gravel of the path continued into the broader patio cleverly links the whole design.

SCROLLWORK

The box hedges along the path are some 30 cm/12 in high; the curving pattern is cut slightly lower. Because there is no planting inside the parterre, it is easy to lay plastic sheets on either side of the hedges to prevent trimmings falling on the gravel.

FRONT GARDEN PARTERRES

Parterres can provide stylish solutions to all kinds of odd-shaped areas. Here a geometric arrangement of clipped box with an aerial screen of pleached limes makes an elegant front garden out of an awkward L-shaped site, one side of which is extremely narrow.

The effect of this garden would be instantaneous from the moment of planting, and even starting with small plants the parterre would be fully formed in five to eight years. This is a year-round garden dependent for its effect on lustrous greens and the architectural and sculptural qualities of the clipped hedges and trained trees. Both are responsive to the play of light at different times of day and throughout the year. Maintenance would consist of clipping the box twice a year – a lengthy but not particularly arduous procedure – pleaching the limes until they are established, and then pruning them in winter, as well as giving them an annual feed of bonemeal.

A cool garden like this one provides a perfect foil to the architecture, especially of warm red brick. It could also be deliberately planted as a contrast to a far more informal flower garden at the back of the house. The formula used here suits the eighteenth-century house, but a parterre would not look out of place in front of a contemporary building, providing its design reflected that of the architecture. Being placed so close to the house, the pleached limes will inevitably make the house darker, and are best suited to a warm, sunny climate. An alternative would be to fill the parterres with flowers.

THE STRUCTURE

The corner site is designed in two sections, in effect as two slightly different front gardens. The narrow strip of about 2 m/7 ft wide in front of the house is filled with a repeat pattern in box, the semi-circles at the front encompassing the trunks of an aerial hedge of pleached limes, and those at the back containing box cones.

PICKET FENCE

The delightful white picket fence adds greatly to the crispness of this composition, providing both contrast and enclosure. Such fences can be custom-built, but several types are now available commercially. Ideally they should reflect the character of the architectural detail – the window frames and doorcases – on the house. The openness of the fence allows light on to the box and also deflects the eye from the confined nature of the space behind.

PLEACHED LIMES

Limes (*Tilia platyphyllos* 'Rubra') are fast-growing and resilient to pruning, and within five years can achieve a good pleached appearance. Early training is best achieved by erecting a temporary framework of strong wires or canes to which branches and eventually the leader can be tied. This, and the pruning back and tying in of side shoots in winter, will require ladders or a mobile platform. The ultimate height of the aerial hedge will be determined by the position and the scale of its surroundings.

PARTERRE PATTERN

Careful consideration has been given here not only to the narrow space but also to the relationship of the design to the façade of the house: the limes, for example, are positioned precisely between the windows, and the solid simplicity of the planting matches that of the architectural detail. In a narrow space such as this, it is especially important to keep the design simple and unfussy. The symmetry is illusory, for the strip is wider at one end than the other. Clipped box balls run down the centre, and a different design on the corner of the house links both gardens, with an urn as a focal point. The wider area at the side of the house has room for a classic parterre design, with symmetrical beds and vases. A design like this one could be used for a larger front garden by making a mirror-image of the pattern on either side of a central garden path.

THE PLANTING

The basic planting is dwarf box (*Buxus sempervirens* 'Suffruticosa'), but other larger-leaved varieties could be used for the topiary specimens. The initial cost would be high if large plants and trained topiary specimens were purchased, but it does not take long to create a substantial hedge from smaller plants, while creating one's own topiary specimens brings a rare sense of horticultural achievement. Yew (*Taxus baccata*), or golden box (*Buxus sempervirens* 'Latifolia Maculata') would be equally successful for the topiary balls and cones, and *Ilex* x *altaclerensis* ' Golden King' would be stunning. A row of small decorative trees, such as amelanchier, malus or crataegus, pruned as mopheads would be a pretty alternative to the pleached limes if screening for privacy was not a priority. They would allow more light and would provide blossom in spring and fruit in autumn.

Right This view along the front of the house shows the pretty white picket fence and the pivotal vase; the garden chiefly depends for its success, however, on the sculptural effect of the clipped box.

Left The view from the balcony steps shows the extremely simple yet effective treatment of a space enclosed by high walls. The treillage acts as a strong architectural frame for the shrubbery of evergreens chosen carefully to ensure good foliage contrasts.

Right The balcony and steps are festooned with Virginia creeper (*Parthenocissus quinquefolia*) and clematis whose small leaves are good foil for the bold foliage of the *Acanthus mollis* underplanted with ivy below.

This tranquil oasis of green in the middle of a bustling capital would lift the spirits on the darkest day. The architecture of many inner cities produces all sorts of unsatisfactory sites for garden-making, often spaces – like this one – hemmed in on virtually every side with tall walls forming a gloomy uninviting well. Yet, with careful planning and skilful planting, such a restricted area can be transformed.

The solution in this instance has been to make the space into a courtyard terrace with a small pool as its focal point which reflects light and is itself enlivened by a modest fountain, pale coloured pea gravel which attracts yet more luminosity and a handsome small tree chosen for the brightness of its lime-green leaves. The fine mesh trellis on all four containing walls contributes an essential element to the scene, bestowing unity and, at the same time, breaking up and having a softening effect on the large expanses of rendered wall.

This is a garden which could more or less look after itself, particularly if it had a computerized watering system; it calls for little more than regular pruning of the shrubs, the addition of compost to the soil and a once-yearly planting of a few bedding plants. The planting is made up of a backbone of robust, reliable favourites such as box, laurel and hebes that are guaranteed to give year-round value, with seasonal in-filling of well-tried summer-flowering plants such as impatiens. Once established, a garden like this will go on for years providing an inviting place to sit and take the air.

AN ENCLOSED URBAN OASIS

THE STRUCTURE

The area here is square, 10 x 10 m/34 x 34 ft, and has been given a strong sense of underlying order by placing the circular pond at the visual centre of the garden, at the crossing of two axes leading from the balcony steps and from one of the house windows. In such a confined space, the simplicity of the scheme is the key to its success. Its essential 'softness' – a combination of lush, evergreen planting and a gravel 'carpet' – offsets the hardness of the built environment in which it is set. It is given cohesion by its continuous framework of trellis, by the smooth gravel, and by the extremely limited colour range of the plants.

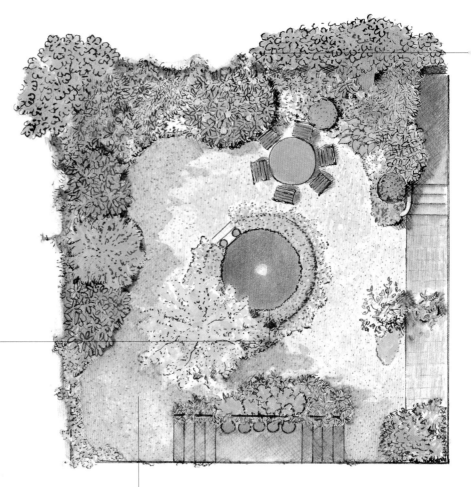

POND (*below*)
The shallow raised pond is the garden's main focal point. A modest jet, driven by an electric pump controlled from the house, adds movement and sound, but an ornament would be an attractive alternative. The rim of the pond is almost wholly concealed by ivy; two pots of clipped box that flank the gap in the circle add interest.

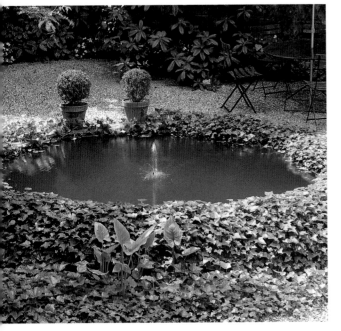

GRAVEL
Gravel is an advantage in cities as it can be raked or even bleached to remove atmospheric pollution. Gravel works particularly well with a casual planting scheme that has no hard edges. Although paving would be easier to keep tidy, it would be less satisfying texturally and any ground-level pattern or geometry would be totally at variance with the scheme. Grass would simply not grow in these conditions.

TREILLAGE

Trellis provides the unifying feature of the enclosure, its effect strengthened by the foil of the pale walls. The deep, glossy green of the trellis helps to make the walls seem farther away and the cream background lightens the space and enhances the green foliage. The formula is easily adapted to any small site as long as its deceptive symmetry is preserved. Because the space is so confined, choose the simplest trellis to maintain the soothing atmosphere and keep the emphasis on the plants and pond. In a larger space it would be possible to make a more complex architectural composition of treillage arches and windows, pilasters and pediments. It is worth investing in the best, most durable quality so that by the time the trellis or walls behind it need repainting, the ivy will have grown sufficiently well to cover the blemishes.

PLANTING

The planting is virtually entirely of shade-tolerant shrubs that provide a year-round background of soothing greens occasionally flecked with a few blooms. Early spring brings scented mahonia flowers and the bright young foliage of the pieris. This is followed by the camellia and rhododendron flowers and then a sprinkling of summer bedding and, in the autumn, with the blazing crimson of the Virginia creeper on the balcony balustrade. A handful of early spring-flowering bulbs would be easy to tuck in among the shrubs, but strident summer colour would ruin the effect of tranquillity. The undefined shape of the border and the informality of the planting makes an appealing contrast to the necessarily rigid boundaries of the garden and the strictly circular pond. An atmospheric pollution-resistant ground-cover of ivy softens most of the lines; but there is always a danger of its encroaching too far. Indeed most of the work in the garden is concerned with control – pruning and clipping-back, and picking up fallen leaves and petals – but with so small an area, this would take very little time.

IVY

1 Being shade- and pollution-tolerant, ivy has been used extensively. It has been planted to scramble up the treillage,

Above Pieris japonica, a shade-tolerant evergreen shrub, is noted for the colour of its spring foliage.

over the pond coping and as ground cover. Once established, it needs little attention except to curb its invasive tendencies and check its vigorous growth. *Hedera helix* has a range of decorative cultivars, with gold, white, grey or slightly pink markings, which could be used for a different overall effect.

BORDERS

These are partly shadowed by a chestnut tree and contain a mixed planting chiefly of shrubs that have been chosen for their shade tolerance and for the variety of their foliage.
2 *Rhododendron* variety.
3 *Choisya ternata.*
4 *Mahonia japonica.*
5 *Pieris japonica.*
6 *Buxus sempervirens.*
7 *Prunus laurocerasus.*

8 *Hebe* variety.
The foreground is filled with hosta varieties, and ground-covering ivy, while impatiens are added for summer-long flowers.

POOL AREA

9 *Gleditsia triacanthos* 'Sunburst' is a small, deciduous tree with delightful fernlike foliage that is golden yellow in spring changing to deep green in summer. An alternative choice might have been a prunus or malus that would give spring blossom and autumn fruit as well as autumn leaf colouring.

STEPS AND BALUSTRADE

10 Box balls in pots.
11 *Acanthus mollis.*
12 *Parthenocissus quinquefolia.*
13 *Pittosporum tenuifolium.*

A PERGOLA BACK GARDEN

-This ravishing inner city garden has been created in a tiny, unprepossessing space. It is a rare example of the marriage of initial low costs to subsequent low maintenance. It seems to recall the exuberant patio gardens of Spain whose essence is to be hidden, enclosed, tiled, to have a small water feature and be vibrant with foliage and flowers ranging from climbers to container plants. Here the concept has been transported to colder climes and clothed with a planting that recalls the romantic traditions of English country gardens.

The planting has been superimposed upon what is a strong asymmetrical structure dominated by the generously-proportioned pergola of painted wood. Tiles, marble chippings and concrete slabs frame a terrace for sitting out, a substantial mixed border and two small ponds – one with a fountain – that bring water, movement and reflected light to the garden. As the space available at ground level is so limited, full use has been made of every vertical surface, the amount of which has been extended by a pergola and by trellis on the containing walls which support an explosion of overhead bloom.

There is nothing in the construction of this garden beyond the capabilities of the competent home handyman, although the installation of the water features requires considerable care. Apart from the containers, which are welcome but dispensable, this is a very low maintenance garden calling for no more than about an hour a week in season, with annual autumn and spring blitzes. There is no lawn to mow and only one major bed to keep weeded. The most demanding elements are the ponds and fountain which need regular servicing, and the roses which need dead-heading, pruning and tying-in. The input, however, is minimal in return for such a flower-filled bower.

Above Viburnum tinus and pink *Rosa* 'Gloire de Guilan' grow below creamy-white *Rosa* 'Rambling Rector' on the left. On the right is a collection of grey foliage plants including santolina and artemisia and beyond is a glimpse of blue *Iris laevigata* arising from one of the ponds.

Opposite Looking down on the garden shows how the relatively stark built structure has been transformed by luxuriant and imaginative planting. The prolific *Rosa* 'Rambling Rector' has engulfed both trellis and pergola on one side, while the climber *Rosa* 'Guinée' threatens to do the same on the other. Both roses are deliciously fragrant. The change of level and the various surface textures – reflective and matt – add greatly to the interest of the composition.

PERGOLA

Simple and sturdy, the white-painted wood will need repainting only every few years – a not impossible undertaking, as *Clematis armandii* can be cut right back in the spring, and roses can be carefully lifted away.

SHADE PLANTING

(below) Cotoneaster, camellia and *Hosta sieboldiana* 'Frances Williams' grow against the wall, pittosporum stands near the support, with containers of dwarf juniper and nicotiana.

THE STRUCTURE

This is a typical L-shaped backyard of a late nineteenth-century urban terrace house measuring 9 x 6 m/30 x 20 ft. Its principal design features are the pergola, which emphasizes the width of what is otherwise a constricted narrow space, a substantial east-facing border and two ponds that echo the rectangular lines of the garden, reflect light and – through the play of the small fountain – bring movement and sound. The choice of the creamy-white marble chippings not only adds an extra texture to the ground surfaces, but also lightens what could easily be a rather gloomy backyard. Atmospheric pollution will progressively blacken them, calling for raking and, in the longer term, periodic replacing.

THE PATIO

The area outside the kitchen doors has been tiled to give the feeling of an outdoor room and left unplanted so that it can be easily swept clean. Jasmine, trained along the south-facing wall, adds fragrance when in bloom.

WATER FEATURES

Having two ponds not only adds extra surface interest, but is practical as waterlilies and moving water are not compatible. Simply constructed and lined with butyl rubber, the ponds are kept clean by a filter system which, like the underwater pump for the fountain, should, in the interests of safety, be installed and serviced by a qualified electrician.

THE PLANTING

This small garden is a lesson in the importance of climbers in a very restricted space, for this way an abundance of colour can be had without encroaching on the ground space. Other plants in the main border have also been chosen because they carry their flowers on spires, thus increasing the amount of colour relative to the space they take up. None of the groupings is labour intensive. The small group of perennials will need dividing every so many years and occasional staking, but little else. Attention, however, should be paid to enriching the soil, seeing that the roses are fed in season, and that the containers are kept well watered. In addition, because they are seen at such close quarters, all the plants would look better if they were kept dead-headed. Every season is catered for in this garden: the year opens with a modest flush of snowdrops, muscari and narcissi tucked into the beds and closes with the scarlet berries of the cotoneaster and the glowing sunset tints of the Virginia creeper on the pergola, leaving an evergreen backdrop of shrubs with varying leaf shapes and textures.

EAST BORDER
1 Along the back wall are two climbing roses, 'Rambling Rector' and 'William Lobb', *Jasminum officinale*, variegated ivy and an espaliered apricot tree.
2 Shrubs include *Viburnum tinus*, a dwarf white rhododendron, an azalea, and an escallonia; *Pieris* 'Forest Flame' contributes spring colour and *Rosa* 'Gloire de Guilan' adds further summer colour. Ground cover includes a prostrate salix, *Euonymus fortunei* and *Ajuga reptans*. Among the perennials and biennials are *Anemone hupehensis* 'September Charm', delphiniums, hollyhocks, tradescantia, euphorbia and lupins.

SOUTH WALL AND PERGOLA
3 Shade-tolerant plants include *Skimmia japonica*, camellia, cotoneaster, pittosporum, hydrangea, hosta and astilbe.
4 All the vertical surfaces support climbers and wall shrubs: evergreen *Clematis armandii* and jasmine provide year-round foliage; and Virginia creeper (*Parthenocissus quinquefolia*) adds autumn colour.

WEST WALL
5 A background planting of variegated ivy covers lower unsightly areas of wall; roses, however, are the most significant plants: 'Blush Noisette', 'Guinée' and 'Gloire de Dijon' make a mix of pretty soft colours and heady scent. They require dead-heading, careful annual pruning and periodic tying-in, demanding but rewarding tasks.

WATER PLANTING
6 As marginal plants and waterlilies do not flourish in moving water, there are only grasses in one corner of the larger pond that contains the fountain.
7 The smaller, deeper, still pond has *Iris laevigata* and waterlilies in submerged planting baskets. All need periodic lifting and dividing but no regular maintenance.

THE GREY COLLECTION
8 Next to the little pond is a collection of sun-loving grey foliage plants, many of which have fragrant leaves: santolina, lavender, *Stachys byzantina*, artemisia, *Salvia officinalis* and white *Dianthus* 'Mrs Sinkins'. These are complemented by pots of white agapanthus and white hydrangea and, in a large tub next to the house, an evergreen jasmine. As so few plants are needed, it is worth treating the dianthus as a biennial and replacing it every two years; santolina and lavender require clipping annually but the other plants only need cutting back when they outgrow their allotted space.

Below *Delphinium* hybrids are hardy perennials that are valuable for their vertical spires of bloom.

Right In the first garden, a formal paved central enclosure is held in by low cushions of *Hedera helix* and sections of low clipped yew hedge and is framed by flowering trees, shrubs and perennials. The pink *Hydrangea* 'Preziosa' on the right is echoed by pink *Hydrangea aspera macrophylla* on the other side. A delightful aerial hedge of pleached lime marks the entrance to, and defines, the second garden.

Left Looking back from the second garden towards the first, the eye is drawn along the full length of the vista by the brilliant red blooms in the vase and in the pots at the end. There are no other brightly coloured flowers in the garden: it is largely a tapestry of green. On the left the feathery foliage of a clump of bamboo (*Fargesia murieliae*) makes a good contrast to the glossy dark green leaves of a tree ivy (*Hedera helix*).

A TWO-ROOMED GARDEN

It is surprising how seldom a long narrow rectangular back garden is divided into sections. This brilliant little Dutch garden, designed by Dick Beyer, should inspire anyone to adopt just such a solution, for it transforms a long narrow site into two highly effective garden rooms – one symmetrical and formal, held in by clipped yew hedges and with a handsome vase as a focal point at its centre; the other asymmetrical and defined by an aerial hedge of pleached lime. By banishing grass in favour of paving and clipped ivy, and by planting shrubs and ground-cover perennials such as hardy geraniums and tiarella, a remarkably stylish easily maintained garden has been achieved. An hour or two a week at most, plus clipping, pruning, fertilizing and an annual clear-up, will keep this little garden in top form. You could create two rooms with a more distinctly different 'feel'. The aerial hedge makes only a lightweight divider: you could create a more solid one with, say, trellis, and emphasize difference by different treatment underfoot. None of this would particularly increase the maintenance.

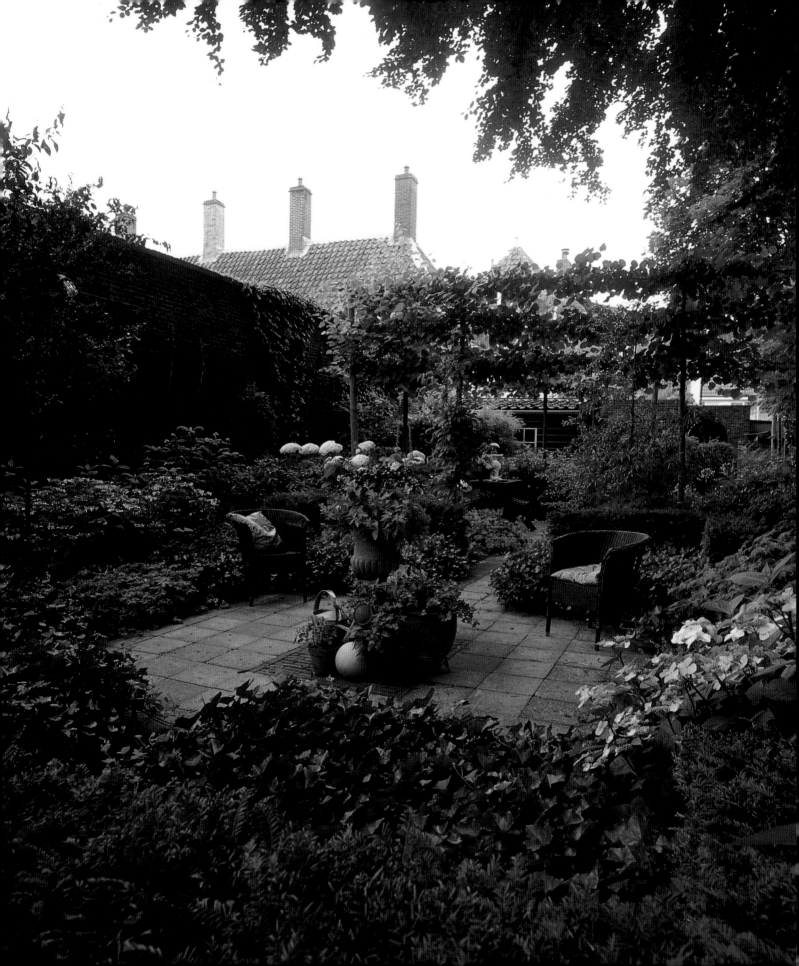

TERRACE

A paved area close to the house has space for seating and for two wooden Versailles tubs which flank the entrance to the first garden. The terrace is south-facing, so it could include a space for culinary herbs. The tubs, like any containers, need a good deal of attention, especially watering in summer, but they do offer an opportunity for seasonal planting. However, they are not essential to the scheme, and could equally well be replaced by a pair of obelisks or finials which would require no maintenance at all.

PAVING

Except for a small square at the centre of the first garden, the paving throughout is of 30 x 30 cm/12 x 12 in slabs. This has the advantage of unifying the whole area, and slabs are the least expensive of hard surface materials, as well as one of the easiest to keep clean. However, the effect would be enriched by using stone, brick or setts (or a mixture of these), provided they were laid in such a way as to echo and emphasize the ground-level pattern.

FOCAL POINT

The vase, like the Versailles tubs, brings the chance to have a splash of year-round colour in the centre of the garden. It would be simple, and not overly extravagant, to keep it stocked at other seasons with bulbs, or winter pansies, in addition to summer bedding such as petunias and gardenias. However, it could be replaced by any ornamental feature that can be viewed from all sides – a sundial, a column or obelisk. Here the vase has been used as the centrepiece of a tableau of pots, emphasized by their platform of brick which has been set into the paving.

THE STRUCTURE

The 21 x 7.25 m /73 x 23 ft rectangular space, lying between high boundary walls, is divided geometrically into what are in effect two smaller internal gardens. This is a garden of squares and rectangles. A bench under the wall of the house looks along its central axis. The first garden follows precisely the lines of the outer boundary, but its paved square centre gives it an illusion of width. Here, the formal symmetry of the design is emphasized by the crisp corners of the yew hedging, and by the neat blocks of ivy at ground level. In the second garden – a wider rectangle delineated by tall pleached limes – symmetry is replaced by geometric blocks of looser planting and a paved area leads to a garden shed.

N

THE PLANTING

This is a planting of well-tried small trees, shrubs, climbers and perennials that enhance the geometry of the design, and allow maintenance to be kept to a minimum. Annual work will include limited staking of perennials, dead-heading in summer, some pruning of shrubs, clipping the yew hedge and ivy, and pleaching the limes. The perennials would need lifting and dividing every five years or so, but this could be staggered. Like any other town garden, this needs an annual dressing of fertilizer, and the addition every few years of a layer of good compost.

FIRST GARDEN

1 The tubs are planted with *Hosta sieboldiana* 'Frances Williams'.
2 Four segments of yew hedging (*Taxus baccata*) frame the internal rectangle.
3 An evergreen ground-covering of ivy forms blocks that outline the central square.
4 and 5 The cross axes are block planted with *Tiarella cordifolia* and *Alchemilla mollis*.
6 A substantial *Viburnum plicatum* 'Mariesii', and two small trees, *Prunus* x *subhirtella* 'Autumnalis' and *Cornus kousa* are underplanted with hostas

and *Cimicifuga simplex*.
7 *Prunus* 'Trailblazer' stands in the middle.
8 *Rosa* 'New Dawn' and clematis clothe the wall.
9 *Hydrangea serrata* 'Blue Bird' and *H. aspera macrophylla*.
10 Beside the terrace, *Geranium macrorrhizum* 'Spessart' surrounds *Viburnum* x *bodnantense* 'Dawn'.
11 *Hydrangea* 'Precioza' grows behind the yew hedge.
12 The wall is clothed with *Hydrangea anomala petiolaris*.
13 *Rhododendron hunnewellianum* 'Cunningham's White' backs this section of yew hedge.
14 In the section between the two gardens *Pyrus salicifolia* 'Pendula' is planted behind

Gypsophila 'Rosenschleier'.
15 *Viburnum* x *bodnantense* 'Dawn' and *Parrotia persica* are underplanted with *Anemone* x *hybrida* 'Königin Charlotte', *Geranium macrorrhizum* 'Spessart' and *Campanula lactiflora* 'Prichard's Variety'.

SECOND GARDEN

16 An aerial hedge of pleached limes (*Tilia cordata*) delineates the space.
17 *Fargesia murieliae* dominates the larger block in the north-west corner, which also contains *Gypsophila* 'Rosenschleier', *Echinacea purpurea*, *Anemone* x *hybrida* 'Honorine Jobert', *Campanula lactiflora*, *Eupatorium purpureum*,

Below Tiarella cordifolia, an evergreen shade-tolerant ground cover, has frothy white flowers in late spring.

Helleborus foetidus, *Geranium endressii* and *Hosta sieboldiana elegans*.
18 *Rosa* 'Lykkefund' grows against the wall.
19 The narrow shady border contains *Tiarella cordifolia*, *Decaisnea fargesii*, *Alchemilla mollis* and *Helleborus foetidus*.
20 In the east border

behind the pleached limes are *Cimicifuga simplex*, *Rodgersia aesculifolia* and *Viburnum plicatum* 'Mariesii'.
21 *Aucuba japonica* dominates the corner.
22 *Viburnum tinus* is planted with arborescent *Hedera helix* and *Hosta sieboldiana elegans*.
23 *Brunnera macrophylla*.

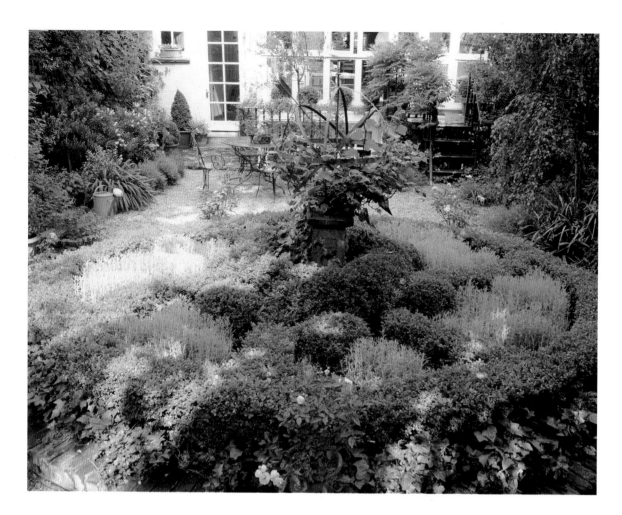

A SECLUDED TOWN GARDEN

This ingenious formal garden, designed by Christopher Masson, is full of illusions. Although it is an ordinary rectangular town garden, its boundaries have been obscured by the planting so that attention is drawn instead to the curves of beds within this frame; two pairs of what appear to be stately gate piers leading who knows where further accentuate the garden's width; and although there is no lawn, the overall effect is cool and green. This dignified formality is, however, broken by the planting which has been deliberately made to erupt out over the boundaries of the containing beds.

The triumph is the achievement of a grand effect with only modest materials: gravel, old brick and trellis. The brick piers are of extremely simple construction, as is the trellis that frames the garden. Together they give the design powerful vertical architectural accents which also ensure privacy and act as supports for climbers.

The display of container plants is dispensable and apart from the clipping of the box and santolina and some tidying of the climbers, the labour input largely depends upon the planting within the borders. The present owners usually spend a couple of hours a week in the garden during the growing season and make time for one or two annual blitzes.

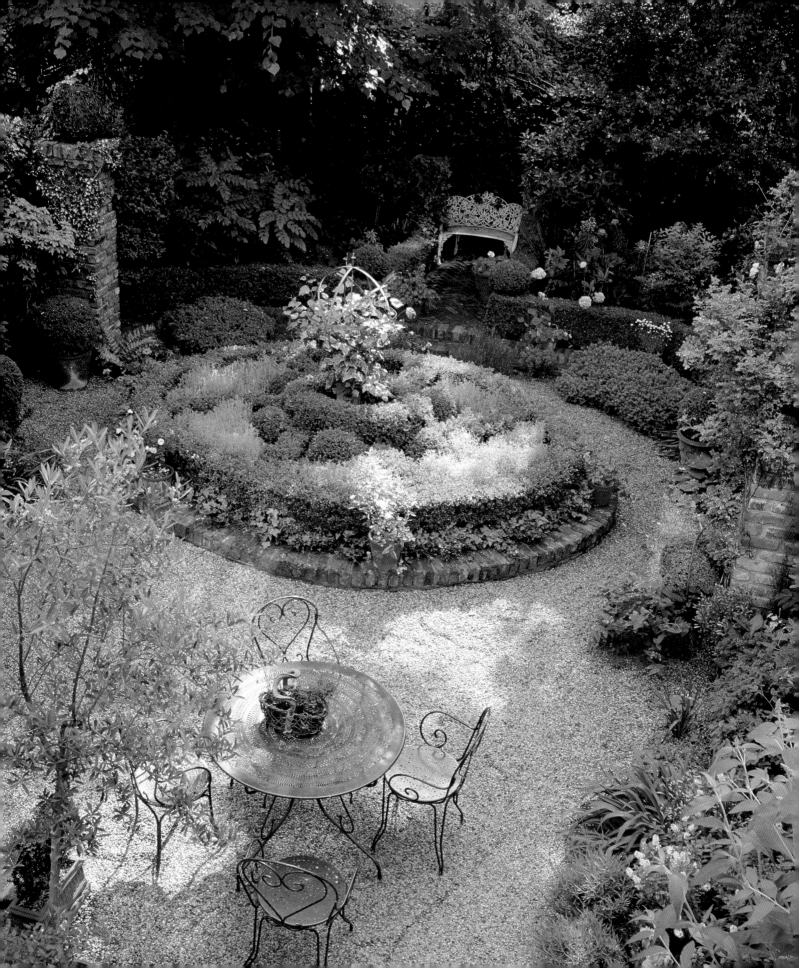

THE STRUCTURE

The garden measures about 10.5 x 6.5 m/45 x 25 ft overall. In such a small space it was a bold decision to confine the cultivated area to the furthest two thirds of the garden, freeing a broad swathe next to the house for use as an open-air room that is dotted with containers and with a table and chairs for alfresco meals. It is essentially an inward-looking garden conceived to secure privacy. One of the design's principal objects is to emphasize the garden's width: it does this by means of the flanking brick piers – which suggest that avenues or pergolas lead off to right and left of the garden – and the curving shapes of the parterre and north border. The absence of high-maintenance grass in favour of easy-care gravel is compensated for by an evergreen box parterre and the abundant evergreen shrubbery which forms the garden's backcloth.

BRICKWORK

The choice of old brick, which complements the house, is used as the linking hard-surface element: it edges the beds, makes the short path to the seat, and forms the piers. The piers are an unusual but arresting feature; the contrast between the taller flanking ones and the shorter ones either side of the seat provides an intriguing and false perspective.

FOCAL POINT

The hub of the composition is a sphere sundial but care must be taken that its contours are not engulfed by ivy. An urn or finial of not less than 1.5 m/5 ft high would be equally striking.

THE GRAVEL

The pale-coloured small pea gravel brings light into the garden and is the most comfortable to walk on. It should be laid over a good base with a built-in drainage system. In cities, atmospheric pollution will gradually blacken it, calling for periodic raking. Weeds are easily coped with by an annual application of herbicide.

THE PLANTING

The survival of plants in this garden is radically affected by the extremely poor soil; by the stagnant bowl of air in which, like so many other town gardens, it is caught; and by a large lime tree and plane tree, which suck in moisture and give fairly dense shade during the summer months. This means that despite regular soil and foliar feeding, some plants will not survive and each year some gaps need to be filled. The nature of the planting changes as it moves from the deep shade of the border into sunlight at the back of the house, a progression from common laurel and hostas to roses and wisteria. The massed shrubbery of evergreens and the climbers and wall shrubs that clothe the two side walls screen out whatever lies beyond the garden. Without the containers which offer additional bloom but are not essential to the garden's success, the workload would be minimal: fertilizing, general tidying up, and some weeding and cutting back, together with annual pruning, tying-in and some plant replacement. The potential workload has been substantially reduced by introducing a computerized surface watering system.

BORDER SCREENING
1 Shade-tolerant evergreens form the background: *Fargesia murieliae*, *Prunus laurocerasus*, *Ligustrum ovalifolium* and *Pittosporum tobira*.
2 Behind the seat is *Ilex aquifolium* 'Golden Milkboy'.
3 In the centre is a mixed planting of *Mahonia japonica*, *Hydrangea macrophylla*, *Nandina domestica*, a standard *Rosa* 'Iceberg' and *Olearia* x *macrodonta*.
4 The foreground planting includes *Euphorbia characias wulfenii*, pulmonaria, *Iris sibirica*, Japanese Anemone, peonies, *Phormium tenax* and *Hosta fortunei obscura*.
5 The border is contained by a clipped box hedge.
6 *Hebe subalpina*, *Polygonatum odoratum*

and *Yucca filamentosa* grow through the gravel.

FLANKING PIERS
7 These support *Rosa* 'Félicité Perpétue', white *R.* 'Iceberg', *R.* 'Phyllis Bide', *Clematis campaniflora* and *Hedera helix* 'Goldheart'.

SOUTH BORDER
8 *Betula pendula*, *Choisya ternata* 'Sundance' and a fig tree are underplanted with tellima, bergenia, *Cotoneaster horizontalis* and *Hosta* 'Frances Williams'.

NORTH BORDER
9 White *Rosa bracteata*, a standard *Lonicera periclymenum* 'Belgica', *Myrtus communis tarentina*, *Convolvulus cneorum*, *Ceanothus* 'Cascade', *Buddleja* 'Lochinch' and *Clematis*

Below Bergenia cordifolia, *an evergreen perennial that tolerates sun or shade and is frost-hardy.*

'Comtesse de Bouchaud' are underplanted with *Phlomis fruticosa*, *Artemisia* 'Powis Castle', pink lavender, *Geranium endressii*, *Ruta graveolens*, *Alchemilla mollis*, *Caryopteris* x *clandonensis*, *Hosta sieboldiana elegans* and violas.

PARTERRE
10 The parterre is of dwarf box infilled with *Santolina pinnata neapolitana*. Ivy is entwined round the sundial.

CONTAINER ACCENTS
11 Clipped box adds formal accents, while perlargoniums bring colour to the central parterre.
12 Next to the house there is an impressive array of container-grown plants including agapanthus, *Solanum jasminoides*, *Pittosporum tobira*, *Trachelospermum asiaticum*, *Olea europaea* and *Argyranthemum frutescens*.

A CHECKER-BOARD YARD

It is no mean achievement to find a successful solution to one of the most depressing of garden sites – a small urban backyard. Here the Dutch designer Mien Ruys has managed to make an unusual yet highly satisfying composition out of a space hemmed in by buildings. It draws on elements of the time-honoured Dutch formal garden tradition, but re-casts them in an intriguing abstract pattern that is particularly striking when viewed from above. Carefully avoiding all vistas and focal points, the designer has created a garden devised to be moved around in and looked at from several sides – as the disposition of the chairs indicates.

Taking the cue from the paving slabs, the garden is divided into three areas whose shapes are square or rectangular. Nearest the house is an open terrace. Next follows a pair of bold rectangular beds, subdivided into smaller rectangles and filled with perennials and blocks of low-clipped box. Furthest away a series of small beds filled with roses and culinary herbs, some edged with box, occupies a rectangular area. Straight narrow beds along the perimeter occasionally widen into rectangles that serve to delineate each of the three areas. Pleached and mophead trees and climbers along the perimeters add essential verticals as well as provide aerial screening.

The large proportion of paving and restricted but choice planting makes this a very easy garden to maintain. Extensive use has been made of box not only to edge beds, but as square cushions which, in effect, take the place of grass, and of ground-cover plants which, once established, will smother weeds and require little attention.

With its interesting contrasts of leaf shapes and textures, and its highlights of whites and creams scattered across a grey and green canvas, this garden exudes an atmosphere of quiet contemplation.

Right The view from an upstairs window shows the architectural structure of this tiny back garden. The squares of low, clipped box fulfil the soothing, evergreen role usually played by grass. The foreground beds, in the shape of blocks echoing the box squares and paving, are filled with a predominantly green and white planting of pulmonaria, gypsophila, alchemilla, hostas, phlox and delphiniums. A screen of pollarded acacias and tall shrubs on the left and climbing roses on the right helps to provide privacy.

Above Looking back towards the house, the tiny beds of herbs are seen just beyond an arching *Rosa* 'Iceberg'. On the left, the beds are filled with bolder groups of *Senecio* "Sunshine', *Acanthus mollis* and *Bergenia* 'Silberlicht'.

THE STRUCTURE

The garden which measures 12 x 5 m/42 x 16 ft runs south-north from the back of the house. Its simple grid pattern could be easily adapted to suit other small town gardens. The easiest approach would be to draw up a scheme on graph paper. If you want to include herbs, locate them where they would get the most sun. The evergreen element – here dwarf box – is essential to the design's success; it provides strong geometry even in winter.

CROSS AXIS (*above*)

Looking east-west across the centre of the garden, standard feathery mophead acacias, interspersed with shrubs, form an aerial screen in front of adjacent houses. The pools of restful green of the clipped box contrast with the pale feathery foliage and flowers.

PAVING

Narrow grey bricks echo the colour of the concrete paving slabs that make up the terrace. They align with the garden's rectangular shapes, making a very subdued ground-level pattern. An intriguing exception has been made in the herb garden where two circles of setts surround a birdbath and a box cone.

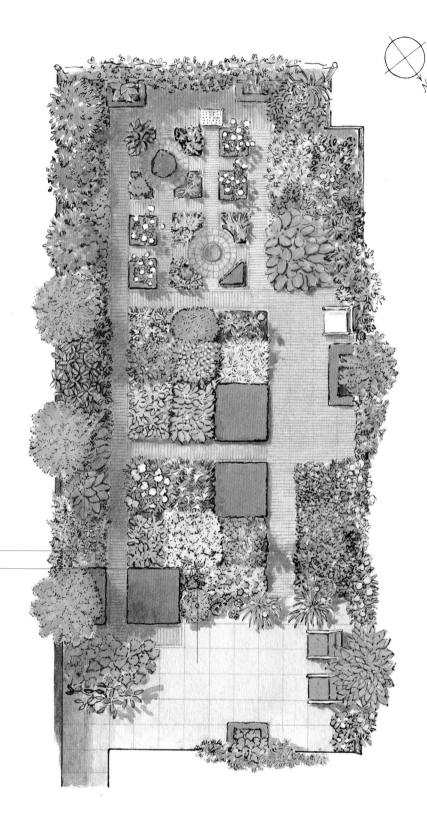

THE PLANTING

Instead of a confused and restless mass of spot planting, there has been a disciplined choice of perennials planted in sizeable blocks. The use of whites, pale pinks and creams adds light to the scheme – an important point in a town garden where light is at a premium. Much of the

Above Rosa 'Graham Thomas', a repeat flowering new English climbing rose with a strong tea rose fragrance.

planting consists of perennials, which need little maintenance other than to be lifted and divided every three or so years, and shrubs that need annual pruning or clipping: the limes could be replaced with climbers that are easier to maintain. The beds do need regular grooming, but in such a minute space the work should not be onerous.

1 Most of the evergreen element is dwarf box (*Buxus sempervirens* 'Suffruticosa').

PERIMETER BEDS
2 Limes (*Tilia platyphyllos*) arising from box-edged beds are being pleached to make an aerial screen. Two tall posts support lateral wires onto which the young branches are tied. They will require hard pruning every winter. A rose climbs between them.
3 Shrubs including *Viburnum* x *bodnantense* are underplanted with *Sedum telephium*, Japanese anemones, *Tanacetum vulgare* and *Lysimachia ephemerum*.
4 The central section of the bed is dominated by three mophead acacias

(*Robinia pseudoacacia* 'Umbraculifera').
5 *Viburnum rhytidophyllum* is underplanted with *Lysimachia clethroides*.
6 Variegated holly is underplanted with nicotiana and *Hosta sieboldiana elegans* and a cushion of box.
7 *Acanthus spinosus, Bergenia* 'Silberlicht', *Euphorbia characias; Gaura lindheimeri* and *Senecio* 'Sunshine' fill the corner bed.
8 *Rosa* 'Blanche Double de Coubert'.
9 *Rosa* 'Graham Thomas'.
10 A sorbus is planted in a box-edged bed.
11 *Rosa* 'Seagull' clambers over an arch.
12 *Rosa* 'Easlea's Golden Rambler' grows above ground-covering *Waldsteina ternata* and arborescent ivy.
13 *Catalpa bignonioides*.
14 Pots of *Hydrangea macrophylla* 'Madame Emile Mouillère'.
15 A box-edged bed contains *Macleaya cordata* and *Clematis montana rubens* .
16 Pots of *Hydrangea aspera*.
17 Pots of agapanthus and *Spiraea japonica*.

NEAR BED
18 Two cushions of box are supplemented by *Pulmonaria officinalis* 'Sissinghurst White', gypsophila, *Alchemilla*

mollis, *Phlox paniculata, Helleborus orientalis, Lilium regale* and *Platycodon grandiflorus* 'Perlmutterschale'.

CENTRAL BED
19 A single cushion of box is balanced by *Hosta fortunei albopicta, Astrantia major, Delphinium* 'Völkerfrieden', *Anaphalis margaritacea, Achillea*

ptarmica 'The Pearl', *Verbascum nigrum, Helleborus* x *sternii* and *Stachys byzantina*.

HERB GARDEN
20 Four box-edged beds contain roses: 'Iceberg', 'Blanche Double de Coubert', 'Apricot Nectar' and 'Nevada'. The eight tiny spandrel beds have culinary herbs in season.

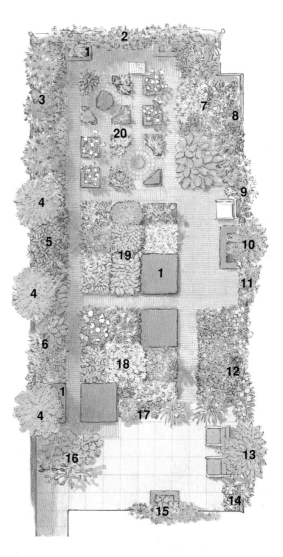

Left A view over the entrance pergola, festooned in wisteria and *Rosa* 'Zéphirine Drouhin', shows the garden's firm ground plan: a split-level octagon lawn held in by paths and encompassing borders and pergolas.

Right Two formal rectangular beds edged with box flank the terrace; each contains a standard *Viburnum carlesii* underplanted with *Rosa* 'The Fairy'.

A FORMAL LAWN GARDEN

The uniquely pleasurable tactile quality of evenly clipped grass has long been rated highly among a garden's delights – indeed, the idea of a garden without a lawn as its centrepiece is unthinkable for many people. Soft and inviting, here it contrasts with the garden's hard landscape and also provides children with a safe area on which to play.

Arabella Lennox-Boyd's design enshrines the lawn at the heart of this garden. The interest generated by its bold octagonal lines, emphasized by brick borders, is further increased by setting it on two levels: one steps down into the central sunken area as into a shallow pool, or as onto a dance floor. Its shape dictates those of the encompassing beds and, beneath a mature horse chestnut tree, a pleasant terrace for sitting.

Two pergolas add height to the composition. One acts as a frontispiece to the garden, the other ensures privacy; both provide welcome shade in summer and straddle gravel paths. There is a succession of flower interest through the seasons. Spring brings flowering camellias, clematis, azalea, viburnums, mahonias, the flowering cherry and the horse chestnut. Summer follows with peonies, clematis and roses. In the autumn the leaves of the prunus contribute bright orange and red.

Two hours work a week in season should keep this garden in perfect condition. It is clearly important that the lawn is well tended, and mowed regularly in the growing season, a process made easier by the brick surrounds. But since it is so small an area, its upkeep is unlikely to be onerous. There is obviously some weeding, clipping, pruning and tying-in to do in the planting surrounding the lawn, and no town garden can go unenriched in terms of soil additives but a composition such as this, in which fairly relaxed planting is firmly held in by built formal structure, is not demanding – provided there has been no skimping in the early stages of its planning and construction.

Container plants need regular watering but they are not an essential ingredient of this scheme. Come the autumn, the mighty horse chestnut will shed its leaves and these will need to be cleared.

THE STRUCTURE

Two narrow gardens were combined to make a single area of about 8 m/ 24 ft square behind tall terraced houses. A pergola runs the whole length of the north-west side of the garden, sited to secure privacy and access to a back gate. A second, shorter, pergola along the southern side spans the entrance to the garden which is approached across a bridge over a basement area. The remaining space has been formalized by insetting an octagon of lawn at the centre enclosed by narrow brick paths. This creates four spandrels; one is a terrace which, facing south-west, enjoys the afternoon sun and a fine view of the pergolas. The other three are planted as mixed borders. The main features of this strong design could be rearranged to suit a different site. The long pergola could either abut the house, for example, or be placed opposite it. The approach to the garden could equally be from the south or east side, dispensing with the box-edged beds. For a narrower site the western pergola arcade could be dropped, keeping only its projecting arch.

PERGOLAS (*left*)
These add an extra storey of colour and interest to the garden as well as providing seclusion and shade. The entrances from the pergolas to the lawn are accentuated by brick paths lined with clipped dwarf box. The view back into the long pergola terminates with a large terracotta pot, planted with a variegated evergreen shrub. Good design and sound structure are essential for pergolas: they are in focus year-round, and must stand alone in the winter months as worthwhile garden architecture. They should never be less than 2.2 m/8 ft high or 2 m/6 ft wide, for plants soon encroach on the space inside. They may be made from wood, as here, which, however well treated with preservatives, will call for maintenance and, eventually, replacement. Other options include brick or reconstituted stone pillars; or iron or plasticized alloy elements. A wide range of ready-made pergolas is available; choose one that complements the style of your house, and one that is robust enough to support the weight of the climbers.

LAWNS

The lawn at the heart of this garden draws the eye at every point. It must, therefore, be of the finest turf and maintained to an impeccable level. It calls for regular attention – for mowing, watering, feeding and weeding – but as the area is so small, the task need not be daunting. An alternative to the grass would be to widen the surrounding paths and make the inner octagon a pond. This would reflect light into the garden and offer opportunities for displays of waterlilies and marginal plants. For less maintenance, either the central lawn or the marginal lawns could be paved. But in this case the paving itself should become a decorative feature, laid in an interesting pattern, perhaps using contrasting materials and allowing spaces for ground-hugging plants to take root and sprawl. If the inner octagon was paved, an urn or sundial would provide an attractive vertical focal point.

THE PLANTING

Apart from the grass, much of the planting is of shade-tolerant plants, as this is essentially a shadowy garden enclosed partly by large, mature trees and partly by the pergolas. Massed evergreen shrubs set off the relatively few flowers which form the foreground of the borders, and the colour comes chiefly from the climbers on both pergolas. Most of the regular input is in keeping the grass in perfect condition, and watering the containers, but the climbers need keeping under control, the borders benefit from attention and clipped evergreens need the occasional manicure as well as annual attention. The climbers and shrubs will, of course, require more serious work at the appropriate pruning season, and the soil needs enriching annually.

LONG PERGOLA

1 This supports *Rosa* 'New Dawn', *Clematis montana*, *C*. 'Perle d'Azur' and *C*. 'Marie Boisselot'.
2 The wall is covered with ivy.
3 The gravel path is lined with silver-margined *Euonymus fortunei* 'Silver Queen'.

SHORT PERGOLA

4 This supports *Rosa* 'Zéphirine Drouhin', *Lonicera periclymenum* and *Wisteria sinensis*.

Below Prunus 'Amanogawa' is a spring-flowering fastigiate tree with good autumn foliage.

BOX-EDGED BEDS

5 Beneath standard *Viburnum carlesii*, the ground is planted with *Rosa* 'The Fairy', which comes into flower after the spring bulbs and forget-me-nots are over.

NORTH BORDER

6 Shaded by the pergola and a large lime tree in a neighbouring garden, this bed is planted with *Mahonia media*, *Viburnum davidii*, camellia, azalea, *Halesia tetraptera* (syn *H. carolina*), euphorbias, astilbe, bergenia and ferns of all sorts including *Osmunda regalis*.

WEST BORDER

7 In front of the larger evergreen shrubs that include camellia, there are hostas, hellebores, grey-leaved artemesias and hebes, and *Iris sibirica*.

SOUTH BORDER

8 This is dominated by a flowering tree, *Prunus* 'Amanogawa'.
9 Beneath the evergreen shrubs, including *Viburnum davidii*, are silver-leaved artemisias and hebes. White roses and a tree peony add further seasonal interest.

CONTAINERS

10 Clipped box balls accentuate the way in and out of both pergolas; and a few other containers of tender flowering plants bring touches of seasonal colour to the terrace.

GARDENS
for the
TIME-WATCHER

The seven gardens which follow are achieved on a weekly input during the growing season of about an afternoon a week. Like the gardens in the previous chapter, they also need extra attention in the spring and autumn when more serious prolonged work is needed to cut down, lift and divide perennials, prune and train shrubs, move and replace any unsatisfactory plants and fertilize. What principally sets these gardens apart from those discussed earlier is the elaboration in the planting. With these gardens we enter the world of more serious plantsmanship; but it is of a kind which can be quantified in terms of time. What anyone who has limited time wishes to avoid is everything having to be done at once. This, with careful planning, can easily be achieved. All that it calls for as you elaborate your planting is to select plants that stagger their calls on your attention through the year. This means, for example, selecting shrubs which will need pruning after flowering in addition to those which require it during the winter months or spring.

With more and more unusual plants the possible garden effects multiply. The herb garden becomes a possibility. Herbs need careful nurture. They tend to sprawl and become untidy, demanding a wary eye, annual cutting down and frequent replanting. A clear geometric framework helps to discipline these attractive but unruly plants. Mixed shrub and herbaceous borders will be another opportunity. These must be carefully planned for a succession of bloom and many of the plants will need staking and cutting back during the season. The beds will also need weeding. A full range of herbaceous plants is there to be selected from. The classic components of borders are the perennials like asters, heleniums, helianthus and penstemons, all of which will need periodic division and staking. You can also include biennials, like aquilegia, foxgloves and hollyhocks, which will self-seed once established. Many gardeners add extra colour to borders by filling gaps with annuals; some of these are self-seeders such as poppies and nigella, others will be bought-in bedding plants; both will add another dimension to the garden picture.

The potential of garden forms like the parterre increases: instead of setting clipped box shapes against coloured gravels, use them to outline beds filled with flowers. These could consist of medium-maintenance perennials intermixed with bulbs for a spring display, or seasonal bedding plants that you buy in and plant out each season.

In a small space some of the biggest opportunities come with

Dividing a long rectangular space into two contrasting areas can double the interest of your garden. Both of these restful, predominantly green gardens are relatively easy to maintain. The first is a box parterre in gravel with ground-cover planting of glossy-leaved vinca held in by an aerial wall of pleached limes. Once established the limes call only for annual clipping and pruning. The box hedges are quick to cut, but trimming the domes and spirals would be more time-consuming. A spring planting of tulips would be lovely in the beds and would take little time to achieve. A second garden beyond has a manicured lawn surrounded by beds planted with lavender and a low containing hedge of yew.

climbers such as roses, clematis, vines, abutilon and wisteria, for they can almost double the plant and flower capacity. Climbers can be trained up the wall of the house, along fences, through trellis, over summerhouses and arbours, through trees and shrubs and up and over arches and pergolas. But they will often call for dead-heading, pruning and careful tying-in. Choose them according to their colour and habit and flowering season.

Water features beyond the simplest small pond or wall fountain can also be yours. These embrace the more complex movement of water by means of an electric pump producing fountains and cascades. Remember that anything to do with water in this sense is potentially dangerous and is best installed by a professional for reasons of safety. Water also means that the world of aquatic plants is open to exploration, with pretty effects to be obtained through combinations of waterlilies and marginals.

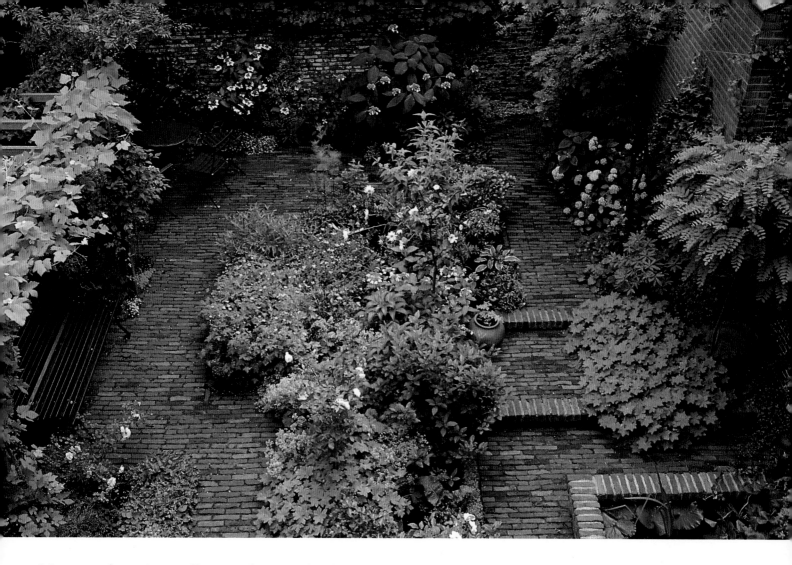

More complex training effects can be essayed either in free-standing formal shapes to punctuate the design or as linear patterns to form screens and hedges. The process takes time, but as plants mature they will assume the status of horticultural art. Topiary, the art of training yew or box plants into shape, adds distinction to any garden, architectural or otherwise. Ready-trained topiary is available but expensive. It is not, however, a complicated art to master, although unless you have a sure eye, it is best to stick at first to simple geometric shapes of ball, cube, cone or obelisk. It is also possible to buy ready-formed wire frames in a greater variety of shapes, including birds and beasts, which simply require you to wait until they fill out before you go to work with your shears.

With a greater input of time, training effects, particularly with trees, can be multiplied. Instead of two mopheads, for instance, six or eight will make a modest stately avenue; instead of a single specimen

This tiny plant lover's town garden is beautifully paved with small brick that swept clean makes a perfect foil for plant forms. Slight variations in level, a modest water feature and a simple arbour add structural interest. All of the owner's energy is devoted to maintaining a balanced mixture of climbers, small evergreen and flowering shrubs and ground-cover perennials such as hardy geraniums. The restricted palette of flower colour tones with the pinky-red brick.

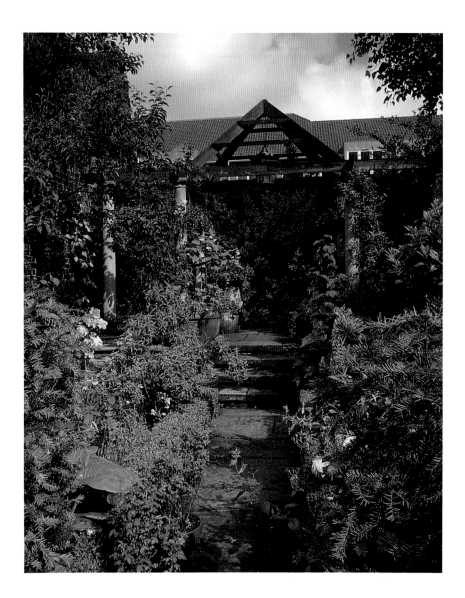

Left Structure plays a crucial role in achieving an illusion of garden order at all times of the year. Even without the labour-intensive containers, this composition of a central path, emphasized by clipped box, leading to a small, raised terrace with a wooden pergola atop four reconstituted stone columns would be strikingly successful.

Right Immaculately kept focal points deflect the vision from untidiness. Here the pretty neo-classical pavilion with its neatly clipped domes of box fills the eye, turning the autumnal muddle around it into an irrelevance in what is a satisfying garden picture. Lawns with deciduous trees anywhere near them risk becoming patterned with leaves. Enjoy the sight as an ephemeral pleasure – then sweep up! The stone edging to the lawn is labour-saving if it is sited out of the way of the mower's blade. The flanking shrub borders need little regular attention but will soon be due for the annual blitz of pruning and tidying.

tree, to take another example, a tunnel of laburnum becomes a possibility. Free-standing fruit trees can be trained as domes or goblets; and fruit trees in espalier, cordon or fan shapes can be grown against a wall or tied into a framework of wires or fencing to make a garden division or screen. For a small space, always select a fruit tree on a dwarf rooting stock.

Containers can be considered. They are, of course, demanding, for they call for soil change, feeding and watering; and the smaller they are, the more work they entail. Joy, however, resides in the fact that the possibilities for their ever-changing contents and positions means

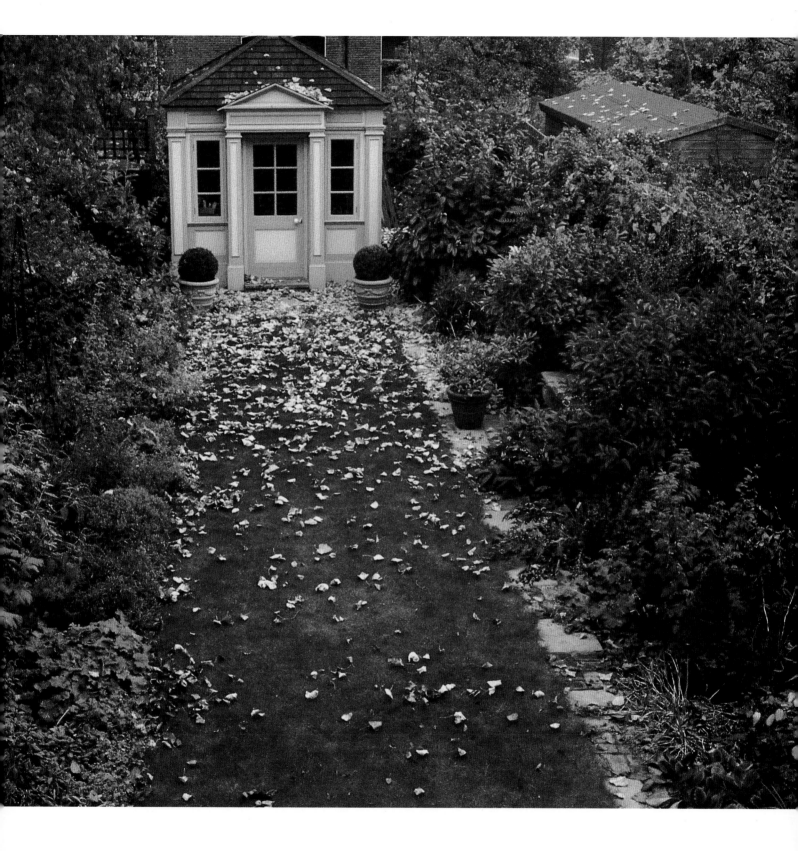

Choosing a colour theme provides beds of mixed medium-maintenance planting with an instant identity. The keynote for the bed is set by the year-round curtain of 'Goldheart' ivy on the wall. The gold variegation of the ivy is echoed in the *Hosta fortunei aureomarginata* and the yellow-green foliage of *Filipendula ulmaria* 'Aurea' at ground level. The flowers – *Anemone* x *hybrida* 'Honorine Jobert', *Agapanthus campanulatus albidus*, *Clematis* 'Alba Luxurians', *Lysimachia clethroides* – are predominantly white, with a shadowing of mauve from *Viola cornuta*. The centrepiece is spiky *Astelia chathamica* in a terracotta vase.

endless permutations of their use. Vases and troughs as part of the garden scene provide opportunities for a sequence of planting through the year from spring bulbs to summer bedding and winter pansies. Used singly or in groups they can form focal points, or can be used to emphasize the ground-level geometry of a garden – along a path or around an ornament. Large, immovable ones, like classical vases, can hold the whole composition of a small garden together, and have the added advantage of being able to be filled with a variety of colour. Containers are also exciting because they are available in so many shapes – from historical to contemporary, and materials – stone,

reconstituted stone, iron, ceramic, terracotta, wood and fibreglass (which, as it is so lightweight, is useful if it needs to be moved).

In this middle range of commitment, balance should be the aim. Decide which of the more elaborate horticultural elements you would most like. (I would start with only one or two. If you become addicted you can easily multiply them.) Let these be the focus of your energies and offset their demands by organizing the rest of the garden on structural low-maintenance lines. Always remember to keep the structural parts in tip-top shape, for they are the essential foil that holds the remainder in good order.

Purple-red tones characterize the planting and act as a foil to the striking green leaf shapes – spiky iris, palmate abutilon, serrated *Melianthus major*. The tapestry of plants in the background – *Cytisus battandieri*, *Clematis viticella* 'Purpurea Plena Elegans' and *Jasminum officinale* 'Argenteovariegatum' – combines with purple-leaved berberis, *Eupatorium purpureum* and the bronzy foliage of *Weigela florida* 'Foliis Purpureis' to cast murky shadows and disguise the fact that this is a narrow bed against a tall boundary wall or fence. *Phlox paniculata* 'Norah Leigh' gleams in the foreground.

A SHADY GOTHIC GARDEN

This is a brilliant and loving solution to one of the most depressing of all garden sites – a small, narrow, shady north-facing town garden. It is achieved by exploiting the shade and giving the garden a strong, identifiable style. This is immediately established by the half-hidden gothic arches leading into mysterious shadows, and reinforced by the feeling of enclosure and the long, lush grass. A galaxy of shade-loving and shade-tolerant plants is offset by climbers which reach for sunlight, while flowers in white and pastel colours, in beds and pots, scatter an illusion of light into the darkest corners. The busy owner is a committed gardener, who tries to find a little time to work in the garden most days during the growing season; but apart from the demands made by the lawn, a garden of rare and dappled mystery could be maintained by spending an afternoon each week on it.

Right The view down the length of the garden, where painted wooden gothic arches frame the entrance to a fernery. Pots of plants, including a clematis supported by a cane wigwam, are dotted along the length of the meandering path. The small area of luxuriant grass must be re-seeded annually with pre-germinated seed.

Left Looking back towards the house, a tiny secluded terrace is approached through a tangle of roses ('Russelliana', 'Souvenir de la Malmaison', 'New Dawn' and 'Buff Beauty'). The borders are crammed with shade-loving plants, among them Japanese anemones, astilbes, astrantias, euphorbias, cranesbill geraniums, hellebores, heuchera and many more.

THE STRUCTURE

The walled garden is long and narrow 4.5 x 10.8 m/15 x 35 ft but its regularity and confines are cleverly concealed. It is bounded by strong architectural features – the house at one end and the symmetrically sited trio of gothic arches at the other. The central space is treated asymmetrically, providing a strong contrasting design sequence which moves from order to disorder and back to order again, the architectural tableau at the far end giving an unexpected and crucial climax to this enchanted glade.

GOTHIC ARCHES

The custom-made metal set-piece, gothic arches are one of the keys to the garden's success. The two side arches frame vases planted with box, while the central arch leads to a fernery.

SHADY TERRACE

(below) A flight of metal steps from the house leads beneath gothic ogee arches to a small paved sitting area which is almost enclosed by foliage.

THE PLANTING

Its success depends ultimately on an informed choice of shade-loving and shade-tolerant plants. Contrasting leaf shapes, textures and colour produce the effect of a bower of greenery flecked with white and pink flowers. It calls for weekly attention, careful training and pruning, periodic plant division and, above all, soil enrichment. This means importing compost in bags. The plants in pots are moved to make the most of the light.

1 A grapevine shades the steps and provides autumn colour.

AROUND THE TERRACE
2 Honeysuckle clothes the west wall and mingles with roses 'Souvenir de la Malmaison' and 'Buff Beauty', *Clematis* 'Jackmanii' and *Hydrangea macrophylla* 'White Wave', to screen the sitting area. Below grow acanthus, alchemilla, nicotianas and ferns.

RAISED BEDS
3 Facing the terrace, these feature *Camellia* 'Lavinia Maggi' and *Rosa* 'Madame Hardy', with hostas and ferns.
4 *Hosta sieboldiana elegans* punctuates the planting with sculptural blue-green leaves.

LAWN INSETS

5 Tiny brick-edged beds include feverfew, oxalis, *Tiarella cordifolia*, wild strawberries and violets.

LAWN

6 To maintain a lawn where light hardly penetrates, this is re-sown annually with pre-germinated seed. Because of the inset beds, it is cut by hand. The result is delightful but labour-intensive.

PATHSIDE CONTAINERS

7 These include herbs as well as ornamentals. *Clematis florida* 'Flore Pleno' and *C.f.* 'Sieboldii' are trained up cane wigwams.

EAST BORDER

8 *Clematis* 'Duchess of Edinburgh', *Rosa* 'New Dawn' and *Hydrangea anomala petiolaris* clothe the wall. The lower storey includes *Dicentra spectabilis alba* and *D.* 'Pearl Drops', toad lilies, geraniums and hostas.

9 *Prunus* x *subhirtella* 'Autumnalis' dominates the east border. Camellias are planted on either side.

NARROW EAST BED

10 The wall is wreathed in *Clematis armandii*, *C.* 'Alba Luxurians', *C.* 'Duchess of Edinburgh' and *C. montana rubens*. *Hydrangea arborescens*

Above Spring-flowering *Clematis montana rubens* only needs pruning to restrict its vigorous growth.

Dryopteris dilatata, *D. filix-mas* and several forms of *D. affinis*. Ferns can be left in clumps for years and are also easily divided. The fern fronds must be cut back to the ground in spring to allow new fronds to unfurl.

GOTHIC ARCHES

13 Each side arch shelters a pyramid-shaped box in a Georgian vase, surrounded in summer with trailing lobelia. Overhead grow *Passiflora caerulea* and climbing *Rosa* 'Blairii No. 2', *R.* 'Céline Forestier', *R.* 'Félicité Perpétue' and *R.* 'New Dawn'.

LAWN BED

14 *Zantedeschia aethiopica* 'White Sails' stands out in a low-level planting of alchemilla, anaphalis, campanula, fuchsias, geraniums, white nicotiana and lime-green *N. langsdorffii*.

WEST BORDER

15 Shrubs include *Viburnum opulus* and *Hydrangea arborescens* 'Annabelle', with *Clematis armandii*, *Rosa* 'Cécile Brunner' and *R.* 'New Dawn' on the wall. In front are hostas, dicentras, foxgloves, geraniums, nicotiana, penstemons and others.

'Annabelle' is underplanted with *Hosta fortunei hyacinthina*, hardy geraniums and *Campanula takesimana*.

11 *Philadelphus* 'Belle Etoile'.

FERNERY

12 This makes a virtue out of the drawbacks of shade and recalls the Victorian fashion for ferns. They include *Adiantum pedatum*; *Asplenium scolopendrium*; *Athyrium filix-femina* forms and *A. niponicum pictum*; *Onoclea sensibilis*; *Osmunda regalis*; decorative forms of *Polystichum setiferum*;

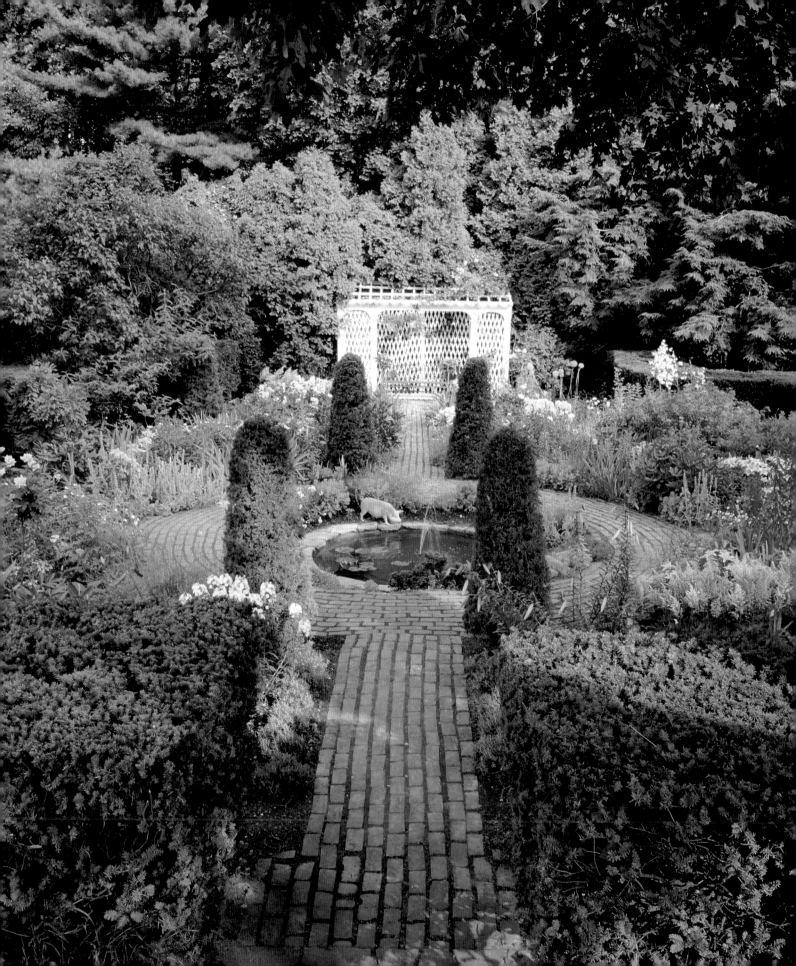

Left The main vista from the house to the gazebo. Clipped junipers act as sentinels and provide a contrast to the more informal and horizontal planting in the four spandrel beds. Notice the pleasing point counterpoint: taut path, pond and junipers; the sprawling content of the beds; the sharp lines of the hedge; and beyond that, the tapestry of trees.

Right Even under snow the formal elements will ensure a pleasing garden picture. Here the winters are so severe that standard roses are protected against frost damage.

A CLASSIC FLOWER GARDEN

Few garden plans are wholly foolproof, but this is one that is: a quartered square with a circle inscribed at the centre. This classic formula has been repeated times without number since it was first used in renaissance Italy, but no amount of repetition can erode the serenity of the composition, with its sense of balance and harmony. Here it has been adapted to a rectangular site on Long Island by the designer Adele Mitchell. She added a substantial rectangular bay with a gazebo at the far end of the garden, thus emphasizing the main vista.

The garden is contained by a low hedge of yew; this delineates the enclosing geometry, holds the encroaching woodland at bay, and provides a rich dark background against which flowers exhibit themselves to perfection. Six junipers, clipped into tall sugar loaves, provide vertical accents, and at the heart of the garden a small round pond with a jet of water brings light and animation to the garden.

Surprisingly, this garden calls for only about two hours of work a week in the growing season – weeding, dead-heading, cutting back and limited staking. The secrets of its low demand are that plants – shrubs, perennials and bulbs – are placed very close together, leaving little space for weeds, and there is also a built-in sprinkler system. Twice a year the owners have a major blitz.

This is a garden for flower-lovers. Skilfully planted, it gives a succession of colour-controlled bloom through spring, summer and autumn, while its firm bones, both built and evergreen, ensure a striking winter picture. The result is breathtaking.

THE STRUCTURE

The space measuring about 10.8 x 15 m/36 x 40 ft has been made into a square with a rectangular bay at the end (a curved exedra would be another possibility), and the designer has used one of the most enduring and satisfying of garden formulae: a square divided into four, with a circle at the centre. She has used brick paths to delineate the geometry of the garden, and the clear-cut lines of clipped hedges to enclose it. Notice the way that even in a strictly symmetrical garden, irregularities can be allowed for. Here, an immovably sited exit on the south side has been accommodated by simply bending the path round at the last minute.

CENTRAL POND

This is a simple shallow circle of water with a few lilies, some fish, and a central jet that requires an electric pump. The water adds light and movement to the garden, but a sundial, a large urn, a well-head or even a large topiary piece would also suffice to hold the composition together.

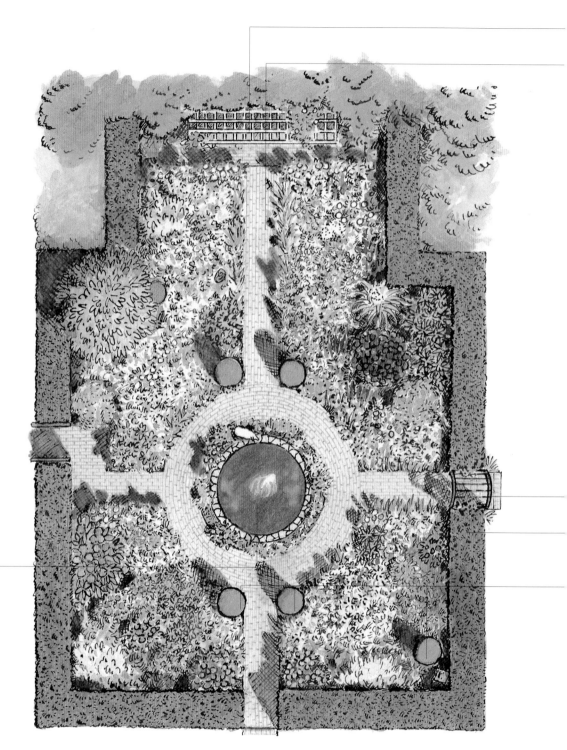

__ PATHS

The small size of the old bricks used in the paths makes the mixed borders seem even larger than they are. The bricks have been laid end-on to emphasize rather than conceal the length of the path from the entrance to the gazebo, but herringbone or basket-weave pattern would also be successful, and a mixture of stone, brick and small slabs would also be attractive. Whatever materials are used, the paths need careful detailing because the eye is constantly drawn to them.

GAZEBO

This is built on a handsome scale, and of antique lattice panels and wooden supports, though the back and roof are new. It is a simple enough structure and any variant of this one, including many ready-made arbours, would be suitable, provided the boldness of scale is preserved. The gazebo here is painted an eye-catching white, which stands out well against the surrounding greens, but needs to be kept in pristine condition. Off-white, greys and grey-greens would provide less startling contrast, and require less attention.

CROSS AXIS (above)
The view across the garden is framed by a wooden tunnel that is planted with roses, honeysuckle and late-flowering clematis. A complementary tableau - perhaps taking the form of a garden seat or another vase – at the far end would add importance to the vista.

__ TOPIARY VERTICALS

The verticals provided by the juniper topiary are important in the garden, but other fastigiate clipped evergreens could be used: yew, box, other varieties of juniper, or fast-growing evergreens such as *Cupressus macrocarpa* or *Ilex vomitoria*. Another

alternative would be to use simple stone ornaments on plinths or trellis obelisks with climbing plants. The number of sentinels could be increased by treating the cross-axis path in the same way as the main path, but symmetrical grouping is essential.

HEDGES

The yew hedges are only waist high, so light is not restricted in the beds and the surrounding woodland becomes part of the garden design. A taller hedge would shade the beds, affecting what could be grown. The rectangularity of the hedges makes a pleasing foil to the planting, but topiary pilasters and

corner bastions could add interest in winter. An evergreen hedge is essential for the design, and yew is by far the best material to use. It would reach this height in about five years. Thuja would be a satisfactory alternative, but Leyland cypress or privet should be avoided, as their coarseness would detract from this exquisite scene.

THE PLANTING

This garden endures long hard winters, but from the moment spring arrives, a succession of flower tableaux provide bloom until well into the autumn. A foundation planting of shrubs and perennials is underplanted with drifts of bulbs for spring and summer, and ends with a finale of chrysanthemums.

Mirror-planting along the paths is supported by an informal balance of planting throughout the garden. It is a less labour-intensive scheme than it first appears because it is so thickly planted and also has a sprinkler system, so feeding, dead-heading, cutting back and some weeding are all that are required during the growing season. In the autumn most plants, except roses, hydrangeas and woody plants that may suffer winter burn, are cut back, and those plants that require winter protection are wrapped in plastic sheeting. In spring the rest of the pruning is done, and the entire garden is mulched with really good compost. From time to time, plants are discarded, replaced or divided, and the bulbs are topped up every few years.

Above Spring tulips include pink Lily-flowered 'Maytime', 'White Triumphator' and double-flowered 'Angelique'.

Above The north-west quadrant in summer includes yellow lilies, white phlox, deep pink spires of lythrum and grey *Stachys byzantina,* while the spiraea, tall yuccas and delphiniums are also in bloom.

SOUTH-WEST QUADRANT

1 *Chrysanthemum nipponicum* in late spring gives way to peonies, roses, astilbes and delphiniums in summer.
2 A swathe of different kinds of tulips makes way for more peonies, roses and phlox, and the flowering seasonr comes to an end with chrysanthemums.
3 *Iris germanica* and stachys line the path to the gazebo.
4 Buddleja.
5 More tulips are followed by astilbe, lupins, phlox, drifts of lilies, and chrysanthemums.
6 Roses and peonies are interplanted with lilies.
7 Juniper sentinels.
8 Iris and hyacinths, lavender, stachys and, later, sweet Williams along the path, are backed by peonies, lilies and roses.
9 Tradescantia and chrysanthemums (grown as annuals) line the path.
10 A standard white wisteria.

NORTH-WEST QUADRANT

11 Roses are interplanted with tall alliums and delphiniums.
12 Tulips make way for peonies, roses, purple loosestrife, a swathe of lilies, and finally chrysanthemums.
13 More peonies and roses take over from tulips, and are joined later by veronica, lilies and chrysanthemums.
14 A yucca stands high above other planting.
15 *Spiraea japonica* 'Anthony Waterer'.
16 Peonies line the hedge and provide a background for other planting.
17 Tulips are followed by baptisia, peonies, veronica, roses, purple loosestrife and chrysanthemums.
18 In spring, hyacinths and iris line the path; at the end of the summer, stachys, lavender and pansies are augmented by the appearance of chrysanthemums.

NORTH-EAST QUADRANT

19 Hyacinths, and later stachys and lavender along the central path are backed by peonies and roses and astilbes.
20 A tree peony (*Paeonia suffruticosa* 'Holiday').
21 Roses against the hedge are underplanted with *Iris ensata* (syn.*I. kaempferi*).
22 Swathes of tulips in spring give way to aquilegias, irises, astilbes,

roses, a mass of lilies, and finally chrysanthemums.
23 Standard 'French Lace' roses are surrounded with tulips, aquilegias, foxgloves and lilies.
24 Hyacinths and *Andromeda polifolia* 'Compacta' line the path.
25 An antique bird house stands in the corner.

SOUTH-EAST QUADRANT
26 A hydrangea makes a bold statement and is surrounded by roses.
27 A mass of tulips is followed by aquilegias, peonies, roses, echinops and many lilies.
28 Hyacinths along the circular path are followed by lavender and chrysanthemums.
29 Tulips are planted behind roses and peonies, and infilled with late chrysanthemums.

POOLSIDE
30 Planting includes lavender, roses, iberis, phlox, hinoki cypress and sedums, followed by chrysanthemums.

GAZEBO
31 Climbing roses include 'Madame Grégoire Staechelin', 'New Dawn' and 'First Prize'.

ARCH
32 Climbers include: *Rosa* 'Madame Grégoire Staechelin', *Lonicera*

periclymenum 'Serotina' and *Clematis flammula*.

33 A yew (*Taxus baccata*) hedge encloses the garden. Its annual clipping is made easier because it is only waist high.

PLANTS
The colour in the garden is orchestrated so that it changes subtly from bed to bed. Some of the plants appear in two, three, or all four of the quadrants, bringing a feeling of harmony to the garden. Astilbes include 'Bergkristall', 'Bridal Veil' and 'Peach Blossom'. Chrysanthemums include 'Grenadine', 'Cherish', 'Chiffon', 'Matador', 'Minnehaha', 'Prom Queen', 'Vulcan' and 'White Grandchild'. Hyacinths include *H. orientalis* 'Amethyst' 'Carnegie', 'City of Haarlem', 'Delft Blue', 'Gypsy Queen' and 'Lady Derby'. Bearded Iris cultivars include 'Charm Song', 'Elysian Fields', 'Grand Waltz', 'Harbor Blue', 'High Above', 'Loop the Loop', 'Mandolin', 'Peach Taffeta', 'South Pacific', 'Tenino', 'Triton' and 'Victoria Falls'. Lilies include *L. regale*, 'Black Dragon', Green Magic, 'Rosario', 'Star Gazer', African Queen, Imperial Silver and Imperial Gold. Peonies include *P. lactiflora* 'Mrs Livingstone

Farrand', 'Elsa Sass', 'Pillow Talk', 'Top Brass', 'Cheddar Cheese', 'Bowl of Cream', 'Bridal Gown', 'Chiffon Parfait', 'Monsieur Jules Elie', 'Raspberry Sundae'; tree peonies include *P. suffruticosa* 'Ariadne' and 'Holiday'. Phlox include *P.*

paniculata 'Bright Eyes', 'Dodo Hanbury Forbes', 'White Admiral' and *P. carolina* 'Miss Lingard'. Roses include 'Brandy', 'Garden Party', 'Honor', 'John F, Kennedy', Peace, 'Seashell', 'Sheer Bliss', 'Sonia', 'Summer Dream', 'Summer Fashion' and

'Tuxedo'. Tulips include 'Angélique', 'Balalaika', 'Ballade', 'Blue Parrot', 'Ivory Floradale', 'Maureen', 'Palestrina', 'Maytime', 'Pink Diamond', 'Queen of Night', 'Scotch Lassie', 'Shirley' and 'White Triumphator'.

OUTDOOR LIVING ROOMS

This is a garden blessed by a climate in which plants thrive and grow quickly and where there are no harsh winters. This means that a garden can be as much for living in as looking at. In this case the designer, Sonny Garcia, has excavated a steep hillside to create a pair of beautiful outdoor rooms, both of which form natural extensions to the house. The use of ceramic tiles, trickling water and the sense of inward-looking enclosure all spring from the patio tradition that travelled to the New World from Spain and Portugal. Here, however, a refreshing new strain has been grafted on to the time-hallowed stem in the form of the post-modernist latticework and gate together with the bronze sculptures of birds.

The initial cost of making this garden was very considerable because of the engineering involved in constructing the substantial retaining walls and because of the sheer quantity of good quality hard landscaping. Because the garden occupies vertical surfaces as well as ground space, it is more extensive than it might seem at first glance. Everything is seen at such close proximity that the garden needs a good deal of housekeeping. However, with electronically controlled systems for sprinklers and the pools, it will reward you with the perfect backdrop for outdoor entertaining for an investment of a regular afternoon's work each week, and an extra day or so every couple of months.

The use of hard surface materials – old, hand-made brick, terracotta and shiny ceramic tiles makes a pleasing contrast to the lush planting – a mix of formally trained evergreens, climbers and colourful perennials and annuals. The arch is entwined with fragrant *Mandevilla laxa* flanked by 'Peace', 'Mutabilis' and 'Graham Thomas' roses.

THE STRUCTURE

The garden measures about 15 x 9 m/50 x 30 ft overall. The 'dining room' is about 4.5 x 6 m/ 15 x 20 ft and the 'living room' is about 5.5 x 7.5 m/18 x 25 ft. The effect that the two main areas form 'rooms' depends very much on the enclosing walls, not one of which is less than about 2 m/6 ft high. The bold and unusual feature of this garden is the division of what might have been merely a long terrace next to the house into two distinct areas by

means of a small change in level and a semi-transparent wall and gate. If the space had been much smaller, it would have been possible to create only one 'room'. Although the terracing is an integral part of the scheme, it is not essential that it be quite so precipitous, or the walls so high – 1.2 m/4 ft would be sufficient to retain the effect of 'rooms', especially if the height was increased with planting or with trellis and climbers.

BRICK PAVING

Brick paving is always attractive, particularly old brick, or hand-made brick with an interesting patina (mass-produced bricks have a flat, unrelieved uniformity). In colder climes, bricks must be frost-resistant. The choice of brick for the 'floors' links these horizontals with the outer retaining walls. The warm colour is particularly appealing in a place where grey skies and sea mists are a regular feature of the

climate. In other situations, and especially where the architecture of the house might suggest it, alternative materials might be more

appropriate. As the garden is looked down on from the house, the pattern and effect of the 'flooring' must always be taken into consideration.

DINING ROOM (*left*) The wall is broken by a pair of magnificent wooden doors that suggest another room beyond, but are, in fact, fake. The frieze and pedestal of yellow and blue tiles provide an

architectural unity to the area. Trellis on the walls on either side of the doors supports *Solanum jasminoides* 'Album'. The staircase behind the pedestal supports containers of shrubs and trailing variegated ivy.

WATER FEATURES
These add movement, sound and reflections but are extremely economical on space. The water is recycled through the masks, and the pool – ingeniously made more mysterious by running underneath a flight of steps – is kept clean by a filter system.

ORNAMENTS (*above*)
A large terracotta pot and the wall plaque – a reproduction of a Renaissance ceramic by Della Robbia – makes an exceptionally effective focal point for the view from the dining area. The framing device of the gate, its curves echoed by the treillage above the plaque, adds further impact. Small garden ornaments are rarely satisfactory, even in a small space; simple additions that lend height or importance can work transformations – in this garden the pot adds scale to the small plaque – in the same way that the colourful tiled pedestal enhances the putto in the dining area.

STEPS
Steps are a vital ingredient in a multi-level site. Here they are imaginatively sited to offer alternative routes to explore the garden, and the flights vary in length. The steps that arch over the pool are as dramatic as any stage setting: they act as a bridge; they are flanked by matching tiled wall panels whose centrepieces are ram's head wall fountains; and they are emphasized by paired containers of ivy topiary placed as accents on the bottom step. The functional flight of steps that leads from the 'dining room' to the terrace above serves as a vertical display surface for a series of trailing foliage plants.

THE PLANTING

The planting here falls into four distinct groups: the structural items including trees, shrubs and evergreens including topiary; the climbers and trailers for vertical interest; the container plants; and finally annuals and perennials. The first two groups provide the garden's backcloth which is embroidered by the others. It would be tempting to swamp the garden with strong colour, but instead it is furnished with an abundance of cooling greens, essential in a warm climate and a compensation for the absence of a lawn. Apart from the terrace, the planting is in close-focus and flaws easily detected, so the garden calls for year-round attention and the plants are occasionally replaced by pot-grown ones.

WIDE TERRACE BORDER

This is about 2.1 m/8 ft wide, and is filled with trees which normally grow to 13.5 m/40 ft or over, but which are kept severely pruned so that they do not over-dominate the site.

1 In the extreme corner there is an Australian tree fern (*Dicksonia antarctica*) and a wych elm (*Ulmus glabra* 'Camperdownii')

2 Flowering cherry (*Prunus* 'Shogetsu').

Right Passiflora 'Amethyst' is a deciduous climber with exotic purple flowers in summer followed by small green fruits.

Above The view of the terrace behind the pool provides contrasts of texture and form, living plants and man-made materials. The legs of the bird sculptures are echoed by the trunk of the prunus and the tall foxglove stems. *Felicia amelloides* breaks the line of the brick wall. In containers neat mounds of box contrast with a haze of *Helichrysum petiolare* 'Limelight'.

PONDSIDE BEDS

14 Herbs, including thyme and chives, and perennials including primulas and pinks have been chosen for their contrasting foliage as well as their flowers.

LATTICE WALL

15 The terracotta pot is surrounded with penstemons, *Berberis thunbergii* 'Rose Glow' and *Nepeta* 'Six Hills Giant'.
16 On the lattice is a passion flower flanked by *Rosa* 'Golden Showers' and *Cotinus coggygria* 'Royal Purple'.

HOUSE STEPS

17 These are flanked by two square beds containing pyramids of box and clipped lavender.

Below Solanum jasminoides 'Album' is a semi-evergreen wall shrub whose flowers are followed by purple berries.

3 The underplanting is of clipped box domes and standard escallonias.

'DINING ROOM' WALL

4 Behind clipped box hedges in raised beds, the white potato vine (*Solanum jasminoides* 'Album') is trained on white trellis on either side of the large double doors.
5 Standard yellow lantana and *Helichrysum petiolare* 'Limelight' are planted in containers above the wall, edging the terrace path.

STAIRCASE WALL

6 The troughs that ascend the steps contain a mixture of plants including variegated *Pieris japonica*, *Fuchsia* 'Gartenmeister Bonstedt' and abutilons; while cascades of variegated *Hedera helix* hang down the wall.

HOUSE WALL

7 A *Magnolia* 'Elizabeth' is tucked into the corner next to the steps that curl up to another door leading into the house. The narrow bed is planted with a changing display of annuals and container-grown perennials together with a *Brugmansia* 'Charles Grimaldi'.

GATE SCREEN

8 *Mandevilla laxa* climbs over the arch, while the gate is flanked by yellow *Rosa* 'Graham Thomas', scented, coppery yellow *R.* 'Mutabilis' and the light yellow Hybrid Tea *R.* 'Peace'.
9 On the 'dining room' side there are clipped box hedges in containers.

NORTH TERRACE BORDER

10 This is about 1.8 m/5 ft wide and is planted with a second *Prunus* 'Shogetsu'.
11 Shrubs chosen for colour and shape – *Spiraea japonica* 'Goldflame', *Berberis thunbergii* 'Rose Glow' and *Lavatera thuringiaca*. The ornamental foliage of *Gunnera tinctoria* and flowers such as *Felicia amelloides* fill the gaps.

'SITTING ROOM' WALL

12 Clipped box, penstemons, *Brachyscome multifida*, lavender, saxifrage, lobelia and *Rosa* 'Handel' are planted above the wall in containers that line the terrace path.
13 Clematis and *Solanum dulcamara* climb the wall behind the bench.

A VISTA GARDEN

There is a welcoming luxuriance combined with a real sense of style about this garden. This clever solution to the perennial problem of the long narrow town back garden is a classic demonstration of the importance of contrasting ground level surfaces: soft verdant grass, crunchy caramel gravel and pale regular paving. Placing these elements in sequence subtly emphasizes the garden's width, and the staggered arrangement of the two small lawns is a more exciting use of space than a predictable central panel. Vertical accents and climbers are also vital elements in the garden's success. The surrounding fence provides privacy through supporting an almost year-round display of flower, and the pergola arch not only divides the space but delightfully frames two enchanting vistas.

Designed by Judith Sharpe, this garden belongs to the tradition of strong structure and luxuriant planting epitomized by the partnership at the turn of the century of Sir Edwin Lutyens, the architect, and Gertrude Jekyll, the plantswoman. The charm of this style is the way the natural forms of the plants blur and soften the underlying geometry of the layout. In terms of maintenance this presents a double challenge for gardeners: they must keep the plants in flourishing health to provide the impression of luxuriance, but at the same time unobtrusively groom and control their growth so that the result is exuberance rather than muddle.

The main vista to and from the house is off-centre and provides a strong axis connecting three different areas: an upper terrace providing a backcloth of shrubs and small trees; a formal garden with the sundial as a focal point; and a lawn that leads to a paved terrace next to the house.

STRUCTURE

This garden measures 23 x 6.5 m/75 x 21 ft. The principles of this design are ideal for a long narrow site such as this: the division across the width, and the creation of a sequence of contrasting gardens. The most important single element is the vista running from a viewpoint in the house through an arch to a sundial and on to a flight of steps which ascend into an illusory tangle of greenery. The sequence and contrast of grass, gravel and paving is another key to its success, providing interesting variations in terms of colour and surface texture. Although the three gardens are separately defined areas, their essential unity is emphasized by an overall colour control running through the whole scheme, progressing through pinks to lavender, lilac and purple.

PAVING

A terrace provides transitional area between house and garden, one in which to sit and place containers. The paving here is of regular slabs, low key and unobtrusive. Always choose paving in tones and materials that harmonize with those of the building. A combination of plain flagstones with details in old brick, setts or cobbles is often attractive, but more expensive to buy and to lay than plain slabs.

MAIN VISTA (*left*)
Looking down from the first floor of the house gives a clear impression of the separate areas and of the remarkable luxuriance of effect achieved within a quite limited space.

TRELLIS

The enclosing wooden fences on two sides have been topped with sturdy trellis treated with wood preservative. Cheap trellis is a false economy. It should be of good quality and treated with preservative to minimize maintenance. Even so, it is a relatively economical way of creating transparent garden screens, in this case adding to privacy and providing support for an explosion of foliage and bloom. It adds aerial architecture which responds to the interplay of light, casting a lattice-work of shadows onto the ground.

BOX HEDGE
This is the most important of the few elements of green architecture in the garden. Box, with its small glossy leaves, compact habit and pungency, is not as slow-growing as many people imagine, but the length of hedge here is so short that it would be well worth purchasing large plants for an immediate effect. It requires at the most two clippings a year to keep it immaculate, and an annual feeding of bonemeal. Euonymus or *Lonicera nitida* would be possible alternatives, though both need more attention than box.

SERVICE AREA SHRUBBERY
Terracing what would have been a gently sloping site into two distinct levels adds an extra dimension to the garden. This cleverly adds to the illusion of the size of the garden at the same time as providing space for a shed for garden tools. Trees and shrubs on being planted immediately look larger if they are on a raised terrace, and the wall allows for a display of prostrate plants. Care must be taken that the earth is held in on all four sides by retaining walls. Here it has a weed-suppressing mulch of wood chips, but an alternative would be paving. The introduction of a very simple bench or seat from which to enjoy the garden's main vista back to the house would be an attractive addition.

PERGOLA ARCH
A beautifully sited simple framing device like this draws and focuses the eye on the sundial beyond. In such a small space it is not only a perfect support for a display of all kinds of climbers but is the crucial architectural structure dividing the garden. There are any number of ready-manufactured arches available from simple larchwood to elaborate Victorian-style ironwork ones, but it is often just as economical to get a local blacksmith to make one to your chosen dimensions. If you opt for timber, be sure that the wood has been properly treated with preservative. Whatever it is made from, make it large enough so that, once smothered with greenery, it can still be walked through and retain its role as a frame; and be sure that it is strong enough to carry the weight of the plants. Remember, too, in siting it that it frames the view both ways.

THE PLANTING

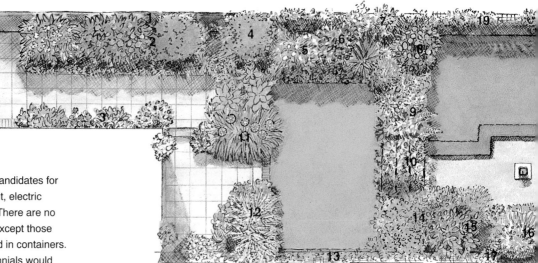

There is a classic, country-house quality to the planting of this garden. It is an orchestration of much-loved flowering shrubs, perennials, roses and climbers. It is often a good idea to use a restricted palette of colour in a small space and here the colour is limited to a range of pinks, blues and purples with an occasional burst of white. Grey and silver foliage plants add a pleasing counterpoint. Careful consideration has been given to the two main borders: the resulting effect is luxuriant for what is a fairly modest input of labour. It is the lawn which is the most taxing commitment during the mowing season, but small areas like this so close to the house would

be ideal candidates for lightweight, electric mowers. There are no annuals except those introduced in containers. The perennials would benefit from some regular grooming to remove fading leaves, and some staking during the growing season, but little serious attention. They call for mulching and feeding each year, and then lifting and dividing every few years. The climbers need tying-in and dead-heading during the growing season, and each

requires annual pruning. In general, once the plants have established themselves, the main problem will be to check their prolific and potentially invasive growth.

NARROW SHADY TERRACE

1 Against the wall and trellis are *Hydrangea anomala petiolaris*, *Lonicera periclymenum* 'Belgica' and *Clematis montana rubens*.
2 In the bed are *Viburnum davidii*, *Hydrangea macrophylla*, *Helleborus foetidus*, hostas and *Viburnum tinus*.

TERRACE CONTAINERS

3 The planting varies from year to year but usually includes *Hedera helix* 'Glacier' and *Helichrysum italicum microphyllum*, and a range of pink, blue-grey and white flowers

Below Narcissus triandrus, a bulb which naturalizes beneath deciduous trees, has long-lasting flowers.

Below Viticella clematis 'Minuet' is a late-flowering, fully hardy variety that does not require pruning.

such as ivy-leaved geraniums, lobelia, petunias, impatiens, nicotiana, trailing *Verbena x hybrida* 'Sissinghurst' and *Nolana* 'Bluebird'.

SOUTH BORDER

4 This is anchored with a *Rhus typhina* underplanted with *Bergenia cordifolia*.

5 Other plants include *Euphorbia characias wulfenii* and hostas.
6 *Cotinus coggygria* 'Royal Purple', *Abelia x grandiflora*, *Eucalyptus gunnii* (stooled), and *Ceanothus thyrsiflorus repens*, with *Stachys byzantina*, *Sedum telephium maximum* 'Atropurpureum' and

'Maidwell Hall', *Rosa* 'Variegata di Bologna' and *Rosa* 'New Dawn' provide bloom from spring to summer.

NORTH BORDER

14 *Acanthus spinosus*, hostas and sedums are paired with those in the opposite border.

15 *Rosa* 'Roseraie de L'Haÿ' and *R.* 'Penelope' are planted behind *Alchemilla mollis* and *Lavandula angustifolia*.

16 *Amelanchier lamarckii* is underplanted with *Iris*

ajuga in front.

7 *Parthenocissus henryana*, *Clematis* 'Perle d'Azur' and *C.* 'Comtesse de Bouchaud' clothe the trellis.

8 *Hydrangea macrophylla*.

9 The arm of the border is filled with *Eryngium variifolium*, *Anemone* x *hybrida*, *Sedum* 'Autumn Joy', *Acanthus spinosus*, *Polygonum affine* and hostas.

PERGOLA ARCH

10 *Clematis* 'Perle d'Azur' and *Rosa mulliganii* climb over the arch, while nepeta grows at their feet.

SMALL RAISED BEDS

Two slightly raised beds contain sun-loving plants.

11 Agapanthus.

12 *Teucrium fruticans*.

NORTH WALL AND TRELLIS

13 *Clematis macropetala*

'Jane Philips', *Astrantia major*, *Viola cornuta* and *V.c.* Alba Group.

17 *Rosa* 'Reine des Violettes' and Viticella clematis 'Minuet' clothe the trellis.

18 *Cotinus coggygria* 'Royal Purple' and *Berberis thunbergii atropurpurea* grows behind lavender and artemisia.

SOUTH WALL AND TRELLIS

19 *Clematis* 'Marie Boisselot' and *Rosa* 'Mme Grégoire Staechelin'.

20 *Lonicera periclymenum* 'Serotina'.

21 *Rosa* 'Mme Alfred Carriere'.

RAISED SERVICE AREA

22 Pots of nicotiana and lobelia cascade down the wall.

23 *Hedera canariensis* 'Gloire de Marengo' and *Clematis montana* 'Elizabeth' cover the shed.

24 *Eucalyptus pauciflora niphophila*.

25 *Pyrus salicifolia* 'Pendula' is underplanted with spring-flowering

white narcissus including *N.* 'Ice Follies' and *N.* 'Mount Hood'.

26 Pots of agaves stand sentinel on the steps.

Below The view from the lawn nearest the house looks over *Anemone* x *hybrida* and *Acanthus spinosus* towards the retaining wall at the far end of the garden.

Left An abstract contemporary sculpture is the garden's focal point. The view towards the brilliantly coloured fencing is softened by the spiky leaves of *Miscanthus sinensis* 'Strictus' and the feathery branches of *Fargesia murieliae*.

Right Painted grey-blue, the bridge which crosses the garden ponds makes a strong contrast to the horizontal red fencing. A bold clump of *Typha latifolia* provides a vertical feature among aquatic marginals which include *Pontedaria cordata*.

This is a garden to satisfy the most ambitious. It boldly sweeps away conventional notions about water in the garden – which usually takes the form of small geometric or irregular pools, cascades or fountains – in favour of an aquatic totality. The garden in this instance *is* water. Essentially, it is two large water-filled containers; its boundaries are evergreen hedging or brightly-coloured fences of slatted wood, and its paths are wooden bridges crossing the water leaving just enough space for beds for water-loving plants at the edges.

This is a refreshing, one might say almost breath-taking extravaganza whose construction could never be anything other than professional and expensive. However, it is money well spent, for, once installed and planted, it requires astoundingly little maintenance during the growing season. The ponds have a sophisticated filter system and the beds and borders are skilfully planted in soil whose type and moisture content have been artificially manipulated by the designer, Henk Weijers.

The result, however, is a unique, indeed thrilling garden experience owing nothing to nostalgia. The bold, almost brutal, rectangularity of the defining enclosures is offset by a lush exuberance of planting, huge drifts of marsh marigolds, spikes of pickerel weed and clumps of bamboo. What is so innovative about this water garden is its deliberate avoidance of phoney naturalistic effects such as artificial waterfalls or irregular edgings of rock. Instead it triumphantly celebrates its own artifice as the work of man.

AN INNOVATIVE WATER GARDEN

DECKING WALKS
The handsome decking provides the walkway linking the north and south terraces. Decking should always be made of high quality seasoned and treated timber. The biggest drawback of wood is that it can prove slippery, particularly in a wet climate. In another setting this pathway could be constructed of stone, brick or setts, or a mixture. If this decision is made it would be important that its design should not be nostalgic but of our own time.

RAISED BORDER (*left*)
The narrow raised border edging the second pond is filled with herbaceous plants, among them orange-yellow *Hemerocallis* hybrid, violet *Scabiosa caucasica* and the dark carmine *Geranium sanguineum*.

The decking walkway on two levels divides the two ponds. On one side there are water marginals *Pontederia cordata* and *Sagittaria sagittifolia*, and on the other side is a huge fountain of *Miscanthus floridulus* foliage.

THE STRUCTURE
The site overall measures roughly 18 x 15 m/60 x 50 ft and is held in by a timber fence on two sides and part of a third, the rest being an evergreen thuja backing hedge running the width of the garden. Within these confines the design is abstract: angular areas of water, decking, planting and terrace at two different levels forming, if seen from above, something akin to a canvas by the painter Mondrian. The essence of the design is the clear demarcation of what are a series of sharply differentiated textures and colours: black reflective water, ribbed shiny wooden decking, stone paved terraces, brightly coloured fencing and beds filled with greenery flecked with flowers. The abrupt juxtaposition of these elements heightens the drama: one pond forms an L-shape outside the living room, bringing water to lap at the foot of a full-length window. Although strikingly of our own time, this garden belongs to the centuries-old tradition of the formal water parterre. Here water has taken the place normally accorded in a garden to grass, forming static mirrors reflecting light at ground level and giving opportunities for planting marginals and aquatics. Although at first sight dramatic, the ponds are, in fact, quite shallow. (However, it is unwise to incorporate even shallow water features in a garden scheme where young children may be present.) The principles of the scheme are adaptable to any flat rectangular site. One pond with its surrounding decking and beds could form either a small garden in itself or be introduced as part of a larger different scheme. Such a composition calls for professional landscaping, although a scaled-down version could well be with reach of an exceptionally capable handyman, provided expert help was sought for the technicalities of plumbing and drainage.

FENCING

Generally not enough use is made of strong colour on the hard built surfaces of today's gardens. This brilliant exception takes its scarlet hue from part of the central sculpture and emphasizes the south-facing terrace. It is deliberately done as a bold vertical statement with no attempt to age the surface or to cover or soften it with climbers. Its horizontal linearity echoes the planking in the decking. Bright blue would be almost as arresting, but not yellow as so many of the flowers are that colour, and yellow is too close to the light greens of much of the foliage.

SCULPTURE

The use of the garden as an open-air gallery for new sculpture is exhilarating. An abstract contemporary piece is placed on the central panel of the decking as the garden's vertical focal point. Viewable from every side, it catches the light and echoes the primary colours of the fencing and flowers.

PONDS

These are not so much ponds as shallow tanks in which to grow plants. They are lined with black flexible polythene sheeting (Butyl is the strongest and most expensive). Another solution would be to have them constructed of concrete. The first fillings of water will be cloudy due to the concrete exuding lime, and the pond will need emptying and refilling until the water begins to 'green up', indicating that algae can survive in it. This process can take some months, though pond sealers will short-cut the procedure. This garden is equipped with an electrically operated filter system to maintain the best possible water conditions and to prevent the ponds from freezing. Filter systems are a worthwhile investment for a garden that relies on its water effects. Late autumn care will demand the raking out of fallen leaves and plant debris unless the water has wire netting placed over it.

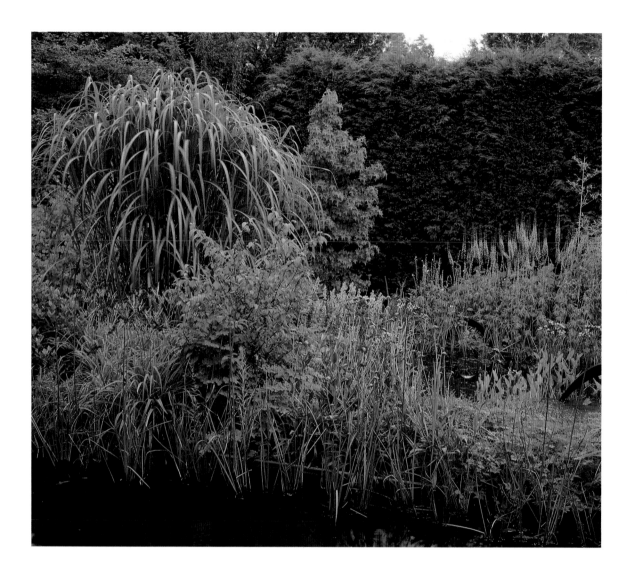

Left The narrow border is filled with violet blue *Scabiosa caucasica* and orange *Hemerocallis* hybrid. Against the hedge arise spikes of *Ligularia* 'The Rocket'. Behind the large bush of *Miscanthus floridulus* there is the *Liquidambar styraciflua*, whose leaves turn claret-red in autumn.

THE PLANTING

The designer has little sympathy for evergreens as they only provide one effect and he prefers deciduous plants which during any year will provide a succession of pictures from bare branches onwards. A careful selection of these, set against an evergreen thuya hedge, makes a backcloth framing the two ponds. As a consequence, for people who do not share this viewpoint, the garden would seem to be chiefly a summertime one. There is some provision for winter, spring and autumn interest in some of the shrubs and trees, the *Viburnum tinus* and *V. farreri*, *Prunus fruticosa* 'Globosa' and *Liquidambar styraciflua*.

But in the main both borders and ponds come to life from the late spring. One exciting aspect of such an 'unnatural' water garden is that no lipservice needs to be paid to the convention of appropriate waterside planting. The beds and borders are artificial environments and their soil type and moisture content are for the gardener to determine. Many of the beds call for weeding and regular general attention such as dead-heading; and perennials will need periodic division. This could be achieved by running a gantry over the water. Once or twice a year the beds need to be judiciously invaded to clip the hedge and prune the shrubs.

POND PLANTS

All these need to be planted in round or square perforated plastic containers of a kind easily obtainable from any garden centre. Different plants call for different sizes. The containers will need to be lined with sacking to prevent soil from seeping into the water. At the bottom should be placed some

well-rotted compost, then medium heavy clay soil and finally small stones to protect the plant's root system. Check the depth at which each plant should be positioned and support it, if necessary beneath with blocks or bricks. Periodic division of the aquatics and marginals – every two or three years – is made easier by simply lifting the planting containers, which also restrict these potentially invasive plants.

1 The marginal plants include *Sagittaria sagittifolia*, *Butomus umbellatus*, *Pontederia cordata*, *Typha angustifolia* and *Alisma plantago-aquatica*.

2 The aquatic plants include *Nymphaea alba* and *N. odorata rosea*, *Ranunculus aquatilis*, *Mentha aquatica*, *Stratiotes aloides* and *Utricularia vulgaris*.

SHORTER POND BORDERS

3 A screening of *Yushania anceps* (syn. *Arundinaria jaunsarensis*) along the south border also includes *Prunus laurocerasus* 'Schipkaensis' and is interplanted with *Euphorbia myrsinites* and *Ligularia przewalskii*.

4 *Weigela* 'Newport Red' stands in the corner where its showy flowers can be appreciated from the terrace.

5 Flowering viburnums, *V. tinus* and *V. farreri*, make a backbone for the colourful border of *Geranium sanguineum*, *Hemerocallis* hybrid and *Scabiosa caucasica*.

6 *Nothofagus antarctica* marks the turn of the border.

7 *Viburnum tinus*, *Asplenium trichomanes*, *Prunella grandiflora* and *Incarvillea delavayi* fill the northern arm of the border.

LONGER POND BORDERS

8 *Miscanthus floridulus* makes a major statement.

9 The wall border has a foundation of trees and shrubs including *Liquidambar styraciflua* and *Cercidiphyllum japonicum* whose leaves contribute brilliant autumn colour, evergreen spring-flowering *Prunus laurocerasus* 'Schipkaensis' and *Viburnum* 'Pragense' and *Prunus fruticosa* 'Globosa' and *Viburnum* x *burkwoodii*. All will need pruning to keep them restricted in size. Between and under these is a range of perennials and shrubs including *Lysimachia nummularia*, *Pleioblastus humilis pumilus*, *Heuchera* x *brizoides*, *Geranium endressii* 'Wargrave Pink', *Waldsteinia geoides*, *Lysimachia punctata*, *L. clethroides*, *Polygonatum* x *hybridum* and *Asplenium scolopendrium*.

10 An evergreen hedge of thuja screens the west boundary.

11 The long narrow border beneath the hedge is planted with *Polygonatum* x *hybridum*, *Ligularia* 'The Rocket', *Lythrum salicaria* 'Robert', *Fargesia murieliae*, *Lysimachia nummularia*, *Anemone tomentosa* 'Robustissima', *Ligularia dentata*, *Asarum europaeum,* and *Astilbe* 'Rheinland'.

12 *Petasites japonicus* dominates the middle portion of the bed.

13 *Iris germanica* and *Fargesia murieliae* make the most impact in the northern arm of the border, and are in-filled with *Tradescantia* 'Innocence', *Miscanthus sinensis*, *Fragaria vesca* and *Astilbe* 'Rheinland'.

EVERGREEN BORDER

14 This substantial screening border is filled with a mixture of junipers, pines, mahonia and ivy.

Below Euphorbia myrsinites is a useful low evergreen prostrate perennial with bright clusters of flowers in spring

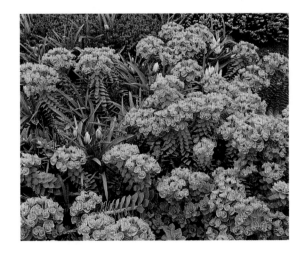

Right The neat box hedging and the small scale paving and bricks superimpose order and strong pattern on to what would otherwise be an unruly scene in the herb garden. An explosion of herbs including rue (*Ruta*), marjoram (*Origanum majorana*) and southernwood (*Artemisia arbrotanum*) as well as *Alchemilla mollis* bring colour and a scent to this part of the garden.

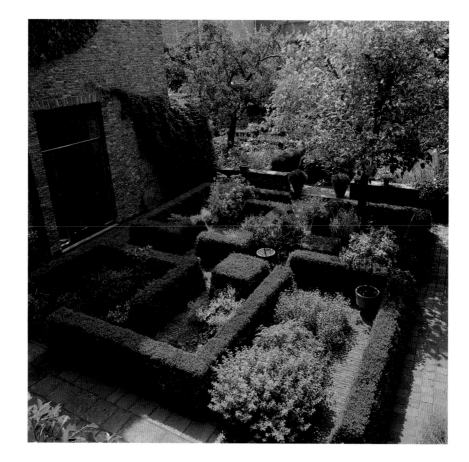

Right A view across the raised pond towards a terrace in the corner of the garden that is overhung with wisteria. The shapely foliage of a fig tree (*Ficus carica*) looms behind the pond. The square cushions of box, one clipped very low, act as substitutes for the cooling effect of a lawn.

A COURTYARD MAZE

This is a garden for flower and herb lovers that is equally satisfying to those who appreciate evergreen structure. Two rectangular mazes are articulated by bold hedges of shiny leaved green box and held in by an aerial tapestry of trained hornbeam. Three tall fruit trees spread their branches over two connecting courtyards which have been transformed into a plant-lovers' paradise. The herb garden brings with it the tradition of centuries, each plant endowed with its special properties. Its gentle tonality forms a striking prelude to the luxuriant galaxy of colour in the flower garden.

What is so striking about this garden, designed by André van Wassenhove, is its sense of control. The rectangularity of the hedging makes a brilliant counterfoil to the carefully orchestrated disarray of the plants, which are grouped according to their preference for sun or shade. The green box compensates visually for the lack of lawn and also eliminates the repetitive boredom of regular mowing. This releases the owners to direct their energies towards maintaining the beds of herbaceous plants which are their passion and which include an impressive array of interesting plants. These will call for constant but infinitely rewarding attention. Two good mornings or afternoons a week could be spent sustaining such horticultural glory, but less time would be needed if you chose undemanding ground-cover plants and slower-growing shrubs in place of the flowering perennials.

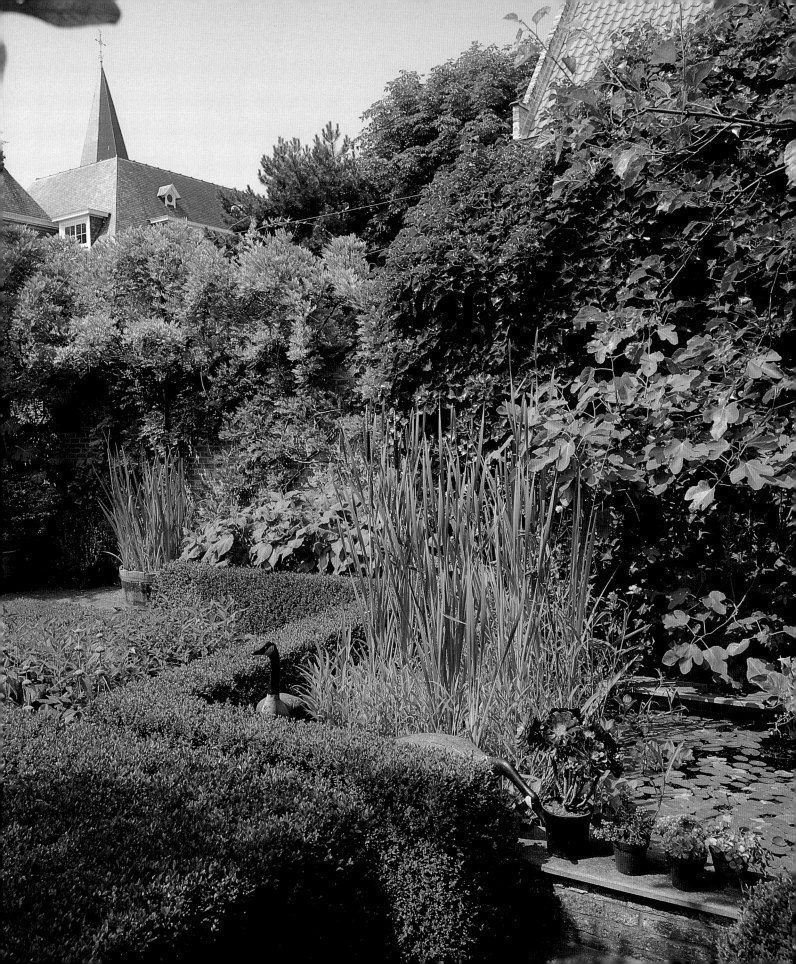

THE STRUCTURE

These are essentially two quite separate gardens, visually linked because both are designed according to the same principles. The inner herb garden is about 12 x 9 m/40 x 30 ft. The outer main flower garden about 17 x 10 m/50 x 34 ft. Both are paved with setts outlining a carefully balanced asymmetrical arrangement of rectangular beds of different sizes. The ancestors of the composition are the parterres and mazes of the seventeenth century, here reinterpreted in terms of twentieth-century abstract art. One of the charms of this design is the open-ended 'U' and 'L' shapes made by the box hedging: the closed squares and rectangles traditionally used to edge beds have a more predictable, heavier effect and are less easy to tend. The hard surfaces, which are undemanding to maintain, allow ease of access to all areas of the garden and provide three delightful areas in which to sit. This design is adaptable to any flat site – and, indeed, the herb garden usefully provides an alternative for a smaller flower garden – although particular care would be needed to ensure that the individual blocks and beds added up to a pattern that made a satisfying overall effect.

AERIAL HEDGE

Pleached hedges can be made out of lime, or, as here, of hornbeam. The young trees need a strong framework of supports – battens, wires or bamboo canes on which to train the lateral branches. You will need access in late summer or winter for the pruning and training. Hornbeam is particularly good because the pliable young growth is easy to tie in and pruning results in a dense, twiggy mass which provides privacy and filters wind. It adds to the green elements in summer and provides an intriguing pattern of entwining branches against the sky in winter.

N

FRUIT TREES
Here three fruit trees add height to what is an essentially low-level composition; they also provide shade, and attractive shadow patterns. The tradition of including fruit trees in a flower garden is very old. Pollination is needed for fruiting: you need compatible varieties or (for a single tree) a self-fertile type. An alternative might be small ornamental trees that produce blossom and then either berries or good autumn foliage, as they need less attention than fruit trees.

FISH POND
Water brings light, movement and the chance to plant aquatics and marginals. The spread of the plants in this pool has to be checked each year. A less labour-intensive alternative would be to omit both fish and planting and opt for water with a simple jet, or to replace it with a bed of the same proportions.

CLIPPED BOX
The introduction of square 'cushions' of box is an ingenious means of making up for the absence of lawn, which normally provides year-round ground-level green. The box hedging provides interest as light and shade articulate its square-cut shapes. The full impact of a parterre or maze is, however revealed only from above. It is from the upstairs windows of the house that the definite ground patterns are best enjoyed.

CONSERVATORY (*right*)
The newly constructed conservatory looks over a dining terrace into the flower garden. To the left the long aerial hedge of hornbeam ensures privacy and shelter.

PLANTING

This is a garden with an abundance of herbs and hardy herbaceous perennials. Nearly all call for attention, certainly in terms of lifting and dividing alone. As this only needs to be done about every five years, one way of coping would be to stagger the task and establish a rota of replanting one or two beds a year. The flower garden includes many plants like delphiniums which demand staking. In addition, to achieve a dazzling display all beds must be annually fed at least with bonemeal or some general purpose fertilizer, but better still with compost and farmyard manure. This is essentially a spring through autumn planting with the main display during the summer months; however, the box provides permanent green framing. To look immaculate, the box may sometimes need clipping twice a year. Anyone embarking on such a garden would wish to make their own scheme, maybe one which would include roses and even a few annuals. Any scheme, however, must be guided by the disposition of the site, with sun-loving plants at one end graduating to those which tolerate shade. Consideration

here has also been given to arrangement according to height, so that each large bed has a group of flowers with spikes of bloom which arise above the green hedge. An apple, a pear and a mulberry contribute spring blossom as well as fruit. The pruning of fruit trees calls for considerable skill. The techniques are best learned from an expert or at the least from a careful study of pruning manuals with good diagrams. Bad pruning can not only

disfigure the tree but reduces its capacity to produce fruit.

TERRACE WALLS
1 The bold foliage of *Macleaya cordata* forms a backdrop to the dining area.
2 *Wisteria sinensis* clothes the adjacent wall.

AERIAL HEDGE
3 Pleached hornbeam (*Carpinus betulus*) makes an airy overhead screen along the north and west boundaries.

HEDGE BORDER
4 The long border beneath the hornbeams is lit up by perennials such as inulas, doronicums, *Telekia speciosa* and *Leucanthemella serotina* (syn. *Chrysanthemum uliginosum*).
5 Nearer the house are *Thalictrum rochebrunanum*, *Cimicifuga racemosa* and *Phlomis russeliana*.
6 The shady corner includes *Hosta rectifolia* 'Tall Boy', *Polystichum setiferum* and *Glechoma hederacea*.

SMALL TERRACE BED
7 *Acanthus hungaricus* (syn. *A. longifolius*) is underplanted with *Prunella grandiflora* and *Thymus serpyllum albus*.

APPLE TREE BED
8 This small bed contains

Delphinium Summer Skies Group, *Phlomis russeliana* and *Meconopsis cambrica*.

LARGE SHADY BED
9 The principal plants are *Cimicifuga simplex* 'White Pearl', *Osmunda regalis* and *Hosta fortunei hyacinthina*, underplanted by *Glechoma hederacea*.

LARGE TERRACE BED
10 This sunny bed includes *Anaphalis triplinervis*, *Chelone obliqua*, *Dianthus* 'Duchess of Fife', *Gypsophila paniculata* 'Rosenschlier', *Malva alcea*, *Nepeta mussinii*, *Oenothera macrocarpa* and *Phlox paniculata* 'Lilac Time'.

SMALL CENTRAL BED
11 *Helleborus orientalis* is followed by *Delphinium*

'Völkerfrieden', *Gillenia trifoliata*, *Phlox paniculata* 'White Admiral' and *Sedum spectabile*.

PEAR TREE BED

12 Under the canopy grow *Brunnera macrophylla*, *Geranium endressii*, *Sidalcea candida*, *Ophiopogon japonicus*, *Anemone* x *hybrida* 'Honorine Jobert' and *Cimicifuga racemosa*. Nearby are *Delphinium* x *belladonna* 'Cliveden Beauty' and *Phlox paniculata* 'Rijnstroom'.

COURTYARD BED

13 Planting here includes *Dicentra formosa* 'Stuart Boothman', wolfsbane (*Aconitum pyrenaicum*) and *Rheum palmatum*, with *Liriope muscari*, *Lysimachia nummularia* and *Ajuga pyramidalis*.

POND AREA

14 *Crambe cordifolia*, *Persicaria amplexicaulis* *Cephalaria gigantea* and *Darmera peltata* grow with a fig tree.
15 Iris and waterlilies thrive in the pond.

HERB GARDEN

16 A range of herbs, not all culinary, is planted randomly in the beds with some ornamentals. Pots of standard fuchsias punctuate the design.
17 The specimen tree here is a white mulberry (*Morus alba*).
18 This wall is clothed with *Fallopia sachalinensis*.
19 *Parthenocissus tricuspidata* 'Veitchii', which contributes good autumn colour, climbs on several walls.

Above *Malva alcea,* is a substantial structural free-flowering perennial.

Left A view from the herb garden looks towards the far wall of the flower garden and the aerial hedge. Tall iris foliage rises from the pond to the right, and beyond that is the south-facing terrace with chairs and table backed by the blue-grey foliage of tall *Macleaya cordata*. To the left the branches of the apple tree spread a leafy canopy over the display of flowers below.

GARDENS
for the
ENTHUSIAST

There will always be people for whom gardening is a way of life, for whom each hour spent tending the garden is one to be treasured. The difference between them and those with less commitment and time is one of priorities. They will either have more time – or have decided to allocate more time – to spend on the garden. High-maintenance gardens call for year-long commitment in all weathers. Over the years the work involved will result in a sophistication of knowledge which links the hand wielding fork or trowel to the one taking a book from the shelf. Committed gardeners will be engrossed both physically and mentally in the garden. On the darkest winter evenings they will turn to garden writers for inspiration, information and sheer pleasure. They will usually be avid garden visitors, anxious to learn from others, and will join one of the many gardening societies to share their enthusiasm. Knowledge will bring speed and shortcuts. It will also open the doors to an even wider range of horticultural effects, in particular those obtained through pruning and training, and to the infinity of plants available through various methods of propagation. The enthusiast will first and foremost be a plantsman, for the more varieties and

the more exotic the plants, the more demanding the garden. Always, however, be honest about the depth of your commitment, for nothing is a sadder sight than a high-maintenance garden in the hands of a low-maintenance gardener.

If, therefore, gardening is to be your consuming passion, then every garden effect, within reason, can be yours. But you will still need to observe the principle of good structure: otherwise your horticultural paradise will descend into plant chaos. Just because your garden is filled with a breathtaking range of difficult-to-grow and obscure plants, it does not mean that you will have a good garden. In a small space, that collection needs to be orchestrated and held together by a strong framework to give it definition, identity and balance. The five different gardens here are successful because they observe that rule.

A rustic arbour and sowing of foxglove spikes provide the vertical accents in this crowded cottage-garden scene. Self-seeding poppies and foxgloves create random effects, but a sure eye has seen that purples, pinks and reds are in rich harmony with the permanent planting of deep pink roses and wine-red clematis festooning the arbour. The challenge for the gardener is that of unobtrusively keeping the profusion from lapsing into chaos.

They are all rich in plants, but equally all are held together by different structural design solutions which display these treasures to the highest advantage.

They include certain types of garden open only to the utterly committed, since their demands are so intensive. One is the plant collector's garden, an explosion of horticultural acquisitiveness and curiosity that again calls for a powerful underlying design to hold it in order as a composition. It is, of course, essential to establish the ideal habitat in which particular plants can thrive and multiply. A collection of snowdrops, for instance, will call for undisturbed shade and lavish applications of leaf mould, while grey foliage plants need sun and do best in light, sandy soil. You then need to work back from your plant passion and consider what structural features will set them off to greatest

A beautifully tended and orchestrated display of perennials and herbs, many of them neatly trained into compact rounded bushes echoing the rhythm of the paving and the simple focal point, a stone bowl filled with stones and water. Clipped box balls and standard euonymus add vital architectural structure to a carefully calculated planting with subtle colour contrasts ranging through the greys and grey-greens. Clipping is vital to keep shrubby herbs like helichrysum (or santolina), rue and lavender from becoming leggy, and the result is beautifully displayed in this well-groomed planting.

advantage, and how best to place them. Many plant-oriented gardeners have little time for the basic concepts of design. This is usually a mistake and often both the gardener and the plants are the losers. Many of the structural solutions presented in this book will accommodate plant collections and provide them with a sure framework in which to flourish and be seen at their best. Just as I have argued that virtually all the designs in the book can be adjusted to minimum labour input by simplifying the planting, the converse is also true: planting can as easily be enriched and elaborated.

A second is the potager, a glorious mixture of fruit, flowers and vegetables woven into a stunning composition. Unlike other gardens, it is closely related to another art, cooking. It would be pointless embarking on one without a keen and firm alliance with the practicalities of the kitchen and the cook. Its creator must pay keen attention not only to the realities of crop rotation, but also to the visual potential of the transitory juxtaposition of vegetable leaf shape and colour. Within its firm geometrical frame, the garden picture will be a different one every year. In that resides much of the excitement of the potager. Constant care and application is essential from the planting of the seeds to the harvesting of the produce. But the result is a rare horticultural masterpiece.

This tiny potager, like an oasis in a wilderness, and cobble-edged beds has an almost hallucinatory quality, yet its ingredients could not be more modest. The area is enclosed by rustic palings in keeping with natural surroundings but which are also functional in keeping hungry rabbits out. Inside, it is symmetrically divided and the cobble-edged beds are jammed with an inspiring mixture of edible and ornamental plants. Towering sunflowers (some not yet in flower), runner bean pyramids and massed nasturtiums blur the boundaries between useful and decorative kitchen-garden plants. Flowers like nicotiana, cleome and cosmos are there purely for decoration, but the scattering of French marigolds in the beds helps deter pests. Every aspect of the planting patently gives pleasure, from the gone-to-seed grasses (bottom left) to the glossy leaves of the ruby chard (top right), but the garden is obviously productive and practical. The narrow beds make cultivation easy.

Left Grass is usually the neutral foil for the more decorative effects of planted beds. Here a large area of lawn is enriched with its own pattern, accomplished by adjusting the mower blade to give different heights of cut. A more commonly seen effect is when paths are mown through long grass planted with naturalized bulbs. Keeping a manicured lawn looking good is labour-intensive, especially in the summer months; achieving this kind of damask effect adds further to that effort.

Right A fan-trained cherry tree is a work of art. It also solves the problem of a shady wall. The branches are trained onto a cane framework but it would take several years of patient work to achieve this effect. The formality of this tableau is emphasized by the containing box hedge and the flanking pillars of clipped pyracantha.

The third type is the Japanese garden which no-one except the initiated should attempt. On first encounter Japenese gardens seem so austere that they appear artlessly simple. But in reality they rank as one of the most demanding of all garden types. They embody not only a style but a philosophy and the two are deeply entwined and both must be seriously studied. Every aspect is governed by strict underlying principles, from the orientation of the entire garden to the detailed siting and association of plants and artefacts.

Enthusiasts in the small garden will probably also wish to experiment with plant propagation using a small propagator in a greenhouse. They might indeed raise annuals from seed and hence be able to indulge in that ultimate extravaganza of bedding-out, which means a spring, summer and autumn planting in succession.

The passionate gardener will be someone with a habit of mind that enjoys the fundamentals of the craft. Tasks which many people find a drudge – gathering leaves for the compost heap, bending double for hours to hand-weed beds, rushing out to beat snow off branches about to break beneath the pressure, or the time-consuming monoto-

ny of mowing a lawn – each will bring to an enthusiast its own particular pleasure. But then the labour and the demands will be offset by the beauty which the gardener's vision has created.

More than anything else serious gardeners will read, and accumulate a library. They will wish to know in depth their craft, moving beyond the rudimentary approach to a garden as an area for profit and pleasure to understanding some of its deeper resonances. They will want to understand the thoughts and actions of the great gardeners and garden-makers through the centuries, and that can only come from books and visits on the ground. Gradually the garden will assume for them something more profound, a philosophy of life.

A PLANTSMAN'S FANTASY

Skilful changes of level, and planting of a jungle-like density combine to make this small town garden quite extraordinary. Its composition bespeaks a warm climate which makes both outdoor living and a year-round profusion of plants possible. This is not a garden formula that would work in more extreme climates, for its success depends on the sheer exuberance of foliage and flowers. A wide spectrum of leaf and flower colour is matched by strategic placing of plants with distinctive silhouettes and habits to make every part of the garden interesting. The owner, the garden designer Sonny Garcia, usually devotes two hours a day to tending his ever-growing collection of exotic plants, and often spends a whole day in the garden at weekends, even though a built-in sprinkler system waters all the plants, and irrigates the trees.

Left Imaginative stepping stones sculpted as mysterious smiling faces peer up amidst the lush ground-cover planting along the path to the left of the decking, and provide access to the plants when working in the garden. The plants include ajuga, tolmiea, and *Geranium rubescens*. The grassy foliage of *Hakonechloa macra* 'Aureola' is just visible in the bottom left-hand corner.

Right The view across the patio shows the open-air barbecue with plants in containers. Wooden decking to the right leads to a flight of steps which in turn leads up to an aerial dining space on an upper deck. The painted pergola, smothered in climbers, is to the right. The success of the garden depends on calculated plant chaos of a high order.

THE STRUCTURE

The garden measures 9 x 13 m/30 x 42 ft and depends for its effect on the contrast between an angular modern use of concrete and wood and the plethora of plants which encroach on to the hard surfaces. The built structure comprises a series of ascending rectangles – a patio and a lower and upper deck – and it is these changes of level that make the garden exciting, providing different spaces for alfresco living, and enabling the plants to be enjoyed from various angles. The planting also provides screening: by placing the built elements at the heart of the garden, privacy is ensured.

PAVING

The exposed aggregate concrete pavers form the most prosaic feature of the scheme, but were deliberately chosen by the designer as a neutral foil for the exuberant planting. Pavers like these are inexpensive, but stone, reconstituted stone, or brick would be an attractive alternative.

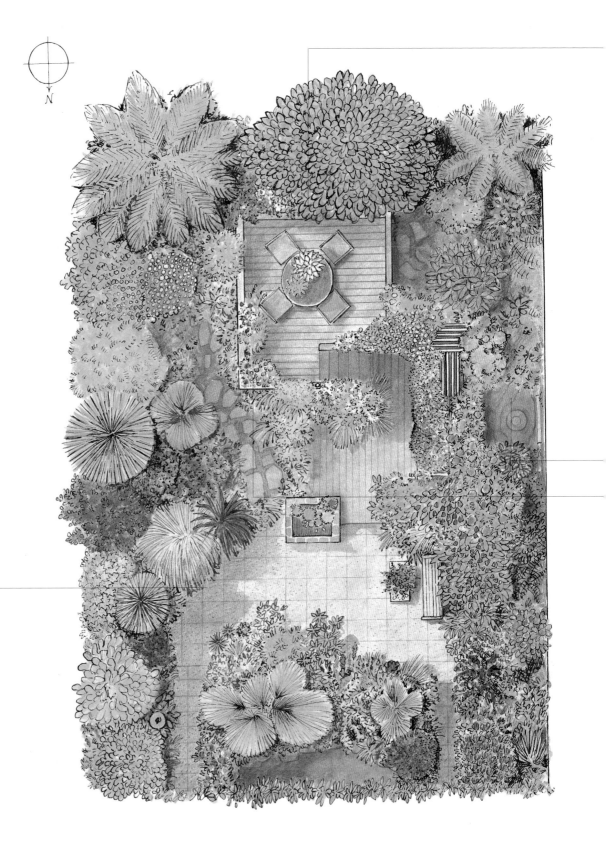

__ DECKING

Wooden decking makes
a warm and agreeable
surface to walk on and
the formal use of natural
materials combines well
with the luxuriant
planting. Constructing
one area of decking at a
higher level than the
other has ingeniously
provided a storage space
below the platform. It is
also a cheaper, easier way
to achieve another level
sitting area than
excavating and terracing
a sloping site. The
woodwork must be
professionally
constructed from
seasoned timber.

__ FOUNTAIN

Behind the pergola is a
trickle fountain of stone
backed by a reflecting
mirror that gives this
part of the garden an
atmosphere of
mysterious depth, as well
as the gently lulling
sound of running water.

__ PAINTED WOODWORK

(above) Colour in this
garden comes not only
from the plants but also
from the built structure.
The wood of the house
itself and that of the
structures in the garden
is painted off-white,
blue-grey and lilac,
linking house and garden
into one unit –
something that is rarely
done. Far from
detracting from the
plants, as a stark white
might do, these hues
enhance the scene.

Shades of grey-green to
deep green would be
another satisfactory
colour scheme. The
simple wooden pergola
that spans the middle
section of the garden
rises to an apex in the
centre, echoing the shape
of the fretwork pediment
of the balcony of the
house. Painted wood
does have serious
maintenance
implications. Unlike
stained and treated wood
that continues to look
natural as it weathers and

fades in the sun, or
gathers lichens in cool
and damp, painted wood
relies on looking pristine
for its full effect. To
disentangle the plants
from their supports and
to rub down and repaint
the wood in this garden
would be a daunting task
– but for those to whom
their garden is all-
important, it would be
worth the effort. Like all
wooden structures out-
of-doors, these elements
will need periodic checks
for rot.

Above A close-up of just a few of the plants at the eastern edge of the patio shows how variety of habit, leaf-shape and colour have been considered in the placing. The striking purple foliage of *Phormium* 'Dark Delight' dominates the group. *Fuchsia excorticata purpurescens* behind it echoes its reddish leaf tones, while the narrow arching leaves of *Cortaderia selloana* 'Sunstripe' and *Spiraea japonica* 'Gold Flame' in the foreground provide clear colour contrast.

THE PLANTING

This plant-collector's garden has about 150 trees, shrubs, climbers, grasses, perennials and other plants crammed into the minute area, and the owner keeps adding new plants in spite of the shortage of space. Plants in pots form drifts along the edges of the paving and decking, and colonize the tables and barbecue. Every corner of this garden offers an interesting composition of forms, textures and colours. The mild winters make it possible to exploit the dramatic silhouettes of members of the palm family such as trachycarpus, chamaerops and the palm-like cordylines, as well as the tall tree ferns dicksonia and cyathea. The grassy, spiky theme is sustained at a lower level with plants like hakonechloa and cortaderia, as well as phormiums and yuccas. Plenty of plants with softer outlines provide a foil to these bold leaf forms. Another characteristic of the garden's planting is the extensive use of foliage colours – particularly golds and reddish-bronzes – which provide a rich context for the many orange, red and pink-toned flowers that thrive here.

Watering is built-in, but fertilizing is done annually by hand. The main regular tasks are those of tidying and neatening the plants – removing dead flower heads and damaged leaves. Plants also need periodic thinning and pruning. To accommodate such concentrated planting, radical pruning of the trees and larger shrubs is essential. This is a major task, but it does allow the wonderful profusion of choice plants to be grown in such a small area. The fact that few of the plants are deciduous means that the garden retains plenty of year-round structure. This also makes maintenance a perennial task. Instead of the single major blitz at the end of the growing season faced by gardeners in temperate climates – sweeping up leaves, removing dead stems, and sometimes lifting and dividing, after which both garden and gardener enjoy a relatively restful period – these plants need keeping in good trim all the year.

POOL BED

Two fan-like palms dominate the bed by the pool near the house.
1 Chusan (*Trachycarpus fortunei*), which has sprays of creamy flowers.
2 A dwarf fan palm (*Chamaerops humilis*).
3 Shrubs in the bed include gold-leaved *Spiraea japonica* 'Goldflame' and *Lonicera nitida* 'Baggesen's Gold'.
4 *Polygala* x *dalmaisiana*.
5 Apple 'MacIntosh Red' is espaliered on the house wall below the balcony.

Below Like many abutilons 'Souvenir de Bonn' is fast-growing and has a long flowering period.

EAST BED

Along the wall is a collection of choice trees and shrubs.

6 *Lycianthes rantonnei.*

7 *Magnolia* x *soulangeana.*

8 *Acer pseudoplatanus* 'Prinz Handjery'.

9 In front, among other shrubs, are the stiff spikes of *Cordyline australis* 'Albertii.

10 *Cortaderia selloana* 'Sunstripe'.

11 *Phormium* 'Dark Delight'.

12 *Fuchsia excorticata purpurescens* sustains the theme of bronze foliage and red flowers.

13 *Prunus cerasifera* 'Pissardii'.

14 *Podocarpus gracilior.*

15 *Brahea edulis.*

16 *Acer palmatum.*

17 *Justicia carnea.*

STEPPING STONES

18 Planting around the path suits ground-hugging shade-tolerant plants such as ajugas, *Tolmiea menziesii* 'Taff's Gold' and hardy cranesbill geraniums, including *G. rubescens*. A variegated toad-lily, *Tricyrtis hirta* 'Variegata', relishes the shady site, and farther along grassy-leaved lilyturf (*Liriope muscari variegata*) provides ground cover beside the stones. Virtually all of these are invasive spreaders and demand regular and ruthless reduction.

SOUTH BOUNDARY

19 A large escallonia stands at the centre iflanked by two tree ferns.

20 *Cyathea cooperi.*

21 *Dicksonia antarctica.* The boundary at the rear of the plot is screened by ivy.

PERGOLA

22 Climbers including pink *Clematis montana*, *Rosa* 'New Dawn' and white-flowered *Jasminum polyanthum* assure a succession of seasonal interest.

PERGOLA SHADE

23 The pergola's canopy deepens the shade in the south-west corner, creating almost woodland conditions. Moist, deep, acidic soil suits a range of shrubs like azaleas and rhododendrons, *Cleyera japonica* 'Tricolor' hydrangeas, as well as perennials such as alpinia, hedychium and carex.

24 Houttuynia grows around the trickle fountain.

WEST BORDER

25 Behind the seat is a galaxy of colourful flowering shrubs, from camellias in spring, through rhododendrons and *Cestrum elegans* to a summer-long display including roses, fuchsias, the Chilean firebush (*Embothrium coccineum*) and *Brugmansia* 'Charles Grimaldi'. Abutilons making a special feature in this bed are 'Souvenir de Bonn', 'Tangerine' and 'Mariane'.

CONTAINER PLANTING

Clusters of pots make ad-hoc plant compositions on the edges of the decks, around the paved area, on the tables and even on the barbecue where cacti and succulents from indoors are spending a summer break. Most of these will outgrow their containers and most require regular repotting in fresh compost to sustain their vigour.

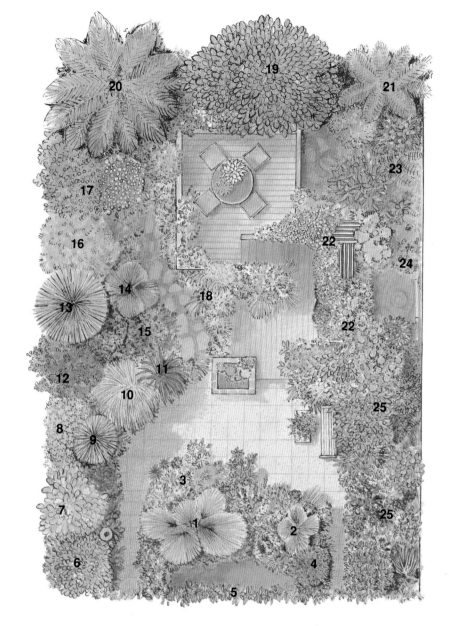

A DECORATIVE POTAGER

The decorative but productive kitchen garden is one of the most ambitious of all forms of garden art. It depends for its effect upon firm geometric structure. In the summer months it should be a cornucopia held in place by formally clipped evergreens, prettily paved paths and trained fruit trees. Even in the depths of winter it should be a place to admire: the skilful gardener would take care to see that during these cold months the potager was enlivened with well-sited cabbages, leeks, parsnips, celeriac, Brussels sprouts as well as frost-resistant salad greens. Moreover, vegetables call for rotation and particular soil conditions so that every year there is the challenge of making a new plan, re-siting the crops not only to produce their annual yield but delight the eye in a different way by thoughtful and surprising juxtapositions of leaf shape, texture and colour.

This Dutch potager is a masterpiece of the genre but a very accessible one. Its structure calls for simple inexpensive materials: a geometric arrangement of brick paths with a modest sundial as a focal point. The enclosing hedges would demand patience as they grew, so too might the topiary and fruit trees unless they were bought in fully trained. Otherwise, as not only most vegetables are annuals, but also many salad crops mature within a few weeks, the effect could be virtually instantaneous.

To maintain the effect demands a great deal of work. To keep a succession of crops in the beds is a challenge in itself; to keep them looking good needs constant vigilance. But the end result would reward you with the creation of one of the most difficult of all garden pictures, and give you the satisfaction of consuming fresh produce all the year.

Right The view from the herb garden shows how the well-defined clean paths make a strong ground-level pattern. The permanent verticals are provided by the clipped box and trained apple trees. To the left the potager is firmly held in and protected with a rich dark green yew hedge through which mophead plane trees have been trained. In winter, this makes a dramatic contrast with the other hedges which are of hornbeam that turns russet.

Left A terracotta pot on a pedestal, here arising above cabbages and potatoes, is a focal point in one of the spandrel gardens. It is strikingly planted with one of the marrow family to give both architectural leaves and edible produce. It would need watering daily, but the delightful effect is well worth the effort. To the left is one of the standard gooseberries.

CENTRAL FOCAL POINT (*left*) The view along the main path that bisects the garden looks towards one of the gates framed by a hornbeam hedge and arch. The sundial in the centre of the garden is encircled by bronze lettuces, (which have been allowed to bolt), cabbages and rhubarb which, by mid-summer almost cover the path. *Lavandula angustifolia* 'Hidcote' and standard 'Iceberg' roses mark the entrances to each of the four gardens-within-the-garden. The central sundial holds the whole composition together, but its place could be taken by a large pot, a fountain or well-head or alternatively, a symmetrically trained specimen tree, or a topiary piece such as a box cakestand or a bay obelisk. Box provides multiple evergreen accents, which anchor the design; while vertical accents are made by symmetrically sited trained apple and pear trees and standard roses.

THE STRUCTURE

The garden is about 15 m/50 ft. square It is surrounded by hedges, with picket gates for access at either end of the cross axis path. The design brings home the importance of strong articulation at ground level in the laying out of any potager. By quartering it, four separate areas are created, the one in the sunniest corner given to herbs framed by beds of strawberries. The other three incorporate some fruit trees and bushes but are basically assigned to a rotation of crops. In this design virtually nothing but straight lines has been used but an equally balanced composition could be achieved using curves, ovals and circles. The important point is to use the hard-surface elements, hedges and vertical accents, like the topiary and fruit trees, to establish overall balance and order. Each of the four spandrels is a composition in itself. Great attention has been paid to all the vistas created by the main paths: each terminates in a seat, a gate or some other focal point. What is ostensibly missing from this potager are some of the essential services; this is because they are sited outside its boundaries. If this was your only garden, or you had no room elsewhere to put them, there is no reason why they could not be incorporated within the main scheme. A well designed garden shed covered in climbers would make a good culmination to one of the vistas; equally, a small greenhouse could become the main feature of one of the quarters, perhaps balanced by a fruit cage in another quarter. A cold frame or two could easily be incorporated into one of the borders. A vegetable garden needs the constant enrichment of its soil, so you will need an area for manure and the making of compost. And you may need space for burning debris.

PATHS

Paths provide working access so must be wide enough for a gardener with a wheelbarrow. Here the paths make effective use of brick, which is suitable for the workman-like, practical ethos of a potager, and also unifies the design. The main paths are given emphasis by being slightly wider than the others, and the way the bricks are aligned, especially at path crossings, helps to guide the eye and articulate the design. Paths must be either hand-weeded or painted annually with weedkiller. You would certainly want to avoid sprays in such proximity to edible plants.

BEDS

Most are small enough to tend easily by reaching in from either side. (It may be useful to introduce stepping stones to the larger ones). Using old railway sleepers or containing coping to edge the beds would raise the soil level a little and so ensure that it did not become waterlogged, and would also help to stop soil spilling on to the paths.

BOUNDARIES

Most fruit and vegetables call for protection from the elements and the creation of a micro-climate. Here yew and hornbeam hedges make the enclosure. Although handsome, they do have disadvantages: they not only cast shade but suck food and water away from the produce unless their roots are contained, for instance, by sinking tough plastic corrugated sheeting to hold them in. Walls and various forms of fencing would be an alternative – and instant – solution; they also offer the attraction of being a surface able to support espaliered fruit and climbers. Many productive gardens also need protection from wildlife, and pest-proof wire netting may have to be incorporated.

THE PLANTING

The structural planting includes the fruit trees, roses and punctuating box bushes. Other permanent plants are the fruit bushes (standard gooseberries and raspberries) and strawberry plants. Apart from perennials in the herb garden, which call for periodic division and re-planting, all the remaining beds are given over to rotation of crops. Many kinds of vegetable are grown and there are not only annual changes but variation from month

vegetables. The first includes legumes and salads which call for freshly manured ground. The second includes root crops that flourish in soil manured the previous season, but also need a fresh dressing of general-purpose fertilizer such as bonemeal. The third includes brassicas which also require fertilizer as well as an additional dressing of lime. The beds are then rotated in sequence to ensure that the ground is not depleted, as each group takes out certain nutrients

Above Chives (*Allium schoenoprasum)* add tangy relish to salads and, if allowed to flower, make pretty edging.

to month, with catch-crops taking advantage of space between slower-growing immature plants. A vegetable garden is traditionally divided into beds according to the cultivation demands of three main groups of

from the soil. Ideally the beds should be arranged on a north-south axis so that both sides receive equal measures of sun. It is essential to draw up a master plan indicating the three-year cycle of each bed that can be referred

to year after year. There are crops such as asparagus, globe and Jerusalem artichokes, that can remain in place. In a more general kitchen garden, herbs and soft fruit also stay in their original beds. If your kitchen garden is to be a potager, you will need to think about extra dimensions in your planning, taking into consideration the visual juxtapositions of colour and leaf shape. Colour need not be a problem, as there is a variety of reds and purples including ruby chard, red cabbage, chicory, lettuce and radicchio, and glaucous blues such as cabbage and broccoli, as well as the wide range of greens. Oriental salad

greens include bright flowers and nasturtiums (*Tropaeolum majus*), which will climb as well as sprawl, and have edible flowers and leaves. Vegetables that climb, such as runner beans, can add strong vertical accents if they are trained up cane supports ranked in seried rows or arranged in wigwams. Marrows or squashes can also be grown up trellis or more elaborate arches. Other pretty effects can be achieved though the use of reproduction antique pottery cloches.

CENTRAL PATH
1 Red lettuce and purple-blue cabbage.
2 Rhubarb.
3 *Lavandula* 'Hidcote' surrounds two groups of

four white standard 'Iceberg' roses. These mark the entrances into the four main quadrants.

HERB GARDEN
4 A wide range is grown in this garden: rue (*Ruta graveolens*), thyme (*Thymus vulgaris*), anise (*Pimpinella anisum*), sage (*Salvia officinalis*), marjoram (*Origanum vulgare*), basil (*Ocimum basilicum*), borage (*Borago officinalis*), fennel (*Foeniculum vulgare*), parsley (*Petroselinum crispum*), French tarragon (*Artemisia dracunculus*) and mint (*Mentha*). Rosemary (*Rosmarinus officinalis*) is grown in a pot and wintered indoors. There is a very large number of herbs, but growing those most

commonly used in cooking would narrow the list down considerably.

VEGETABLES
5 Legumes and salad crops.
6 Runner beans on cane wigwams.
7 Spinach.
8 Brassicas.
9 Courgettes (zucchini) grow in a pot.
10 Potatoes.

SOFT FRUIT
11 Strawberries.
12 Blackcurrants.
13 Raspberries and redcurrants.

TRAINED FRUIT
Well trained fruit trees provide both decorative structure and produce, and this garden makes exemplary use of many forms. When planning to grow fruit, go to a good nurseryman for advice on the appropriate choice for your area, on root stocks suited to the space available and on compatible varieties for cross pollination. Many fruit tree growers can now supply ready-trained trees and bushes.
14 Standard gooseberries mark the four corners of the brassica bed.
15 Two pairs of dwarf apple trees trained as aerial goblets.

16 Espaliered pear trees line the path.
17 Arbour of espaliered pear trees.

Above Small trained apple trees contribute spring blossom and summer fruit and also form valuable living structure.

Below The view down the cross-axis path looks towards the pear arbour that frames a double iron seat. The apple trees, trained as goblets, stand as sentinels to the vista. Just in front of them are two terracotta jars used to blanch produce such as rhubarb or celery, while behind them rise the outsize leaves of rhubarb.

Left The view across the front garden to the path from the entrance gate. A handsome *Acer palmatum* 'Butterfly' rises above the lantern, and a planting of shrubs and ferns. A carefully sculpted *Nothofagus antarctica* stands at the corner of the house, and fine white gravel, symbolizing the stream of life, ties the different elements together.

Right The vista from half way down the tiny back garden, where the wall of clipped thuja frames an exquisite composition of manicured evergreens, small flowering shrubs and trees set amidst rocks, ferns and moss.

A JAPANESE GARDEN

This remarkable garden has been created over a period of twenty years. It is a passionate attempt to recreate an authentic Japanese garden. Few will wish to emulate this extraordinary and exacting achievement, but it provides inspiration in terms of style, design and planting, and provides an object lesson on the handling of small spaces. Japanese garden tradition consists of miniaturizing and formalizing the essence of natural landscape in a highly sophisticated and symbolic way.

The evolution of the Japanese garden has taken many centuries. Unlike our modern gardens in the western world, Japanese gardens are imbued with an esoteric network of allusions and symbols, all readily understood by the garden visitor. Each garden, however small, embraces a complex series of pictures that evoke mountains and valleys, rivers, lakes or the sea. To interpret these scenes in the way that the Japanese would do so requires intensive study of Japanese garden art and philosophy. Where we see a group of stones placed with aesthetic precision, the Japanese will not only see a whole mountain range, but each stone as a spiritual symbol.

To make a garden exactly like the one that is included here is an aspiration for only the most dedicated, though a richly rewarding one, but the garden still contains many achievable ideas.

ENTRANCE (*left*)
A path leads from the entrance arch or chuman. Traditional Japanese stepping stones are incorporated into the setts, and bamboo is used for the fencing and gate grille.

THE STRUCTURE

These two gardens, in a site that measures 18 x 7 m\60 x 22ft overall at the front and back of a semi-detached house in a village in Holland, are each based on a specific category of Japanese garden. The front garden was inspired by a monastery garden in the hills near Kyoto, and includes features such as a stone slab bridge over a meandering stream of white gravel and a bamboo water-operated deer scare. At the back is a traditional tea garden where a paved area overlooks a pond fed by a waterfall and a miniature landscape of stones, moss, trees, shrubs and ferns.

DEER SCARE

A traditional deer scare inside a bamboo lattice fence in the front garden was originally used to scare off wild boar and deer from crops. Water runs through a thin bamboo pipe into a thicker length of bamboo with a hollowed-out chamber, and as the water empties, the pipe falls back, hitting a rock with a sharp clack. This never-ending movement and sound suggests the process and effects of time on the unchanging elements in the garden.

LANTERNS

Japanese lanterns have complex symbolic associations, though their prime purpose is to illuminate. In the front garden, two lanterns – a snow-viewing lantern and a buried lantern – are sited to light the way to the front door. In the back garden, two light the way to the tea house, and a third is placed near the pond to create reflections. Imported lanterns like these are sometimes available.

WATERFALL

To the Japanese, a waterfall is symbolic of the source of life. It should convey the impression of falling from a stream in a valley behind; it must be sited where sun and moonlight falling on it can be appreciated; and it must have a basin of rocks through and into which the water can plunge, symbolizing the obstacles that everyone has to overcome in their lifetime. With modern electrically powered pumps the construction of a feature like this would pose few problems, but it is essential that the water is kept clean and clear so that it can reflect the surrounding plants.

TEA HOUSE OR CHESAKI

The tea ceremony, an elaborate ritual designed to instill the virtues of modesty, politeness, restraint and sensibility, has an important role in Japanese life, and a tea house has a correspondingly important place in the garden. Here it is simply constructed of a canopy of beams over a paved area, but it commands the key garden picture – the pond and waterfall. A Japanese tea house will contain one spray of flowers in a vase, and the status and attention accorded to that spray explains the virtual absence of flowers that might detract from it in the garden itself. A water spout for ceremonial hand-washing before the tea ceremony stands beside a garden shed disguised by a covering of bamboo matting.

STONES AND STEPPING STONES

Stones are essential elements in a Japanese garden, where each one is carefully chosen and imbued with meaning. For aesthetic reasons, they are placed with studied irregularity, but they are also used to direct visitors through the garden so that they may appreciate its every detail. Stepping stones lead from the house to the pergola – a passage to self-illumination.

THE PLANTING

Japanese planting is based on religious belief rooted first in Shintoism and later in Buddhism; both hold nature in the deepest reverence. The aim once again is the symbolic representation of elements found in nature, and anyone attempting to make a Japanese garden should try to understand the complexities of choice, siting and cultivation of plants. Not only must every plant be in a position that corresponds to its native habitat, but a balanced composition must also be achieved.

Plants will include deciduous trees and shrubs such as cherries, magnolias, azaleas and rhododendrons. Gravel, stone, sagina moss and ferns are used to link the planted elements together. Attention is paid to subtle gradations of colour through the year, and deciduous trees are chosen for their all-year-round beauty, their branch formation, bark texture, leaf shape and changing colour through the seasons.

Anyone embarking on a full-scale Japanese garden would first have to make a prolonged study of Japanese garden philosophy and horticultural practices, including a ruthless and highly sophisticated approach to pruning.

Below Magnolia stellata slowly forms a dense bushy shrub whose fragrant spring flowers precede the leaves.

FRONT AND SIDE GARDENS

1 A flowering cherry.
2 *Acer palmatum* 'Butterfly'.
3 *Sinarundinaria murieliae*.
4 Ranged along the front border are *Ilex crenata* 'Convexa', *Pinus pumila* 'Nana' and *Osmanthus heterophyllus*.
5 *Styrax japonicus*.
6 *Ilex crenata* 'Convexa'.
7 Around the deer scare are *Osmanthus heterophyllus*, *Magnolia stellata* 'Royal Star' and *Pieris japonica* 'Prelude'.
8 *Prunus strobus*.
9 *Acer palmatum* 'Garnet'.
10 A group of *Buxus sempervirens* 'Suffruticosa', Japanese azaleas and *Osmanthus heterophyllus*.
11 Ferns and ophiopogon are tucked in near the stone bridge.
12 Grouped near the corner of the house are *Buxus sempervirens* 'Suffruticosa', *Rhododendron kiusianum* 'Album', *Pinus pumila* 'Nana' and *Pieris japonica* 'Prelude'.
13 *Nothofagus antarctica*.
14 Flowering cherry.
15 *Dryopteris erythrosora*.

BACK GARDEN

16 A group of rhododendrons.
17 *Rhus glabra*.
18 *Osmanthus heterophyllus* grows beneath a mature *Wisteria*

Right This view from the waterfall end of the pond shows the concentrated but carefully placed planting of acers, pieris, azaleas and ferns among the rocks, stones and moss. The pine on the left, a *sine qua non* of every Japanese garden, symbolizes the dignity of the masculine power of longevity.

sinensis 'Alba'.
19 *Magnolia liliiflora* 'Nigra' and rhododendrons.
20 Rhododendrons and ferns.
21 *Acer tataricum ginnala*.
22 A mixed planting of hostas and ferns.
23 A group of pink, white and mauve-flowering Japanese azaleas.
24 *Acer palmatum atropurpureum*.
25 Waterlilies grow in the pool.
26 *Ginkgo biloba*.
27 *Pinus*.
28 *Pieris japonica*.
29 *Acer palmatum dissectum* 'Dissectum Ornatum'.
30 Juniper, pine and rhododendron.
31 *Dryopteris erythrosora*.
32 Clipped thuja hedge.

Right Looking down on the garden gives a vivid impression of the prolific use of climbers and evergreens to make up for the absence of trees and a lawn. The circular pergola around the pond creates the effect of a room within a room and forms a shady cloister in which to sit on sunny days.

Opposite Around the small circular pond there are in the main moisture-loving plants including purple loosestrife (*Lythrum salicaria* 'Robert'), the umbrella plant (*Darmera peltata*) and *Iris sibirica*. A simple container terminates the vista and is framed by an arch covered in climbers.

AN URBAN BOWER

This small courtyard garden brilliantly solves many of the common problems which arise in urban garden-making at the same time as creating a habitat for a stunning array of plants. Its strong ground pattern goes back to the earliest renaissance garden plans, a square or rectangle divided into four quarters with a circle at the centre. There is no room for large trees, but the designer, K.T. Noordhuis, has handsomely met the need for height with a circular pergola enclosing the pond area, an arch, pleached limes as aerial boundary screening, and an abundance of climbers that double the bloom potential of the garden. This defined structure is host to a rich array of both shade-tolerant and sun-loving plants. The basic design is so strong that the planting could be accommodated to any level of commitment: here the scheme is the proud creation of avid gardeners who enjoy spending time tending it, but, with simplification, the format would make a superb low-maintenance town garden.

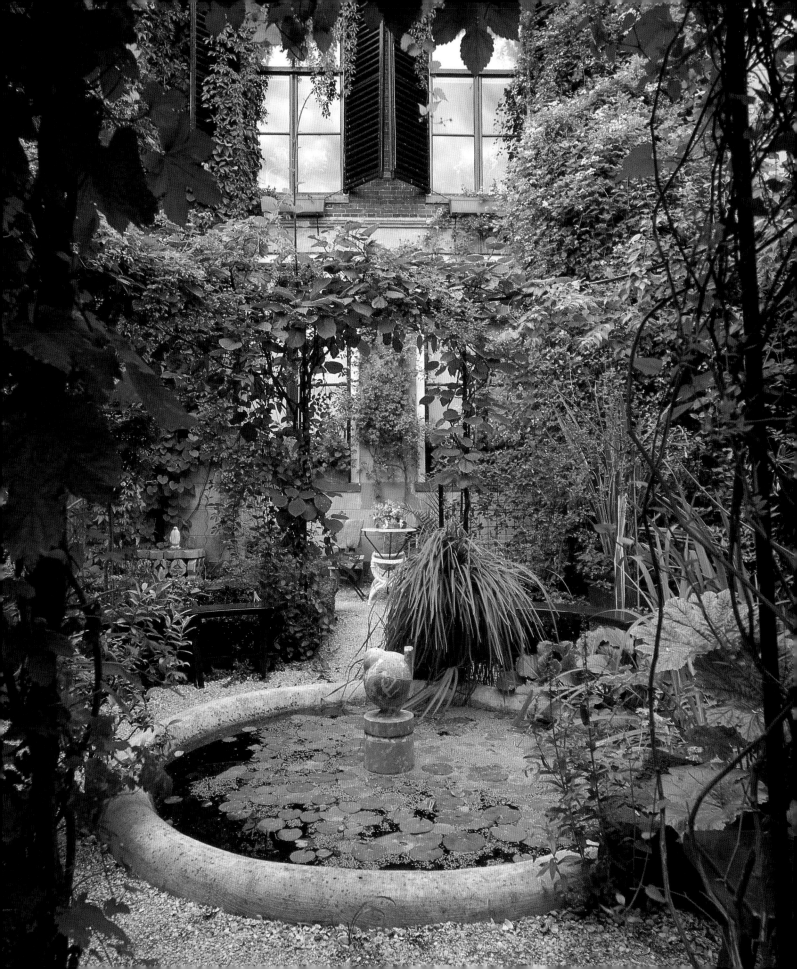

THE STRUCTURE

This is a classic formula adaptable to many sites: an irregular space, roughly 10 x 10 m (32 x 32 ft), has been given a deceptive symmetry by the superimposition of what is almost a square divided into four spandrels. By jamming the formal garden rectangle against two boundary walls, space has been released to make terraces setting off the two façades of the back of the house. Each view across the garden and the central pond terminates in its own special feature: a garden seat, a wall-fountain, a table for dining alfresco and a wall-fountain. Care has also been taken that the cross-axes relate to the architecture of the house, in one case a window and in the other a space between two windows.

AERIAL HEDGING

Pleached lime trees whose branches have been trained along horizontal bamboos make perfect aerial hedging, which is a wonderful means of securing privacy, or screening out unsightly views. The trees will call for an annual winter prune, ruthlessly cutting off all offending branches and twigs, and careful tying in.

PERGOLA

The central cloister pergola is a custom-built but simple cast-iron structure. It creates a circular central room furnished with four symmetrically arranged black-painted curved wooden benches.

WATER FEATURES (*left*)

The circular pond is the garden's focal point and the water acts as a mirror reflecting light into the courtyard. The coping is of a kind that is available in reconstituted stone. The water is pumped around a circuit via a rivulet to the elaborate wall-fountain. The pump also oxygenates the water. As the fountain – a stylized bird on a column – is only the barest trickle, the water in the pond remains virtually undisturbed and so therefore it is possible to grow water lilies and marginals.

ARCHES AND PILLARS
Cast-iron arches preside over three of the entrances to the central paths, each framing a viewpoint. These and the wire-mesh pillars provide support for climbers. Painted or stained wood may be less durable and require more maintenance but would be an attractive, cheaper alternative.

BOX HEDGING
Low evergreen box hedging defines the ground pattern and holds in the spandrel flowerbeds. Other possibilities, though less satisfactory would be euonymus, *Lonicera nitida* or yew, although it would be difficult to keep them so low. All call for annual clipping, regular feeding and, from time to time, the severance of roots that have invaded the flowerbed.

PATHS
All the paths are covered in small shells laid over old tiles. The pale shells lighten the effect but make the courtyard appear bigger than it is. Gravel, stone or brick would be alternatives, but when making the choice, always take the materials of the house into consideration.

THE PLANTING

This is a beautifully and skilfully planted garden. Careful attention has been paid to every season. Planted so that they grow up between other plants, hundreds of small bulbs including *Anemone blanda*, chionodoxa, crocus, fritillaries, iris and narcissi and snowdrops flower in spring, followed by allium and lilies in summer and cyclamen and *Crocus sativus* in autumn. In particular it is a lesson in the use of climbers which add leaf and bloom for many seasons and virtually double the ground-level planting. The climbers involve a major labour commitment: they need annual pruning, training and tying-in to ensure that they are contained. The plants in the beds also call for pruning, cutting down, staking and general attention. Each bed is intensively cultivated, so constant enrichment of the soil is essential. To reduce the work load, it would be possible to simplify the planting by choosing climbers that require minimal pruning, and fill the spandrel beds with ground-cover perennials, putting a strong evergreen vertical accent such as a clipped juniper or a sculptural feature such as a puttio to represent each of the seasons at the centre of each bed.

1 The four spandrel beds are enclosed by dwarf box

Below Epimedium x rubrum *is excellent evergreen ground cover that tolerates sun or shade.*

hedging (*Buxus sempervirens* 'Suffruticosa').

SOUTH SPANDREL BED
2 *Hedera helix* clambers up the shady walls.
3 *Skimmia japonica* and *Pieris japonica* are surrounded by *Primula beesiana*, *P. bulleyana* and *P. florindae*.
4 Ivy-leaved toadflax, greater celandine and red Mollis azaleas.
5 *Caragana arborescens* 'Pendula' makes a strong vertical feature in the middle of the bed.

WEST SPANDREL BED
6 *Lamium orvala*, epimedium, *Cornus sericea* and ferns including *Matteuccia struthiopteris*.
7 *Paeonia suffruticosa*.
8 *Helleborus viridis*, *H. niger* and codonopsis.

NORTH SPANDREL BED
9 Vinca, hosta, campanula and sedum.
10 *Ligustrum ovalifolium* 'Aureum' is trained as a mophead.
11 *Viola riviniana*

Purpurea Group, *V. sororia* and cleomes.
12 Mahonia and *Tiarella cordifolia*.

EAST SPANDREL BED
13 Ferns, Soloman's seal, figwort (*Scrophularia*) and marsh marigolds (*Caltha palustris*) make the most of the shade and moisture near the wall fountain.
14 *Rosa* 'Red Dorothy Perkins' on a support makes the vertical centrepiece.
14 Several varieties of *Ajuga reptans* make good

ground-cover.
15 Hostas.
16 *Symphytum ibericum.*

POND
17 Small waterlilies are
planted in the pond.
18 Nearby are the
umbrella plant (*Darmera
peltatua*), *Lythrum
salicaria* 'Robert', *Salix
helvetica*, *Bergenia
cordifolia*, *Iris sibirica* and
*Sisyrinchium
angustifolium.*

CIRCULAR PERGOLA
19 This is covered in a
mixture of evergreen and
flowering climbers
including scented
honeysuckle (*Lonicera
henryi* and *L. japonica*
'Halliana'), *Humulus
lupulus*, American
Bittersweets (*Celastrus
scandens* (f) and *C.s.*

'Hercules' (m)'), actinidia
hybrids (m and f), potato
vines (*Solanum
jasminoides* 'Album' and
S. dulcamara 'Variegatum').

ARCHES AND PILLARS
20 *Clematis tangutica, C.
tibetana vernayi* and
Hedera helix 'Goldheart'.
21 *Clematis vitalba.*
22 *Parthenocissus
quinquefolia.*

AERIAL HEDGING
23 Pleached lines (*Tilia
platyphyllos* 'Rubra') are
trained as an aerial scren
over the gate and flanking
the wall fountain. Against
each is planted a Viticella
hybrid clematis: 'Minuet',
'Little Nell' and 'Etoile
Violette'.
24 Fruiting red currants
and Japanese wine berry
are trained along a frame.

Below Fritillaria meleagris is a spring flowering bulb that is
best left to naturalize in shade.

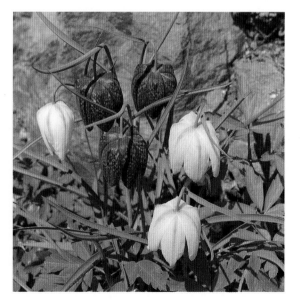

ENCLOSING WALLS
25 *Clematis tangutica*
climbs over the tiled roof.
26 Each of the climbers
that clothe the walls has
been carefully selected
according to the aspect,
so that shady walls are
covered with *Hedera helix*
and *H. colchica* 'Dentata
Variegata', *Hygrangea
anomala petiolaris* ,
*Kadsura japonica,
Euonymus fortunei* 'Silver
Queen' and *Jasminum
nudiflorum.* Sunnier walls
are host to *Ceanothus* x
delileanus 'Gloire de

Versailles'. *Buddleja* 'Ile
de France', *Wisteria
sinensis, Campsis
radicans, Solanum
crispum* 'Glasnevin' *and
Passiflora caerulea.*
Among other climbers are
*Clematis alpina, C.
montana, C.* 'Mrs Robert
Brydon', *C.* 'Mrs
Cholmondeley' and *C.*
'Royal Velours'.

CONTAINERS
27 Ferns, agapanthus and
agaves can be moved to
suit their shade or sun
requirements.

Above Like all the beds,
the north spandrel is
densely planted. Beneath
the mophead ligustrum
are *Campanula carpatica*,
vinca, *Meconopsis
betonicifolia, Saxifraga
cortusifolia fortunei*,
sedum, mahonia and
Tiarella cordifolia.

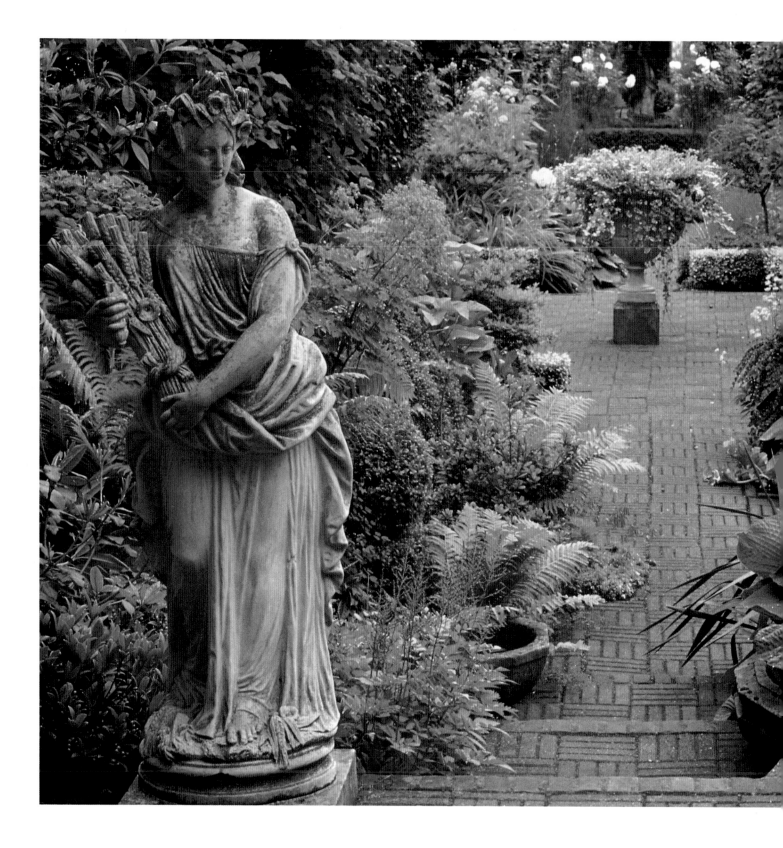

A SIX-STAGE GARDEN

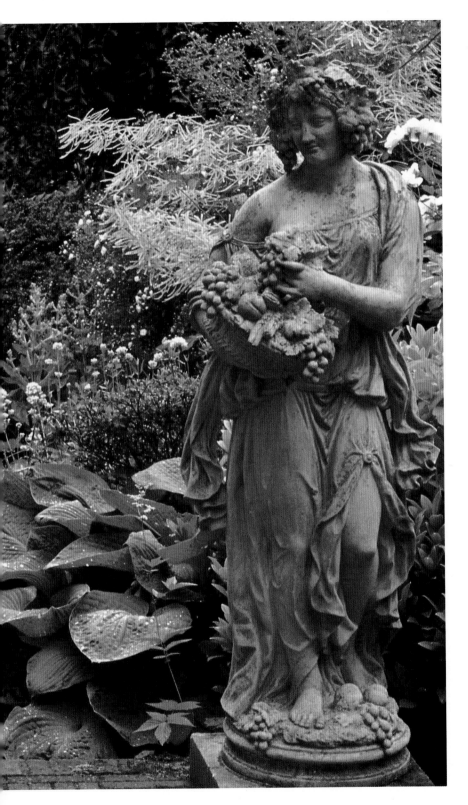

This ambitious and perfectly articulated narrow town garden marries a rich and abundant planting with an unerring sense of geometry. An understated terrace next to the house acts as a forecourt from which an enchantingly luxuriant vista progresses through another five contrasting garden experiences. Statues stand at the head of the steps, and from here lavishly planted mixed borders lead to a formal enclosure where symmetrical planting bordered by box hedging surrounds a stone vase on a pedestal. A second pair of borders follow, and then comes the climax: a rose and herb garden of geometric simplicity, enclosed by a beech hedge and presided over by an arbour spangled with roses and clematis, with a statue embowered within. A final coda introduces a simple summerhouse with a marble pillared entrance, reached by a small bridge separating two lily ponds.

This plant-lover's paradise is crammed with some two hundred trees, shrubs, climbers, roses and herbaceous perennials, as well as having box and beech hedging; even waterlilies find a place. All this requires a dedicated horticultural commitment to ensure that the garden is in top condition at all times of the year. However, the whole area is paved, so there is no mowing, and the strong structure containing the plants means that a complex garden such as this could be kept in perfect order by someone working the equivalent of one afternoon a week throughout the year.

Statues of Ceres and Pomona frame the garden's central axis, emphasizing the strong architectural framework. Foliage, particularly of hosta, astilbe, ferns and box hedging breaks the line of the brick paving, and the eye is led past the vase to the rose garden with its central statue.

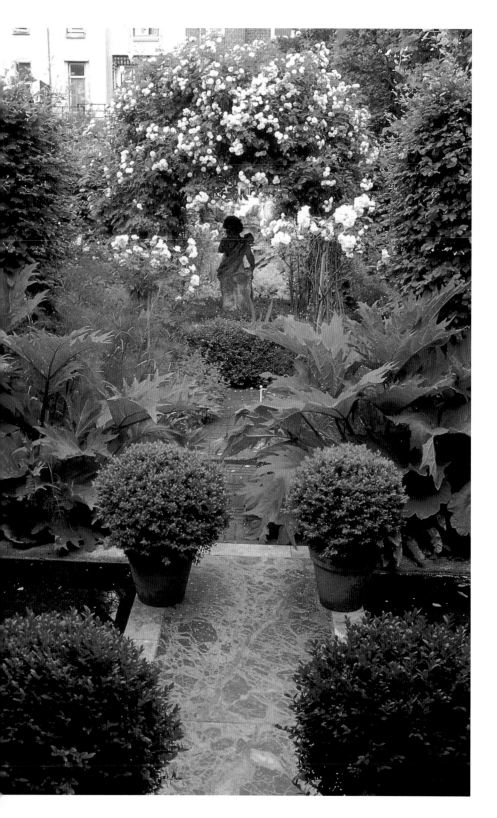

THE STRUCTURE

In this long narrow site of about 6 x 33m \20 x 110ft, the controlling element is the central axis which widens and narrows to bind together a succession of contrasting gardens. The different areas change from open to closed and from informal to formal, with the planting in different colour schemes reflecting these changes. The result is that the garden seems bigger than it actually is. A plan of this kind offers endless possibilities of adaption – rearranging the sequence according to the space

CENTRAL VISTA (*left*)
The view from the summerhouse at the far end of the garden leads past clipped box balls on the marble bridge and the stately foliage of *Rheum palmatum* to the rose and herb garden. Standard 'Iceberg' roses frame a statue beneath an arbour covered in a tumbling canopy of *Rosa* 'Félicité Perpétue' and climbing *R.* 'Souvenir de la Malmaison'.

PONDS (*right*)
Water spouts into troughs that overflow into the lily pools, adding movement and sound to the composition. Small central water jets would be an alternative way of achieving this.

ROSE AND HERB GARDEN

This garden is formed of squares within a perfect square. An arched iron frame rising from the four corners of the central bed forms a canopy smothered in climbing roses and clematis, and provides shelter for a statue. A similar structure could also be made of painted wood and trellis or even, though less attractively, of plasticized metal alloy. Rails make delightful and unexpected frames for the herb beds, each planted with a standard rose.

VASE GARDEN

A formal interlude between the two pairs of long borders, the planting is structural and repetitive. Behind a rectangle defined by a low clipped hedge of *Buxus sempervirens* and *B.s.* 'Latifolia Maculata' is a mirror planting of clipped weeping purple beech alternating with box cubes and underplanted with ferns. The vase overflows with helichrysum, verbena and glechoma.

PAVING

The frost-resistant bricks are inexpensive, durable, and easily swept. Their small size makes the garden appear larger than it is, and their uniformity provides good foil to the luxurious planting.

ORNAMENTS

The flanking statues on the terrace make a stunning entrance to the garden, just as the marble pillared archway does at the far end: but neither is essential to the overall design. The beautiful stone vase on its pedestal, on the other hand, and the arbour in the rose garden, are essential ingredients of the garden plan. Of course, alternative objects could be used, and there are plenty of well-designed garden ornaments in terracotta or reconstituted stone on the market today.

THE PLANTING

Most of the planting is concentrated in the two parallel but irregularly indented borders that run virtually the entire length of the garden. Colour schemes are carefully planned, and many plants are chosen for their foliage.

WATER GARDEN

1 *Wisteria sinensis* 'Alba' and *Rosa* 'Veilchenblau' are trained along the front of the summerhouse.

2 The pools contain red *Nymphaea* Hybrids.

3 The bridge is punctuated by box clipped balls in pots.

4 The two beds have mirror-image plantings of *Foeniculum vulgare* 'Purpureum', *Artemisia schmidtiana*, *Rheum palmatum*, *Hydrangea arborescens* 'Annabelle', *Heuchera* 'Pluie de Feu' *Asplenium scolopendrium*, and *Alchemilla mollis*.

ROSE AND HERB GARDEN

5 A hedge of *Fagus sylvatica* encloses the area.

6 A low inner and outer hedge of *Buxus sempervirens*, infilled with blue *Iris germanica*, contains the arbour which supports *Rosa* 'Félicité Perpétue', *R.* 'Climbing Wedding Day', *R.* 'Souvenir de la Malmaison', *Clematis* 'Pink Fantasy', *C.* 'Etoile Violette', and the white, repeat-flowering Bourbon *Rosa* 'Boule de Neige'.

7 The twelve small square beds each contain a standard rose: the four corner beds *R.* 'Ice Fairy', and the rest 'Iceberg'. Each is underplanted with a different herb.

FIRST BORDER GARDEN

The south-facing bed concentrates on blues, lilacs, pinks and whites while the north-facing bed opposite has warmer creams, yellows and apricots offset by ferns and evergreens.

8 A container overflowing with *Alchemilla mollis*, and also *Primula veris*.

9 Larger shrubs and perennials give height at the back: purple and lilac *Syringa vulgaris*, white *Hibiscus syriacus*, *Hydrangea aspera sargentiana*, *Rosa glauca* (syn. *R. rubrifolia*) and *Salvia sclarea*.

10 In the middle ground are a blue *Hydrangea macrophylla*, *Aquilegia alpina*, *Viburnum opulus* 'Roseum', *Aconitum* 'Spark's Variety', a blue *Delphinium* hybrid, *Phlox paniculata* 'Amethyst', *Thalictrum rochebrunanum*, a standard *Rosa* 'Charles de Gaulle', *R.* 'Königin von Dänemark' and *Hosta seiboldiana* var. *elegans*.

11 Closer to the path are *Artemisia schmidtiana*, *Geranium* 'Johnson's Blue', *Iris sibirica* 'Caesar', *Hebe pinguifolia* 'Pagei', *Nepeta* x *faassenii*, *Pulmonaria angustifolia*, *Viola* 'Molly Sanderson', bearded iris 'Dusky Dancer', *Ajuga reptans* 'Atropurpurea', *Brunnera macrophylla*, *Veronica gentianoides*,

Left Looking over a bank of *Alchemilla mollis* and through the beech hedge to the rose and herb garden and its rose-bedecked arbour. Two neatly railed beds are filled with herbs beneath standard 'Iceberg' roses.

Viola odorata 'Alba', Lavandula angustifolia, Viola odorata, two clipped box balls, Centaurea montana, Gypsophila paniculata 'Bristol Fairy', Salvia nemorosa 'Mainacht', Anchusa azurea and Rhododendron 'Blue Tit'.
12 At the back of the north-facing bed, under the beech hedge, are Corylus avellana, Matteuccia struthiopteris, Kirengeshoma palmata, Aruncus dioicus, Osmunda regalis, Ilex aquifolium and Scabiosa caucasica 'Bressingham White'.
13 In the centre are two standard Chamaecyparis, Ligularia przewalskii, Angelica archangelica 'Sativa', two standard Rosa 'Dutch Gold', Hydrangea quercifolia, Aconitum lamarckii, an apricot Azalea Hybrid and Hydrangea arborescens 'Annabelle'.
14 In the foreground are Artemisia schmidtiana, Lamium galeobdolon 'Florentinum', Euphorbia

amygdaloides, Hosta fortunei aureomarginata, Corydalis lutea, two Buxus sempervirens, Hemerocallis altissima, Hydrangea paniculata 'Grandiflora', Alchemilla mollis, Artemisia ludoviciana 'Silver Queen', two standard Chamaecyparis obtusa 'Nana gracilis', Hosta 'Zounds', H. fortunei and Hemerocallis 'Carthage'.

VASE GARDEN
15 The vase is planted with Helichrysum petiolare, purple Verbena and Glechoma hederacea 'Variegata'.
16 Contained by a low mixed hedge of Buxus sempervirens and B.s. 'Latifolia Maculata', the two mirror-image borders in this garden introduce a dramatic change of colour and scale.
17 Each border contains three weeping Fagus sylvatica 'Purpurea Pendula', with clipped box cubes between, and underplanted with Osmunda regalis.

18 The climbers on the north wall are Lonicera henryi and Clematis vitalba.

SECOND BORDER GARDEN
19 Climbers on the wall behind this border are Hedera helix and Clematis florida bicolor 'Sieboldii'.
20 The south facing 'white' border has a background planting of Osmunda regalis, standard Rosa 'Iceberg' and R. 'White Dorothy', Aruncus dioicus, Hydrangea paniculata 'Grandiflora' and Cornus kousa.
21 In the middle ground are Hydrangea arborescens 'Annabelle', Crambe cordifolia, Phlox paniculata 'Fujiyama', a standard Rosa 'Iceberg' and Rhododendron 'Alice'.
22 In front of these, along the path, are Hesperis matronalis, two Paeonia suffruticosa, Salvia argentea, Geranium richardsonii, Viola odorata, Astrantia major, Iris germanica, Hosta sieboldiana elegans, Crambe maritima, Rosa 'Snow Carpet', a standard Cotoneaster, Epimedium x youngianum 'Yenomoto', Cerastium tomentosum, two clipped balls of Buxus sempervirens, Anemone x hybrida 'Honorine

Jobert', Iris 'Babyface', Saponaria ocymoides, Artemisia ludoviciana, a white Azalea Hybrid and Filipendula purpurea alba.
23 At the back of the north-facing border, which is dominated by strong pinks and whites are three Rhododendron Hybrids and Syringa x chinensis.

Below Kirengeshoma palmata, a shade-tolerant shrub, useful for its interesting foliage and late summer flowers.

24 In the middle ground are Hydrangea macrophylla 'Teller's Pink', Phlox paniculata, a standard Ribes sanguineum, two standard Rosa 'Sexy Rexy' and Fuchsia magellanica are interspersed with more Osmunda regalis.
25 In front are two bright pink Azalea Hybrids, Sempervivum tectorum, Geranium macrorrhizum, four clipped balls of Buxus sempervirens, Anemone x hybrida 'Königin Charlotte', a pink

Geranium, a pink Paeonia Hybrid, two Dicentra formosa, Astilbe 'Europa' and Skimmia reevesiana.

HOUSE TERRACE
26 The climbers on the south-facing wall include Wisteria sinensis that is trained on to the house, and three clematis – two

C.'Capitaine Thuilleaux' and one C. 'Marie Boisselot' – as well as a Jasminum nudiflorum to flower in the winter.
27 At either end of the bed below are standard Rosa 'The Fairy', and in between, Hydrangea macrophylla is underplanted with Primula veris.
28 On the wall opposite are Rosa filipes 'Kiftsgate' and Hedera helix.
29 Chamaecyparis pisifera are planted for screening behind Rhododendron Hybrids.

INDEX

ACKNOWLEDGMENTS

The publisher thanks the photographers and organizations for their kind permission to reproduce the photographs on the following pages in this book:

Endpapers Vincent Motte; 1 Eric Crichton; 2-3 Garden Picture Library /Marijke Heuff; 5 Jerry Harpur; 6 Andrew Lawson; 7-8 Oman Productions Ltd; 9 Clive Nichols; 10 Andrew Lawson; 11 Oman Productions Ltd; 12-13 Architecture & Wohnen /Arwed Voss; 14 Brigitte Perdereau /designer Timothy Vaughan; 15 Marianne Majerus (sculpture by Alexander Relph); 16-17 Marijke Heuff (Mr & Mrs Voûte-van Heerde); 18 Lanny Provo /artist John Millan (John Cram/Kenilworth gardens, Asheville NC); 19 S&O Mathews; 20 Neil Campbell-Sharp; 21 Brigitte Perdereau /designer Timothy Vaughan; 22-23 Ianthe Ruthven (Georgie Walton); 25 Andrew Lawson; 26-27 Marijke Heuff (Margot Voorhoeve-van Suchtelen); 29 Marijke Heuff (Mr & Mrs Van Groeningen-Hazenberg); 31 Marijke Heuff (Mr & Mrs Van Groeningen-Hazenberg); 32-34 Brigitte Perdereau (François Catroux); 35 Andrew Lawson; 36-38 Jerry Harpur (Jacqui and Colin Small); 39 Clive Nichols; 40-41 Garden Picture Library /Henk Dijkman /designer Dick Beyer; 43 Andrew Lawson; 44-45 Elizabeth Whiting & Associates /Andreas von Einsiedel /designer Christopher Masson (Lee Wheeler); 47 S&O Mathews; 48-50 Garden Picture Library /Henk Dijkman /designer Mien Ruys; 51 S&O Mathews; 52-54 Neil Campbell-Sharp /designer Arabella Lenox-Boyd (Irène Beard); 55 Tania Midgley; 56-57 Marijke Heuff /designer Els Proost (Mr & Mrs Bakker-Mulder); 58 Andrew Lawson /designer Anthony Noel; 60 Christian Sarramon; 61 Marijke Heuff /designer Els Proost (Mr & Mrs Arends-Buying); 62 Jerry Harpur /Malcolm Hillier; 62-63 Ben Loftus /designer Ben Loftus (Carrie Hart); 64-65 Neil Campbell-Sharp (Mike & Wendy Perry); 66-68 Garden Picture Library /Ron Sutherland (Ann Mollo); 69 S&O Mathews; 70-74 Rob Gray /designer Adele Mitchell; 76-79 Jerry Harpur /designer Sonny Garcia (Genevieve di san Faustino); 80 above Jerry Harpur /designer Sonny Garcia (Genevieve di san Faustino); 80 below Andrew Lawson; 81 Photos Horticultural; 82-84 Jerry Harpur /designer Judith Sharpe (Liz and Nick Bliss); 86 left Tania Midgley; 86 right Photos Horticultural; 87 Jerry Harpur /designer Judith Sharpe (Liz and Nick Bliss); 88-92 Garden Picture Library /Steve Wooster /designer Henk Weijers; 93 Photos Horticultural; 94-97 George Lévêque /designer André van Wassenhove; 99 above Photos Horticultural; 99 below George Lévêque /designer André van Wassenhove; 100-101 George Lévêque (Mrs Etta de Haes, Middleburg); 102 Karen Bussolini; 103 Jerry Harpur (Lucy Gent); 104 Christian Sarramon; 105 Marijke Heuff /designer Liesbeth Sillem (Riny Blaisse); 106-107 Mick Hales /designer Dean Riddle; 108 Graeme Moore; 109 Marianne Majerus /designer Peter Aldington; 110-113 right Jerry Harpur /designer Sonny Garcia; 114 left Jerry Harpur /designer Sonny Garcia; 114 right Photos Horticultural; 116 Marijke Heuff (Ineke Greve); 117 George Lévêque (Ineke Greve); 118 Marijke Heuff (Ineke Greve); 120 Photos Horticultural; 121 above Eric Crichton; 121 below Marijke Heuff (Ineke Greve); 122-124 Garden Picture Library /Henk Dijkman (Geert Jansen); 126 Andrew Lawson; 127 Garden Picture Library /Henk Dijkman (Geert Jansen); 128-130 Garden Picture Library /Henk Dijkman /designer K T Noordhuis; 132 Photos Horticultural; 133 above Marijke Heuff /designer K T Noordhuis; 133 below Photos Horticultural; 134-138 Marijke Heuff (Pierre & Anne-Marie Feijen, Manu, Breda); 139 Garden Picture Library /Brian Carter.